The Complete Graphic Works of Ben Shahn

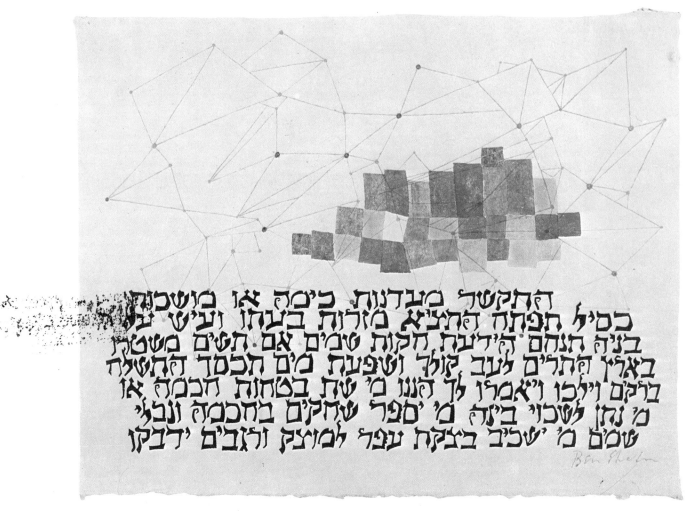

Figure 42 — PLEIADES. 1960

The Complete Graphic Works of Ben Shahn

Kenneth W. Prescott

Quadrangle/The New York Times Book Co.

128280

Library of Congress Catalog Card Number: 73-79928

International Standard Book Number: 0-8129-0367-6

Designed by George Goodstadt

To
Emma-Stina

CONTENTS

PREFACE

Having been an avid collector for many years of books, prints, drawings and miniatures, I have gradually become aware that besides collecting these specific objects, I have simultaneously been collecting people. It is this last factor which contributes so much to the collector's enjoyment and enthusiasm.

Among the people collected, Ben Shahn was one of the rarest and most cherished. I knew well that he did not belong to me alone; hosts of others felt the same way about him: that he was a valued friend, a delightful companion, a wise and sincere man.

What was there about this quiet, forceful character that endeared him to so many? I think it was his ability to transform the best of the old into new and vital forms and channels; his wry sense of humor; his profound consciousness of and concern for the injustices and tragedies of the world in which we live; his great joy of life and deep sympathy for the "underdog."

Ben's method of presentation was symbolic of the man himself. Very often he would use lettering as an integral part of a biting protest against oppression or as an expression of deep spiritual feeling, the words combining esthetically with the image. He acquired his own personal alphabets from close study, great effort, and endless practice. He was equally conscientious in delineating what he had to say and how he said it. His lettering symbolized, for me, his pertinacity and erudition, while his art spoke for his sincerity and understanding.

All who knew him will treasure his memory and will be better citizens by reason of his modesty, his fearlessness, and his example.

LESSING J. ROSENWALD

FOREWORD AND ACKNOWLEDGMENTS

Shortly after assuming the post of director of the New Jersey State Museum in the fall of 1963, I initiated a policy of assembling a significant collection of Ben Shahn prints. I had long been an admirer of Shahn's art and it seemed a fitting way of focusing attention on the work of this internationally acclaimed artist who had chosen New Jersey as his home state. Collecting Shahn drawings or paintings was, for financial reasons, out of the question, and the museum already owned several Shahn prints. The lack of a State Museum purchase fund suggested that even assembling a print collection was overly ambitious. However, the Treasurer of the State of New Jersey agreed that occasional purchases of prints could be authorized from existing State Museum funds and that I could use unrestricted financial contributions to purchase art for the museum collection. Armed with this authority, I made my first appointment to call on Ben Shahn in Roosevelt, New Jersey. His friendly smile, the direct and open discussions seasoned with cups of Bernarda Bryson Shahn's unexpectedly strong and delicious coffee, marked the beginning of a warm personal relationship. My subsequent immersion in the varied world of Shahn's graphic work finally led me to undertake the writing of this book. At first, due to insufficient funds, the growth of the collection was slow, though steady. Whenever money became available, I would phone Shahn to learn if I might come to his studio to pick another print for the collection. Together we would examine his latest works, discussing their meaning, and relating them to earlier pieces.

As the embryonic collection began to develop, donors and collectors caught the spirit and importance of the venture, and their generosity allowed the purchase of many prints until, by the time of Shahn's death in 1969, the State Museum's collection of his graphics was the most extensive to be found in any institution. Yet, it was far from being the definitive collection I wanted it to be. In the year and a half that followed, a great number of works came to light and were made available with the cooperation of Shahn's dealer, Lawrence A. Fleischman, and the Shahn Estate. With the patient and generous help of donors, many experimental variations and other rare prints were acquired.

The elusive goal finally became a reality. The definitive collection of Shahn graphics is now assembled and housed at the New Jersey State Museum. Based on the best information available to me, the collection is complete, although it is possible that a unique print or an experimental state of a known work has not yet come to light. It was not unusual, for instance, for Shahn to give copies of works-in-progress to close friends who happened to call at his studio. In this manner, I suspect, a number of trial proofs, early states of prints, or even experimental color proofs may have escaped my attention.

In the museum collection and in this book I have included photo-offset and letterpress reproductions. I have done this for several reasons: first, because Shahn himself kept photo-reproduction copies of some drawings and paintings that had been commissioned for commercial purposes. These he sometimes signed and inscribed to friends as mementos of their visits to his studio. (The existence of such signed works can cause the print collector some uneasy moments.) Shahn also authorized reproduction of some drawings to be used as greeting cards and note paper. All known reproductions of these types are included in *Part Four* and should be regarded as quite distinct from the fine arts prints: the serigraphs, lithographs, and wood-engravings. Another reason for including photo-reproductions in this book is that they further illustrate Shahn's versatility.

In the following pages, where attention has been drawn to illustrations in other books, I have been careful to footnote the source so that the interested reader can track down the reference. In most instances, this has been done in order to give the reader a better grasp of the way in which Shahn reworked images and concepts over and over again. Although I have attempted to correlate all such relationships among the prints, it sometimes seemed prudent to refer also to certain corresponding examples found in Shahn's paintings and drawings.

The seemingly insignificant details listed in the print descriptions may not be welcomed by the casual reader. Yet, because questions have arisen concerning print variations, sizes, papers, colors, etc., it seemed best to include all information in order to insure accurate identification. The illustrations and their descriptions should adequately identify every Shahn graphic known at this writing. Fraudulent reproductions of some black and white prints, however, are extremely difficult to identify and virtually impossible to detect when framed. The collector should be wary of unusual "bargains" that are priced substantially below market value, and should have the authenticity of such prints verified by a museum curator or by a reputable dealer.

ORGANIZATION

For the convenience of the reader, Shahn's graphics have been artificially grouped into four classes and arranged accordingly:

Part One — Prints, including serigraphs, lithographs, and wood-engravings, produced or authorized to be produced by Shahn, and issued individually (i.e., not in portfolios or as posters);

Part Two — Portfolios, including graphics, regardless of medium, produced or authorized by Shahn and issued in portfolio editions;

Part Three — Posters, in all mediums, including some exhibition posters reproduced from Shahn paintings;

Part Four — Miscellaneous Reproductions and Greeting Cards, including copies known to have been signed or inscribed by Shahn as gifts for friends; *Unpublished Works* and *Works Published Post-humously,* including the two major lithographic series Psalm 150 and the Hallelujah Suite.

Shahn did not make a practice of dating graphic work. The attributed dates are based on the best evidence known to me, i.e., correlations with other published material, Bernarda Shahn's recollections, correspondence with museum officials, galleries' and publishers' records, my memory, and so on; but the assigned dates are not infallible. The graphics are arranged chronologically by year within each part of the book. Although this arrangement gives a clearer view of the evolution of Shahn's style, it may pose a problem for those looking for particular works without knowing their dates. In such cases, the index will be helpful.

DESCRIPTIVE FORMAT

Each of Shahn's graphics is illustrated here in black-and-white or color. Descriptive information is given with each illustration, beginning with the technical data: print medium, measurements, edition, type of paper, the nature of the signature, etc. The accession number refers to the specific impression being described. Measurements are in inches, to the nearest one-eighth, with height preceding width. In signature descriptions, the italicized portion indicates exactly the lettering as it appears on that particular impression. The types of paper were determined on the basis of water mark and information supplied by the publisher. When all other sources were exhausted, I relied on the informed judgment of Alexander J. Yow, Conservator at the Pierpont Morgan Library, who was kind enough to travel to Trenton to examine and identify the many undocumented papers.

The type of print (serigraph, lithograph, etc.), is listed beneath each title. In general, the attributions given here agree with available sources

except in the case of some posters. The posters, together with the reproductions included in *Part Four,* were closely examined by Jacques Mourlot, then of Mourlot Graphics Ltd., New York, and represent his considered judgment of the process. The responsibility for errors is mine alone since, in the end, I had to decide whether to accept or reject those few recommendations that were at variance with information accorded elsewhere. Mourlot also read the descriptions of Shahn lithographs printed in his New York studio and at his father's studio in Paris, suggesting minor changes.

There will always be uncertainty as to the size of many Shahn editions since Shahn was philosophically opposed to numbering his prints. Although he did number much of his late work (e.g., "10/75" or, occasionally, "75/10.") the figures still do not account for artists' proofs, which are rarely recorded and about which we have little reliable information. Edition sizes given in earlier publications are not always accurate, and various museum records sometimes give conflicting information. Shahn did keep records. Whenever I bought prints from him, he carefully noted my purchases on long slips of drawing paper, one for each title, which he kept in his studio. However, Bernarda Shahn and I have been unable to find these important records and we presume them to be lost.

Most of the edition sizes given here are estimates based on the number of prints known to exist in private and public collections, on information gathered from sales records of The Downtown and Kennedy Galleries, and on prints remaining in the Shahn Estate. However, where Shahn wrote an edition number on a print, this has been used. Barring the unlikely event that Shahn's written records will be found, I am afraid we shall never have more exact edition information than that given here.

ACKNOWLEDGMENTS

Although donor credits are included with the technical descriptions of the prints, I want to mention the consistent support received from the Association for the Arts of the New Jersey State Museum. I also wish to acknowledge the important roles played by three contributors, without whose support, advice, and encouragement the collection could never have been assembled. Shortly after Shahn's death, wondering whether to continue toward my goal of assembling a complete collection of Shahn graphics, I sought the advice of Lessing J. Rosenwald, the eminent collector and authority on prints. I asked him if he thought such a collection would be an important contribution to the history of art and valuable in documenting Shahn's career. Then, too, I wondered if Shahn collectors and enthusiasts from around the country would rally to the project, even though they may have little knowledge of the New Jersey State

Museum. Mr. Rosenwald's positive and encouraging response to these questions confirmed my resolve. Later, thanks to contributions from his foundation, I had the pleasure of affixing his name to several rare acquisitions. My deep appreciation goes to Barbara Wescott (Mrs. L. B. Wescott) and Esther Johnson (Mrs. J. Seward Johnson), donors and friends, who not only gave generously of their own time and funds, but also helped elicit gifts from other sources. To those who contributed to the project but wished to do so anonymously, I also extend my thanks.

During the years of collecting and research, Bernarda Bryson Shahn graciously shared her time and knowledge. Her enthusiasm and assistance are gratefully acknowledged. To Lawrence A. Fleischman of the Kennedy Galleries, a special note of appreciation is due since this book would not have been written, at least by me, without his cooperation. In a sense, the book is his child; he conceived of it, and was convinced from the beginning that it should include a description and illustration of every known Shahn graphic. He gave unstintingly of his time and knowledge—a knowledge based on many years of friendship with Shahn. Moreover, he authorized the full cooperation of the galleries' staff members, who gave considerably of their time and talents. Fleischman's faith in the project, and his good-natured prodding have been extremely important in helping me overcome a very understandable hesitancy to publish my research in a field which I embrace with greater enthusiasm than preparation, since my formal training was concentrated in the fascinating but hardly related field of ornithology.

I am indebted also to Morris (Moshe) Bressler, Shahn's neighborhood friend, who shared with me his knowledge of Hebrew characters and historic literature. His translations when included in this book vary, in some instances, from those published elsewhere, but are used in preference to other versions because it was he who originally worked with Shahn on the Hebrew themes. In spite of his early background, Shahn was not knowledgeable in the intricacies of Hebrew translations. The important role that Bressler played in suggesting appropriate themes, checking the literature, and verifying the characters written by Shahn has not been previously acknowledged in print. It is a pleasure to be able to do so here. Bressler's son Martin was also most helpful to me. He had grown up knowing Shahn (the Bressler and Shahn homes were on the same block in Roosevelt) and Shahn had retained him as his lawyer toward the end of his life. Subsequent to Shahn's death, Martin Bressler became executor of the Shahn Estate.

The State Museum staff cooperated not only in a professional capacity but also with personal enthusiasm. Mrs. Leah Phyfer Sloshberg, then Assistant Director, now Director, and Zoltan F. Buki, Curator of Art, good-naturedly accepted the additional workload that this project imposed upon them. Mrs. Karen Copeland, Art Registrar, carefully checked all measurements, accession numbers, donors' credits, etc. against those in the State Museum files and called my attention to discrepancies that otherwise would have passed unnoticed. Mrs. Peggy Lewis, then State Museum Publications Editor, prepared the initial Shahn bibliography (Appendix B). My warm thanks go to all of them.

During the several years involved in preparing this book, two secretarial assistants devoted much of their personal time to typing the manuscript and to attending to the voluminous correspondence. To Miss Carol Yopp and Miss Connie de Remiges I am deeply indebted. Miss Susan Rumfort, Supervisor of General Reference, and her staff at the New Jersey State Library, were most helpful in locating obtuse quotations and references. Mrs. Alan Hart read and critically evaluated Part One and offered helpful suggestions for the narrative descriptions. I am grateful, also to Geoffrey Clements, not only for his excellent photographs but also for his friendly cooperation and advice. It is a special pleasure to recognize the contributions made by George J. Goodstadt in the design and layout of this book, and those of Thomas Froncek, the editor, for his helpful suggestions and general assistance with the manuscript.

I do not believe that a serious work on Ben Shahn's graphics could be written without reference to Kneeland McNulty's *The Collected Prints of Ben Shahn;* to the two earlier basic books by James Thrall Soby, *Ben Shahn His Graphic Art* and *Ben Shahn Paintings;* and to Seldon Rodman's *Portrait of the Artist as an American.* The importance of each author's contribution to this book will be obvious from the footnotes and references in the text. Moreover, when certain problems arose, "Ding" McNulty was generous with his personal knowledge of Shahn prints.

Since the role traditionally played by American politicians in relation to the fine arts has not always been what one might wish it to be, I am especially pleased to express my gratitude to New Jersey's former governor, Richard J. Hughes, and former treasurer, John A. Kervick, who were in office while the Shahn collection was being assembled. By giving their official approval to the project, they made it possible to overcome the many bureaucratic obstacles and prejudices inherent in large governmental organizations.

In conclusion, I must record the role played by my wife, Emma-Stina Prescott. An admirer of Shahn's work, she has read every word of the manuscript, has suggested revisions, and has corrected factual errors that might otherwise have slipped by. In truth, her contribution to this volume is such that she might almost be considered a co-author.

Without her help this book could never have reached its present form and its completion would have been long delayed.

This volume represents a partial payment of the debt I owe Ben Shahn. When I see a building under construction framed against the New York City skyline, I see it as part of *All That Is Beautiful* (fig. 55). Supermarket baskets and TV antennae instantly call to mind Shahn's printed concepts (see figs. 20, 27 and 28), and I cannot fail to recall the image of Shahn's despairing mourner (see fig. 54) whenever the tragedy of the Warsaw ghetto is mentioned. In truth, Shahn's expressions of the world in which he lived have colored and enriched the world in which I live. I shall always be grateful.

KENNETH W. PRESCOTT

INTRODUCTION

Because this book is devoted to the graphic works of Ben Shahn, one may be tempted when reading it to view Shahn's prolific output in this field as an entity, separate from his other artistic achievements. But Shahn was not primarily a printmaker, a painter, or a muralist. He was all of these. The subject of one of his drawings might turn up in any one of the mediums; and sometimes the same theme will appear in a print, a painting, *and* a mural.

As we view Shahn's prints on the following pages, it would be difficult to grasp their significance and relevance without knowing something of his life, spanning some seven decades. Impressions from his childhood and early youth often found expression in his art, and his perceptive and compassionate nature, his keen awareness of this country's democratic heritage, are similarly reflected throughout his career.

Born in the city of Kovno, Lithuania, in the year 1898, Ben Shahn was eight years old when he and his family immigrated to the United States in 1906. Throughout his life, he retained vivid memories of the years spent with parents, grandparents, and other relatives in what was then a province of Czarist Russia. He never forgot the beauty of the undulating wheat fields or the colorful gaiety of the country fairs. Many years later these memories were enriched by new impressions of the same subjects in his adopted country, and together they found their way into his work (see figs. 9, 21 and 35).

Shahn enjoyed drawing even at a tender age, and one of his first pictures was of an uncle, a member of the Czarist cavalry, whom he had never seen, but who had been made famous to him through stories told by parents and grandparents. Shahn later recalled that the portrait of *Uncle Lieber Sitting on a Horse* was pleasing except for the fact that the horse "looked more like a cow."[1] In these early years, too, Shahn loved to draw letters, copying them from the prayer book and learning the relations of their parts, one to another. Later, as painter and print maker, he often gave his works appropriately hand-lettered inscriptions (see figs. 12, 31, 55, 60, 69, 80, 87-96, 101-112, 164, 167, and 206).

Before coming to America, Shahn's schooling consisted mostly of biblical studies. As he later recalled, nine hours a day were devoted to "learning the true history of things, which was the Bible; to lettering its words, to learning its prayers and its psalms, which were my first music, my first memorized verse. Time was to me then, in some curious way, timeless. All the events of the Bible were, relatively, part of the present. Abraham, Isaac, and Jacob were 'our' parents — certainly my mother's and father's, my grandmother's and my grandfather's, but mine as well."[2]

In America, Shahn found himself encountering a life utterly different from that he had known. On his first day he witnessed—to the sound of a blaring brass band—the unveiling of a statue of George Washington in Williamsburg Bridge Plaza, in the section of Brooklyn where he and his family took up residence.[3] Entering grade school, he marveled at American and world history, which introduced him to an unsettled, changing world, very different from the comforting confines of the Old Testament. He was surprised to find that none of his new friends could draw or carve, and that none shared his joy in fashioning letters. From his father, who was a wood-carver, from his grandfather, who had carved him a pair of ice skates back in Lithuania, and from his mother's family of potters, he had acquired a deep respect for craftsmanship. The interests of the children in Brooklyn seemed far removed from his. Yet, he continued drawing and became fascinated by all interesting and varied shapes of the new alphabet he was learning. By the time Shahn had reached fourth grade, he was at ease with the new language. His voracious appetite for reading was economically satisfied by an uncle who worked in a bindery and who lent him copies of unbound books.[4]

The Brooklyn environment of Shahn's boyhood gave him an early familiarity with many of the city scenes that were to appear in his work. There were the newly arrived immigrant families (see fig. 2), the corner policeman (see figs. 8 and 10), and the ever-present neighborhood boys' gangs. There is no record of Shahn belonging to one gang or another, but gang members knew of his ability to draw and enjoyed his sidewalk chalk sketches of sports heroes. Years later, Shahn well remembered the persuasive talent of a local bully, who wanted to show off his (Shahn's) drawing skill. When Shahn refused, his arm was twisted until the logic of pain forced him to follow the command, "Draw, you little — — — —, draw!"

Perhaps the most vivid memories that Shahn carried from childhood were of two fires he experienced. The first occurred when he was very young, in the little Russian village where his grandfather lived. He never forgot the image of flames being fought by lines of men—a bucket brigade carrying water from the nearby river. The other fire, in Brooklyn, nearly

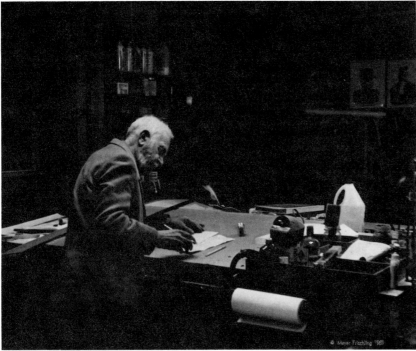

curve, every serif, every thick element of a letter and every thin one..."[6] Once, when Shahn was confronted with the problem of how to space the letters to make a perfect line, the shop foreman advised him to imagine a small measuring glass of water, which had to be poured into the spaces between the letters in such a way that each space, regardless of shape, contained exactly the same amount of water. In such ways Shahn discovered that letters and their spaces are quantities to be measured and arranged by the hand and the eye. To him the relationship of these quantities became an art. Thus he learned many alphabets, how to embellish and ornament letters, and how to relate them to words and lines of words[7] Such routine and repetitive work might have been boring to some, but to Shahn it was the beginning of a life-long love affair with the history of letters. Throughout his career he lavished as much care on the fashioning of each letter in a title or phrase as he did on the drawing of images. Whether in the uneven folk alphabet of *Immortal Words* (fig. 33) or in the elegantly flowing Hebraic forms of *Decalogue* (fig. 48), there is evidence of a balanced relationship of letters and space, consciously achieved in accordance with the "water glass" formula.

Although his training as a lithographer's apprentice was limited to the years 1913-17, the skills Shahn learned provided him with his main source of income until about 1930. Commissions for lettering, illustrations, anonymous poster work and other forms of advertisement saw him through several years of study at New York University, the City College of New York, and The National Academy of Design, besides covering expenses for two trips to Europe and North Africa. At college, he became so immersed in biology that he won three summer scholarships to the U.S. Marine Biological Laboratory at Woods Hole, Massachusetts. For a brief period he considered a career in biology, but his training and his years of preoccupation with art and craft were not to be cast aside. Yet he retained his interest in science, which later found its way into such works as *Blind Botanist* (figs. 46 and 47), *Scientist* (fig. 26), *Lute* (fig. 25), and *Lute and Molecule, No. 1* and *No. 2* (figs. 29 and 30).

Emerging Artist

Accompanied by his first wife, Tillie Goldstein, whom he had married in 1922, Shahn went abroad for the first time during the year of 1924. In 1927 they went abroad again, this time remaining for almost two years. Traveling in Europe and North Africa, Shahn feasted on the diversity of architectural forms and the classical works of European painters and sculptors. His impressions of the colorful Arabic world are captured in books filled with rapid sketches. Years later, these sketches became inspirations for paintings and prints (see figs. 36, 66, and 121). As seen in

cost him and his brothers and sisters their lives, and he bore in his mind forever the image of his father, painfully burned, climbing up the drainpipe to carry the children down to safety, one by one. His mother's hair turned white from the ordeal, and everything the family owned was consumed.[5] Shahn's feelings of horror and fascination were relived years later, when he was asked to illustrate the Hickman fire in Chicago (see fig. 12).

Finishing elementary school at fourteen years of age, Shahn apprenticed to a lithographer by day and attended high school at night. Learning a craft seemed a natural thing to do, and Shahn's lifelong regard for hard work and fine craftsmanship are surely related to this period as well as to his early childhood. Shahn's secret goal, however, was to further his knowledge of drawing, and no matter how agreeable it may have been to learn the lithographer's skill, Shahn soon discovered that "people who drew were the aristocrats of the lithographic trade. First I had to learn the hard things, like grinding stones and running errands and making letters—thousands and thousands of letters until I should know to perfection every

Algerian Memory (fig. 36) Shahn's quick line sketches are more related to the mature work of his later years than to the French-influenced paintings of landscapes and portraits that mark his work of the 1920's and early 1930's. Shahn referred to his landscape paintings of this period as being "in a Post-Impressionistic vein," reflecting his academic training in the United States and the influence of works he had studied abroad.

It was in this early stage of his artistic career that Shahn's inner critic began to trouble him seriously:

> With such ironic words as, "It has a nice professional look about it," my inward demon was prone to ridicule or tear down my work in just those terms in which I was wont to admire it.
>
> The questions, "Is that enough? Is that all?" began to plague me. Or, "This may be art, but is it my own art?" And then I began to realize that however professional my work might appear, even however original it might be, it still did not contain the central person which, for good or ill, was myself. [8]

Shahn's childhood influences, his training as a lithographer, his fondness for words and letters and their history, his knowledge of the laws of science, and his concern with the political and social implications of contemporary events—none of these were reflected in his early tradition-bound painting, and all contributed to the rebellion within him. The inner conflict and its resolution is described at length in Shahn's *The Shape of Content* and *The Biography of a Painting*, in which he vividly reveals and painstakingly analyzes his own transformation from a conventional, although competent painter, to a mature artist with a style that was unquestionably his own.

Shahn had brought back from France a small book on the historic Dreyfus case. Absorbed by the subject, he decided to do "some exposition of the affair in pictures." [9] The result was a series of portraits of characters from the trial, each accompanied by an identifying text. In their directness and simplicity the portraits marked a turning point in Shahn's career as an artist. (Unfortunately, he never made any prints based on the series.)

While still in Paris, Shahn had become interested in the Sacco and Vanzetti case. The Boston trial of the two Italian immigrants, who were charged with murder, judged guilty, and sentenced to die, was having international reverberations. The demonstrations in Paris against the seeming injustice of the verdict moved Shahn to create a series of twenty-three gouache paintings, which were exhibited in 1932 and received with favor by both critics and public. The three serigraphs he

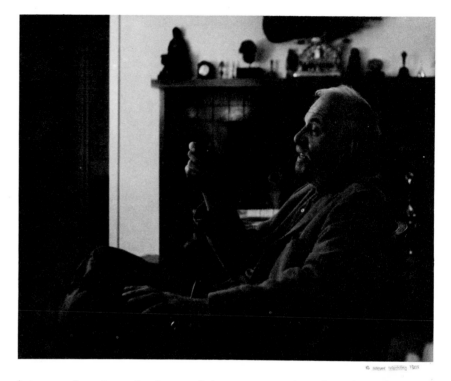

later produced on the basis of the paintings (see figs. 31-33) are of special importance to the student of Shahn's prints, for they reflect his transition from a dissatisfied academician to an artist with a unique style. Never again would the demon within mock him about the "professional look" of his paintings; rather, from this time forward his work had a "Shahn look" about it, a distinctive style which needs no identifying signature for those familiar with Shahn's incredibly varied pictorial world. This is made abundantly clear when the serigraphs are compared to the earlier *Levana* lithographs (see figs. 87-96), where the lettering is characteristic of Shahn's later work, but where the figures are a curious hybrid of a derivative and an emerging personal style.

From this point on throughout his career, Shahn's work is marked by an absence of landscapes, still lifes, and portraits done in the "accepted" manner. In their place emerged a stream of drawings, paintings, and prints reflecting a wide variety of social and philosophical concerns: man's relations with the world around him (see figs. 97-112); the heights of his understanding of the divine (see fig. 52); the depths of his despair (see figs. 54 and 59); the vulnerability of little children (see figs. 17 and 160); and the evils of war (see figs. 143-144, 157, and 171). Even a

cityscape might have a social message (see figs. 20 and 55), for Shahn's inquiring, challenging mind would not let him be neutral to his surroundings. He needed always to express graphically his interpretation, his position.

Depression Years

In 1932 Shahn assisted Diego Rivera in the execution of a mural for Rockefeller Center in New York City. Working with the Mexican muralist, he learned new ways of looking critically at his own work. He also acquired an interest in murals as an avenue of expression—an interest that eventually led to the mosaics of his later years. During the depths of the depression, 1934-35, Shahn participated in the Public Works of Art project, at which time he painted a series of eight small tempera pictures on the theme of prohibition. One of the best known, W.C.T.U. Parade[10] was never the subject of a print, but it is related in style and composition to Seward Park (fig. 1), Immigrant Family (fig. 2), and Prenatal Clinic (fig. 3). These prints, however, reflecting the totally different sentiments with which the artist approached his subjects, lack the satirical humor Shahn expressed in the group portrait of the determined ladies of the Women's Christian Temperance Union.

During the period 1934-35 Shahn was also collaborating with Lou Block, the painter, on a New York City commission to design murals for the Riker's Island Penitentiary. Visiting prisons and talking to inmates gave Shahn a sense of what the prisoners themselves would like to see on the walls. The resulting mural cartoons were accepted by the Mayor and the Commissioner of Correction as well as by the majority of the prisoners who were questioned, but the Municipal Art Commission found the sketches unsuitable. This rejection was a bitter pill for Shahn to swallow and may well have laid the foundation for his enduring mistrust of appointed authorities and bureaucrats; however, it did not impair his willingness to accept subsequent governmental commissions or future employment by federal agencies.

In the fall of 1969, the Fogg Art Museum presented a major exhibition of Ben Shahn's photographs. For, as was pointed out in the introduction to the exhibition catalogue, Shahn "was a photographer as surely as he was a graphic artist and a painter." Most of his work, however, dates from the mid-1930's. Of the sixty-nine photographs in the Fogg show, only five dated from later than that period. Shahn's camera, a Leica he had won on a bet from his brother in 1932, proved to be of immeasurable importance, both for the variety of images that Shahn captured on film and for the use he subsequently made of them in his paintings and graphic works. He once said: "What the photographer can do that the painter can't is to arrest that split second of action in a guy stepping into a bus, or eating at a lunch counter."[11]

Shahn put the camera to good use in preparing for the Riker's Island mural cartoons, photographing New York City street scenes and the life of the prison inmates. From 1935 to 1938, he worked as a photographer, designer, and artist for the Farm Security Administration. During this period, he traveled extensively through the southern and mid-western states, taking over six thousand photographs of rural and urban scenes. Using a right angle viewer, he was able to take candid pictures of people without making them aware of his intention. "We just took pictures that cried out to be taken," he later remembered. "We did get a lot of pictures that certainly add something to the cultural history of America." In terms of their relation to his paintings, Shahn observed that "these weren't just photographs to me; in a real sense they were the raw material of painting. Photographs give those details of forms that you think you'll remember but don't—details that I like to put in my paintings."[12]

In 1937 Shahn was commissioned by the Farm Security Administration to paint a large fresco mural for the community center at Roosevelt, New Jersey. The village, originally named Jersey Homesteads, was designed and built as a cooperative commune for unemployed garment workers of New York's Lower East Side. Artistically, the Roosevelt mural reflects Shahn's earlier association with Diego Rivera. The subject matter is a portrayal of the immigrant experience as seen through the eyes of the artist. There is the hope represented by Einstein and the doubt represented by Sacco and Vanzetti. There are allusions to sweat shops and to deplorable working conditions; and there are suggestions of the power of union activity, and of the progress to be achieved through reform—the latter idea represented by a portrait of Franklin D. Roosevelt. The mural symbolized the objectives and ideals of many an immigrant, and of the utopian community that offered them new hope.

Shahn's later graphics attest to his continuing interest in the themes of the mural. Besides the prints dealing with the Sacco and Vanzetti theme (figs. 31, 32, and 33), there are also portrayals of Einstein (fig. 241) and Roosevelt (figs. 151, 151a, and 152), and posters promoting union activity (see figs. 140-142, 145-150, and 154-156).

More government commissions came Shahn's way in the years 1938-39 when the Treasury Department asked him to paint thirteen large fresco murals for the Bronx Central Annex Post Office, depicting scenes of American life. He was assisted in this project by Bernarda Bryson, who was to become his second wife and devoted companion until his death.

The Depression years, with their hunger, poverty, and legions of unemployed, made a deep impression on Shahn. They also brought him a new understanding of human nature. "I had then crossed and recrossed many sections of the country," he said later, "and had come to know…many people of all kinds of belief and temperament [sic], which they maintained with a transcendent indifference to their lot in life. Theories had melted before such experience."[13] Eventually these impressions led Shahn to reject "social realism" for what he called a more "personal realism"—a transition that was complete by the end of World War II.

War Years

In 1942 Shahn went to Washington, D.C. to work in the Office of War Information, assisting William Golden of CBS in designing posters for the war effort. Golden's genius for design eventually won Shahn's deep respect, and he was later to extend Shahn's post-war career into the profitable world of commercial advertising. But their initial collaboration, which Shahn referred to as "the first round," seemed to bode ill for any future relationship. Together they had worked out a verbal concept for a war poster. But after struggling fruitlessly to express the idea in visual form, Shahn decided on his own to start out afresh, this time beginning with the visual image. The resulting poster, one of Shahn's finest (see *We French Workers Warn You,* fig. 143), was emphatically rejected by Golden, though it was later published by the War Production Headquarters.

Shahn's war posters did not lend themselves to being used as instruments for inspiring patriotism. Shahn in no way presented the conflict in heroic terms. He portrayed what was uppermost in his mind: the suffering and loneliness that war inflicted on the individual; and the desolation and brutality that resulted when civilization gave way to barbarism. Within the Office of War Information he had access to a wealth of photographs and other documents that had been sent back from the war areas: "There were the secret confidential horrible facts of the cart loads of dead; Greece, India, Poland."[14]

Only one additional poster, *This Is Nazi Brutality* (fig. 144), was published by the government during Shahn's eleven months with the Office of War Information. However, many of his rejected ideas were among posters published later by the Political Action Committee of the CIO (see figs. 145-147, 149-152, and 154-157). James Thrall Soby described these as some of the finest and most compelling posters yet seen in our period and country.

Aside from his posters, Shahn's graphic work during the war years was limited to five serigraphs (see figs. 2-6), produced in 1941 and 1942. They deal with social and political subjects, but do not reflect his anguish over the war. Some years later, when evidence of Nazi war atrocities became common knowledge, the depth of this anguish was expressed in the serigraph, *Warsaw 1943* (fig. 54).

Shahn felt that the paintings he did during the war years, which are considered some of his best, did not depart sharply in style or appearance from his earlier work, but were becoming more private and more inward looking: "A symbolism which I might once have considered cryptic now became the only means by which I could formulate the sense of emptiness and waste that the war gave me, and the sense of the littleness of people trying to live on through the enormity of war."[15]

By the end of the war Shahn had emerged a mature and respected artist. His work was well received when shown in group exhibitions at The Museum of Modern Art in New York in 1943 and at the Tate Gallery in London in 1946, and in a one-man exhibition at the Downtown Gallery in New York in 1944.

Mature Artist

In his nearly quarter of a century of work after World War II, Shahn enjoyed extraordinary success. Hardly a year passed without at least one exhibition in private or public galleries at home or abroad. His output of paintings, drawings, prints, and posters increased dramatically and his work sold well. He received commissions for mosaic murals and stained glass windows and he illustrated other authors' writings as well as his own. He was well received at Harvard University as a Charles Eliot Norton professor, and was elected to the National Institute of Arts and Letters and to the American Academy of Arts and Letters. He represented the United States at the Venice Biennale with Willem de Kooning and won numerous awards and prizes. In addition Shahn now found himself sought after as a commercial artist. Hitherto he had regarded commercial art as a necessary evil, which he practiced anonymously in order to support his creative talents. Now, in demand because of his fame and eminence as a creative artist, he began producing drawings and paintings for television and documentaries, covers for phonograph records and books, and illustrations for advertising copy. Corporations had awakened to the realization that good art could also mean good business, and Shahn benefited from their patronage.

In 1947 Shahn was asked by *Harper's* magazine to illustrate a feature story by John Bartlow Martin, dealing with a tenement fire in Chicago which became known as the "Hickman fire." Four Negro children had been burned to death, and their father, believing that the

print, *Mine Building* (fig. 22) resulted from this series.

An important segment of Shahn's post-war commercial work was done in collaboration with William Golden who, after returning to CBS as art director, had enlisted Shahn's help in preparing a folder for a television program called "The Eagle's Brood," dealing with the rising problem of juvenile delinquency. Shahn was pleased with the result: "I made a drawing that, to me, very well expressed both the compassion and the anger that the situation aroused...." The network's acceptance of his work (see fig. 238) "gave it a new importance" in Shahn's eyes.[16]

Thus the remarkable relationship between Shahn and Golden was resumed. In the following years Shahn prepared hundreds of drawings for CBS, some for newspaper ads, others for booklets. Many later found their way into paintings and prints. Together, the drawings testify to the sensitivity with which Shahn approached his subjects, and to the enthusiasm he must have felt for those assignments he accepted. Besides "The Eagle's Brood," 1947, the CBS commissions which are reflected in his graphic work include: "The Empty Studio," 1948 (see figs. 11 and 207); "Mind in the Shadow," 1949 (see fig. 133); "Harvest," 1955 (see figs. 35 and 211); and "The Big Push," 1957 (see figs. 28 and 209).

Shahn and Golden, working together intermittently from 1947 until the latter's death in 1959, proved that art which is appropriate for museums, galleries, and collectors, can also be used to advantage for commercial purposes. As Shahn later wrote of Golden: "His life-work was to bring something of highest quality into the public ken, to elevate public standards, never to be guilty of depressing them."[17] These ideals undoubtedly governed Shahn's own contributions to the business world as well.

Shahn insisted on complete independence in his commercial assignments. When the Chrysler Corporation once asked him to paint a picture for its collection that would comment on the automotive age, Shahn bristled at the mild suggestion. Turning down the commission, he wrote:

> Unless there is in the objective situation which he [the artist] is about to paint, some element which, on the one hand, may offer him a challenge as to an aesthetic solution; or, unless there is a human or personal problem which he feels the need to present and interpret, there is little honest motive for making a painting. The value of any painting must, therefore, necessarily derive from the importance which the artist himself places on it. If he feels a powerful urgency in a situation, and if he has at his disposal the

landlord had deliberately set the fire, sought him out and killed him. The ensuing trial, at which Hickman was acquitted, attracted wide public attention. James Thrall Soby has pointed out that Shahn's already awakened interest in allegory matured as he faced the alternatives of how to illustrate this tragic event. Moved by the story, and drawing on his still vivid memories of the fires of his own childhood, Shahn created one of his finest paintings, *Allegory*, in which a horrendous fire-beast looms over the stiffened bodies of the Hickman children. Shahn later used this allegorical fire-beast to create other images, including the one titled *Where There Is a Book There Is No Sword* (fig. 12).

Shahn illustrated another *Harper's* feature story in 1948, "The Blast in Centralia, No. 5," which was also written by John Bartlow Martin. The story was about a mine disaster that had killed one hundred and eleven men. Shahn, deeply shaken by the tragedy and touched by the sorrow of the victims' families and friends, prepared one hundred drawings for the article, of which twenty-four were reproduced. As in the case of the Hickman story, he rebelled against the needless waste of life and the seemingly helpless plight of the "little people." Only one

technical proficiency to realize that urgency fully, the resultant work of art will be one of value to himself and others. Therein lies its aesthetic value.

For an artist to make a painting which is without significance to himself is simply to commercialize his past achievements..[18]

Between the years 1955 and 1968, the editors of *Time* commissioned Shahn to do eight covers for their magazine. The resulting portraits of Andre Malraux (1955), Sigmund Freud (1956), Alec Guinness (1958), Adlai E. Stevenson (1962), Vladimir Ilyich Lenin (1964), Martin Luther King, Jr. (see figs. 72, 105, and 216) (1965), R. Sargent Shriver (1966), and Johann Sebastian Bach (1968), are penetrating but hardly flattering studies of the subjects, and bear the unmistakable mark of Shahn's brush.

Shahn also produced drawings for Cipe Pineles Golden, an editor at *Vogue* magazine, and the wife of William Golden. Another editor, Helen Valentine, asked for many illustrations for *Charm* and *Seventeen* magazines. The Container Corporation of America gave him several assignments, including three for their series, "Great Ideas of Western Man" (see fig. 200). The serigraphs *Andante* (fig. 65) and *Praise Him with Psaltery and Harp* (fig. 73) are well known and were done for the Olivetti and Benrus corporations respectively.

Shahn's commercial assignments alone could serve as a subject for a treatise. Besides providing him with a welcome source of income, they added excitement and variety to his work. He chose those assignments that evoked his sympathy, that stimulated his thinking, that challenged his creativity and craftsmanship, and that gave him an opportunity to play a role in contemporary society. Time and again he demonstrated his belief that the artist should devote the same interest and standards to commercial art as to fine art, and that the true worth of any piece of work derives not from its function, but from its artistic conception and realization.

Much of Shahn's later work emerges from a reawakened interest in the Biblical stories that had been so much a part of his early childhood. Nourished by the Old Testament texts and by their beautiful Hebrew calligraphy, Shahn created a rich Biblical imagery; and his numerous celebrations of the ancient documents include some of his most pleasing compositions (see figs. 24, 45, 48, 49, 54, 61, 68, and 73).

Also apparent in his later work is Shahn's continuing love of musicians and their instruments. In his prints and paintings appear instruments of all ages, from ancient and medieval to the most modern (see figs. 25,

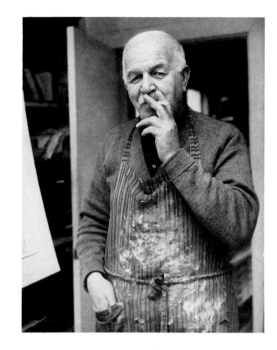

29, 30, 177, 219, 250-257, and 259-282). Though the prints lack the color and multiple images of the paintings, they are joyful things nonetheless, suggesting in visual terms much of the pleasure that Shahn found in music itself.

Nor did Shahn ever lose his early zeal for reading and learning. To be with him for a few hours—no matter what the occasion—was to be guaranteed a lively conversation on topics ranging from the philosophic views of Maximus of Tyre (see fig. 52) to the science of Robert Hooke (see fig. 46); from the writings of Mark Twain (see figs. 212 and 214) to the poetry of William Carlos Williams (see fig. 18); from the religious history of his forefathers (see figs. 48, 60, and 70) to the theology of Martin Luther (see figs. 40 and 67). His mind ranged freely across history, compelling him to juxtapose in his work men, ideas, and events widely separated in time and place: Mark Twain with Gandhi (see figs. 212 and 214); the twentieth century tragedy of the Warsaw ghetto with the thirteenth century prayer for Yom Kippur (see fig. 54); Pheidias, the sculptor from fifth century B.C. Athens, with the demolition of buildings in twentieth-century Manhattan (see fig. 55).

Like the rich symbolism of his later work, Shahn's use of familiar images in new settings has often been a source of puzzlement as well as delight to his admirers. For instance, the familiar fire-beast of *Where There*

Is a Book There Is No Sword (fig. 12) is used in a new context in *Credo* (figs. 40 and 67), where it is combined with the stirring words of Martin Luther. Similarly, in his memorable homage to Goya, a 1956 watercolor, *Goyescas* (see *Ben Shahn Albertina*, fig. 175), Shahn draws on the "cat's cradle" motif of earlier works (see figs. 37 and 38) to express his contempt of the military mind, showing, amid a heap of corpses, a flamboyant officer indulging in the children's game.

Elsewhere, we find Shahn commenting on what he felt to be the nation's overemphasis on the physical sciences by rather whimsically combining a molecular structure with a musical instrument in the serigraphs *Lute and Molecule, No. 1* and *No. 2* (figs. 29 and 30). The theme is also found in a much more ominous setting in *Scientist* (fig. 26) as well as in the 1957 painting, *Helix and Crystal,*[19] where a sightless and earless scientist, enmeshed in the crystal's structure, pursues his research even as the officer in *Goyescas* pursued his game—oblivious of the consequences.

With Shahn's growth as an artist came an even deeper understanding of the social and spiritual needs of mankind, and the exclusion or suppression of those needs never failed to rouse his indignation.

As he himself once wrote:

> I have no quarrel with scientific skepticism as an attitude. I am sure that it provides a healthy antidote to fanaticism of all kinds, probably including the totalitarian kind.
>
> But as a philosophy or a way of life it is only negative. It is suspicious of belief. It negates positive values. Aesthetically, it refuses to commit itself.
>
> For society cannot grow upon negatives. If man has lost his Jehovah, his Buddha, his Holy Family, he must have new, perhaps more scientifically tenable beliefs, to which he may attach his affections. Perhaps Humanism and Individualism are the logical heirs to our earlier, more mystical beliefs.…But in any case, if we are to have values, a spiritual life, a culture, these things must find their imagery and their interpretation through the arts.[20]

Perhaps no other statement can better express Shahn's profound commitment to his beliefs and to his art.

PART ONE
PRINTS

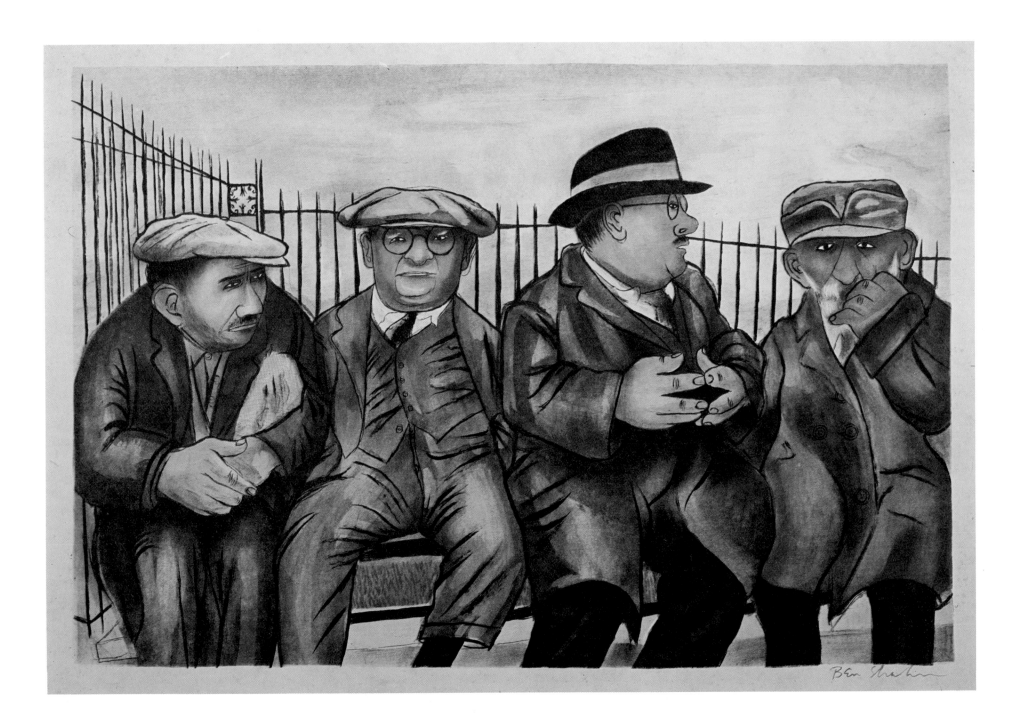

Ben Shahn

Figure 1 — SEWARD PARK. 1936
Lithograph in colors
Sheet: 15¾ x 22¾" Composition: 11¾ x 17¾"
Paper: Rives
Edition: Unspecified; 6 known
Signature: *Ben Shahn* in red with brush lower right
Collection: New Jersey State Museum; gift of The Dorothy
 and Sydney Spivack Acquisition Fund. Accession
 No: 69.288.10

Seward Park follows closely the style of Shahn's paintings of this period. A later tempera painting, *Sunday Morning*,[21] is similar to this print in arrangement. Both depict four dejected men seated on a park bench and both include an angular fence extending from the left, from behind the group. Although the faces and positions differ, the feeling of the group is the same. *Seward Park* reflects Shahn's life-long compassion for the "little" people who are the first to suffer in a depression. Jobless wage earners, like these, congregated on street corners and park benches in the 1930s, sharing tales of their misfortunes. Shahn has captured and preserved for us a mood of the times.

This is the first lithograph Shahn attempted after his disappointment with the 1931 *Levana and Our Ladies of Sorrow* business venture (see p. 86), and was done for the federal government's Resettlement Administration. His next print, *Immigrant Family* (fig. 2), was done five years later and was his first use of serigraphy, a technique he adopted in place of traditional lithography. Not until 1963 did he return to lithography, following his visit to the Fernand Mourlot atelier in Paris, where he produced three lithographs (see figs. 50, 51, 53).

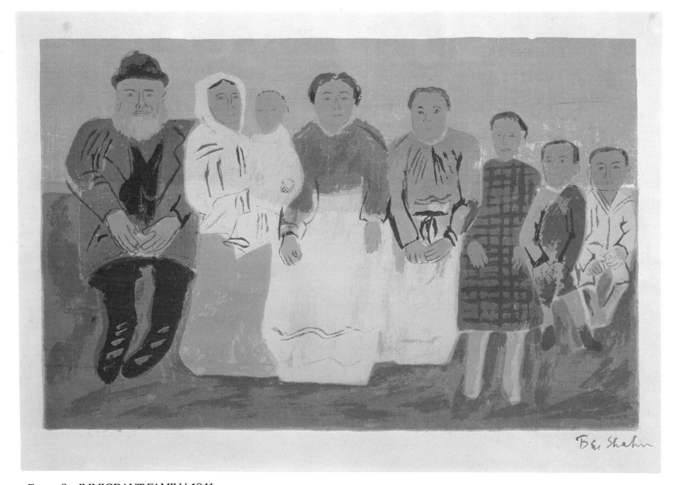

Figure 2—IMMIGRANT FAMILY. 1941
Serigraph in colors
Sheet: 19¼ x 25¼" Composition: 11½ x 18"
Paper: Wove rag, nineteenth or early twentieth century
Edition: Unspecified; 3 known
Signature: *Ben Shahn* in red with brush lower right
Collection: New Jersey State Museum; gift of
 Mrs. J. Seward Johnson. Accession No: 69.288.5

In 1961, Shahn recalled that "At some point very early in my life I become [sic] absorbed—not with Man's Fate, but rather in Man's State."[22] *Immigrant Family* clearly reveals this interest. Completely reflecting his early painting style, this print was followed by five others, all similar in technique and feeling: *Prenatal Clinic* (fig. 3), *4½ Out of Every 5* (fig. 4) *Vandenberg, Dewey, and Taft* (fig. 5), *The Handshake* (fig. 6), and *Laissez-faire* (fig. 8). Much of Shahn's early life in Brooklyn took place in ghetto areas, where peoples of other lands with strange languages, clothing, and customs were well known to him. In this portrait grouping, he sympathetically presents three generations of an immigrant family in the new world.

As the first serigraph made by Shahn, *Immigrant Family* is extremely important, for he had then mastered a new printmaking technique, with which he would experiment widely in the years ahead. It allowed him to express himself without the aid of assistants and opened almost unlimited possibilities for him personally to produce multiple images of chosen themes with the option of making variations in the individual prints.

This, Shahn's second serigraph, is similar in technique to the other serigraphs of the 1940s, resembling his early paintings rather than his later line drawings.

Kneeland McNulty, curator of the Philadelphia Museum of Art, points out that this print illustrates one of Shahn's main themes: *"people who wait*—endlessly, and when whatever it is arrives, they wait again, pathetic people...."[23] The two women in the setting of a dreary, sickly green waiting room indeed seem resigned to wait endlessly without any overt expression of objection. The thick undulating lines of the chairs enclose each patient and add to the impression of separation and loneliness.

A c. 1944 watercolor, titled *The Clinic* is almost identical to this print. In describing the painting, Shahn wrote, "My type of social painting makes people smile. The height of the reaction is when the emotions of anger, sympathy, and humor all work at the same time. That's what I try to do—play one against the other, trying to keep a balance."[24] Critic Robert M. Coates, referring to *The Clinic,* has commented that "Shahn's great value as an artist is that he understands...often overlooked moments and interprets them succinctly and expertly."[25]

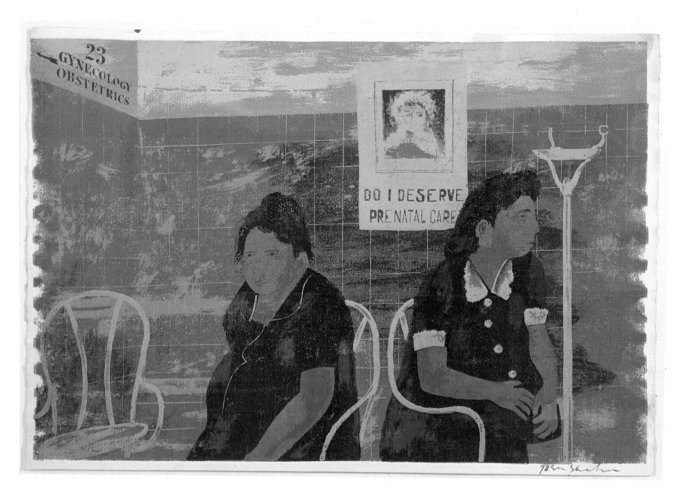

Figure 3—PRENATAL CLINIC. 1941
Serigraph in colors
Sheet: 15⅛ x 22⅜" Composition: 14⅜ x 21¾"
Paper: J. Whatman
Edition: Unspecified; 10 known
Signature: *Ben Shahn* in red with brush lower right
Collection: New Jersey State Museum; gift of the
 Association for the Arts of the New Jersey State
 Museum. Accession No: 69.288.9

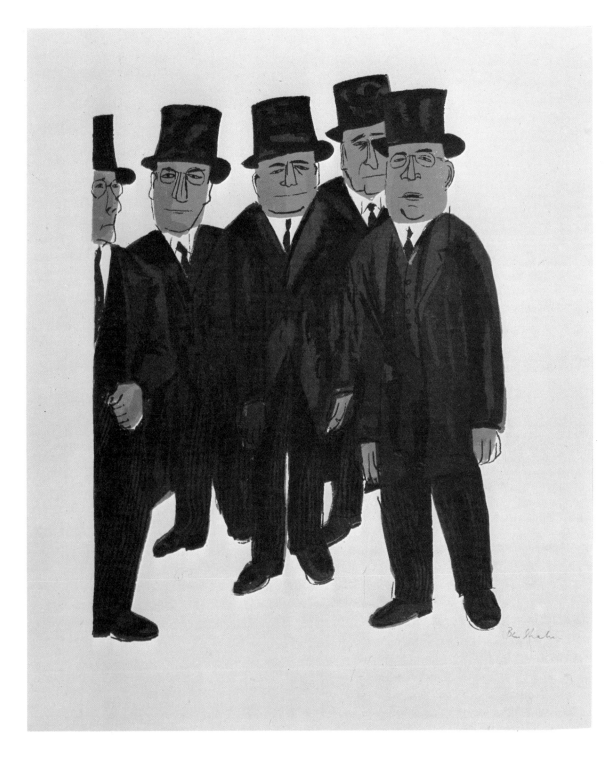

Figure 4 — 4½ OUT OF EVERY 5. 1941
Serigraph in colors
Sheet: 25¼ x 19⅛"
 Composition: 13¾ x 10½"
Paper: Machine-made wove rag
Edition: Unspecified; 3 known
Signature: *Ben Shahn* in red with
 brush lower right
Collection: New Jersey State Museum;
 purchase. Accession No: 69.288.7

Satirizing the common advertising jargon, "four and a half people out of every five use, do, or have such and such," Shahn epitomizes such imagined authorities, whom others are encouraged to emulate.

While still in the style of his early paintings, the irregular lines of the facial features and the glasses suggest Shahn's future line drawings. The colors used in this print are similar to those in *Vandenberg, Dewey, and Taft* (fig. 5); in both, the faces and hands are two shades of dull green, and the facial features are outlined with the brown of the suits. Deep brown is used for shading as well as for the shoes and hats. Shahn saved the clear white of the paper for the shirts.

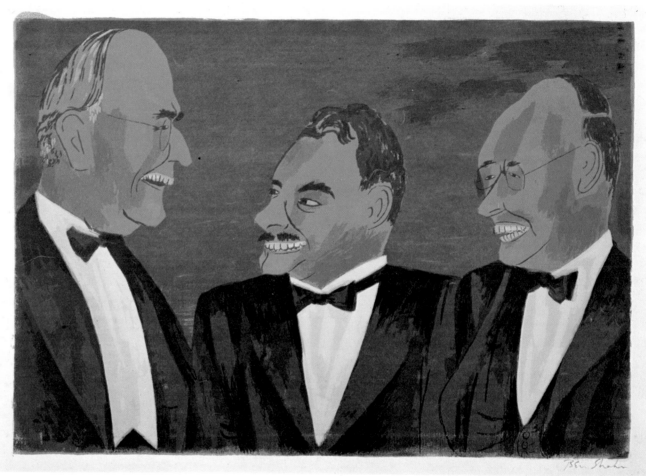

Figure 5—VANDENBERG, DEWEY, AND TAFT. 1941
Serigraph in colors
Sheet: 19¼ x 25¾" Composition: 15 x 22⅛"
Paper: Machine-made wove rag
Edition: Unspecified; 4 known
Signature: *Ben Shahn* in red with brush lower right
Collection: New Jersey State Museum; anonymous donor.
 Accession No: 69.288.3

This early serigraph follows the Shahn painting style of the period. Shahn good-naturedly satirized the omnipresent professional smiles of politicians by giving these men rows of too perfect teeth set in frozen, grinning faces. The same artificial smiles with overly emphasized teeth occur in the poster images of Truman and Dewey in *A Good Man Is Hard to Find* (fig. 158). Political themes occur frequently in Shahn's work.

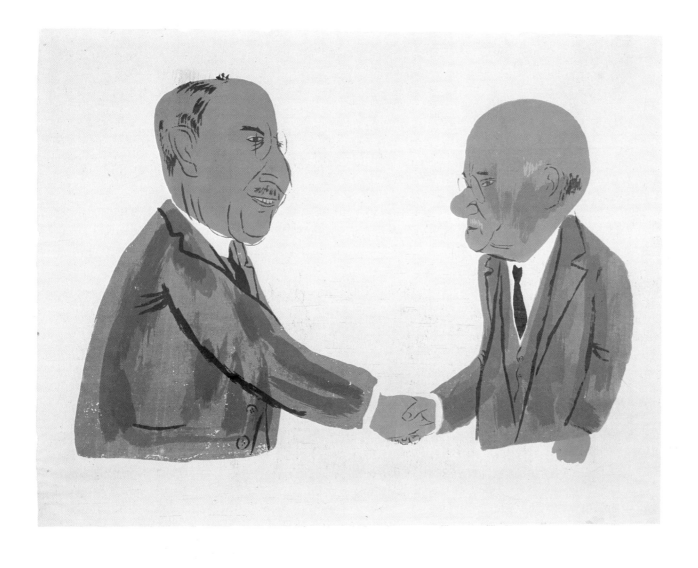

Figure 6—THE HANDSHAKE. 1942
Serigraph in colors
Sheet: 19¼ x 25¼" Composition: 15 x 22"
Paper: Machine-made wove rag
Edition: Unspecified; 3 known
Signature: Unsigned
Collection: New Jersey State Museum; gift of The
 Dorothy and Sydney Spivack Acquisition Fund.
 Accession No: 69.286.2

Although these two men somehow seem familiar, the viewer strives in vain to match their faces with known figures of the nation's capital, where, during the early forties, Shahn made this print. Shahn humorously referred to the handshake as "dyspeptic." [26]

The empty background of this print and of *4½ Out of Every 5* (fig. 4) is more characteristic of Shahn's later work than of the prints and paintings of this early period.

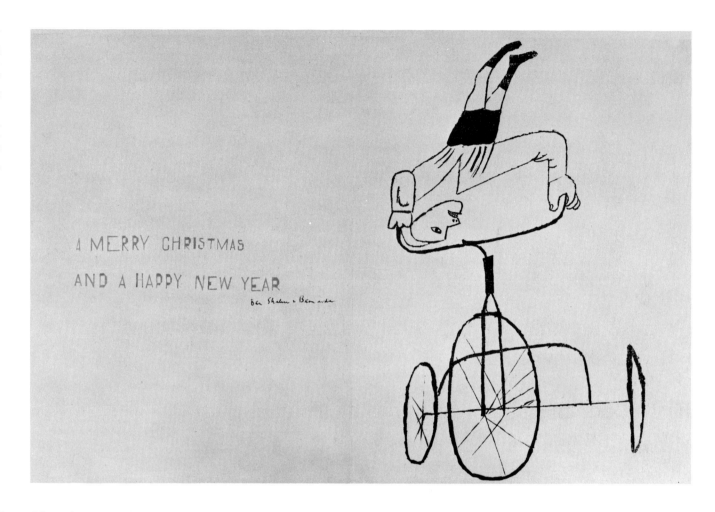

Figure 7—BOY ON TRICYCLE. 1947
Serigraph in black and red
Sheet: 15 x 23⅞″ (unfolded)
Composition: 14½ x 9″
Paper: Machine-made wove rag
Edition: Unknown
Signature: *Ben Shahn & Bernarda* in black
with brush, center
Collection: New Jersey State Museum; gift of
Monroe Wheeler. Accession No: 70.155.3

This is one of four rare Christmas cards that exist as fine arts prints (see also figs. 9, 10, and 12; see Part Four for Holiday Greetings produced by photomechanical means). There are several versions of this print, varying in size as well as in the placement and wording of the greeting and the signature. In this example, the printed image appears on page one of the folded sheet, pages two and three are empty, and page four has the greeting in red ink:

A MERRY CHRISTMAS AND A HAPPY NEW YEAR

Kneeland McNulty's version has the printed text: "A Merry Xmas and a Happy New Year." [27]

Artist Leo Lionni records the card as personally silkscreened by Shahn.[28] Shahn, in his book *Love and Joy About Letters,* included this serigraph as an illustration.[29] Two lithograph versions were published by Kennedy Graphics for its 1968 Shahn exhibition: one as a poster (see fig. 197) and the other as a print without lettering (see fig. 79). Shahn reworked the image slightly, changing the hand positions and adding more spokes to the wheels. He also used the theme of cycles and acrobatic skills in a poster (see fig. 173), and in the 1950 tempera painting *Epoch,*[30] in which an acrobat is doing a handstand on the heads of two other acrobats riding bicycles.

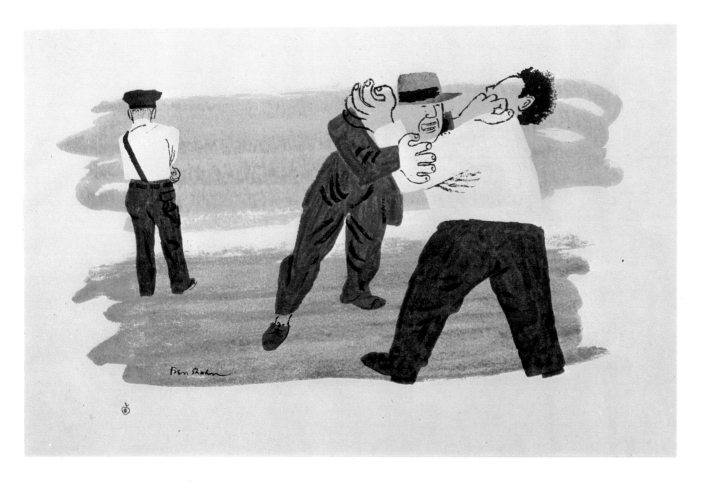

Figure 8 – LAISSEZ-FAIRE. c.1947
Serigraph in colors
Sheet: 14 x 21" Composition: 8¾ x 16¼"
Paper: Machine-made laid
Printer: Unknown
Edition: 250 by Ben Shahn; unknown by others
Signature: *Ben Shahn* in black on the screen lower left
Marks: Copyright symbol lower left, Pippin Press, New York
Collection: New Jersey State Museum; gift of Mr. and Mrs.
 Michael Lewis. Accession No: 69.323

This example is presumed to be from a pirated edition, because it does not have Shahn's signature in pencil, lower right. According to Shahn, it was also given an unauthorized title by others: "The title…[*Les Affaires*] is as phony as are the prints being sold by an unauthorized printmaker. What happened was that the original print, entitled 'Laissez-faire' was authorized by me to be made by two competent young printmakers. They went out of business and sold their screens to another printmaker who has been printing them horribly and selling them without any authorization from me whatever—not to mention, without any payments whatever." [31]

Like Shahn's first serigraphs, this print was done in a manner reminiscent of his early paintings. It portrays a policeman looking away while two men settle their affairs. A 1947 watercolor, *Two Men Fighting*,[32] is very similar; however, in the watercolor Shahn gave more detail to the men's faces and omitted the policeman. The hand grasping the antagonist's face and the well-defined ankle in the print are also missing in the painting. The clothing in the print shows more detail. The loose wash treatment of the fore- and background seems almost identical in the serigraph and the painting. Shahn's 1947 tempera, *Trouble*,[33] is of two men fighting in a fair ground environment.

Figure 9—DESERTED FAIRGROUND. c.1948
Serigraph in colors
Sheet: 11⅞ x 14⅝" Composition: 11½ x 14⅝"
Paper: Modern machine-made rag
Edition: Unspecified; 3 known
Signature: *Ben Shahn* in pencil lower right to the left of
Ben Shahn in black on the screen
Exception: McNulty example is signed *Ben Sh.* on the
screen; a second example in the New Jersey State
Museum Collection (accession no. 70.155.2) is signed on
the screen as *Ben Shahn*
Collection: New Jersey State Museum; purchase.
Accession No: 68.31.6

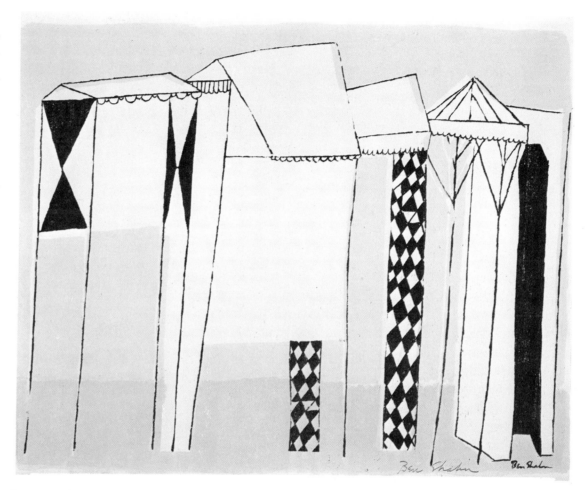

Issued as a Christmas card by Shahn and sent to his friends, this subdued print is now rare. Perhaps Shahn was right in thinking that in the early days most of his friends did not appreciate gifts of his art or, at any rate, did not value his art highly enough to save it. In all probability, many of his Christmas cards were disposed of along with unwanted debris in post-holiday house cleanings.

The black geometric forms in this restrained statement contrast strongly with the white of the paper and the gray sky. The soft pink in the foreground, which is printed over gray, gives a quiet mood to the composition. This fairground is devoid of the masses of people and garish colors that typify a fair in full swing.

Shahn was apparently inspired to do this print by a visit to the State Fair in Trenton, New Jersey, the day after it closed.[34] The following year, he painted another version of the fair, *The Anatomical Man*.[35] There he used vivid colors, reds predominating, with the main interest focused on a nude man, anatomically numbered. In *The Anatomical Man* and in this print, the general configurations of the tent tops and vertical lines are almost identical. There is a 1951 watercolor, entitled *Harlequinade*,[36] which is also related to *Deserted Fairground*.

Figure 10—SILENT NIGHT. 1949
Serigraph in black
Sheet: 12¼ x 18⅜" (unfolded)
Composition: 10⅜ x 7⅜"
Paper: Sunray Ingres
Edition: 200 by Ben Shahn; unknown by others
Signature: *Ben Shahn* in black with pen lower right
Collection: New Jersey State Museum;
gift of Monroe Wheeler. Accession No: 70.155.1

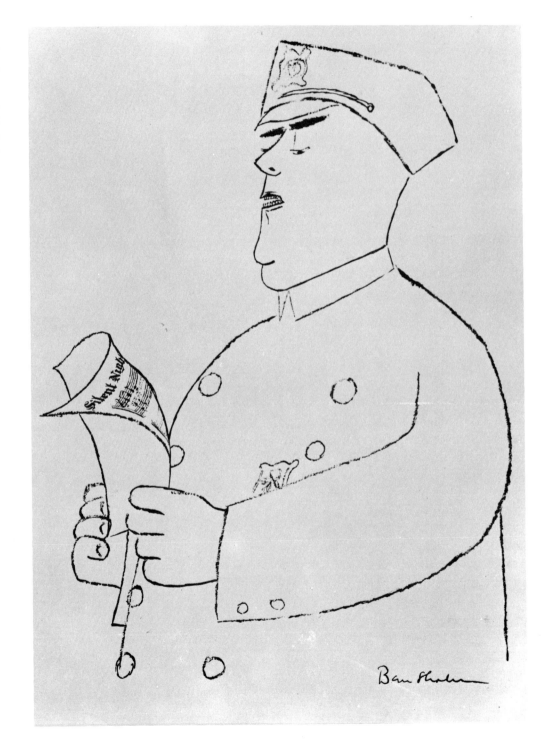

The careful lettering on the music in this print is an example of Shahn's love of older, classical forms. In *Love and Joy About Letters* Shahn has included a drawing almost identical with *Silent Night*.[37] While the general treatment is the same, some details differ, indicating that Shahn made at least two different drawings on this theme.

Shahn and his wife, Bernarda, used this print as a Christmas card, apparently for the holiday season of 1949. *Silent Night* also appeared as an illustration in *Portfolio,* the 1951 Annual of the Graphic Arts.[38]

Although this print is unnumbered, some examples are both numbered and signed. The one in the Milwaukee Art Center Collection is numbered in pencil *31/200.* It is evident from this and other cases that Shahn was not consistent in numbering his editions. The print used as an illustration in McNulty's book, *The Collected Prints of Ben Shahn,*[39] is not only unsigned and unnumbered, but also differs in detail from the two versions just described.

Shahn authorized two young printmakers to print both *Silent Night* and *Laissez-faire* (fig. 8), but pirated editions subsequently appeared as well.

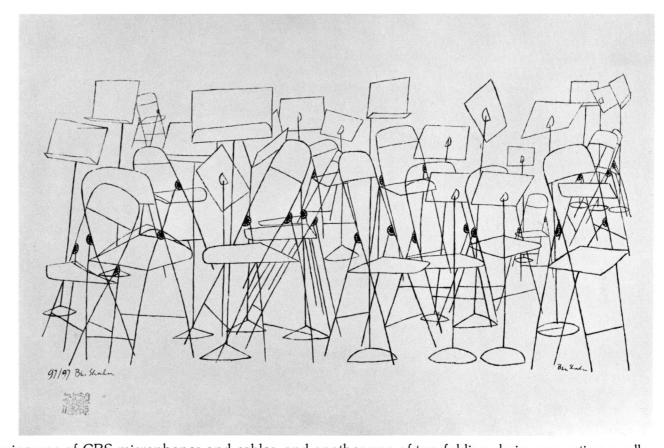

This is undoubtedly the best known of Shahn's prints due in large part to the success that followed the first appearance of a version called *The Empty Studio,* one of a series of drawings commissioned in 1948 by William Golden of the Columbia Broadcasting System to illustrate a four-page folder promoting the radio network. Another drawing was of CBS microphones and cables, and another was of two folding chairs supporting a cello.

The Empty Studio was reproduced on two pages above a printed message. Left of the fold was the title "The empty studio..." and on the right hand page were the words which inspired the drawing: "No voice is heard now. The music is still. The studio audience has gone home./ But the *work* of the broadcast has just begun. All through the week...*between* broadcasts.../ people everywhere are buying the things this program has asked them to buy...."[40]

A 1948 tempera, *Silent Music,*[41] is similar to this serigraph; however, the arrangement of chairs and stands differs somewhat. Both the tempera painting and this serigraph carry Shahn's signature between the second and third chair legs from the right. The CBS drawing and reproductions made from it (see fig. 207) have the signature between the outermost two legs.

Selden Rodman, art critic and collector, recalls Shahn's laughing comment about *Silent Music:* "Don't you know the real title of that one? No? Well, it's 'Local 802 on Strike!'" In other comments on the absence of musicians, Shahn explained that "the emotion conveyed by great symphonic music happens to be expressed in semi-mathematical acoustical intervals and this cannot be transposed in terms of ninety portraits or caricatures of performers."[42] Variously titled *Silent Music, Musical Chairs, The Empty Studio,* and *Local 802 on Strike,* this serigraph was the first one planned by Shahn as a limited edition.[43]

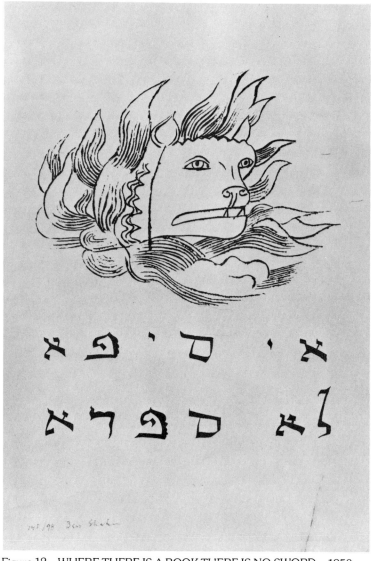

Figure 12—WHERE THERE IS A BOOK THERE IS NO SWORD. 1950
Serigraph in black
Sheet: 21 x 14½" Composition: 14 x 11⅝" Paper: Japan
Edition: 145 numbered plus approximately 155 others; *145/98* in
 brown conté crayon
Signature: *Ben Shahn* in black with brush lower left
Collection: New Jersey State Museum; gift of Mr. and Mrs. Robert D. Graff.
 Accession No: 69.275.2

Shahn presented more than one hundred examples of this print to friends as a holiday greeting. Later, the artist was dismayed to find one punched through with a nail and hanging on the wall in a friend's basement. McNulty writes that Shahn, upset by this abuse, returned to his studio and numbered all remaining prints, hoping that this would call attention to them as works of art.[44] Some time later, Shahn told this author about the same incident, still vivid and painful in his mind.

The beast is the result of a number of drawings with which Shahn experimented as he struggled to portray the horror he felt at the death of the four Hickman children in a Chicago ghetto fire in the late 1940s (see Introduction, pp. xix-xx). Out of one group of sketches emerged a lion-like head. "I made many drawings, each drawing approaching more nearly some inner figure of primitive terror which I was seeking to capture. I was beginning to become most familiar with this beast-head. …I incorporated the highly formalized flames from the Hickman story as a terrible wreath about its head….In the beast…I recognized a number of creatures….The stare of an abnormal cat…that had devoured its own young….The wolf…the most paralyzingly dreadful of beasts…."[45] Shahn returned repeatedly to the image of the fire-beast. A drawing, very similar to this serigraph, is used for the book cover of the 1960 Vintage edition of *The Shape of Content,* and the image again appears in *The Biography of a Painting.*[46]

Morris Bressler, Shahn's friend and neighbor, recalls a conversation he had with Shahn during the 1948 Henry Wallace campaign in which he quoted to the artist this old and popular Talmudic saying: The man of the sword/ Is not a man of the book. Impressed by the phonetic play of the words, Shahn asked to see it written in Hebrew. A few days later, he had combined the quotation, written in old Aramaic script, with the fire-beast. This drawing was subsequently rejected by *Jewish Life* magazine for their election month issue. It is the antecedent of two later drawings and the serigraph. In a gesture of friendship, Shahn designed a bookplate for Bressler, also using the fire-beast image (see fig. 242).

PHOENIX THEME

The phoenix was a favorite subject of Shahn's. It appears as early as 1944 on a poster, which he painted for a one-man exhibition at the Downtown Gallery (see fig. 153). Three *Phoenix* serigraphs derive from this original poster painting: one in black only (fig. 13) and one in black over a hand colored image (fig. 14), both dated 1952; and a 1956 poster for an exhibition at the Fogg Art Museum (fig. 165). The black silkscreen image is identical in all three.

Shahn illustrated *The Biography of a Painting* with a drawing of a similar phoenix, although its proportions and details differ markedly.[47] Related to this version is the 1966 watercolor, *Second Phoenix*[48] and the 1968 serigraph *Phoenix* (fig. 85) which followed. Shahn also included a variation of the phoenix on the cover of his *Paragraphs on Art*.[49] In all of these versions, the artist surrounded the birds with the waving, fiery flames which he used so successfully with his fire-beast (see fig. 12). The phoenix is also one of several motifs in Shahn's mural for the Brady High School in Brooklyn, New York.

A *Peace* poster (fig. 206) features a dove which is colored horizontally in a manner similar to the hand colored *Phoenix*.

The brightly colored birds harken back to the sacred birds of antiquity. The phoenix, from the Greek, meaning bright-colored, was a large mythical bird of gorgeous plumage, always a male, that lived a long life (from 500 to 12,954 years). Eventually, he built a nest of spice tree twigs, set it afire, and burned himself to death. Then, from the ashes, he arose again. Beginning with Herodotus (fifth century B.C.), the story has been told, retold, believed, and disbelieved in classical, Jewish, Christian, and Mohammedan legends.

In an old Hebrew legend, the Phoenix bird (Anrishne) was one of the animals on Noah's ark. Because some animals fed mainly by night and others by day, their care and feeding was a continual chore. For several days the Phoenix could not be found. When the bird was located, Noah asked why he had not come forth for food. Phoenix replied that seeing Noah having so much work to do, he could not bring himself to add to his burden. Noah, according to the story, was much impressed by this considerate and selfless bird. When Shahn's friend, Morris Bressler, told him this Hebraic version, Shahn replied that that was not his kind of bird. Shahn's *Phoenix* is proud and arrogant.

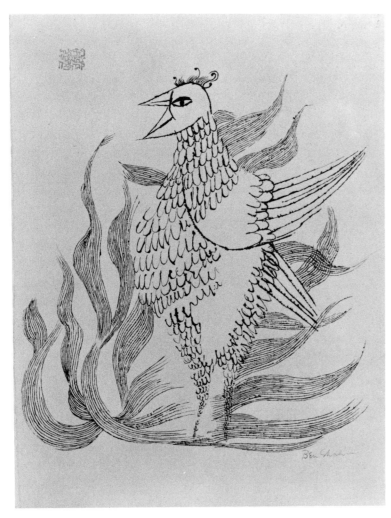

Figure 13—PHOENIX. 1952
Serigraph in black
Sheet: 30¼ x 22⅛"
Composition: 22⅞ x 22¼"
Paper: Unbleached Arnold—
 England
Edition: Unspecified;
 120 known, of which about
 70 are signed
Signature: *Ben Shahn* in red
 with brush lower right,
 orange-red chop upper left
Collection: New Jersey State
 Museum; purchase.
 Accession No: 68.40.2

Figure 14—PHOENIX. 1952
Serigraph in black with
 hand coloring
Sheet: 30¾ x 22⅜"
Composition: 22⅞ x 22¾"
Paper: Russell Flint Handmade
Edition: 100; *81-100* in black
 ink lower left
Signature: *Ben Shahn* in red
 with brush lower right
Collection: New Jersey State
 Museum; purchase.
 Accession No: 65.14.1

The black serigraphic image is identical to those of figs. 14 and 165 in this series. With the absence of color, the flames are more prominent and the bird seems more vulnerable to their assault.

The seal, or chop, seen in the upper left corner of the print, was not acquired until 1960 (*see* note, fig. 24), but Shahn took great pleasure in using the chop and sometimes applied it to prints done prior to 1960. Thus, it is inaccurate to assume that prints bearing his chop date from 1960 or later.

Shahn once pointed out that this serigraph "was the first of those prints that I made (and make) in which I painted in color and then printed an image in black, registering that with the colors painted. This was to obtain a richness that I felt could not be achieved through simple color printing. The original painting for the *Phoenix* was done as a poster for an exhibition of mine."[50] (See figs. 17, 22, and 153.) Although members of his family sometimes helped Shahn with the hand coloring, he did the *Phoenix* himself.

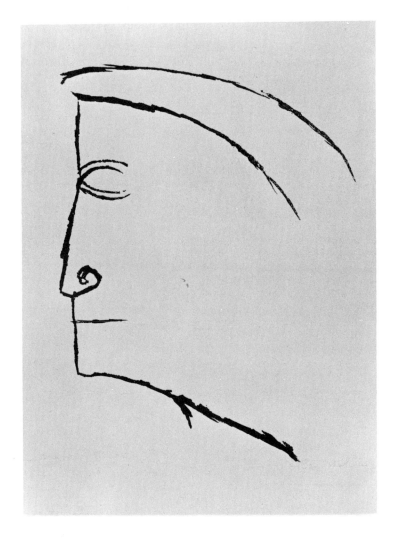

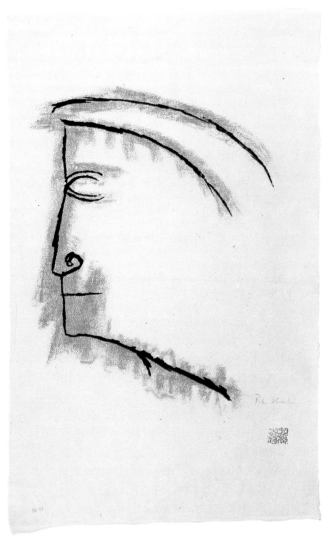

Figure 15—PROFILE. 1952
Serigraph in black
Sheet: 38¾ x 25⅜"
Composition: 23½ x 18"
Paper: Unbleached Arnold—England
Edition: Unspecified; 5 known
Signature: *Ben Shahn* in pencil lower
 right
Collection: New Jersey State Museum;
 purchase. Accession No: 70.170.3

Figure 16—PROFILE. 1952
Serigraph in black and umber
Sheet: 39½ x 25"
Composition: c.26¼ x 20¼"
Paper: Japan
Edition: 97 (*92-97* in black ink
lower left)
Signature: *Ben Shahn* in red with
brush lower right above orange-red
chop
Collection: New Jersey State Museum;
purchase. Accession No: 65.14.7

The black outline is identical in both versions of *Profile:* this one in black and the other (see fig. 16) in black and umber.

A beautifully restrained statement, the drawing displays the utmost economy of line. The iris is excluded and only a thin line delineates the lips.

Shahn made at least five copies of this print, but he preferred the black and umber version.

In the two versions of *Profile* (see fig. 15) the black line is identical. However, the addition of the umber "shadow" makes this a very different print from the other. (The umber, extending beyond the black line, also accounts for the larger composition dimensions.) This was the version Shahn himself preferred and he had it printed in an edition of ninety-seven. It recurred as a reduced reproduction in a 1959 poster (see fig. 168) and as a 1968 poster lithograph (see fig. 199).

Figure 17 — TRIPLE DIP. 1952
Serigraph in black with hand coloring
Sheet: 34⅜ x 27¼ " Composition: 29⅛ x 21"

Edition: 58 (72 known, including artist's proofs); *45-58*
lower left in black ink
Signature: *Ben Shahn* in black with brush lower right
Collection: New Jersey State Museum; gift of Mr. and Mrs.
James E. Burke. Accession No: 69.275.3

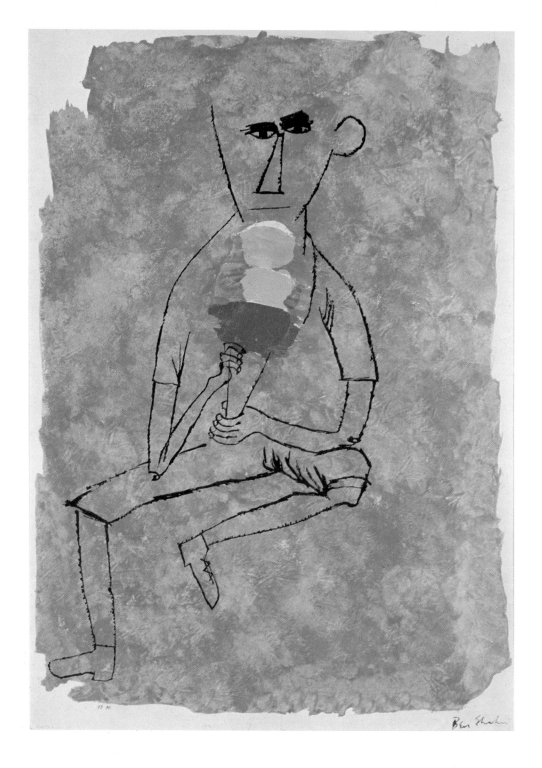

Triple Dip is one of the most colorful and appealing of Shahn's prints. As in *Phoenix* (fig. 14), the bright colors were first painted on the paper and then the black, serigraphic lines were overprinted. McNulty points out that Shahn drew the image directly on the screen rather than tracing it from his prepared drawing.[51]

Shahn liked to recall how, when his children were chafing under the prolonged quarantine for chicken pox, he took them through the woods to fetch them the triple dips. The memory of that occasion was the inspiration for this print. The partial outline of the boy's head, the look of complete concentration, the spindly legs and arms compared to the immense size of the ice cream cone, all suggest that on a hot summer's day, a triple dip can be the most important thing in a child's world.

PATERSON THEME

Shahn's work on this theme was inspired by a passage from the poem *Paterson,* by William Carlos Williams, who practiced medicine in Rutherford, New Jersey. The poem was Williams' most ambitious literary effort, and the following lines attracted Shahn's attention:[52]

> without invention nothing is well
> spaced
> ...the old will go on
> repeating itself with recurring
> deadliness....

The 1948 tempera drawing *Brick Building,*[53] and the 1950 painting *Paterson,*[54] are similar to the two serigraphs on this theme (see figs. 18 and 19). McNulty points out that the hand colored *Paterson* serigraph is associated with Shahn's studies for the painting of the same title, and that Shahn was fascinated by the dye patterns in the windows of the Paterson buildings.[55] (Dye-making was an important industry in the town.) The bright colors of the serigraph (fig. 19) reflect Shahn's impression of the variegated patterns in the windows. They occur again in the posters *Pavillon Vendome* (fig. 162) and *Ballets U.S.A.* (fig. 167).

The black printed outline of the two serigraphs is not identical; i.e. the one is not simply a hand colored version of the other. Details of the roof, cornice, and railroad tracks differ markedly.

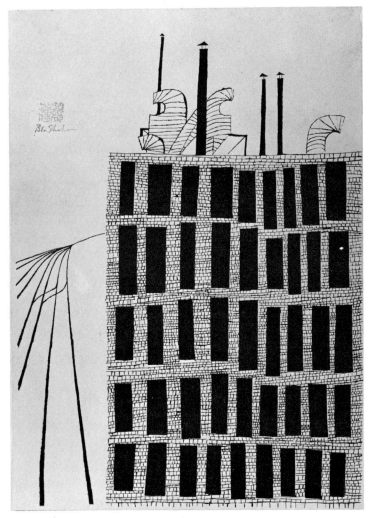

Figure 18—PATERSON. 1953
Serigraph in black
Sheet: 31⅞ x 22¾"
Composition: 29⅞ x 22⅝"
Paper: Rives
Edition: 50
Signature: *Ben Shahn* in red
 with brush upper left below
 orange-red chop
Collection: New Jersey State
 Museum; anonymous donor.
 Accession No: 69.288.2

Figure 19—PATERSON. 1953
Serigraph in black with hand
coloring
Sheet: 30¾ x 22⅜"
Composition: 30 x 22"
Paper: Handmade wove
Edition: 60 (85 known,
including artist's proofs); *15/60*
lower left in black ink
Signature: *Ben Shahn* lower
right in red with brush
Collection: New Jersey State
Museum; purchase.
Accession No: 69.308.5

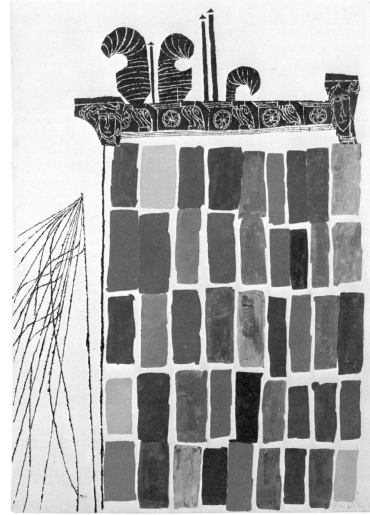

This version, without the elaborate cornice of the color serigraph (fig. 19), is quite similar to Shahn's tempera *Brick Building,*[56] which, however, does not include the railroad tracks. The relative locations and shapes of the vents and stacks on the roof are almost identical in the two works. The slightly curving railroad tracks in the black print are not as complex as in the color version and rather than converging on the horizon, disappear as one track behind the building. (Pencil notation apparently Shahn's.)

The black printing in this serigraph includes the rooftop, the cornice, the left edge of the building, and the converging railroad tracks. The rectangles of color, hand applied by stencil, are reminiscent of the colors in *Phoenix* (fig. 14).

The elaborately detailed cornice, the vents, and the chimneys are all exaggerated in scale. The ribbon-like railroad tracks serve to give elevation to the building.

Figure 20—TV ANTENNAE.
1953
Serigraph in black
Sheet: 25¼ x 38⅝"
Composition: 16⅛ x 36¾"
Paper: Unbleached Arnold
Edition: 100 (102 known,
including artist's proofs);
63/100 in black ink lower left
Signature: *Ben Shahn* in red
with brush lower right
Collection: New Jersey State
Museum; purchase.
Accession No: 68.36.7

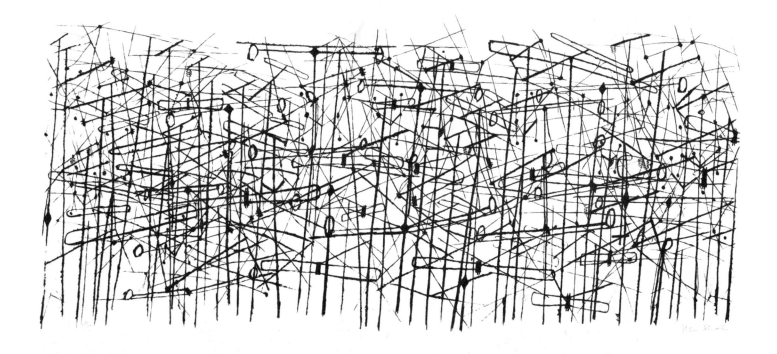

We are so accustomed to the TV antennae as part of our man-made environment—even perching birds now include them as "natural" elements for territorial defense during the nesting season—that one forgets the suddenness of this addition to the rooftops of mid-twentieth century America.

A 1952 drawing, *Television Antenna,*[57] has a cluster of intercepting lines, circles, and rectangles similar to the ones in this serigraph, except that the drawing is done on a vertical plane. In *The Shape of Content* Shahn included an illustration of a drawing of TV antennae which shows still another variation.[58] The print, shown here, is also known as *Calabanes* and *Caliban,* a title based on the humorous association of TV aerials with the characters Ariel and Caliban in Shakespeare's *The Tempest.*[59]

William Golden of CBS commissioned Shahn in 1955 to do the drawings for a double-page network advertisement. On the left hand page the title, "Harvest," was printed in large block letters above a drawing of a wheat field (see fig. 211). A drawing of antennae was featured on the right hand page, with the word "Harvest" repeated in smaller letters above the drawing, and a message arranged in seven short paragraphs beginning: "Each year America's rooftops yield a new harvest—a vast aluminum garden spreading increasingly over the face of the nation...."[60] Shahn's interpretation has translated this metaphor into a superb visual image. The CBS drawing is seemingly identical to this serigraph but in fact has an additional column of antennae on the right. Also, Shahn signed the CBS drawing along an arc, lower right, unlike his signature here.

Figure 21 — BEATITUDES. 1955
Wood-engraving with colors
Sheet: 16 x 21" Composition: 10⅛ x 15⅛"
Paper: Japan
Edition: 400 (*30/400*) in pencil, center
Engraver and Printer: Leonard Baskin
Publisher: International Graphic Arts Society, Inc.,
 New York

Signature: *Ben Shahn* in black with brush lower left;
 Leonard Baskin. Sculpsit. in pencil lower right and
 title *"Beatitudes"* in pencil, center; *Ben Shahn* in black
 in the block lower right and *LB SC* in black in the
 block lower left
Collection: New Jersey State Museum; purchase.
 Accession No: 68.31.2

Based on a painting, this edition was engraved and printed by Leonard Baskin in his studio.[61] Baskin called it *Beatitudes* rather than the singular *Beatitude* which McNulty gives as the correct title.[62] The black in this print is the engraved impression. The colored areas were applied by Baskin from linoleum cuts. The 1969 lithograph *Epis* (fig. 86) is similar to this engraving, but treatment of the man and the sky is quite different. There exists also an unpublished, black version of *Beatitudes* (fig. 243).

The 1950 Shahn drawing, *Man Picking Wheat*,[63] appears to be the antecedent work. Very much like it is a drawing used as an illustration in Shahn's *Paragraphs on Art*.[64] James Thrall Soby, a leading authority on Shahn's work, has written that in *Man Picking Wheat* "the atmosphere is quiet and thoughtful and the large figure is beautifully contrasted with the slender plants amid which he stands."[65]

The subdued colors and dark free-floating forms surrounding the bent figure in this print combine to give a sense of solemnity to the scene. Shahn's characteristic treatment of the man's hands endows them with great strength, although they seem to be caressing rather than picking the lovely plants.

Figure 22—
MINE BUILDING. 1956
Serigraph in black with hand coloring
Sheet: 22⅜ x 30¾"
Composition: 17 x 28½"
Paper: Unbleached Arnold Linen
Fibre—England
Edition: Unspecified; 63 known
Signature: *Ben Shahn* in red with
brush lower right
Collection: New Jersey State Museum;
gift of The Dorothy and Sydney
Spivack Acquisition Fund and
The Frelinghuysen Foundation.
Accession No: 69.294

Shahn loved to experiment and to find different ways of expressing his artistic objective. Here the colors were applied first, in heavy layers, and then the black areas of the building were printed over the painted surface. Since the hand coloring of the various prints is far from identical, each print is endowed with a unique quality. This example is brighter than most others examined. Shahn enlisted the aid of his daughter, Suzie, in painting *Mine Building,* which may account for some of the variations. To emphasize the colors, Shahn let the clear white paper show through in the upper center of the building. *Phoenix* (fig. 14) and *Triple Dip* (fig. 17) were executed in the same manner.

Shahn referred to the ambience of this work as resulting from "the dismal and sick beauty that accrues to those dark sooty mine buildings that had once been painted, and that take on strange efflorescences."[66] Soby is satisfied that the artist was successful in translating his thoughts and feelings: "The idiosyncrasy of buildings and their humanistic allusions interest Shahn most. He frequently tells fortunes by the places people inhabit or in which they work. Could any image more poignantly express the dour life of miners than the dark *Mine Building?*"[67] It is related to the series of drawings Shahn made in 1947, when asked to illustrate a *Harper's* magazine article on a mine tragedy in Centralia, Illinois.[68]

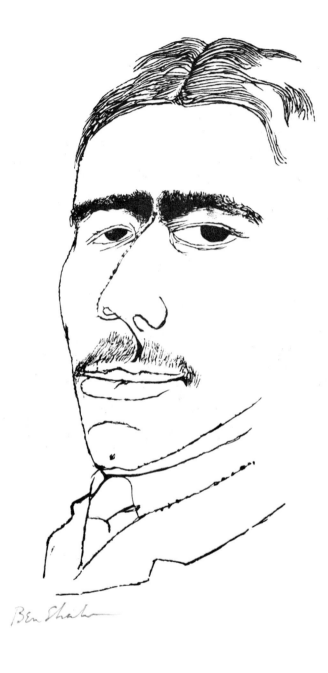

Ben Shahn

Figure 23 — WILFRED OWEN. 1956
Wood-engraving in black
Sheet: 11½ x 9¼" Composition: 7¾ x 3¾"
Paper: Japanese Vellum
Edition: 400
Engraver and Printer: Leonard Baskin
Signature: *Ben Shahn* in red with brush lower left;
 Leonard Baskin, sculpt. in pencil lower right
Collection: New Jersey State Museum; purchase.
 Accession No: 68.31.12

This portrait of the British poet Wilfred Owen was based on a Shahn drawing and was engraved by Leonard Baskin. It was used as the frontispiece in *Thirteen Poems,* an edition of Owen's verse published in 1956 by the Gehenna Press, Northampton, Massachusetts. Thirty-five copies of the book carried this engraved portrait.

Owen (1893-1918) is considered one of the best of the young poets of World War I. Killed a week before the armistice, he had forcefully described the horror and cruelty of the battle front. It is safe to assume that Shahn sympathized with the philosophy of the poet: "My subject is War, and the pity of War. The Poetry is in the Pity."

Shahn's economy of line in portraiture is evident here. No lines enclose the right side of the head. Emphasis is placed on the expressive eyes and heavy brows which Shahn has chosen as most telling features of his subject.

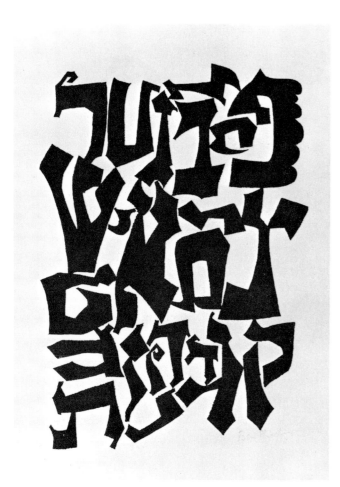

Figure 24 — ALPHABET OF
CREATION. 1957
Serigraph in black
Sheet: 38¾ x 27¼"
Composition: 31¼ x 22"
Paper: A. Milbourne and Co.,
British Handmade
Edition: Unspecified; 80 known
Signature: *Ben Shahn* in pale red with
brush lower right
Collection: New Jersey State Museum;
anonymous donor.
Accession No: 69.288.13

Shahn's "alphabet" is an extremely effective and original arrangement of calligraphic forms, incorporating the twenty-two letters of the Hebrew alphabet which Shahn designed for his 1954 book, *The Alphabet of Creation*. Printed in black on white stock, the "alphabet" also appeared on the October 14, 1954, cover of *Print* magazine. Later, Shahn used it as an illustration in his book *Love and Joy About Letters,* and on the book's slipcase, where it was printed white on black stock.

In *Love and Joy About Letters,* Shahn talks about his lifelong interest in calligraphy, which began with his apprenticeship to a lithographer and subsequently was expressed in many of his drawings and paintings: "All letters, of course, were once pictures. Can one still discern the head of the ox in Aleph and Alpha and A? Can one see the house in Beth and Beta and in B? Why does every Greek letter so resemble the Hebrew equivalent in its name—was that its origin? Have they a common origin? All this while one works painstakingly, almost painfully, the lip fixed between the teeth, contemplating, wondering about the mysteries, the mystic relationship of the letters growing under one's hands."[69]

Two black ink drawings attest to Shahn's continual interest in the alphabet motif: *Alphabet,*[70] done in 1954, and *Third Alphabet,*[71] done in 1957. This serigraph, *Alphabet of Creation,* was used in three additional graphics, *Alphabet and Maximus* (fig. 63), *Alphabet and Warsaw* (fig. 64) and *Alphabet and Supermarket* (fig. 245).

When Shahn with his wife, Bernarda, visited Japan in 1960, he had a chop, or seal, made from a modified version of his "alphabet" (i.e., more letters were placed on the horizontal than on the vertical plain). It produced a charming design when stamped in the traditional oriental orange-red color. The alphabet signature was a thing of pleasure and beauty to Shahn. Before placing it on a print, he would pause a few moments, considering the design as a whole, before choosing the correct spot. Shahn had several mirror image replicas of his seal made in the form of gold pins. He gave the first one to his wife.

LUTE AND MOLECULE THEME

While Shahn was a Charles Eliot Norton Professor at Harvard University in 1956 and 1957, he found one day that someone had left a lute lying in his studio beside a "marvelous model of a molecule" lent to him by a scientist. "The accidental juxtaposition intrigued me and I did a screen on that theme."[72] Shahn's fascination with the subject eventually resulted in several paintings and four graphics (see figs. 25, 29, 30, and 270).

A 1957 gouache[73] is almost identical to the serigraph *Lute* (fig. 25), and a 1958 gouache[74] is almost identical to the serigraphs *Lute and Molecule, No. 1* and *No. 2* (figs. 29 and 30). However, the 1957 watercolor, *Lute #, 2*[75] is quite distinct from the other versions, being drawn in the vertical, having multi-colored strings, and showing only a slight suggestion of molecular structure. A 1970 lithograph in the posthumous *Hallelujah Suite* (see fig. 270) is also quite different from the serigraphs, being devoid of color and having been drawn on the plate with heavier lines.

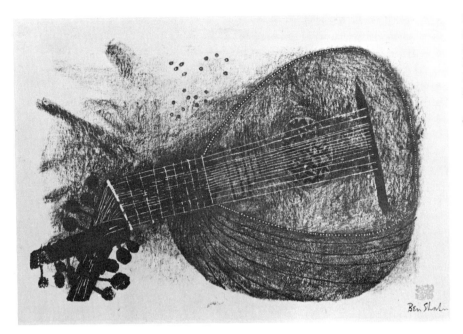

Figure 25—LUTE. 1957
Serigraph in brown
Sheet: 25 x 37" Composition: 19¾ x 33¾"
Paper: Japan
Edition: Unspecified; 2 copies known
Signature: *Ben Shahn* in black with brush lower right
 below orange-red chop
Collection: New Jersey State Museum; gift of The
 Dillon Fund. Accession No: 69.308.1

This print was probably an experimental, graphic version of *Lute, I,* a 1957 gouache (see p. 26), to which it is nearly identical in composition, in details of white against the dark wood of the instrument, in color pattern, and in reduction and location of the atomic model. These characteristics distinguish this rare print from the other two serigraphs of the series (see figs. 29 and 30).

Shahn told McNulty that he was not satisfied with this experimental version;[76] however, he did sign and chop both known copies of it.

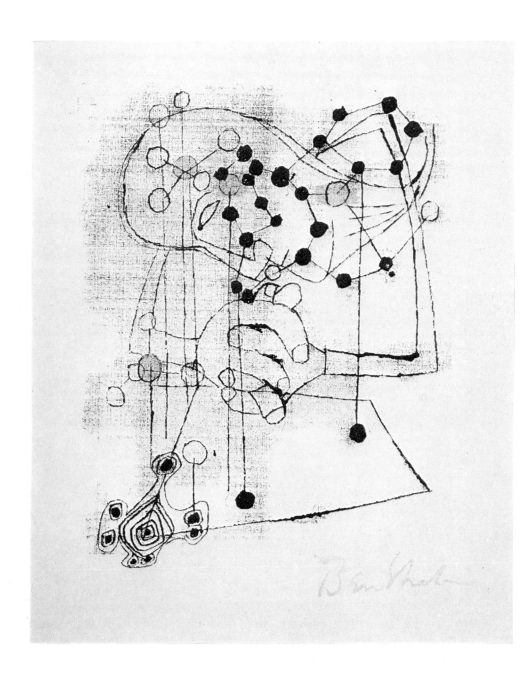

Figure 26—SCIENTIST. 1957
Serigraph in black with hand coloring
Sheet: 11½ x 10″ Composition: 8¾ x 6¾″
Paper: Umbria handmade wove rag
Edition: 320 known
Signature: *Ben Shahn* in red with brush lower right
Collection: New Jersey State Museum; purchase.
 Accession No: 70.216.3

The black outline of the scientist with head bowed, hands folded, and eyes partially closed, is suggestive of a man in prayer. The scientist is enveloped in an atomic molecule of black and colored atoms. The configuration and density of the atoms focus attention on the scientist's face. From the face, vertical lines carry the eye downward to the paper on the desk.

In the Downtown Gallery Exhibition Catalogue of 1959, Shahn expressed a view of the scientific era in which he lived: "I doubt that what now seems to be an atomic age, or is in any case a scientifico-mechanical age, will ever be greatly distinguished for its contribution to the human spirit. But perhaps later generations, if there are to be later generations, will discover in it qualities which the near view prevents one's seeing."[77] And in 1949 he wrote: "We are living in a time when civilization has become highly expert in the art of destroying human beings and increasingly weak in its power to give meaning to their lives."[78]

In *Love and Joy About Letters,* Shahn reproduced this print in color. The illustration of a scientist in *The Biography of a Painting* is also identical except for the colored atoms which are light brown and only three in number.

The edition number is based on one print in the Kennedy Galleries which Shahn numbered *7/70,* plus the prints included in each of the two hundred fifty numbered copies of James Thrall Soby's 1957 book, *Ben Shahn His Graphic Art.*

SUPERMARKET THEME

"Supermarket" is one of four motifs based on drawings that Shahn was commissioned to do for CBS (see also *Silent Music,* fig. 11; *TV Antennae,* fig. 20; and *Wheat Field,* figs. 35 and 211). A reproduction of the drawing, *The Big Push* (see fig. 209), was carried as a network ad in *Variety,* June 12, 1957. The three words of the title were arranged in vertical order above the tallest basket on the right of the composition, and the right hand column carried a printed message, starting: "This summer America's consumers will fill their shopping baskets fuller than any summer in their history. And they will fill them with the products they know best—the brands they see on television...."[79]

The same serigraphic image is seen in *Supermarket* (figs. 27 and 28) and *Alphabet and Supermarket* (fig. 245).

Figure 27—SUPERMARKET. 1957
Serigraph in black
Sheet: 25¼ x 38¾" Composition: 17 x 38¼"
Paper: Unbleached Arnold
Edition: Unspecified; 57 known
Signature: *Ben Shahn* in red with brush lower right
Collection: New Jersey State Museum; anonymous gift.
 Accession No: 70.1.3
Condition: Waterstained around margins, particularly
 upper right

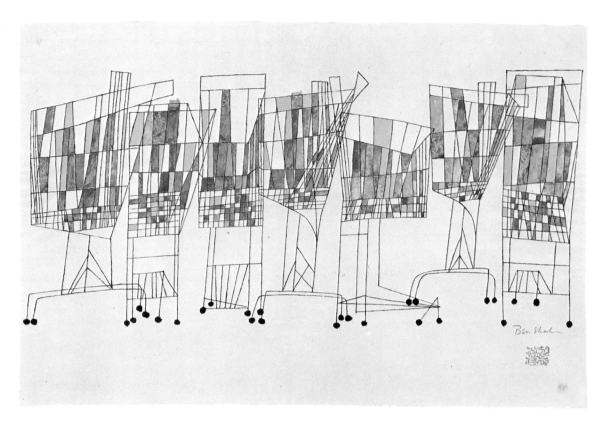

There is obviously a close relationship between *Supermarket* and the drawing reproduced in *Variety* as *The Big Push* (see p. 29). However, in the serigraph, Shahn decided to simplify the image by including a lesser number of baskets, allowing for more open spaces between lines and clearer definition of forms.

In referring to the prints based on drawings he made for CBS, Shahn said that, "To me, this print, *Supermarket,* along with the ones called *Silent Music, TV Antennae,* and the print called *Wheat Field,* are among the abiding symbols of American daily life, to be celebrated and brought into awareness."[80]

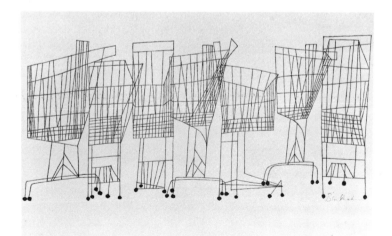

Figure 28—SUPERMARKET. 1957
Serigraph in black with hand coloring
Sheet: 25¼ x 38⅝" Composition: 17 x 38¼"
Paper: Unbleached Arnold
Edition: Unspecified; 80 known
Signature: *Ben Shahn* in red with brush lower right above
 orange-red chop
Collection: New Jersey State Museum; purchase.
 Accession No: 68.36.6

The colors, applied to selected sections of the baskets, result in a vibrancy that is lacking in the black version. According to McNulty, Shahn's daughter, Suzie, and his son, Jonathan, helped in the coloring.[81]

Here is another case in which Shahn applied his chop, acquired in 1960, to a print of an earlier date (see figs. 13 and 24).

Figure 29—LUTE AND MOLECULE,
 No. 1. 1958
Serigraph in black with hand coloring;
 Brown Version
Sheet: 27¼ x 40¾"
Composition: 24½ x 38½"
Paper: A. Milbourne & Co.,
 British Handmade
Edition: Unspecified; 35 known
Signature: *Ben Shahn* in blue with brush
 lower right
Collection: New Jersey State Museum;
 purchase. Accession No: 69.288.12

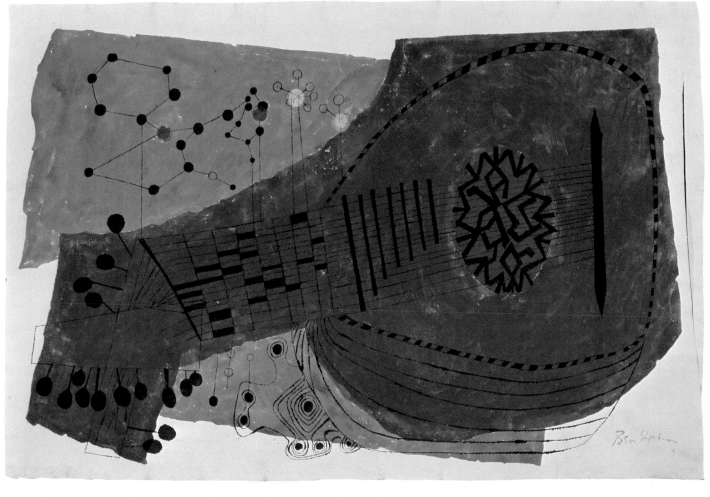

The black serigraphic image of lute and atoms is identical
in this and the white version (*see* fig. 30), although the addi-
tion of colors in this print produces a very different *effect.*
The brown, extending beyond the instrument, makes the
lute appear much heavier. The blue-gray wash in the back-
ground softens the black atomic structure. The deep blue
furnishes an *effective* background to the vibrating, calli-
graphic forms of the sound hole, which are at once decora-
tive and symbolic of sound.

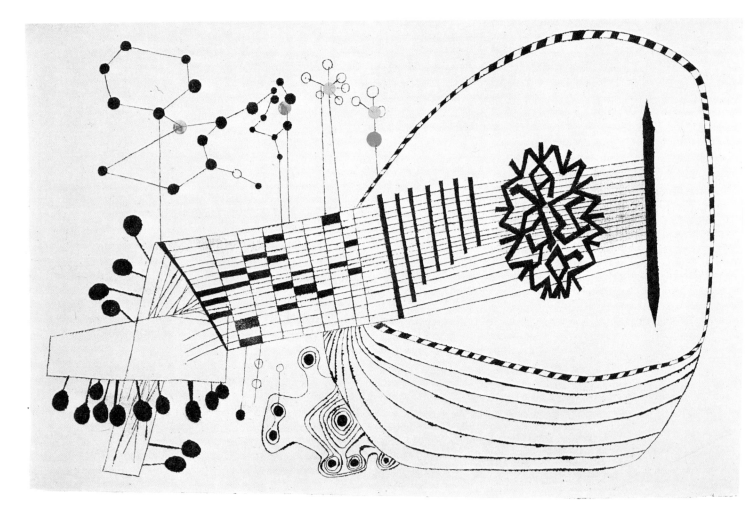

Figure 30—LUTE AND MOLECULE,
 No. 2. 1958
Serigraph in black with hand coloring;
 white version
Sheet: 25¼ x 38½"
Composition: 23½ x 36"
Paper: Unbleached Arnold
Edition: Unspecified; 100 known
Signature: Unsigned
Collection: New Jersey State Museum;
 purchase. Accession No: 69.288.11

As one examines the two versions of *Lute and Molecule* side by side, one is struck by the light and airy feeling of this print in comparison to the brown version (*see* fig. 29). Here black printed lines dominate. The vibrating, calligraphic forms on the soundboard fairly dance in both versions.

The hand colored atoms are similar, but the colors are more vivid against the white paper and there is an additional atom in orange.

Both serigraphic versions are easily distinguishable from the 1970 *Hallelujah* lithograph, *Lute* (fig. 270), published posthumously.

SACCO AND VANZETTI THEME

Early in Shahn's career as an artist, two Italian-born Americans, Nicola Sacco and Bartolomeo Vanzetti, attracted attention by their "radical" strike activities and their flight to Mexico in 1917 to evade the draft. In 1920, they were arrested and charged with the murder of a Massachusetts paymaster. Although witnesses claimed that the two were miles away at the time, and although there were other weaknesses in the case, Sacco and Vanzetti were found guilty and condemned to death. Their lawyers charged that the court was prejudiced; but a stay of execution was denied and the two died on August 23, 1927.

The execution touched off an international cry of outrage. Demonstrations and protest parades by students and workers erupted in Europe and Latin America as well as in the United States. Renowned writers such as H. G. Wells, Edna St. Vincent Millay, Sinclair Lewis, and John Dos Passos, and the physicist Albert Einstein, protested that Sacco and Vanzetti had been executed not because they were guilty of the payroll crime but because of their ethnic origin, radical beliefs, and draft evasion.

In 1930, reflecting upon this tragedy, Shahn began a series of twenty-three gouache paintings based on the trial. This series and earlier paintings, depicting the main participants in the Dreyfus case, marked Shahn's emergence from traditional painting to a more personal style.

A 1932 exhibition of the Sacco and Vanzetti works created quite a stir. "The Downtown Gallery is apt to become something of a storm center during the two weeks of the exhibition and Mr. Shahn is henceforth someone to be reckoned with," wrote a reviewer.[82]

Three serigraphs (see figs. 31, 32, and 33), produced in 1958, testify to Shahn's continuing interest in this highly emotional issue, as does a 1962 poster (see fig. 176). The antecedent work seems to be a 1931-32 tempera painting, *Bartolomeo Vanzetti and Nicola Sacco*.[83] The prints are specifically related to the 1952 drawing, *Sacco and Vanzetti*.[84]

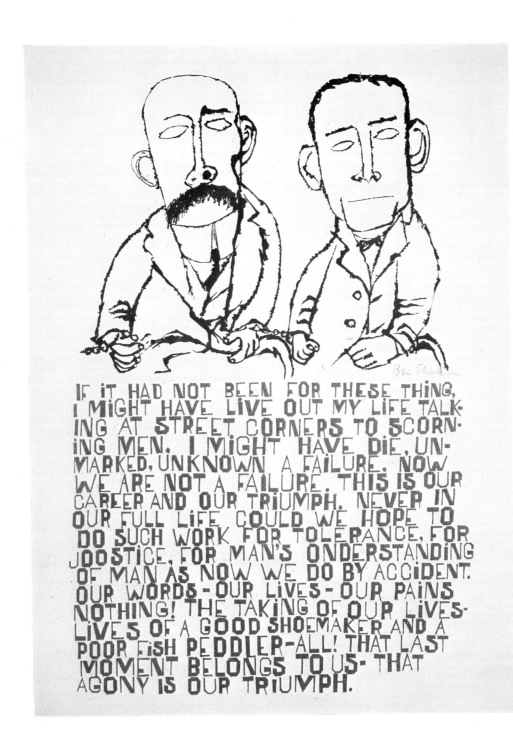

IF IT HAD NOT BEEN FOR THESE THING, I MIGHT HAVE LIVE OUT MY LIFE TALKING AT STREET CORNERS TO SCORNING MEN. I MIGHT HAVE DIE, UNMARKED, UNKNOWN A FAILURE. NOW WE ARE NOT A FAILURE. THIS IS OUR CAREER AND OUR TRIUMPH. NEVER IN OUR FULL LIFE COULD WE HOPE TO DO SUCH WORK FOR TOLERANCE, FOR JOOSTICE, FOR MAN'S ONDERSTANDING OF MAN AS NOW WE DO BY ACCIDENT. OUR WORDS - OUR LIVES - OUR PAINS NOTHING! THE TAKING OF OUR LIVES - LIVES OF A GOOD SHOEMAKER AND A POOR FISH PEDDLER - ALL! THAT LAST MOMENT BELONGS TO US - THAT AGONY IS OUR TRIUMPH.

Figure 31 — PASSION OF SACCO AND
 VANZETTI. 1958
Serigraph in black with brown text
Sheet: 30½ x 22⅝"
Composition: 25¾ x 17½"
Paper: A. Milbourne and Co.,
 British handmade
Edition: Unspecified; 90 known
Signature: *Ben Shahn* in red with brush
 lower right above calligraphy
Collection: New Jersey State Museum;
 gift of The Lessing and Edith Rosenwald
 Foundation. Accession No: 69.288.6

This print combines the portraits and text which are the components of all three serigraphs on the Sacco and Vanzetti theme. Here Shahn chose to print the text in a soft brown color which, in spite of the larger calligraphic area, allows the portraits to retain their dominance. The text is based on a transcription made during the trial by reporter Philip Strong. The spelling, grammar, and the folk alphabet have been combined by Shahn to immortalize the words of Bartolomeo Vanzetti.

One of the recurrent themes which Shahn regarded as characteristic of his work, the "indestructability [sic] of the spirit of man"[85] is poignantly reflected in this portrayal of two condemned men.

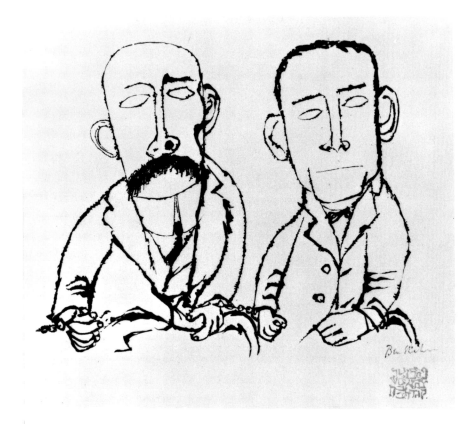

Figure 32—PORTRAIT OF SACCO
 AND VANZETTI. 1958
Serigraph in black
Sheet: 25 x 19½"
Composition: 12¾ x 15⅞"
Paper: Japan
Edition: Unspecified; 55 known
Signature: *Ben Shahn* in red with brush,
 lower right above orange-red chop
Collection: New Jersey State Museum;
 purchase. Accession No: 65.14.9

Without the Vanzetti text (see fig. 31), the disproportionate relationship of the large heads to the small bodies is even more apparent. The distortion, however, is an important factor in Shahn's attempt to present the tragic plight of the handcuffed pair—an attempt so successful that even today there seems to be no need of explanatory calligraphy. Shahn relied heavily on news photographs to create these portraits, and indeed, to the newspaper reader of the day, the principals in the trial would have been readily identifiable.

In discussing this subject with Selden Rodman many years later, Shahn recalled that in the Sacco and Vanzetti series of paintings, "I was trying to take advantage of the spectator's existing feeling and set fire to that. I didn't try to convince Judge Thayer, or those who believed them guilty. But I do think that by presenting the two anarchists as the simple, gentle people they essentially were, I increased the conviction of those who believed them innocent."[86] Shahn was, of course, speaking about presenting this tragedy anew to the American people in the 1930s, after the case itself was closed and the victims were dead.

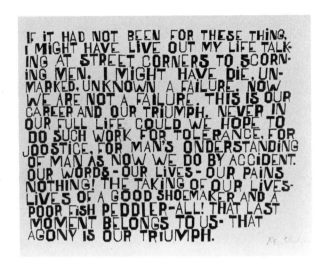

IF iT HAD NOT BEEN FOR THESE THiNG, I MiGHT HAVE LIVE OUT MY LIFE TALK-ING AT STREET CORNERS TO SCORN-ING MEN. I MiGHT HAVE DiE, UN-MARKED, UNKNOWN A FAILURE. NOW WE ARE NOT A FAILURE. THIS IS OUR CAREER AND OUR TRIUMPH. NEVER IN OUR FULL LIFE COULD WE HOPE TO DO SUCH WORK FOR TOLERANCE, FOR JOOSTICE, FOR MAN'S ONDERSTANDING OF MAN AS NOW WE DO BY ACCiDENT. OUR WORDS-OUR LiVES-OUR PAINS NOTHiNG! THE TAKiNG OF OUR LiVES-LiVES OF A GOOD SHOEMAKER AND A POOR FiSH PEDDLER-ALL! THAT LAST MOMENT BELONGS TO US- THAT AGONY IS OUR TRiUMPH.

Figure 33—
IMMORTAL WORDS. 1958
Serigraph in black
Sheet: 15½ x 20⅜"
Composition: 12¾ x 17⅜"
Paper: Handmade laid
Edition: Unspecified; 29 known
Signature: *Ben Shahn* in red
 with brush lower right
Collection: New Jersey State
 Museum;
 anonymous donor.
Accession No: 69.288.4

Figure 34—THREE PENNY
OPERA. 1958
Monotype
Sheet: 28½ x 22"
Composition: 28¼ x 21¼"
Paper: Composition board
with machine-made wood
pulp paper facing
Edition: Unique
Signature: *nhahS neB*
(Ben Shahn in reverse in
black lower left)
Collection: New Jersey State
Museum; gift of The
Lessing & Edith Rosenwald
Foundation.
Accession No: 69.286.1

Whereas Shahn used brown for the text in *Passion of Sacco and Vanzetti* (fig. 31), here he chose a heavy black color to contrast with the white of the paper. The irregular spelling and lettering emphasize that these are the words of Vanzetti himself. As Shahn explained: "I first used the amateur or folk alphabet very seriously in making a print concerning Sacco and Vanzetti. I wanted to use the entire text of the historic statement of Vanzetti, the tragic words….I wanted the words to be pictorial in their impact rather than to have a printed look. And I wanted them to be serious. The folk alphabet seemed appropriate to the halting English as well as to the eloquent meaning of the words. Furthermore, this alphabet, with its unfamiliar structures, halted the reading somewhat and produced a slower effect, and all this seemed to me desirable."[87]

During the thirties, Shahn had photographed hand-lettered signs that he had seen along the highways and in small towns, and he enjoyed reproducing them in his work. In *The Shape of Content,* for instance, a drawing of a countryside gas station is reproduced in which the dominant elements are the hand-lettered signs "EATS" and "GAS."[88] From the thirties on, folk lettering was a characteristic of his work.

Shahn reproduced *Immortal Words* as the central portion of his poster *Ben Shahn Graphik Baden-Baden* (fig. 176).

In *Love and Joy About Letters,* Shahn used for illustration a brush drawing of three gentlemen, identical to this print in every aspect except that the images are reversed.[89] The signature on this monotype, which is as indefinite as the rest of the impression, suggests that Shahn signed the original drawing while it was still wet and made this print immediately by pressing the paper against it. As a rule Shahn did not sign a work until it was finished and he was satisfied with it.

Lettered across the top of the drawing, but missing from this print, is the title: "Die Dreigroschenoper." The title is placed an inch or so above the tall, silk hat. If it had been on the wet drawing when this monotype was made, it would have extended beyond the upper edge of the paper and thus could not have been transferred. There is a record in the Shahn Estate of a 1958 drawing, *Three Penny Opera;* however, there is no indication whether the drawing had a title lettered across the top.

In *Love and Joy About Letters,* Shahn wrote: "From time to time, I return to the older forms of lettering, the Medieval Church Letters, or the classic Roman, perhaps just to show myself that I can. Thus, the German letters that I made recently for the 'Dreigroschenoper'…"[90]

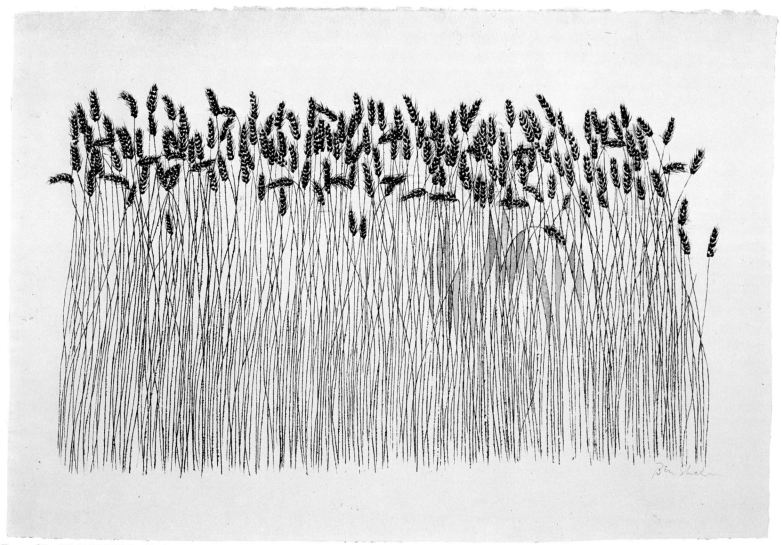

Figure 35—WHEAT FIELD. 1958
Serigraph in black with hand coloring
Sheet: 27⅜ x 40⅝" Composition: 20½ x 35¼"
Paper: A. Milbourne and Company,
 British Handmade
Edition: Unspecified; 90 known
Signature: *Ben Shahn* in red with brush lower right
Collection: New Jersey State Museum; purchase.
 Accession No: 68.82

This serigraph is based on the drawing *Harvest,* used in a CBS-TV advertisement (*see* figs. 20 and 211). The clear sky in this print allows for full appreciation of the delicacy and beauty of the tall and slender stalks of wheat, their heads bowing with the weight of ripe grain. The touches of color contribute to make this one of the most appealing of Shahn's hand-colored serigraphs.

In his *Ecclesiastes,* Shahn included an illustration of a sensitively colored wheat field.[9] A wheat field is also a major element in other prints (*see* figs. 21 and 86).

Figure 36—ALGERIAN MEMORY.
 1959
Serigraph in brown
Sheet: 25 x 19½"
Composition: 16½ x 11¼"
Paper: Japan
Edition: Unspecified; 70 known
Signature: *Ben Shahn* in black with
 brush lower right
Collection: New Jersey State Museum;
 gift of The Frelinghuysen Foundation.
 Accession No: 69.286.3

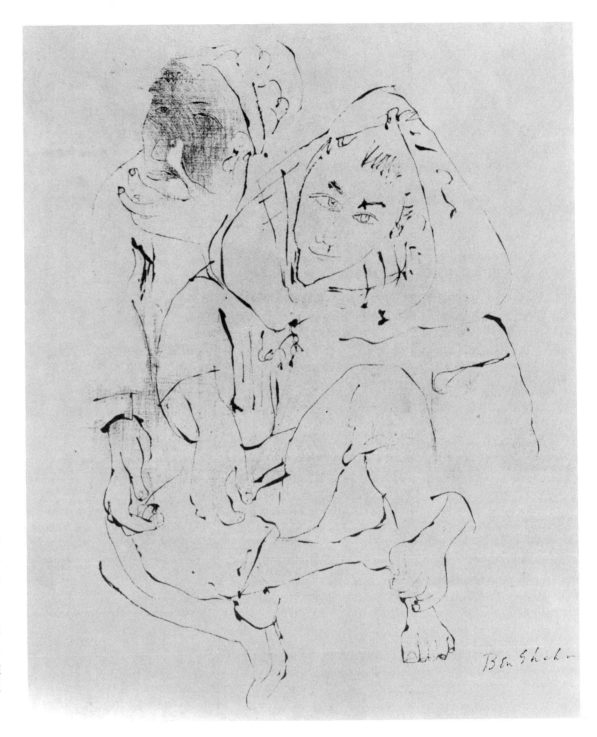

This print, based on a sketch made by Shahn on his third trip to North Africa in 1929, was made during a demonstration of the silk-screen printing process[92] (serigraphy).

The faintly brown image is printed on thin and partially transparent Japan paper. The wavering line ingeniously merges the seated figures.

CAT'S CRADLE THEME

Ben Shahn loved children and he enjoyed playing with them. I well remember an evening at our home many years ago, when Shahn spent more time telling stories to my two young daughters than he did talking with the grown-ups. What fun it was for him to set the tine of a fork vibrating against the table top, while he challenged the children to explain the enigmatic sound, or to make the water glasses sing by rubbing the rims! Surely, the game of cat's cradle must have similarly intrigued him, and he could not long have resisted the temptation to draw the string-entwined fingers.

There exists an undated drawing,[93] in which the game has just begun; and a drawing reproduced in *The Biography of a Painting* shows the game well advanced.[93] For *The Shape of Content,* Shahn drew a four-armed man completely preoccupied with the game. He is looking at the strings stretched between two upraised hands, while his two other hands are tightly clasped below. The artistic problem of attaching four arms to the body is not solved quite convincingly, but Shahn's humorous allusion to the frustrations of the game can be appreciated.[95]

A version of *Cat's Cradle* appears in the Albertina poster (see fig. 175). The two serigraphic versions (see figs. 37 and 38) utilize the same black printed image of the string and fingers. This image is quite distinct from the many other drawings he made of the subject.

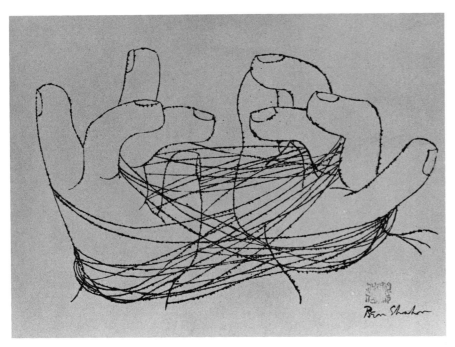

Figure 37 — CAT'S CRADLE. 1959
Serigraph in black
Sheet: 20½ x 29⅛" Composition: 16⅛ x 25½"
Paper: Composition board with machine-made wood pulp paper facing
Edition: Unspecified; 6 known
Signature: *Ben Shahn* with brush in black lower right below orange-red chop
Collection: New Jersey State Museum; purchase. Accession No: 68.36.1

I have only seen two examples of this print, and both were printed on cream-colored composition board. Shahn applied the chop and signed his name on this example in his studio, in 1968, when we selected several works for Museum purchase. Shahn rarely signed an entire edition at one time. When preparing prints for sale or exhibition, he applied the missing signatures as he selected the prints.

Figure 38 — CAT'S CRADLE. 1959
Serigraph in black and blue
Sheet: 20¼ x 26¼" Composition: 18½ x 26⅛"
Paper: Japan
Edition: Unspecified; 50 known
Signature: Unsigned
Collection: New Jersey State Museum; gift of the Association for the
Arts of the New Jersey State Museum. Accession No: 70.10.1

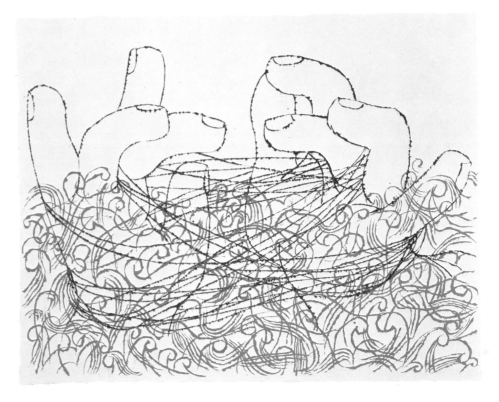

Both versions of *Cat's Cradle* have the same black serigraphic image. Here, however, Shahn has emphasized the complexity of the game by adding wave-like configurations to the lower portion. This is the version Shahn must have preferred since he had it made into an edition. Printed in blue over the black, the waves somewhat obscure the string and the hands. Above, the fingers, free of entanglement, continue their intricate game.

According to McNulty, this subject was drawn directly on the silkscreen.[96] Shahn referred to the blue configurations as water. They are similar to the water in *Branches of Water* or *Desire* (fig. 56); therefore, this print is often referred to as *Cat's Cradle with Water.*

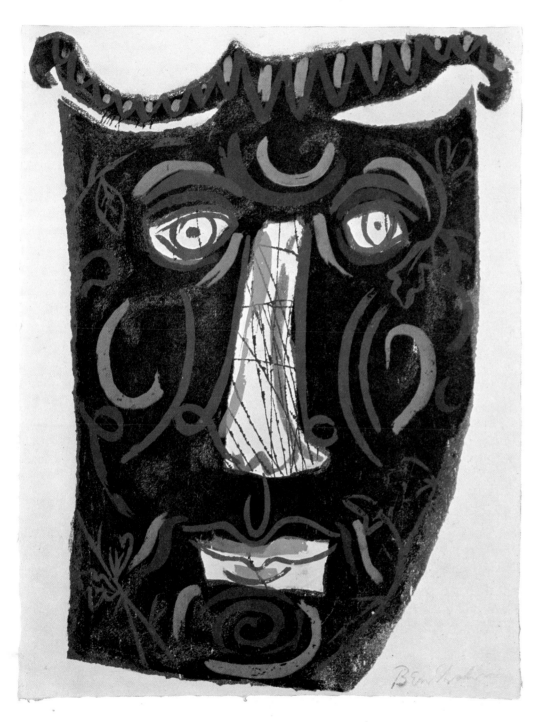

Figure 39 — MASK. 1959
Serigraph in colors
Sheet: 26¼ x 20¼" Composition: 26 x 19½"
Paper: Japan
Edition: Unspecified; 70 known
Signature: *Ben Shahn* in red with brush lower right;
 "#60" in pencil, verso
Collection: New Jersey State Museum; purchase.
 Accession No: 65.14.2

The mask appears in two print versions, this serigraph and the 1963 lithograph (see fig. 51). A 1958 watercolor entitled *Mask of the Devil (or JB's Blue Satan)*[97] and a poster (see fig. 171) are similar in many respects. But there the dark face is devoid of the colorful markings found in the prints. This is also the case in another version Shahn drew to illustrate his book, *The Biography of a Painting*.[98]

In this print, Shahn emphasized the eyes, nose and mouth by exposing the white of the paper. He further defined these features by overprintings in color. "The colors were suggested by a Sicilian pot that I once owned," he told McNulty.[99]

Shahn treasured iron and papier-mâche masks, which were made from this motif by James Kearns.

CREDO THEME

Several prints and drawings reflect Shahn's interest in the writings of Martin Luther. According to McNulty, the *Credo* serigraphs evolved from Shahn's study of Luther, which he undertook when he was asked by the Lutheran Church to design a symbol for a button.[100]

A small *Credo* (fig. 40) includes the image of a fire-beast similar to that in the 1950 print *Where There Is A Book There Is No Sword* (fig. 12). The beast is placed above a quotation taken from Martin Luther's testimony at the Diet of Worms, 1521. Another and larger *Credo,* made in 1966, combines the fire-beast and the Luther statement with a third element, a man holding a book (fig. 67). There the fire-beast is printed on the book and the text is printed below in blue. A photostatic copy of a work whose whereabouts is unknown (see fig. 217) is clearly related to the larger *Credo.*

In still another version used as an illustration in *The Biography of a Painting,*[101] the same angular man is holding a book, but now the Luther statement is printed in brown on the book, and the beast is missing entirely. It is a tribute to Shahn's genius that he could so successfully employ elements from different themes and arrive at new expressions, possessing their own freshness and vitality.

Shahn created the fire-beast as he attempted to portray the horror of the burned Hickman children (see pp. xix-xx) and later formalized it in the 1948 painting *Allegory.*[102] The dramatic association of the fire-beast with Martin Luther's great statement of moral conviction is curious. Is Shahn perhaps implying the terror of fire and the burning at the stake that threatened Luther and made his affirmation more than a mere philosophical exercise? The very fact that Shahn perceived this courageous statement as a credo and one with significance in his lifetime, illuminates our understanding of Shahn, the philosopher-artist.

Figure 40 — CREDO. 1960
Serigraph in black
Sheet: 16⅜ x 21⅝" Composition: 13¾ x 20"
Paper: Japan
Edition: Unspecified; 20 known (14 unsigned)
Signature: *Ben Shahn* in brown conté crayon lower right below fire-beast but above
 calligraphy; orange-red chop upper left
Collection: New Jersey State Museum; purchase. Accession No: 68.31.4

In this small version of *Credo,* the fire-beast and the calligraphy are printed in black. This print is unusual in that Shahn added with brown conté crayon all the dots on the "i's" and periods which were missing on the screen impression. He did this while I was in his studio, waiting for him to affix his signature.

This small version of *Credo* is also incorporated in the larger 1966 version (see fig. 67) but in that print, blue replaces the black lines.

The quotation is from Martin Luther's statement at the 1521 Diet of Worms, an assembly before which Luther defended his beliefs.

Figure 41 — FUTILITY. 1960
Wood-engraving in black
Sheet: 6¼ x 8½" Composition: 4¾ x 5¾"
Paper: Japan
Edition: Artist's Proof
Signature: *Ben Shahn* in black on the block lower right; *Ben Shahn* in pencil lower center; *Futility*
 and *Engraved by Stefan Martin* in pencil lower left
Collection: New Jersey State Museum; purchase. Accession No: 68.40.1

Shahn's close friend, Stefan Martin, engraved and printed *Futility* in his Roosevelt studio from a drawing Shahn had made as an illustration for *Thirteen Poems* by Wilfred Owen. An edition of 300 engravings was then commissioned by the International Graphic Arts Society Inc., N.Y. Prints from the IGAS edition are on larger sheets (10 x 12⅝"), carry the block signature lower right, *Ben Shahn* with a brush lower left, and *Stefan Martin sc.* in pencil lower right.

The printed portions of this handsome work are the black calligraphy and light gray outline of the constellation. The delicate gray is printed over the squares of color and gold leaf. Shahn's son Jonathan helped color this print.

The beautiful Hebrew calligraphy, boldly black against the white background, seems suspended against the outline of the Pleiades. The quotation is from the Book of Job 38:31-38 (*Books of the Bible,* The Soncino Press, 1946): Canst thou bind the chains of the Pleiades,/ Or loose the bands of Orion?/Canst thou lead forth the Mazzaroth in their season?/Or canst thou guide the Bear with her sons?/Knowest thou the ordinances of the heavens?/Canst thou establish the dominion thereof in the earth?/Canst thou lift up thy voice to the clouds, that abundance of waters may cover thee?/ Canst thou send forth lightnings, that they may go/And say unto thee: 'Here we are'?/Who hath put wisdom in the inward parts?/Or who hath given understanding to the mind?/Who can number the clouds by wisdom/Or who can pour out the bottles of heaven,/When the dust runneth into a mass,/And the clods cleave fast together?/Regarding this print, Shahn once remarked that, "whereas scientists present their own theories regarding the origins of life, when Job was unconsoled he challenged God himself." [103]

Shahn used constellations in other works, including a mosaic mural, *Tree of Life* (1963-64), now in the New Jersey State Museum, and a 1963 tempera, *Tree of Life.* [104]

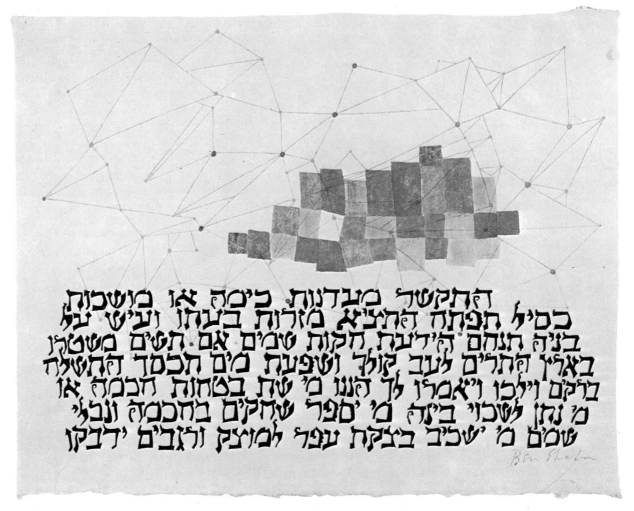

Figure 42—PLEIADES. 1960
Serigraph in black and gray with hand coloring and gold leaf
Sheet: 20½ x 26½" Composition: 18 x 24¼"
Paper: Japan
Edition: Unspecified; 54 known (3 unsigned)
Signature: *Ben Shahn* in red with brush lower right
Collection: New Jersey State Museum; purchase. Accession No: 68.36.3

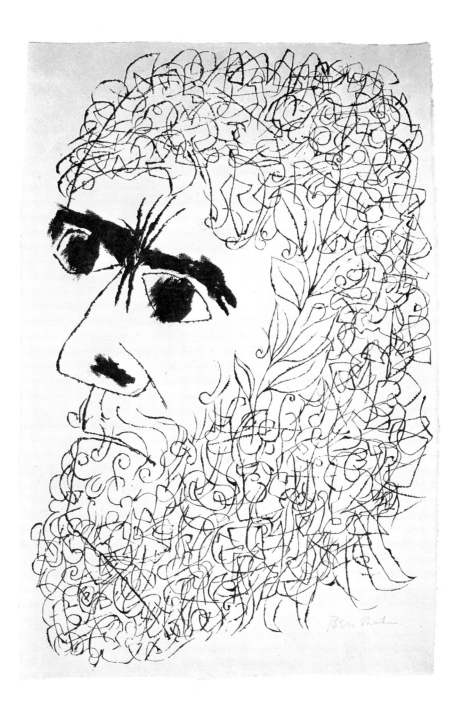

Figure 43—POET. 1960
Serigraph in two shades of brown
Sheet: 40⅝ x 27½" Composition: 39⅛ x 26"
Paper: A. Milbourne and Company, British Handmade
Edition: Unspecified; 60 known
Signature: *Ben Shahn* in red with brush lower right
Collection: New Jersey State Museum; purchase. Accession No: 65.14.6

Shahn seems to have given his brush free range in creating the poet's wealth of hair. The fine and intricate lines, printed in light brown, contrast with the heavy and darker brown of the fiercely furrowed brows and wide-open eyes, giving the composition an interesting balance of opposites. The impression is of a man aroused and deeply concerned. As one studies the apparently random lines of the hair, a leafy stem emerges at the side. Could it be laurel ascending to the crown of the poet?

Figure 44—FRAGMENT OF THE POET'S BEARD. c.1960
Original brush drawing
Sheet: 20⅞ x 28¾"
Composition: 14⅛ x 23¼"
Paper: Japan
Signature: *Ben Shahn* in black with conté crayon lower right below handwritten *Fragment of the Poet's Beard* and to the right of the orange-red chop
Collection: New Jersey State Museum; gift of the Atlantic Foundation.
Accession No: 70.170.2

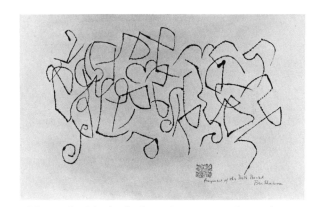

Although Shahn's handwritten title indicates that this drawing represents a fragment of the beard in *Poet* (fig. 43), one looks in vain for the precise section of the beard that matches the drawing. Very similar to the drawing are two serigraphs about which little is known.

Figure 45 — PSALM 133. 1960
Serigraph in colors
Sheet: 20½ x 26½"
Composition: 19¾ x 26¼"
Paper: Japan
Edition: Unspecified, 78 known; (295 in
pencil lower left; 59 in pencil verso)
Signature: *Ben Shahn* in black with brush
lower right; *"A Song of Degrees of David.
Psalm 133"* in pencil, to right of signature
Collection: New Jersey State Museum;
purchase. Accession No: 296

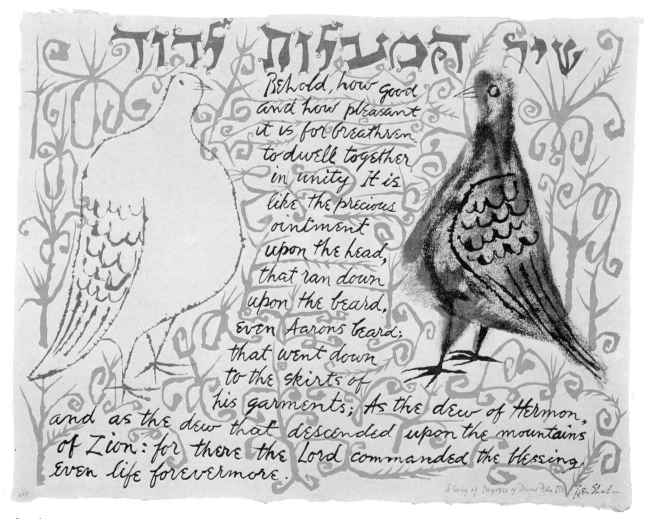

In choosing the subject for this print, Shahn described his motivation as a "hopeless pleading for people to get together.[105] Here coupled with the doves, symbols of peace, Psalm 133 is a beautiful poem on the theme of brotherly love. By presenting one dark dove and one white, Shahn may have tried to relate the psalm's message to the struggle for racial harmony.

The blue Hebrew calligraphy at the top translates as: A Song of Ascents of David and refers to the ascension of the Hebrew pilgrims to Jerusalem.

Later Shahn produced a very similar color lithograph (see fig. 53); and a slightly altered version for the Nine Drawings Portfolio (see fig. 106). The dove motif is also used in a holiday card (see fig. 235).

BLIND BOTANIST THEME

Ben Shahn was intrigued with the theme of the blind botanist, which he used in three prints (see figs. 46, 47, and 50) as well as in various paintings and drawings. The recurring image is that of a seated and sightless man, holding a spiny plant. In the two serigraphs (see figs. 46 and 47), Shahn has included a quotation from Robert Hooke's classic work *Micrographia,* written in 1664.

In all three print versions the plants have fibrous roots, which are missing in a 1954 drawing, *Blind Botanist.*[106] But in other respects the prints closely resemble the drawing. In a 1964 tempera painting, *Blind Botanist,*[107] the blue plant has fibrous roots in vibrant shades of red and yellow. The painting shows the botanist seated on a simple, red metal chair, which appears in neither the prints nor the drawing. In a painting used in Shahn's book, *The Biography of a Painting,* the botanist is also seated.[108] In that instance, however, he is portrayed as a youth with a full head of hair, and the rootless plant with thistle-like blossoms is held away from the face.

Shahn's long preoccupation with the theme of the blind botanist illustrates his concern with what he called "The paradox of man's goals,"[109] as when the scientist becomes the victim of his own research.

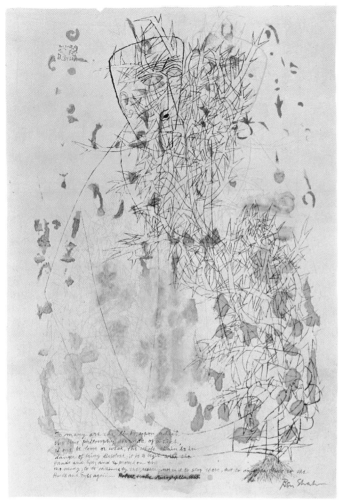

Figure 46—BLIND BOTANIST. c.1961
Serigraph in black and gray, with hand coloring, green
 wash and hand calligraphy
Sheet: 40 x 28" Composition: 38 x 24½"
Paper: Composition board with machine-made
 newsprint facing.
Edition: Unique
Signature: *Ben Shahn* in red with brush lower right;
 orange-red chop upper left
Collection: New Jersey State Museum; gift of the
 Association for the Arts of the New Jersey State
 Museum. Accession No: 70.4.1

This unique version is an experimental one. The same printed outline as in *Blind Botanist* (fig. 47) is present, but there is in addition a faint gray mirrored image of the botanist. It is not clear how Shahn produced this opposite image, placed slightly higher and to one side.

Shahn applied a green wash variously throughout the composition. The eyes, empty in most versions, are here painted in faint hues. A 1963 lithograph on the same subject (see fig. 50) has a suggestion of these color patterns in the botanist's eyes.

The hand calligraphy, in black, is here arranged in straight lines rather than following the curving arm as in fig. 47. It is evident that Shahn experimented with lettering and spacing.

The quotation, from the *Micrographia* (1664) by the English scientist Robert Hooke, is another illustration of Shahn's inquiring mind and his familiarity with classic literature:

As Shahn wrote it on this print, the quotation reads as follows:
 So many are the links, upon which
 the true philosophy depends, of which
 If one be loose or weak, the whole chain is in
 danger of being dissolved; it is to begin with the
 Hands and the Eyes; and proceed on th [sic] [*e memor* is
 stopped out]
 the memory; to be continued by the reason; nor is it to
 stop there, but to come to come to the
 Hands and Eyes again....
 Robert Hooke, Micrographia, 1665 [sic]

The botanist in this print is sparsely out-lined, the few details centered on hands and face. A furrowed brow empha-sizes the emptiness of blind eyes. The thorny plant is a maze of twisted branches, and its dark fibrous roots draw attention to the bottom of the composition, where the calligraphy conforms to the curve of the botanist's arm.

Handwritten on the screen and printed in a soft green color, the callig-raphy does not compete with the elon-gated botanist and his thorny bush.

The original drawing from which this serigraph was taken is in the collection of the Minnesota Museum of Art, Saint Paul, Minnesota. At first glance the drawing appears to be identical to the serigraph, even to the similar place-ment of the chop; however, there are slight differences in the length and curvature of some of the thorny points and the signature on the drawing is green rather than red as here.

Figure 47—BLIND BOTANIST. 1961
Serigraph in black with green calligraphy
Sheet: 39⅞ x 25⅜"
Composition: 38¼ x 23½"
Paper: Arches
Edition: 100
Signature: *Ben Shahn* in red with brush lower right; orange-red chop upper left
Collection: New Jersey State Museum; purchase. Accession No: 295

Figure 48—DECALOGUE. 1961
Serigraph in dark green and gray with hand color-
 ing and applied gold leaf
Sheet: 40 x 26 1/16" Composition: 37 1/2 x 24 1/8"
Paper: Rives, rag wove handmade
Edition: Unspecified; 37 known
Signature: *Ben Shahn* in "gold" with brush upper
 left under orange-red chop
Collection: New Jersey State Museum; New Jersey
 Bell Telephone Co. Purchase Award. Accession
 No: 67.35

The printed portions of this delicate print consist of the green, plant-like designs and the fine lines delineating the two halves of the composition, which represent the two "tables" of commandments given to Moses on Mount Sinai. Shahn tenderly painted the flowers and applied the gold leaf by hand. The Hebrew letters on the right tablet are the initial letters of the first five commandments; those on the left are variations of the same letter, which represents the Hebrew word *lamed,* meaning "thou shall not"— the introductory phrase of the last five commandments. Shahn avoided monotonous repetition by varying the letter's graceful, gazelle-like form.

Figure 49—MARTYROLOGY. c.1962 Serigraph in black
Sheet: 7¾ x 23¾" Composition: 7¼ x 23½"
Paper: Machine-made wood pulp
Edition: Unique
Signature: *Ben Shahn* in black with brush upper left below
 orange-red chop; verso *martyrology*
Collection: New Jersey State Museum; purchase.
 Accession No: 70.12

Mr. Morris Bressler, Shahn's close friend and a Roosevelt neighbor, recalls that Shahn once won a competition for an art work commemorating the tragedy of the Warsaw ghetto, and that he refused the five hundred dollar prize when told that his drawing would remain the property of the sponsoring organization. That drawing was the basis for *Warsaw 1943* (fig. 54) and for *Alphabet and Warsaw* (fig. 64).

The Hebrew calligraphy in this print and in fig. 54 relates a prayer which Bressler suggested to Shahn. It is taken from the Musaf Service for Yom Kippur, which in turn is based on a legend of the execution of ten Hebrew sages in Palestine by the second-century Roman Emperor Hadrian. Ostensibly, they were found guilty of teaching the Torah, but, the legend recounts, Hadrian chose to condemn them because the ten sons of Jacob had gone unpunished for selling their brother Joseph into slavery.

Shahn chose the name of this print from the common designation of the prayer as the "ten martyrs' prayer." The calligraphy is printed twice, with the second impression approximately one inch off center from the first. Bressler suggests that the double printing creates the impression of tears running down from the letters. He translates the prayer as follows:

These martyrs I well remember, and my soul is melting with secret sorrow. Evil men have devoured us and eagerly consumed us. In the days of the tyrant there was no reprieve for the ten who were put to death by the Roman Government.

Figure 50—BLIND BOTANIST. 1963 Lithograph in colors
Sheet: 26¾ x 20½″ Composition: 25¾ x 19⅞″ Paper: Arches
Printer: A. Manaranche, Fernand Mourlot, Paris
Edition: Approximately 200
Signature: *Ben Shahn* in red with brush lower right; *A. Manaranche
 Grav. Lith.* on plate lower left
Collection: New Jersey State Museum; purchase. Accession No. 68.81

In this lithograph, solid areas of color have replaced much of the line drawing of the serigraph versions (see figs 46 and 47). The sweep of the botanist's arm leads the eye to the strong hands, enmeshed in the thorny branches.

The red, fibrous roots are similar in treatment to those in the tempera painting, *Blind Botanist* (see p. 47).

This lithograph was printed by A. Manaranche, who also produced Shahn's *Mask* (fig. 51) and *Psalm 133* (fig. 53).

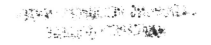

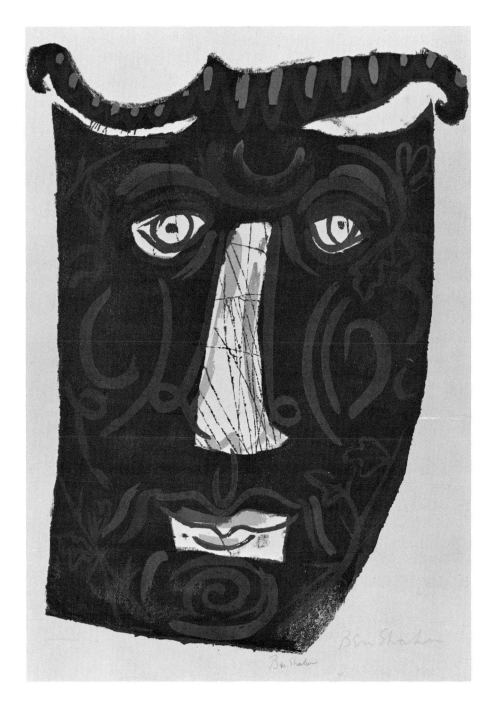

Figure 51—MASK. 1963
Lithograph in colors
Sheet: 30 x 21" Composition: 25½ x 19¼"
Paper: Arches
Printer: A. Manaranche, Fernand Mourlot, Paris
Edition: Approximately 200
Signature: *Ben Shahn* in beige on the plate lower right
 and *Ben Shahn* in pencil lower center right;
 A. Manaranche Lith. in beige lower left on the plate
Collection: New Jersey State Museum; purchase.
 Accession No: 68.31.9

This is one of three zinc-plate lithographs, based on earlier serigraphs, which were produced in Paris at the Imprimerie Mourlot in 1963; the others are *Blind Botanist* (fig. 50) and *Psalm 133* (fig. 53). Shahn invited the printer A. Manaranche to place his name on the print.

This lithograph is so faithful to the colors and forms of the 1959 serigraph *Mask* (fig. 39) that they are almost indistinguishable. However, the presence of *A. Manaranche Lith.* in the lower left hand corner is an infallible identification of this print.

Figure 52—MAXIMUS OF TYRE. 1963
Serigraph in black with hand coloring
Sheet: 36 x 26¼" Composition: 34¼ x 26"
Paper: Japan
Edition: Unspecified; 34 known (10 unsigned)
Signature: *Ben Shahn* in red with brush lower right below orange-red
chop; to the left of the signature in Shahn's hand: *Closing Paragraph of
Dissertatis VIII of Maximus of Tyre (1st Cent. A.D.)*
Collection: New Jersey State Museum; gift of Mr. and Mrs. L. B. Wescott.
Accession No: 69.308.6

The image in this print is one that Shahn frequently used in original works and as reproductions in books. The authoritative figure with the upraised arm sometimes emerges out of the waters, as in the 1958 tempera *Parable*,[110] and in the drawing *Drowning Man*.[111] It is the central element in *Alphabet and Maximus* (fig. 63). Stephen S. Kayser in the preface to *Haggadah for Passover* speaks of "leitmotifs like the 'mighty hand' and the 'outstretched arm', the powerful symbols of Divine liberation."[112]

The quotation chosen by Shahn for this print was a favorite of his, and excerpts from it appear in other works: the 1967 serigraph *Words of Maximus* (fig. 76); the 1965 serigraph *All That Is Beautiful* (fig. 55); a 1967 mosaic mural *Maximus of Tyre*,[113] a 1963 tempera *Tree of Life* (see p. 44); and a 1963-64 mosaic mural of the same subject and title.[114] Shahn lettered and illustrated a book in 1964, *Maximus of Tyre,* Spiral Press, which is a rich elaboration of the theme.

Each *Maximus of Tyre* serigraph which I have examined is printed on two papers of equal size. The sheets are joined horizontally with tape, matching exactly the calligraphy and image. The printed portions consist of the calligraphy, the outline of the arm, and the details of hair and facial features. A handpainted wash covers the luxuriant hair, and a lighter wash below is carried up over the arm to add to the weight of the commanding gesture.

Movingly united with the majestic figure are the profound words of Maximus of Tyre.

Behold, how good and how pleasant it is for breathren to dwell together in unity. It is like the precious ointment upon the head, that ran down upon the beard, even Aarons beard; that went down to the skirts of his garments; As the dew of Hermon, and as the dew that descended upon the mountains of Zion: for there the Lord commanded the blessing, even life forevermore.

Ben Shahn

Figure 53 — PSALM 133. 1963
Lithograph in colors
Sheet: 20⅝ x 26¾"
Composition: 20 x 26¼"
Paper: Arches
Printer: A. Manaranche, Fernand Mourlot, Paris
Edition: Approximately 200
Signature: *Ben Shahn* in red with brush lower right; *A. Manaranche Grav. Lith.* on the plate lower left in blue
Collection: New Jersey State Museum; purchase. Accession No: 68.31.10

This 1963 lithograph produced by Shahn in Paris, in collaboration with the printer Manaranche, closely resembles the *Psalm 133* (fig. 45) serigraph and at first glance may be confused with it. The lithograph has more of an open margin around the composition and slightly lower color values, particularly in the shading of the dark dove. Moreover, it bears the name of the printer, A. Manaranche, in the lower left hand corner.

The other two zinc lithographs which Shahn and Manaranche produced are *Blind Botanist* (fig. 50) and *Mask* (fig. 51).

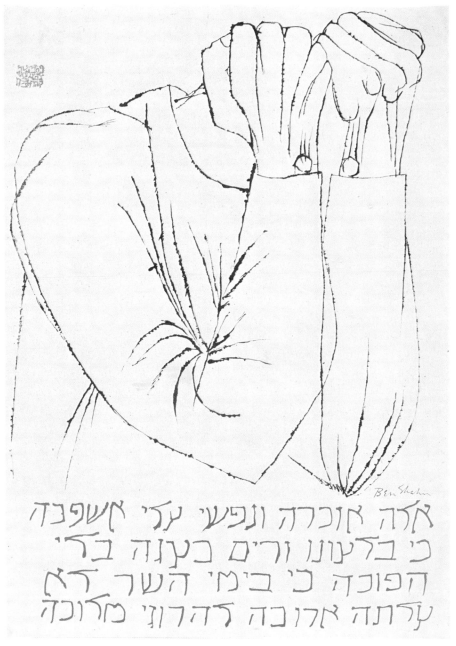

Figure 54—WARSAW 1943. 1963
Serigraph in black with brown calligraphy
Sheet: 36¾ x 28⅛" Composition: 33½ x 23½"
Paper: Japan
Edition: 97
Signature: *Ben Shahn* in red with brush lower right above calligraphy;
orange-red chop upper left
Collection: New Jersey State Museum; purchase. Accession No: 65.14.4

The Warsaw ghetto was created by the Nazis in 1940 to confine the local Jewish population and deportees from other countries. Its population soon increased from 300,000 to half a million people. In July, 1942, the Nazis began their systematic liquidation of the Warsaw ghetto Jews, and thousands were deported daily for uncertain destinations. By fall of 1942, only some 40,000 people remained.[115]

In the meantime, an underground movement had prepared the people for resistance, and when the Nazi forces arrived in April, 1943, to remove the remaining Jews, they met with armed resistance. After the Nazis had leveled the ghetto with tanks and flame throwers, only a few dozen survived.[116]

It was this tragedy—the incredible courage of the Warsaw Jews and the futility of their resistance—that Shahn commemorated with this print in 1963. The Nazis could announce, as they did in 1943, that Warsaw was at last free of Jews. But the tortured hands in Shahn's print remain to remind us of these acts of barbarism.

Shahn, a man of great compassion, whose abhorrence of violence was well known in his lifetime, chose to accompany the anguished figure with the thirteenth-century prayer he had used earlier in *Martyrology* (fig. 49).

In *Alphabet and Warsaw* (fig. 64), this same figure is covered by a mass of seemingly unintelligible symbols, from which emerge the strong but powerless hands.

Shahn had earlier included a similar image of a tortured man in a 1951 painting, *Composition with Clarinets and Tin Horn*.[117] There the figure is seated behind a row of vertical instruments. Another version is in his book, *The Biography of a Painting*.[118]

56

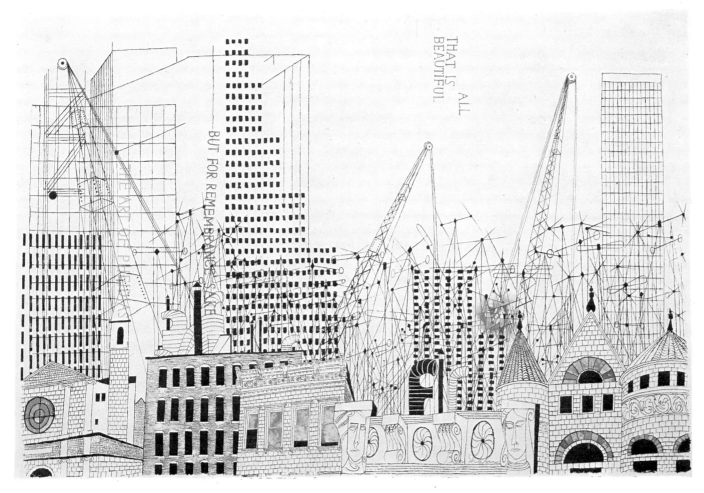

Figure 55—ALL THAT IS BEAUTIFUL. 1965
Serigraph in colors with hand coloring
Sheet: 26 x 38¾" Composition: 24½ x 38¼"
Paper: Rives
Edition: Unspecified; 34 known
Signature: *Ben Shahn* in red with brush lower right, center
Collection: New Jersey State Museum; purchase.
 Accession No: 66.24.1

Shahn's love of history and respect for the art of ancient civilizations are reflected in the text of this print. With the quotation, he has effectively juxtaposed the past and the present—a modern city being built through destruction of the old.

The phrases, from *Maximus of Tyre* (fig. 52), are in multicolored blockletters:

> ALL THAT IS BEAUTIFUL
> BUT FOR REMEMBRANCE' SAKE
> THE ART OF PHEIDIAS

Pheidias, considered the greatest of the sculptors by the ancient Greeks themselves, was admired most for his colossal figures in gold and ivory of Zeus at Olympia and of Athena Parthenos at Athens, neither of which has survived.

Shahn describes the inspiration for this print as: "The pain of seeing the city I grew up in being covered by the new wave of concrete and glass."[119] His love for this city manifests itself in the many details of the old buildings, which are carefully rendered and enhanced by hand-applied colors.

Living far from New York City, in rural Roosevelt, Ben Shahn created a work that reflects fond memories of his youth and poignantly portrays one of the dilemmas of the contemporary American scene.

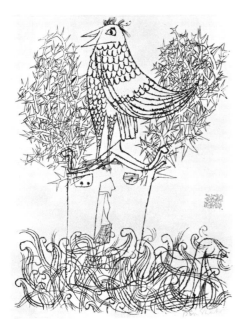

Figure 56 — BRANCHES OF WATER OR DESIRE.
1965
Serigraph in black
Sheet: 26⅜ x 20½" Composition: 26 x 19½"
Paper: Japan
Edition: Unspecified; 25 known
Signature: *Ben Shahn* in red with brush lower
 right; orange-red chop lower center right
Collection: New Jersey State Museum; purchase.
 Accession No: 66.24.2

This print charmingly combines elements from earlier works: the bird from *Phoenix* (fig. 13); the spiny plant from *Blind Botanist* (fig. 47); the *Mask* (fig. 39); and the "water" from *Cat's Cradle* (fig. 38). The wonder of it is that Shahn was able to merge all these diverse elements into one print without over-crowding the work. Each of these motifs was drawn as a variant on the original theme. It appears that the print was made in several stages: first, the cactus-like plants, then the bird and water, then an over-printing of the mask. One print in the Kennedy Galleries has the notation *30-31* which suggests that the edition may be 31; however, I have seen no other numbered copies, and it is not certain that this notation accurately reflects the size of the edition.

For an issue of *Art in America*,[20] Francine du Plessix invited twenty-two American painters to choose any contemporary poem and illustrate it with a black and white work. The artists were given freedom of expression, medium, and their choice of a single or double page layout. Shahn chose Alan Dugan's poem, "The Branches of Water or Desire," which begins:

> Imagine that the fast life of a bird
> sang in the branches of the cold
> cast-off antlers of a stag
> and lit the points of bone
> with noises like St. Elmo's fire.

He used a double page layout with Dugan's poem in two columns on the right. The illustration, filling the entire page on the left, is similar to this serigraph even to the placement of the chop.

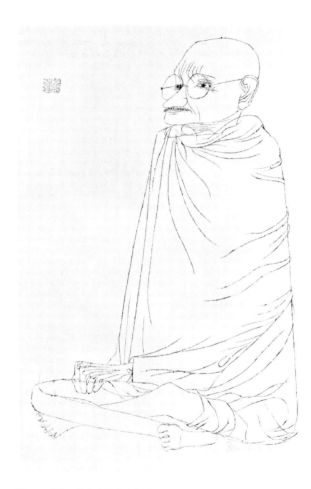

Figure 57 — GANDHI. 1965
Serigraph in black
Sheet: 40⅛ x 26"
 Composition: 36¼ x 24⅛"
Paper: Rives
Edition: Unspecified; 29 known
Signature: *Ben Shahn* in red with brush
 lower right; orange-red chop upper left
Collection: New Jersey State Museum;
 purchase. Accession No: 65.14.3

It is not surprising that Shahn wanted to pay his respects to this great man, the prophet of non-violence. Through the magic of his inimitable brush line, Shahn has imbued the seated Gandhi with a quiet grandeur. The figure commands attention. The curved line of the head, the wrinkles of the brow, lead directly to the steady gaze of the eyes. The thin legs, abnormally small feet, and the bony hand emphasize the elongated torso of the figure, seated in the cross-legged position of meditation. The erect back suggests controlled strength and perhaps, by implication, a moral and ethical strength as well.

Shahn's brush and ink drawing of the seated Gandhi first appeared in a 1964 issue of *Look* magazine. Subsequently, he produced three print versions: this serigraph, a collotype (see fig. 214), and a smaller broadside (see fig. 215). The latter two are accompanied by a quotation from Mark Twain. The *Look* drawing, which is virtually indistinguishable from this serigraph, was reproduced full page to illustrate a feature article on Gandhi by Leo Rosten, who describes him as an "ugly, skinny, fearless little man [who] was a 'moral genius', a triumph of sheer character and will."[121]

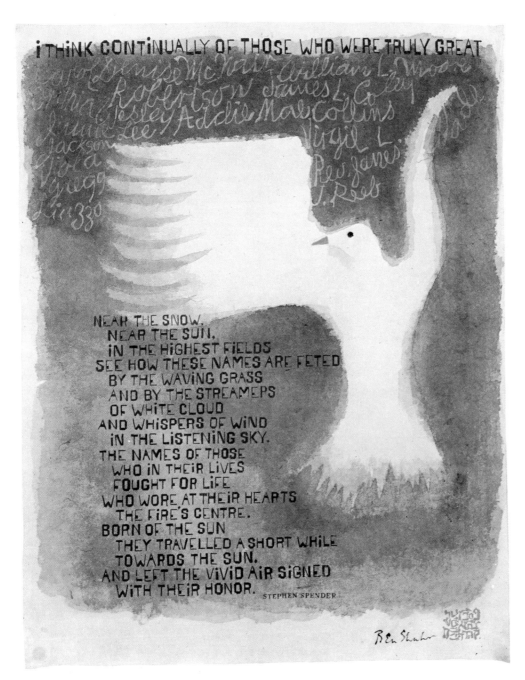

I THINK CONTINUALLY OF THOSE WHO WERE TRULY GREAT

NEAR THE SNOW,
NEAR THE SUN,
IN THE HIGHEST FIELDS
SEE HOW THESE NAMES ARE FETED
BY THE WAVING GRASS
AND BY THE STREAMERS
OF WHITE CLOUD
AND WHISPERS OF WIND
IN THE LISTENING SKY.
THE NAMES OF THOSE
WHO IN THEIR LIVES
FOUGHT FOR LIFE
WHO WORE AT THEIR HEARTS
THE FIRE'S CENTRE.
BORN OF THE SUN
THEY TRAVELLED A SHORT WHILE
TOWARDS THE SUN,
AND LEFT THE VIVID AIR SIGNED
WITH THEIR HONOR. STEPHEN SPENDER

Ben Shahn

Figure 58—I THINK CONTINUALLY OF THOSE WHO WERE
TRULY GREAT. 1965
Serigraph in brown and white with hand wash and hand coloring
Sheet: 26½ x 20¾" Composition: 24¼ x 20¾"
Paper: Japan
Edition: Unspecified; approximately 100 (plus 16 nearly completed
and 82 with lettering only)
Signature: *Ben Shahn* in black with brush lower right to the left of
orange-red chop
Collection: New Jersey State Museum; purchase.
Accession No: 65.14.5

The blurred contours in this print suggest the softness
and delicacy of the dove, and the spread feathers of wings
and tail give an illusion of suspended flight. Shahn used
the white of the paper for the dove, defining the form with
a gray wash, which he applied by hand in varying densities.
He painted the eye black and ingeniously created the
bright orange beak by dipping a pointed eraser in paint
and pressing it to the paper.[122] The image is also found
in the 1965 Nine Drawings Portfolio, *I Think Continually
of Those Who Were Truly Great* (fig. 107) and in the 1968
Rilke Portfolio, *How the birds fly* (fig. 119).

Shahn intended this print as a tribute to the civil rights
martyrs: Carol Denise McNair; William L. Moore; Cynthia
Robertson; James L. Coley; Wesley Addie; Mae Collins;
Jimmie Lee Jackson; Viola Gregg Liuzzo; Virgil L. Wade;
and Rev. James J. Reeb. Written in a child-like hand across
the heavens and around the dove of peace, the ghostly
names contrast in form and color with the more formally
lettered title and text. Perhaps the handwriting is meant
to signify the youth and innocence of the victims.

The printed portions of this work are the title and the
text in brown, and the names of the martyrs in off-white.
The words are from a poem by the British poet Stephen
Spender.

JEREMIAH THEME

Shahn printed two versions of a lamenting woman which he entitled *And Mine Eyes a Fountain of Tears.* The image in both is the same, but one has a quotation in Hebrew calligraphy while the other has a short phrase translated into English. In his book, *Ecclesiastes,* the artist included an illustration in which the reversed profile is almost identical to the serigraphic image.[123]

Jeremiah, the great prophet of Jerusalem, lived in the late sixth century B.C.—a period of transition marked by the decline of the Assyrian empire, the downfall of the Egyptians, and the capture of Jerusalem by the Babylonians.

Jeremiah protested the moral and religious degradation of his people. Speaking through him the Lord accused Israel: "For my people have committed two evils, they have forsaken me, the fountain of living waters, and hewed them out cisterns, broken cisterns, that can hold no water." (Jer. 2:13) The Lord upbraided them for the worship of false gods: "Saying to a stock, Thou art my father; and to a stone, Thou hast brought me forth." (2:27) "And they have built the high places of Tophet…to burn their sons and their daughters in the fire; which I commanded them not, neither came it into my heart." (7:31) For these sins, the Lord said "will I cause to cease from the cities of Judah, and from the streets of Jerusalem, the voice of mirth, and the voice of gladness, the voice of the bridegroom, and the voice of the bride: for the land shall be desolate." (7:34)

The quotation which Shahn used for his Hebrew version (see fig. 60) reads in translation: "Oh that my head were waters, and mine eyes a fountain of tears, that I might weep day and night for the slain of the daughter of my people!" (9:1) The English version (see fig. 59) carries only the phrase, "and mine eyes a fountain of tears." Shahn's comely woman with her head sorrowfully bowed, epitomizes the lamenting women of Israel, as they fulfilled the Lord's command: "And let them make haste, and take up a wailing for us, that our eyes may run down with tears, and our eyelids gush out with waters." (9:18)

And mine eyes a fountain of tears

Figure 59—AND MINE EYES A
 FOUNTAIN OF TEARS. 1965
Serigraph in black with brown English
 calligraphy
Sheet: 18¾ x 16"
Composition: 13¼ x 10¼"
Paper: Japan
Edition: Unspecified; 52 known
Signature: *Ben Shahn* in brown with
 conté crayon middle right and
 orange-red chop middle left
Collection: New Jersey State Museum;
 anonymous donor.
 Accession No: 69.288.8

Figure 60—AND MINE EYES A
FOUNTAIN OF TEARS. 1965
Serigraph in red with black Hebrew
calligraphy
Sheet: 23⅞ x 17⅞"
Composition: 15¾ x 12¼"
Paper: Japan
Edition: Unspecified; 52 known
Signature: *Ben Shahn* in black with
conté crayon, lower right above
calligraphy and under orange-red chop
Collection: New Jersey State Museum;
purchase. Accession No: 66.24.3

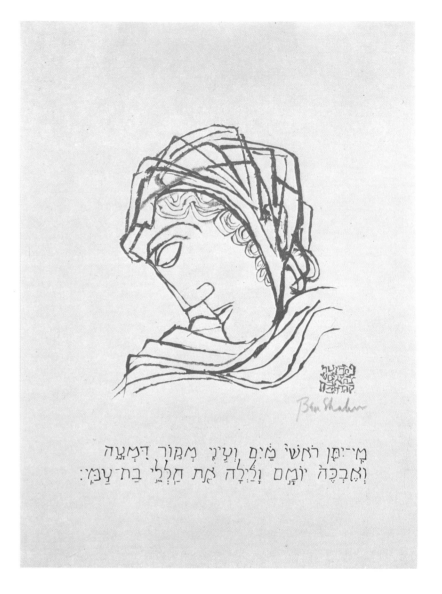

The title for the two versions of this print comes from Jeremiah 9:1. Here the English script is written in brown with conte crayon, apparently the same as that used for the signature.

Shahn always paid careful attention to the overall composition when choosing a place for his signature and chop. Usually his signature is similarly located throughout an edition, particularly when he signed all the prints at one time. When variations are found within an edition it usually means that the various copies were signed or chopped at different times.

In presenting this subject, Shahn used a somewhat heavier brush stroke than usual. It is similar to that he would later use in such prints as *Skowhegan* (fig. 62) and *Credo* (fig. 67).

The exquisitely balanced head of the woman and the eye left empty impart a feeling of boundless suffering. The Hebraic calligraphy is more in keeping with the classic dignity of this print than is the lettering of the English phrase used in the preceding version (fig. 59).

Shahn's quotation in translation is from Jeremiah 9:1:

Oh that my head were waters, and mine eyes a fountain of tears, that I might weep day and night for the slain of the daughter of my people!

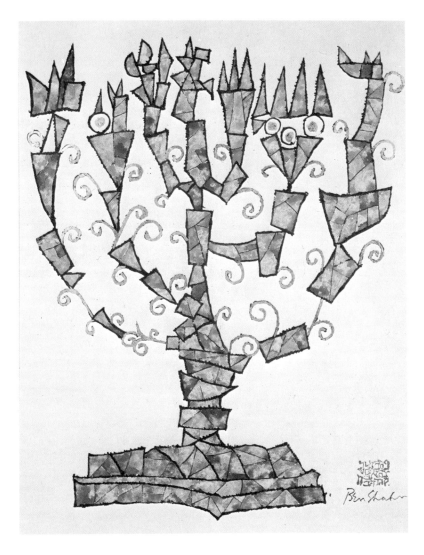

Figure 61—MENORAH. 1965
Serigraph in black and gray with hand coloring and applied gold leaf
Sheet: 26⅜ x 20½" Composition: 23⅝ x 19"
Paper: Japan
Edition: Unspecified; 25 known (2 unsigned)
Signature: *Ben Shahn* in black with brush lower right below orange-red chop
Collection: New Jersey State Museum; purchase. Accession No: 65.14.8

The printed portions of this serigraph are the black outline of the menorah and the gray lines which subdivide the multi-colored areas. The various shades of blue and purple were painted in by Shahn at a later time. The colors differ somewhat from print to print, and the application of the gold leaf is not consistent. Consequently, each print is unique, and each carries with it Shahn's special affection.

Made up of beautifully colored geometric shapes, the menorah was used by Shahn in other works. The frontispiece for his 1965 *Haggadah for Passover* featured the menorah with Hebraic calligraphy and was later issued as the lithograph *Haggadah* (fig. 70). An exceptionally beautiful menorah watercolor, *Hanukkah Prayer*,[124] has form, coloration, and gold foil similar to this print, and in addition is adorned with bold black and gold calligraphy. Here, as elsewhere, Shahn worked with the same general image, but with variations dictated by his mood and artistic inclination of the moment.

This print has always been a favorite of mine. When I first saw Shahn working on it, I requested a copy for the Museum collection. Shahn needed persuading, for he said he was tired of applying the gold leaf and wanted to move on to other works. The Museum's print is unnumbered, but Shahn told me it was the third one he had completed. Subsequently, he produced others, but the print shown here is an unusually choice example from a small edition.

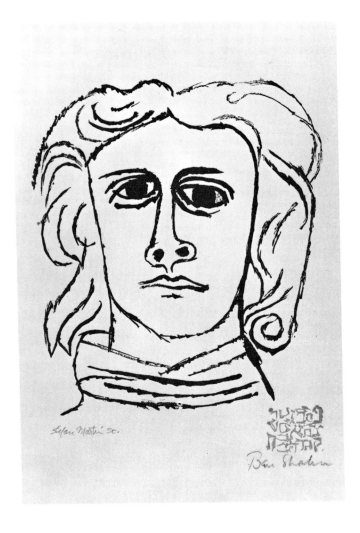

Figure 62—SKOWHEGAN. 1965
Wood-engraving in black
Sheet: 16¼ x 12⅛"
Composition: 9¼ x 8¼"
Paper: Japan
Engraver and Printer: Stefan Martin
Edition: 200 (?)
Signature: *Ben Shahn* in brown conte crayon
 lower right under orange-red chop;
 Stefan Martin sc. in pencil lower left
Collection: New Jersey State Museum;
 purchase. Accession No: 69.31.11

According to the recollection of John Eastman, Director of the Skowhegan School of Painting and Sculpture, at Skowhegan, Maine, Shahn made the drawing for this print in 1965, the year of a benefit exhibition for the Skowhegan School and the Lenox Hill Hospital. A print was given for each one hundred dollar donation.

Shahn entrusted his friend, Stefan Martin, with the engraving and printing of the *Skowhegan* edition. Following Shahn's drawing, Martin cut the block and pulled the prints in his Roosevelt studio. Shahn regarded Martin as an excellent printmaker. To my knowledge, he and Leonard Baskin are the only two artists with whom Shahn collaborated in printmaking (*see* figs. 21, 23, 41, 72, 77, 246–249).

Shahn's drawing was also used for a poster, *Lenox Hill Hospital and Skowhegan School* (fig. 188).

The edition is based on one print in the Yale University Art Gallery which carries the number of the print as 64/200; however, Martin informed me that he recalls pulling an edition of 300.

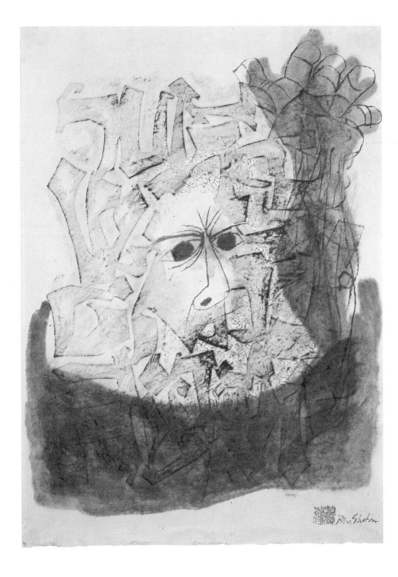

Figure 63—ALPHABET AND MAXIMUS.
 1966
Serigraph in black with watercolor and
 conté crayon rubbing
Sheet: 36½ x 26"
Composition: 34 x 25½"
Paper: Japan
Edition: Unique
Signature: *Ben Shahn* in black with brush
 lower right to the right of orange-red chop
Collection: New Jersey State Museum;
 gift of The Dillon Fund.
 Accession No: 70.1.2

In this unique print, as in *Alphabet and Warsaw* (fig. 64) and *Alphabet and Supermarket* (fig. 245), Shahn combined the image of *Alphabet of Creation* (fig. 24) with another print, in this case *Maximus of Tyre* (fig. 52). In *Alphabet and Warsaw* the conte crayon rubbing of the letters, applied with the aid of a cutout cardboard, is very dense, but here the letters are faint and softly surround the face of Maximus, where attention is focused on the expressive eyes. A watercolor wash, covering the lower portion and the upraised arm, is similar to that in *Maximus of Tyre.*

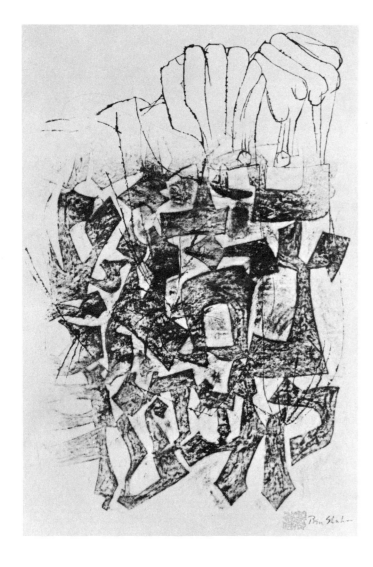

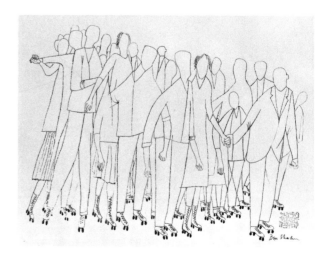

Figure 64—ALPHABET AND
 WARSAW. 1966
Serigraph in black with watercolor
 and conté crayon rubbing
Sheet: 35 x 23½"
Composition: 32 x 22¼"
Paper: Japan
Edition: Unique
Signature: *Ben Shahn* in black with
 brush lower right to the right of
 orange-red chop
Collection: New Jersey State Museum;
 gift of The Dillon Fund.
 Accession No: 70.170.4

Figure 65—ANDANTE. 1966
Serigraph in black
Sheet: 18½ x 23¾" Composition: 17⅛ x 22⅞"
Paper: Japan
Edition: 50
Signature: *Ben Shahn* in brown conté crayon lower right
 under orange-red chop
Collection: New Jersey State Museum; purchase.
 Accession No: 68.31.1

This unique print combines the image of *Warsaw 1943* (fig. 54) with *Alphabet of Creation* (fig. 24). Using a cardboard cutout of *Alphabet of Creation,* Shahn applied the conté crayon rubbing over the printed image of *Warsaw 1943.* The opaque rubbing obscures much of the figure.

In the two experimental prints, this and *Alphabet and Maximus* (fig. 63), which was done in the same way, Shahn left exposed what he considered to be the main points of interest: in Maximus the central part of the face with its furrowed brow and eyes and here the clenched fists.

Another experimental print of this type is *Alphabet and Supermarket* (fig. 245), where the serigraph *Alphabet of Creation* was superimposed over *Supermarket* (fig. 27).

In September, 1966, the Olivetti Company (now the Olivetti Corporation of America, New York) commissioned Shahn to do a serigraph. *Andante* was completed in November, 1966, and the company distributed copies as holiday gifts.

The print was preceded by a 1956 drawing entitled *Skating Rink.*[125] At first glance the two seem identical. However, in the serigraph Shahn increased the number of feet, although the number of people stayed about the same. Contrasting with the complete lack of detail in face and clothing, the elaborately outlined shoelaces draw attention to the adventure on wheels.

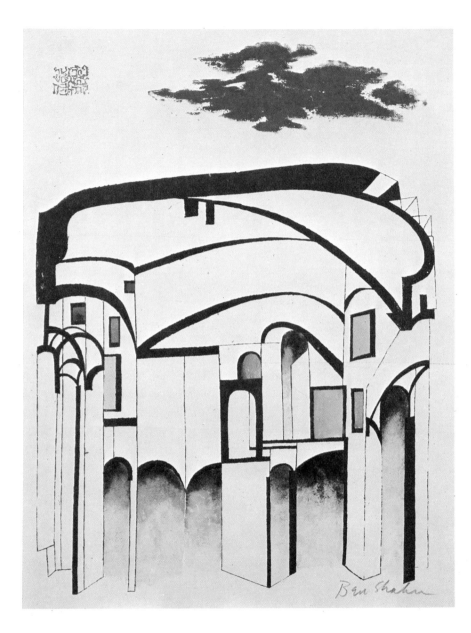

Figure 66—BYZANTINE MEMORY. 1966
Serigraph in black and brown with hand coloring
Sheet: 26⅜ x 20½" Composition: 24½ x 18"
Paper: Japan
Edition: Unspecified; 33 known
Signature: *Ben Shahn* in black conté crayon lower right and
 orange-red chop upper left
Collection: New Jersey State Museum; the Honorable
 Fairleigh Dickinson, Jr. Purchase Award.
 Accession No: 68.31.3

The intricate structure in this serigraph, with its multi-leveled doors and windows, is very oriental in feeling. The subject must have been one distilled from fond memories of past travels, because Shahn used it with ingenuity in many different versions. In each case, the sweeping lines of the structure and shaded archways give emphasis to the sunbaked walls.

In a 1951 tempera *Byzantine Isometric,*[126] a structure much like this one provides the background for a youthful figure. Strong colors are prominent throughout, with red the dominant hue. In a 1965 tempera, *Byzantine in Israel,*[127] a structure nearly identical to the one in this print is used as part of a landscape. Later, Shahn used the motif in *To roads in unknown regions* (fig. 121) of the 1968 Rilke Portfolio. And he included a slightly altered version in the 1968 lithograph *Birds Over the City* (fig. 78), where its beauty is a major element in the composition.

The cloud and the heavy outline of the structure are the screened portions in this serigraph. The sensitive shading and coloring were done by hand.

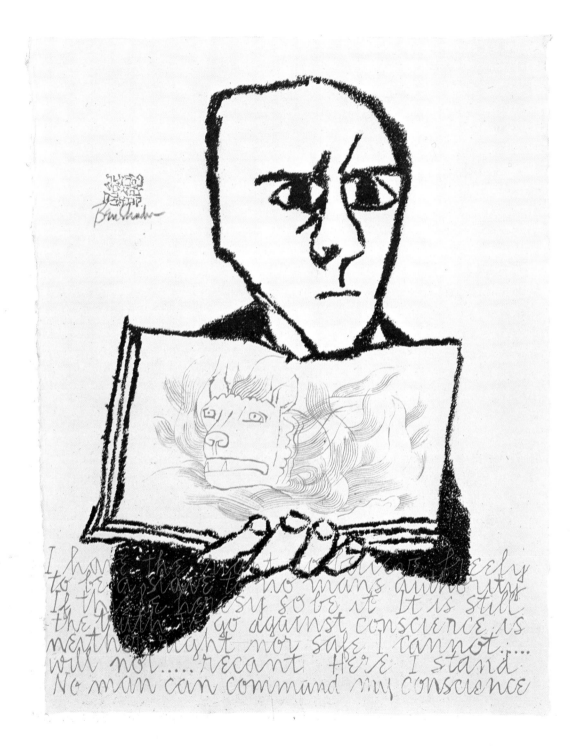

Figure 67—CREDO. 1966
Serigraph in black and blue
Sheet: 26½ x 20⅞" Composition: 24½ x 19⅝"
Paper: Japan
Edition: Unspecified; 48 known
Signature: *Ben Shahn* in black conté crayon upper
 left under orange-red chop
Collection: New Jersey State Museum; gift of Mr. and
 Mrs. Robert F. Goheen. Accession No: 68.31.5

This large version of *Credo* was printed in two stages. The first, in black, shows a man holding an open book; the second, in blue, is the exact image, with calligraphy, of the 1960 *Credo* (fig. 40). Shahn repeated the theme of a man holding the book as an illustration for *The Biography of a Painting*.[128] There the text has replaced the fire-beast on the book.

The quotation is from Martin Luther's statement before the 1521 Diet of Worms (see p. 42). The concept presented in Luther's manifesto—that the individual conscience is the highest moral authority—is as heatedly debated today as it was in Luther's time. For Shahn it was as important an affirmation as his statements of political conviction.

ECCLESIASTES THEME

The theme of *Ecclesiastes* incorporates three human and three animal heads in a complicated composition, relating to the three ages of man. Shahn produced two serigraphs on this theme (figs. 68 and 69), utilizing the same screen but varying the manner of printing. Differing greatly from these serigraphs are two illustrations in his book, *Ecclesiastes*, which were produced as separate lithographs, *Ecclesiastes Man* (fig. 74) and *Ecclesiastes Woman* (fig. 75). One or both were enclosed with copies of the 1967 deluxe edition of the beautifully handwritten and illustrated book. A wood-engraving, *Ecclesiastes*, done by Stefan Martin after a Shahn drawing, was one of three original prints bound into the 1965 *Ecclesiastes or, The Preacher.* This version (fig. 246) was also issued as a separate edition, posthumously.

A reproduction of a drawing in *The Shape of Content*[129] shows another variation; there, the upper half of the human body and the turban-like covering of the heads are missing. A portion of the theme is used in *The Biography of a Painting*,[130] where a drawing of three animals heads is reproduced.

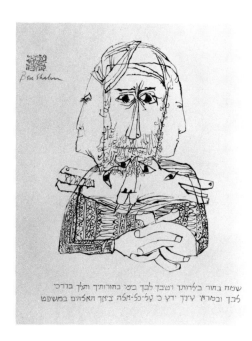

Figure 68 — ECCLESIASTES. 1966
Serigraph in black with sepia
 calligraphy
Sheet: 26½ x 20½"
Composition: 20½ x 12¾"
Paper: Japan
Edition: Unspecified; 132 known
Signature: *Ben Shahn* in black conté
 crayon upper left below orange-red
 chop
Collection: New Jersey State Museum;
 gift of Edward T. Cone in memory
 of Ben Shahn.
 Accession No: 68.31.7

שמח בחור בילדותך ויטבך לבך בימי בחורותיך והלך בדרכי
לבך ובמראי עיניך ידע כי על-כל-אלה יביאך האלהים במשפט

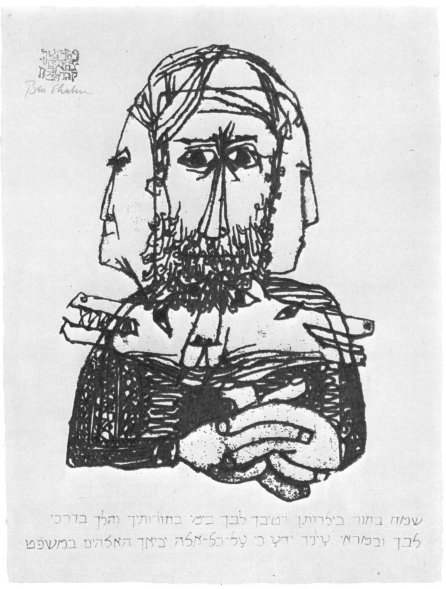

Figure 69 —
ECCLESIASTES. 1966
Serigraph in sepia with
black calligraphy
Sheet: 22⅞ x 17¾"
Composition: 18 x 12¾"
Paper: Japan
Edition: Unspecified; 10
known
Signature: *Ben Shahn* in
black with conté crayon
upper left under orange-red
chop
Collection: New Jersey State
Museum; anonymous
donor.
Accession No: 68.31.8

שמח בחור בילדותך ויטבך לבך בימי בחורותיך והלך בדרכי
לבך ובמראי עיניך ידע כי על-כל-אלה יביאך האלהים במשפט

Three human and three beast heads merge in this print into one complex image representing the three ages of man. In the two serigraphic versions (see figs. 68 and 69) and the 1965 wood-engraving (see fig. 246) Shahn has included the upper body and arms of a man whose folded hands rest upon an elaborately designed garment.

The quotation, printed in Hebrew calligraphy, is from Ecclesiastes 11:9:

Rejoice, O young man, in thy youth;
and let thy heart cheer thee in the days
 of thy youth,
 and walk in the ways of thine heart,
 and in the sight of thine *eyes*:
 but know thou, that for all these *things*
 God will bring thee into judgement.

In producing this print, Shahn used the same silk screen as in fig. 68. Here, however, the screen was only partially cleaned with solvent;[131] as a result, the lines are blurred rather than crisply clean. The heavier accumulation of pigment covers the intricate pattern of the garment, giving it a beaded effect.

Figure 70—HAGGADAH. 1966
Lithograph in black and gray with hand
coloring and applied gold leaf
Sheet: 15¼ x 23¼"
Composition: 13⅞ x 21⅝"
Paper: Richard de Bas, 1326
Printer: Imprimerie Mourlot, Paris
Edition: Approximately 300
Signature: *Ben Shahn* in black with
brush lower right of menorah below
orange-red chop
Collection: New Jersey State Museum;
gift in memory of M. George Coleman
from his wife and children.
Accession No: 68.31.13

This beautiful lithograph is identical to the frontispiece of the 1966 deluxe edition of Shahn's 1965 *Haggadah for Passover.* It is one of a limited number of impressions pulled without the center fold for distribution as individual prints. While the principal drawings for the book were made by Shahn in the mid-1930's and reflect his early painting style, the frontispiece was made especially for the book at a later date.

Based on drawings by Shahn, the lithograph was printed from stones at the Imprimerie Mourlot in Paris. The printed portions consist of the black and gray lines of the menorah and the black calligraphy. Mourlot, following Shahn's instructions, applied the gold leaf and added the colors by hand, using stencils for the yellow calligraphy and the branching design.

Written under the menorah is a well known prayer of celebration recited during high religious holidays and at special family gatherings:

Blessed art thou, Lord our God, King of the universe, who hast granted us life and sustenance and permitted us to reach this occasion.

The large yellow letters to the left announce the title of the book, *Haggadah for Passover.* The title is repeated in black with some additional information regarding the publication:

Haggadah for Passover/Handwritten and illustrated by/Benimin [Benjamin] Shan [Shahn]/with Translation/Introduction and Commentaries/by Bezalel [Cecil] Roth/Paris/The print of Trianon/Year 724 [5724]

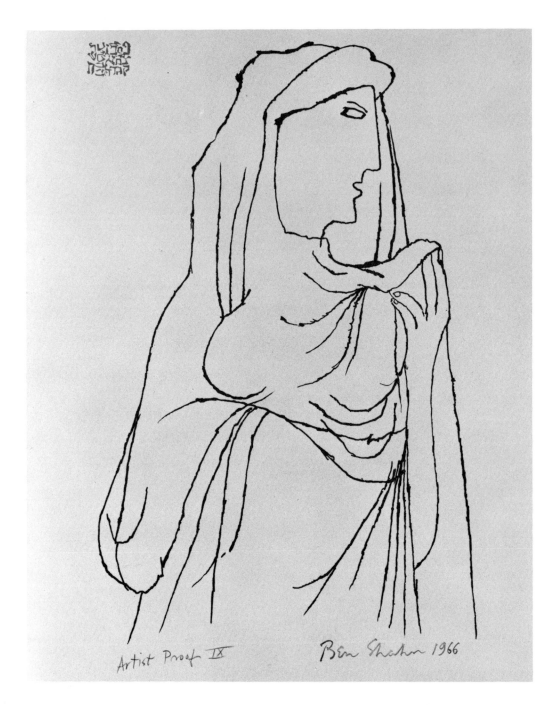

Artist Proof IX Ben Shahn 1966

Figure 71—LEVANA. 1966
Lithograph in black
Sheet: 30 x 22⅛" Composition: 21⅞ x 14⅛"
Paper: Rives
Printer: Gemini G.E.L., Los Angeles, California; on stone from
 transfer drawing on Charbonnel paper by Shahn; verso #1197
 in pencil adjacent to ink stamp GEMINI G.E.L./LOS ANGELES,
 CALIF., embossed symbols © Ⓘ lower right under signature
Editon: 150
Signature: Ben Shahn 1966 in red with brush lower right; Artist Proof
 IX in black conté crayon lower left; orange-red chop upper left
Collection: New Jersey State Museum; purchase.
 Accession No: 68.40.3

The *Levana* in this print dates back to the 1931 Portfolio of the same name, where the exact image is found in gold outline on the cover. It is vastly different in style from the lithographs of that series (see figs. 87–96). Levana, the Roman goddess, held Shahn's interest over a span of many years. He used a version of the subject for the 1964 frontispiece to Wendell Berry's *November Twenty-six, Nineteen Hundred Sixty-three,* The goddess also occurs as an illustration in Louis Untermeyer's *Love Sonnets,*[132] where she is furnished with the heavenly setting that the legend assigns to her (see p. 86).

MARTIN LUTHER KING THEME

One edition of wood-engravings by Stefan Martin (see fig. 72) and several reproductions portraying Martin Luther King originated from the same Shahn drawing of the civil rights martyr.

The drawing was used for the cover of *Time* magazine of March 19, 1965. In the same year, Shahn allowed a portfolio of nine of his drawings to be published for the benefit of the Lawyers Constitutional Defense Committee of American Civil Liberties Union. One of the drawings, produced as a photo-offset lithograph, was of Dr. King (see fig. 105), and had the title "REV. MARTIN LUTHER KING" centered across the top in burnt sienna.

In 1968, Shahn authorized another photo-offset edition, this time taken from the Stefan Martin wood-engraving on which he had lettered an excerpt from King's famous speech. It was to be used in a fund-raising effort by the Southern Christian Leadership Conference. The following year he donated a similar edition to the Friends of Clinton Hill's *Masters of American Art* exhibition (see fig. 216). Ill at the time, he sent for the edition from his hospital bed and signed each impression. These works, undoubtedly the last signed by Shahn, are proof of his never-failing support of causes in which he believed.

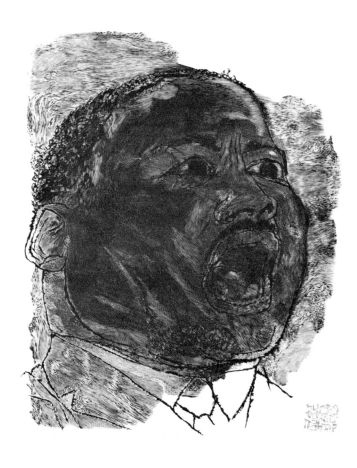

Figure 72—MARTIN LUTHER KING. 1966
Wood-engraving in black
Sheet: 25 x 20⅛" Composition: 18⅝ x 15¼"
Paper: Japan
Edition: 300
Engraver and Printer: Stefan Martin
Published: The International Graphic Arts Society, Inc.,
 New York
Signature: *Ben Shahn* in pencil lower right below
 orange-red chop; *Stefan Martin s.c.* in pencil lower left
 and *artists proof* in pencil lower center
Collection: New Jersey State Museum; purchase.
 Accession No: 68.36.2

When faced with the task of presenting Martin Luther King, Shahn chose to portray him as a strong and dramatic orator.

Taken from the Shahn drawing for a cover of *Time* magazine of March 19, 1965, this wood-engraving by Stefan Martin is a work of excellent craftsmanship. Both Shahn and Martin signed this print when I was present in Shahn's studio.

Two photo-offset editions were subsequently made from this wood-engraving (see fig. 216).

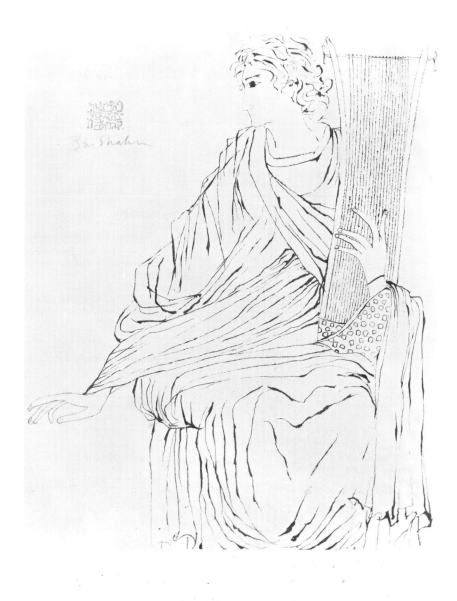

Figure 73—PRAISE HIM WITH PSALTERY AND HARP.
 1966
Serigraph in black
Sheet: 24 x 24¾" Composition: 23¼ x 18¼"
Paper: Japan
Edition: 300
Signature: *Ben Shahn* in black conté crayon upper left
 below orange-red chop
Collection: New Jersey State Museum; purchase.
 Accession No: 68.36.4

Although this print is devoid of calligraphy, it was inspired by Psalm 150:3, A Hallelujah Chorus:

> Praise him with the sound of the trumpet: praise him with the psaltery and harp.

There is a timeless beauty in this classically robed and seated figure, holding an ancient cithara in her lap. The lines indicating the folds of the garment lead to the gracefully elongated hands.

This serigraph was commissioned by the Benrus Watch Company.[133] In the past it has generally been assigned the date 1963, but on the basis of new and conclusive evidence furnished me by Mrs. Mary S. Kiniry of the Benrus Corporation the print is here dated 1966. A number of serigraphs, signed and numbered by Shahn, were sent to selected customers in December, 1966. Moreover, a greeting card was reproduced from one of the prints and distributed by company officials the same year (see fig. 237).

Shahn also drew a version of this subject for an unfinished mural commissioned in 1969 by the Jewish Community Center of Rockville, Md.[134] The brush drawing is immediately identifiable with this print, but there the elongation is even more emphasized. A final variation is included in the posthumous Hallelujah Suite, *Youth With Cithara* (fig. 282).

Figure 74—ECCLESIASTES MAN.
 1967
Lithograph in red
Sheet: 15⅛ x 11⅛"
Composition: 12⅜ x 6⅜"
Paper: Arches Verge
Edition: Approximately 270
Signature: *Ben Shahn* in pencil
 upper right under orange-red chop
Collection: New Jersey State
 Museum; anonymous donor.
Accession No: 69.308.2

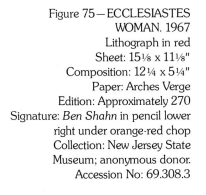

Figure 75—ECCLESIASTES
 WOMAN. 1967
Lithograph in red
Sheet: 15⅛ x 11⅛"
Composition: 12¼ x 5¼"
Paper: Arches Verge
Edition: Approximately 270
Signature: *Ben Shahn* in pencil lower
right under orange-red chop
Collection: New Jersey State
Museum; anonymous donor.
Accession No: 69.308.3

Ecclesiastes Woman (fig. 75) and this print were used as lithographic illustrations in the 1967 edition of Shahn's book, *Ecclesiastes.* Unbound impressions were included in this deluxe edition and presumably numbered, as were the books, A-Z, 1–200, and I–XIV. In addition, an unknown number of prints were made for Shahn's private use. Some of these remained unsigned at the time of his death. Others were unnumbered but signed and bear his chop, as does this example.

The simple outline of a seated man is quite different from Shahn's earlier serigraphic versions of *Ecclesiastes* (figs. 68 and 69). The sparse figure against the empty background seems to epitomize the uniqueness and loneliness of man.

Ecclesiastes Man (fig. 74) and this print are based on drawings Shahn made for his 1967 handwritten and illustrated book *Ecclesiastes.* While vastly different from the two serigraph versions of *Ecclesiastes* (figs. 68 and 69), they are characteristic of the work of his late period. Here the curving lines masterfully define the female figure.

This impression is one of an unknown number of lithographs, none of which are numbered and some of which carry Shahn's signature and chop. Signed and numbered impressions were included in the deluxe edition of *Ecclesiastes* (see p. 69).

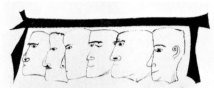

GOD HIMSELF, THE FATHER AND FASHIONER OF ALL THAT IS, OLDER THAN THE SUN OR THE SKY, GREATER THAN TIME AND ETERNITY AND ALL THE FLOW OF BEING, IS UNNAMEABLE BY ANY LAWGIVER, UNUTTERABLE BY ANY VOICE, NOT TO BE SEEN BY ANY EYE. BUT WE, BEING UNABLE TO APPREHEND HIS ESSENCE, USE THE HELP OF SOUNDS AND NAMES AND PICTURES, OF BEATEN GOLD AND IVORY AND SILVER, OF PLANTS AND RIVERS, MOUNTAIN PEAKS AND TORRENTS, YEARNING FOR THE KNOWLEDGE OF HIM, AND IN OUR WEAKNESS NAMING ALL THAT IS BEAUTIFUL IN THIS WORLD AFTER HIS NATURE- JUST AS HAPPENS TO EARTHLY LOVERS TO THEM THE MOST BEAUTIFUL SIGHT WILL BE THE ACTUAL LINEAMENTS OF THE BELOVED, BUT FOR REMEMBRANCE' SAKE THEY WILL BE HAPPY IN THE SIGHT OF A LYRE, A LITTLE SPEAR, A CHAIR, PERHAPS, OR A RUNNING GROUND, OR ANYTHING IN THE WORLD THAT WAKENS THE MEMORY OF THE BELOVED. WHY SHOULD I FURTHER EXAMINE AND PASS JUDGEMENT ABOUT IMAGES? LET MEN KNOW WHAT IS DIVINE, LET THEM KNOW: THAT IS ALL. IF A GREEK IS STIRRED TO THE REMEMBRANCE OF GOD BY THE ART OF PHEIDIAS, AN EGYPTIAN BY PAYING WORSHIP TO ANIMALS, ANOTHER MAN BY A RIVER, ANOTHER BY FIRE-I HAVE NO ANGER FOR THEIR DIVERGENCES, ONLY LET THEM KNOW, LET THEM LOVE, LET THEM REMEMBER.

Figure 76—WORDS OF MAXIMUS. 1967
Serigraph in black
Sheet: 26⅜ x 20½" Composition: 22½ x 16¼"
Paper: Japan
Edition: Unspecified; 47 known (22 unsigned)
Signature: *Ben Shahn* in black conté crayon lower right
 under orange-red chop; *Closing Paragraph of
 Dissertatis VIII from Maximus of Tyre (2d. Cent. A.D.)*
 in pencil lower right
Collection: New Jersey State Museum; gift of Mr. and
 Mrs. James E. Burke. Accession No: 68.31.16

Shahn believed that the subject as well as the object of art was Man. An undated drawing of six heads, which antedated this print, is reproduced in *The Alphabet of Creation* and in *The Shape of Content*.[135] The poster for the *Freda Miller Memorial Concert* (fig. 169) includes five similar heads.

The quotation here is the same as that used for the 1963 *Maximus of Tyre* (fig. 52). Shahn wrote the date of the quotation on the 1963 serigraph as "1st. Cent. A.D." and here as "2d. Cent. A.D."; Maximus of Tyre lived at the turn of the century, so either date could be correct.

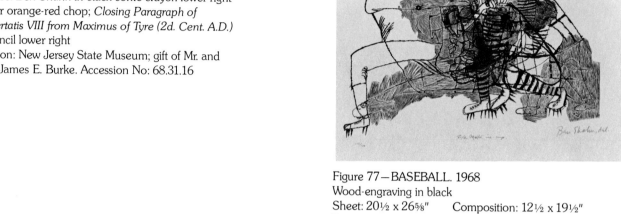

Figure 77—BASEBALL. 1968
Wood-engraving in black
Sheet: 20½ x 26⅝" Composition: 12½ x 19½"
Paper: Japan
Edition: 350; *246/350* in pencil
Publisher: International Graphic Arts Society, Inc.,
 New York
Engraver and Printer: Stefan Martin
Signature: *Ben Shahn, del.* in black conté crayon lower
 right, orange-red chop upper right; *Stefan Martin
 inc. imp.* in black conté crayon lower center
Collection: New Jersey State Museum; purchase.
 Accession No: 68.170

Stefan Martin based this print on Shahn's 1955 brush drawing *National Pastime*.[136] It is a faithful translation into the medium of wood-engraving, executed by Martin in his Roosevelt studio.

Baseball depicts the split-second following the impact of bat and ball. The frozen force displayed in the long line of the batter's arm and bat, the restrained power in the stocky figures, the thrust of the outstretched leg, give this picture an exciting sense of action.

Shahn made several other drawings dealing with this subject, always with the same careful selection of details and distortions.

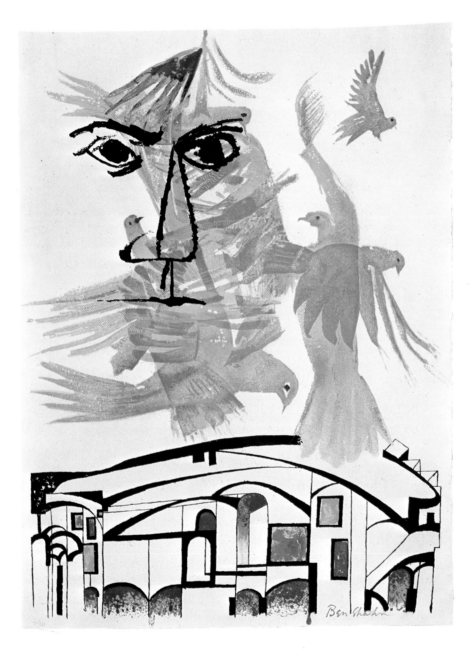

Figure 78 — BIRDS OVER THE CITY, 1968
Lithograph in colors
Sheet: 29 x 21⅝" Composition: 28¾ x 20½"
Paper: Arches
Printer: Atelier Mourlot Ltd., New York
Edition: 135; *132/135* in pencil lower left
Signature: *Ben Shahn* in red with brush lower right
Collection: New Jersey State Museum; purchase.
 Accession No: 68.111.1

This is an interesting and effective combination of Shahn motifs. The building and its colors are similar to *Byzantine Memory* (fig. 66). The man's features are essentially those of the frontispiece to the Rilke Portfolio (see fig. 113). The flying doves are similiar in feeling to those in Louis Untermeyer's *Love Sonnets*.[137] The face and the flying doves of this print were also used for a poster (see fig. 198) in which the lettering replaced the Byzantine structure.

In this print, the gray and softly rounded doves seem to be floating in the air, in contrast to the heaviness of the other two major elements, which are outlined in black. The varying sizes of the doves give an illusion of depth to the white background.

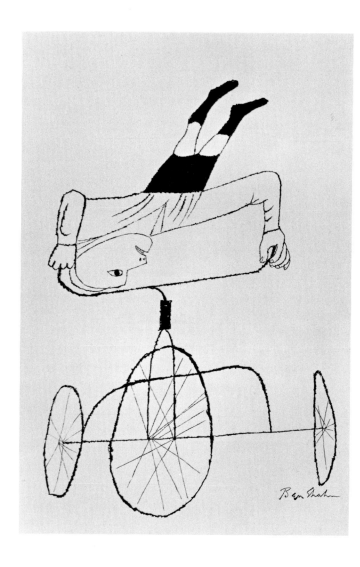

Figure 79—HEADSTAND ON TRICYCLE. 1968
Lithograph in black
Sheet: 36¼ x 24⅜" Composition: 30¾ x 21"
Paper: Velin d'arches
Edition: 200
Publisher: Kennedy Graphics, Inc., New York
Printer: Atelier Mourlot Ltd., New York
Signature: *Ben Shahn* in black on the plate lower right
Collection: New Jersey State Museum; gift of The
 Frelinghuysen Foundation. Accession No: 69.288.1

This image of a boy doing a headstand on a tricycle is essentially that in the serigraph *Boy on Tricycle* (fig. 7), which Shahn distributed as a Christmas card in 1947.

In 1968, Kennedy Graphics, Inc., New York, issued a lithographic poster version (see fig. 197) for a Shahn exhibition at the Kennedy Galleries. Shahn's distinctive signature is printed across the top, and on the bottom, printed in red brown, is the gallery's name with the exhibition dates. This lithograph is a separate edition from the same plate but without the announcement.

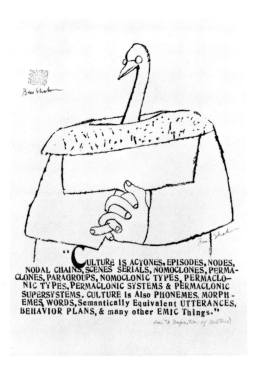

Figure 80—CULTURE. 1968
Serigraph in black with brown
 calligraphy
Sheet: 26½ x 20¾"
Composition: 22¼ x 18¾"
Paper: Japan
Edition: Unspecified; 72 known
 (10 unsigned)
Signature: *Ben Shahn* in black
 conté crayon upper left under
 orange-red chop and *Ben
 Shahn* center right; lower
 right in Shahn's hand: *from
 "A Definition of Culture"*
Collection: New Jersey State
 Museum; purchase.
 Accession No: 68.31.15

Figure 81—CULTURE. 1968
Serigraph in black with red
 calligraphy
Sheet: 26½ x 20½"
Composition: 22¼ x 18¾"
Paper: Japan
Edition: Unspecified; 73 known
 (9 unsigned)
Signature: *Ben Shahn* in black
 conte crayon upper left under
 orange-red chop
Collection: New Jersey State
 Museum; gift of Ruth and
 George Pellettieri. Accession
 No: 70.216.2

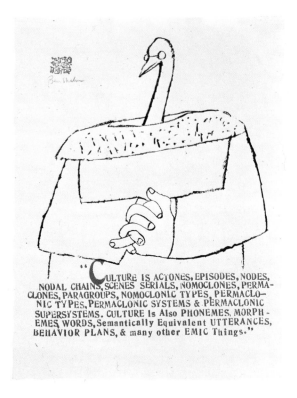

Shahn made several satirical drawings indicating his disdain for academic verbosity and pomposity. The elegantly gowned "bird" in this print is wearing what appears to be a traditional scholar's robe adorned with an ermine-like collar. The line connecting the empty eyes suggests a pair of wire spectacles. The hands, always conveyors of Shahn's thoughts, are piously folded, quite befitting someone who is about to deliver a learned definition of culture.

As an illustration for Alastair Reid's *Ounce Dice Trice*,[138] Shahn drew two similar "birds" wearing long, formal gowns. One, with its beak open, is apparently delivering an important statement, while the other is listening in an attitude of deference, its long neck gracefully curved downward, its hands folded and its eyes closed. In *The Biography of a Painting*,[139] three long-necked and gowned birds are shown engaged in discussion.

In the two versions of *Culture* identical screens were used for the black image and for the calligraphy; however, in one version, Shahn printed the calligraphy in brown and in the other red. He wrote in pencil on my personal copy that the satirical quotation is from "The Nature of Cultural Things" by Marvin Harris.

When Shahn first showed me this print he could scarcely conceal his enjoyment of my futile attempts to comprehend the improbable definition of culture. Chuckling heartily, he inscribed a copy "for Ken Prescott to be used as a shield." Shahn had served with me as a member of the State Museum's Advisory Council and knew firsthand the many difficulties the museum staff faced in establishing a fine arts program, particularly when it came to defining "good" and "bad" art, choosing standards of selection, etc.

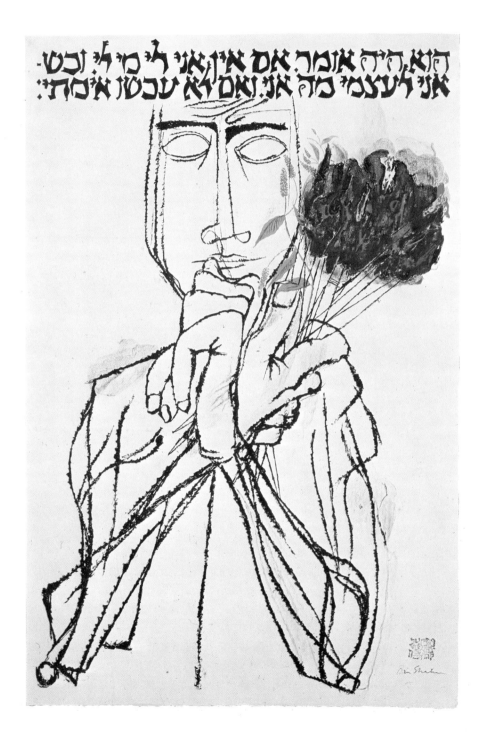

Figure 82 — FLOWERING BRUSHES. 1968
Lithograph in colors
Sheet: 39⅝ x 26⅝" Composition: 38¼ x 25"
Paper: Velin d'arches
Edition: 200
Publisher: Kennedy Graphics, Inc., New York
Printer: Atelier Mourlot Ltd., New York
Signature: *Ben Shahn* in black with brush lower right
 below orange-red chop
Collection: New Jersey State Museum; purchase.
 Accession No: 69.190.1

This is one of several versions Shahn developed of "the artist" absorbed in thought, his chin in one hand and a colorful paintbrush "bouquet" in the other. The Hebrew quotation running across the top of the composition and covering the top of the artist's head is one of the famous sayings of Hillel the Elder, a great personality of Jewish history, who lived during the reign of Herod. Morris Bressler's translation of the passage reads:

 He [Hillel] used to say: If I am not for myself, who is
 for me?
 If I care only for myself, what am I? If not now, when?

This lithograph is similar to the Container Corporation poster *You Have Not Converted a Man* (fig. 200). Other variations are: the 1953 drawing *Artist,* which is reproduced in *The Shape of Content* and also as the frontispiece in *Ben Shahn His Graphic Art;* the 1953 brush drawing *Artists and Politicians;* and the artist on the cover of the paperback edition of Shahn's *The Biography of a Painting.*[140] In *Artists and Politicians* the hand holding the brushes has been lowered considerably to make room for two gesticulating politicans who peer over the artist's shoulders.

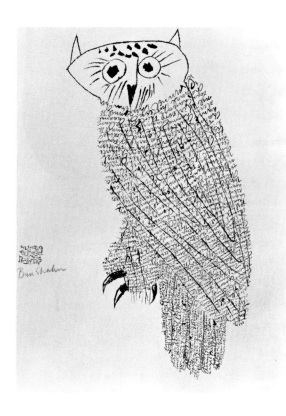

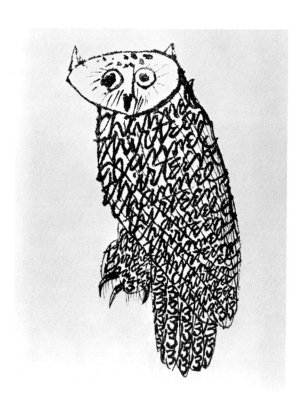

Figure 83 — OWL No. 1. 1968
Lithograph in black
Sheet: 26⅜ x 20⅜" Composition: 23¾ x 13"
Paper: Arches, 160 Gr. with "Mourlot" watermark
Printer: Atelier Mourlot Ltd., New York
Edition: 250
Signature: *Ben Shahn* in black with conté crayon left
 lower center under orange-red chop
Collection: New Jersey State Museum; purchase.
 Accession No: 70.188.1

Figure 84 — OWL No. 2. 1968
Lithograph in black
Sheet: 26⅜ x 20¼"
Composition: 23¾ x 12¾"
Paper: Arches with *Mourlot* watermark
Edition: 250
Signature: None
Collection: New Jersey State Museum; gift
of Mr. and Mrs. Charles Levy.
Accession No: 70.320.2

Channel 13, a non-profit, educational television station serving the New York–New Jersey area, was one of the many causes and institutions to which Shahn donated his time and talents. During one of the station's fund raising drives, Shahn, together with Mr. and Mrs. Lawrence A. Fleischman conceived of an appealing way to raise money. Shahn would donate a design based on Channel 13's emblem, an owl; the Atelier Mourlot Ltd. of New York would be asked to produce the prints for free, while the Fleischmans would absorb all other expenses.

"The Friends of Channel 13" launched the project, offering a print to listeners for a two hundred dollar contribution. However, when examining his drawings, Shahn was unable to choose between two versions and so had both printed. The edition of *Owl No. 1* soon sold out, and the edition of *Owl No. 2* began to move well.

With a minimum use of lines, Shahn captured in this print the principal characteristics of a horned owl: the widely opened eyes, the hooked beak, the powerful yet softly rounded body. When examined, the squiggles filling in the plumage turn into "Channel 13."

In this second version of *Owl,* printed by Atelier Mourlot Ltd. for the benefit of Channel 13, a heavier brush stroke is used for the body of the bird and for the lettering that depicts the feathers. Consequently, this owl has quite a different appearance from *Owl No. 1* (fig. 83). This example is unsigned, but many impressions of the edition were signed by the artist before his death.

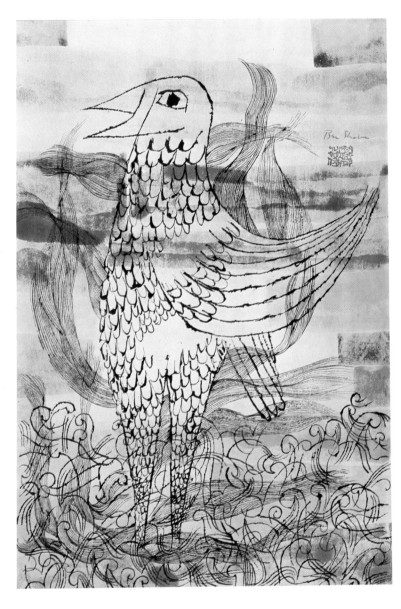

Figure 85—PHOENIX, c. 1968
Serigraph with watercolor wash
Sheet: 35 x 23⅝" Composition: c. 34¾ x 23⅝"
Paper: Japan
Edition: 5 known.
Signature: *Ben Shahn* in black conté crayon on upper
 right above orange-red chop
Collection: New Jersey State Museum; purchase.
 Accession No: 70.10.2

In this rare version, Shahn first silk-screened the black outline of the phoenix and then added the colors by hand—unlike an earlier *Phoenix* (fig. 14), in which the serigraph was printed over the previously painted horizontal stripes. The date and edition are based on information furnished by Mr. Lawrence A. Fleischman of the Kennedy Galleries who recalls being in Shahn's Roosevelt studio while Shahn was adding the colors to approximately five *Phoenix* serigraphs.

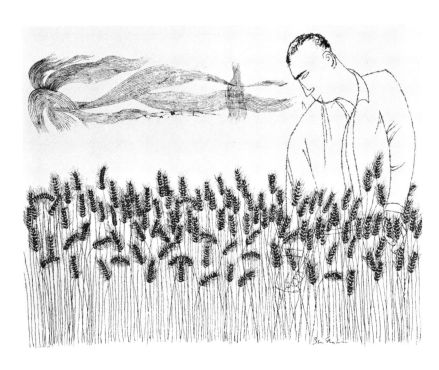

Figure 86—EPIS. 1969
Lithograph in black
Sheet: 27⅛ x 41⅛" Composition: 23¾ x 32¼"
Paper: Velin d'arches
Publisher: Kennedy Graphics, Inc., New York
Printer: Mourlot Graphics Ltd., New York
Edition: 120
Signature: *Ben Shahn* in black on the stone lower right;
 J. Mourlot Grav. Lith. on the stone lower left
Collection: New Jersey State Museum; gift of Dr. & Mrs.
 Albert L. Rosenthal. Accession No: 69.275.1

This lithograph resembles the wood-engraving *Beatitudes* (fig. 21) and is also closely related to the 1950 drawing *Man Picking Wheat.*[141] Shahn drew several variations on the subject.

 The graceful swirls of lines, representing clouds in this print, were preceded by Shahn's development of formalized flames (see pp. xix-xx), a motif he used in many of his works: *Where There Is a Book There Is No Sword* (fig. 12), *Phoenix* (fig. 13), and *Credo* (fig. 40).

 Jacques Mourlot told me that he proposed the name *Epis,* taken from the French, meaning heads of grain.

PART TWO
PORTFOLIOS

LEVANA AND OUR LADIES OF SORROW PORTFOLIO/1931

The Levana series of lithographs represents Shahn's first venture in producing prints as artistic expression. As a youthful lithographer's apprentice, he had learned basic skills and a respect for craftsmanship which would serve him well in the various printmaking media for nearly forty years. These early prints differ markedly from his later work.

The series grew out of a suggestion made by Philip Van Doren Stern that he and Shahn collaborate in producing a portfolio based on "Levana and Our Ladies of Sorrow," an essay from Thomas De Quincey's *Suspiria de Profundis*. Not printed since it first appeared in *Blackwood's Magazine* in 1845, the essay was a sequel to *The Confessions of an English Opium Eater*. According to Rodman,[142] Stern financed the printing and binding costs, and Shahn produced ten original lithographic plates. Stern generously suggested that all profits would go to the artist.

The edition was limited to two hundred and twelve portfolios, each containing the text of De Quincey's essay in booklet form and ten lithographs, approximately 13 x 10", printed in sepia on Canson and Montgolfier's *Papier Ancien*. In the portfolios numbered 1-12 each lithograph was signed and mounted. The booklet accompanying the portfolio in the New Jersey State Museum Collection is signed in black ink by Shahn and Stern on the back cover and numbered *3* in black ink above the signatures. The signed but unnumbered lithographs are enclosed in a blue buckram portfolio. The cover carries the title printed in gold letters and an outline in gold of Levana, as she was later reproduced in a 1966 lithograph (see fig. 71).

The project turned out to be a financial failure, with sales reimbursing Stern for approximately one-half of the printing cost. While preparing for a 1967 Philadelphia exhibition, Shahn recalled that only about ten copies were sold, and that he had destroyed the remainder of the edition in anger and frustration.[143] There is, therefore, no way of knowing how many portfolios are extant. At this writing, there are fewer than ten copies of the signed portfolio known to the author, although there are about the same number signed only on the stone. There are records of portfolios at the Brooklyn Museum, the Museum of Modern Art, and the Princeton University Library.

Levana (from Latin, levare, "to raise up"), as Thomas De Quincey informs the reader of his essay, was "The Roman goddess that performed for the new-born infant the earliest office of ennobling kindness" by having him lifted off the ground to "Behold what is greater than yourselves!" She was also the goddess who watched over human education: "Not the poor machinery that moves by spelling-books and grammars, but by that mighty system of central forces hidden in the deep bosom of human life, which by passion, by strife, by temptation, by the energies of resistance, works forever upon children." Grief is part of this system and therefore "Levana often communes with the powers that shake man's heart." According to De Quincey, he had often seen Levana in his dreams, conversing with Our Ladies of Sorrow (also referred to as "Sisters" and "Sorrows") who are "impersonations" not of individual sorrow but of "the mighty abstractions [of sorrow] that incarnate themselves in all individual sufferings of man's heart."

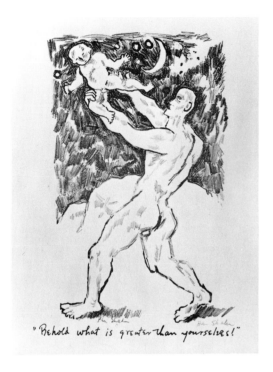

"Behold what is greater than yourselves!"

Figure 87 — BEHOLD WHAT IS GREATER
(Levana Portfolio). 1931
Lithograph in sepia
Sheet: 13⅛ x 9⅞" Composition: 11¾ x 8"
Paper: Canson and Montgolfier's *Papier Ancien*
Edition: 212
Signature: *Ben Shahn* on the stone lower left; *Ben Shahn*
in pencil lower right
Collection: New Jersey State Museum; gift of Mr. and
Mrs. Robert D. Graff. Accession No: 69.185.2a

Figure 88 — I SAW DIMLY RELIEVED
(Levana Portfolio). 1931
Lithograph in sepia
Sheet: 13⅛ x 9⅞" Composition: 10⅜ x 8"
Paper: Canson and Montgolfier's *Papier Ancien*
Edition: 212
Signature: *Ben Shahn* on the stone lower right; *Ben
Shahn* in pencil lower left
Collection: New Jersey State Museum; gift of Mr. and
Mrs. Robert D. Graff. Accession No: 69.185.2b

...I saw (dimly relieved upon the dark background of
my dreams) the imperfect lineaments of the awful Sisters

According to De Quincey, Levana always acted by proxy. When an infant was born and had "tasted for the first time the atmosphere of our troubled planet" it was immediately raised off the ground by his father or a kinsman, who "bade it look erect as the King of all this world, and presented its forehead to the stars....This symbolic act represented the function of Levana."

Shahn closely followed the legend in his artistic interpretation. The child is held high against the starry firmament. The low, mountainous outline in the background gives heroic proportions to the man and infant.

In this print, De Quincey is pictured by Shahn as a young man already familiar through dreams with the Three Sorrows or "awful Sisters," as they are referred to at this point in the text. De Quincey speaks of himself as knowing thoroughly only one of the Sorrows at this young age, though he knew that the future would bring intimate knowledge of the other two. The right angle formed by the figure in the foreground partially frames the Three Sisters in the background; Shahn has made them very small and distant, thus creating a dream-like effect.

Eternal silence reigns in their kingdoms

Figure 89—ETERNAL SILENCE REIGNS
(Levana Portfolio). 1931
Lithograph in sepia
Sheet: 13⅛ x 9⅞" Composition: 9⅛ x 8"
Paper: Canson and Montgolfier's *Papier Ancien*
Edition: 212
Signature: *Ben Shahn* on the stone lower left; *Ben Shahn*
 in pencil lower right
Collection: New Jersey State Museum; gift of Lessing J.
 Rosenwald. Accession No: 69.185.2c

Figure 90—RACHEL WEEPING
(Levana Portfolio). 1931
Lithograph in sepia
Sheet: 13⅛ x 9⅞" Composition: 11¾ x 8⅛"
Paper: Canson and Montgolfier's *Papier Ancien*
Edition: 212
Signature: *Ben Shahn* on the stone lower left; *Ben Shahn*
in pencil lower right
Collection: New Jersey State Museum; anonymous gift.
Accession No: 69.185.2d

Rachel weeping for her children and refusing to be comforted.

"Three Sisters they are [Our Ladies of Sorrow], of one mysterious household….amongst themselves is no voice nor sound….Theirs were the symbols; *mine* are the words." In his dreams, De Quincey often saw the Sisters converse with Levana, sometimes about himself: "I read the signals."

There is a classic beauty in the Three Sisters as Shahn portrays them here. The hair and head coverings are suggested with soft outlines and shading. The short strokes Shahn used for the sky give it a radiant effect. Shahn's lifelong preoccupation with hands and fingers is evident here in the slender and expressive finger each woman has raised to her lips.

"The eldest of the three [sisters] is named…Our Lady of Tears. She it is that night and day raves and moans, calling for vanished faces….This Sister…it is that carries keys more than papal at her girdle, which open *every* cottage and *every* palace."

In Shahn's composition, Rachel, seated crosslegged in the foreground with a child in her arms, dominates the scene. The heavy maternal figure contrasts with the slender woman to the right, whom Shahn has drawn with an unusually elongated neck. The woeful apparition in the background is presumably Our Lady of Tears.

"Rachel weeping for her children and refusing to be comforted" is from De Quincey's text and, although slightly different from the King James Version, occurs in the New Testament in allusion to Herod's Massacre of the Innocents after the birth of Christ (Matt. 2:18).

She it was that stood in Bethlehem on the night when Herod's sword swept its nurseries of Innocents.

Figure 91 — SHE IT WAS THAT STOOD (Levana Portfolio). 1931
Lithograph in sepia
Sheet: 13⅛ x 9⅞" Composition: 11½ x 8¼"
Paper: Canson and Montgolfier's *Papier Ancien*
Edition: 212
Signature: *Ben Shahn* on the stone lower right;
 Ben Shahn in pencil lower left
Collection: New Jersey State Museum; gift of Mrs. Donald
 B. Straus. Accession No: 69.185.2e

Figure 92 — EVERY SLAVE (Levana Portfolio). 1931
Lithograph in sepia
Sheet: 13⅛ x 9⅞" Composition: 11¾ x 7¼"
Paper: Canson and Montgolfier's *Papier Ancien*
Edition: 212
Signature: *Ben Shahn* on the stone lower right; *Ben
Shahn* in pencil lower left
Collection: New Jersey State Museum; gift of Mr. and Mrs.
 James E. Burke. Accession No: 69.185.f

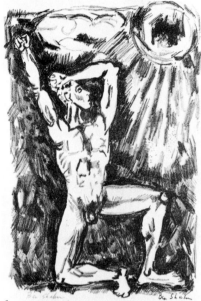

Every slave that at noonday looks up to the tropical sun with timid reproach...

Here Shahn has placed Our Lady of Tears among the lifeless children, who are spread around like discarded dolls in a nursery. The hovering angel and the crucifixion connote divine intervention and resurrection from the dead.

As De Quincey's text implies, the scene in this print also refers to Herod's Massacre of the Innocents.

"The Second Sister is called…Our Lady of Sighs.…She weeps not. She groans not. But she sighs inaudibly at intervals.…She is humble to abjectness. Hers is the meekness that belongs to the hopeless." The slaves are among the people whom she visits.

If Shahn's slave is frightened and awed by the power of the sun, he does not give the impression of submissiveness. Rather, he seems confident and vigorous, shielding the sun's glare with one arm and raising a clenched fist as if in protest or defiance.

The athletic pose, revealing anything but timidity, contrasts with the quotation from De Quincey's essay.

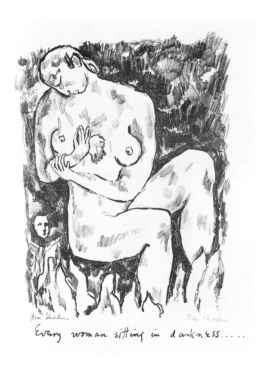

Every woman sitting in darkness.....

Figure 93 — EVERY WOMAN (Levana Portfolio). 1931
Lithograph in sepia
Sheet: 13⅛ x 9⅞" Composition: 9½ x 7¼"
Paper: Canson and Montgolfier's *Papier Ancien*
Edition: 212
Signature: *Ben Shahn* on the stone lower left; *Ben Shahn*
 in pencil lower right
Collection: New Jersey State Museum; gift of the
 Honorable and Mrs. George Pellettieri. Accession No:
 69.185.2g

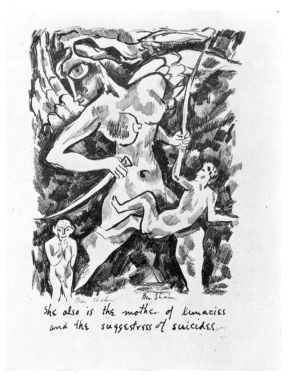

She also is the mother of lunacies
and the suggestress of suicides....

Figure 94 — SHE ALSO IS THE MOTHER
(Levana Portfolio). 1931
Lithograph in sepia
Sheet: 13⅛ x 9⅞" Composition: 10¾ x 7¾"
Paper: Canson and Montgolfier's *Papier Ancien*
Edition: 212
Signature: *Ben Shahn* on the stone lower center right;
Ben Shahn in pencil lower center left
Collection: New Jersey State Museum; gift of Mr. and
Mrs. Arthur J. Sills. Accession No: 69.185.2h

Our Lady of Sighs, the Second Sister, also visits, according to De Quincey, "every woman sitting in darkness without love to shelter her head, or hope to illumine her solitude, because the heaven-born instincts kindling in her nature germs of holy affections, which God implanted in her womanly bosom, having been stifled by social necessities, now burn sullenly to waste…."

In Shahn's print, the seated woman, who seems to be cuddling a child in her empty arms, is the largest figure in the portfolio. The small face peering at her from the lower left is probably that of Our Lady of Sighs and helps to emphasize the woman's gigantic proportions.

The Third Sister, Our Lady of Darkness, is the youngest of De Quincey's Ladies of Sorrow. "Deep lie the roots of her power; but narrow is the nation that she rules. For she can approach only those in whom a profound nature has been upheaved by central convulsions; in whom the heart trembles and the brain rocks under conspiracies of tempest from without and tempest from within."

It is the Lady of Darkness whom Shahn has pictured in this print as a winged fury, armed with curved daggers.

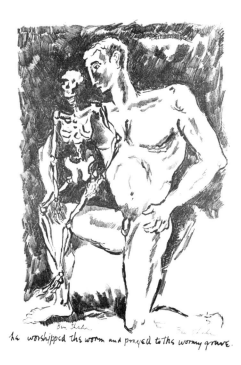

he worshipped the worm and prayed to the wormy grave.

Figure 95 — HE WORSHIPPED THE WORM
(Levana Portfolio). 1931
Lithograph in sepia
Sheet: 13⅛ x 9⅞" Composition: 11⅝ x 7⅝"
Paper: Canson and Montgolfier's *Papier Ancien*
Edition: 212
Signature: *Ben Shahn* on the stone lower left; *Ben Shahn*
in pencil lower right
Collection: New Jersey State Museum; gift of Mr. and
Mrs. Julian Aresty. Accession No: 69.185.2i

Figure 96 — TO PLAGUE HIS HEART
(Levana Portfolio). 1931
Lithograph in sepia
Sheet: 9⅞ x 13⅛" Composition: 7⅜ x 11¼"
Paper: Canson and Montgolfier's *Papier Ancien*
Edition: 212
Signature: *Ben Shahn* on the stone lower right;
Ben Shahn in pencil lower left
Collection: New Jersey State Museum; gift of Mr. and Mrs.
W. Park Armstrong, Jr., Mr. and Mrs. James E. Burke,
Mr. Michael J. Desiderio, and the Samuel-Nathan
Feldman Foundation. Accession No: 69.185.2j

..... to plague his heart until we had unfolded the capacities of his spirit"

At the end of the essay, it becomes clear to De Quincey that the Lady of Tears has beguiled him and led him astray, and she reveals what still awaits him: "Him, this young idolator, I have seasoned for thee, dear gentle Sister of Sighs! Do thou take him now to *thy* heart, and season him for our dreadful sister [of Darkness]."

Shahn gave the idolatrous young man a muscular, athletic body. By having him thoughtfully contemplating a skeleton, symbol of death and corruption, Shahn portrayed the futility of young De Quincey's "languishing desires."

The last print in this portfolio represents the purpose of the sufferings of De Quincey, as revealed to him by Our Lady of Tears.

Shahn has drawn his figures against a background that gives the impression of vast open spaces. The winged, motherly figure represents Our Lady of Tears helping to raise the young De Quincey from his reclining position: "So shall he read elder truths, sad truths, grand truths, fearful truths. So shall he rise again *before* he dies. And so shall our commission be accomplished which from God we had—to plague his heart until we had unfolded the capacities of his spirit."

This is the only print in the series where the composition is arranged with its longest axis in the horizontal plane.

FREDERICK DOUGLASS PORTFOLIO/1965

Shahn's four drawings of Frederick Douglass reflect his interest in the cause of black people in general and the admiration he held for this great historic leader in particular. The portraits reveal Douglass (1817?-1895) as Shahn saw him in the different stages of his life.

Born in slavery at Tuckahoe, Maryland, Douglass lived his first nine years on plantations before being sent to Baltimore, where he secretly learned to read and write. With money he earned from blacking shoes, he purchased his first book, *The Columbian Orator*, a prophetic choice, for he was to become an accomplished speaker. His early apprenticeship to a ship caulker made him so familiar with ships that he was able to masquerade as a sailor and escape to England. There he helped to arouse English sympathy against slavery.

Upon his return to the United States, Douglass lectured against slavery throughout New England and the Middle Atlantic states for the Massachusetts Anti-Slavery Society. During the years 1845-47, he returned to the British Isles to enlist support for the cause of the abolitionists in America. Douglass subsequently became American Minister in Residence and Consul General to the Republic of Haiti and held other positions of national trust and honor.

Shahn, an active supporter of the struggles of the Negro minority in the North and South, allowed this portfolio to be reproduced and sold by the Museum of African Art in Washington, D.C., for the benefit of its Frederick Douglass Institute of Negro Arts and History. The drawings were reproduced by photo-silkscreen, and Shahn signed and numbered each print.

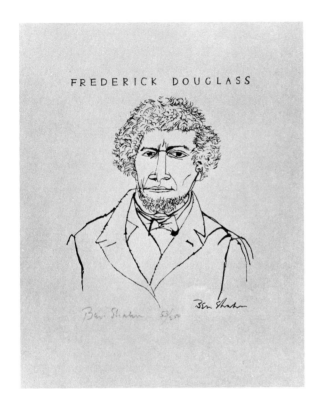

FREDERICK DOUGLASS

Ben Shahn 53/250 Ben Shahn

Figure 97—FREDERICK DOUGLASS, I
 (Frederick Douglass Portfolio). 1965
Photo-silkscreen in black and raw umber
Sheet: 22 x 16¾" Composition: 12¼ x 10"
Paper: Japan
Publisher: Museum of African Art, Frederick Douglass
 Institute, Washington, D.C.
Edition: 250; *53/250*
Signature: *Ben Shahn* in black on the screen lower right;
 Ben Shahn with red conté crayon, lower left
Collection: New Jersey State Museum; anonymous donor.
 Accession No: 70.16a

Figure 98—FREDERICK DOUGLASS, II
 (Frederick Douglass Portfolio). 1965
Photo-silkscreen in black and raw umber
Sheet: 22 x 16¾" Composition: 12¼ x 9⅛"
Paper: Japan
Publisher: Museum of African Art, Frederick Douglass
Institute, Washington, D.C.
Edition: 250; *53/250*
Signature: *Ben Shahn* in black on the screen lower right;
Ben Shahn in red conté crayon, lower left
Collection: New Jersey State Museum; anonymous donor.
Accession No: 70.16.b

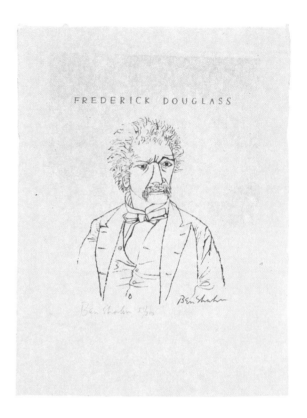

FREDERICK DOUGLASS

Ben Shahn 53/250 Ben Shahn

This portrait represents the active, young lecturer and author who was well known on both sides of the Atlantic.

Printed in black, the face is strong and determined with a clipped beard and no moustache. "FREDERICK DOUGLASS," printed across the top in umber, is identically placed in all four prints of this portfolio.

In the 1840s, Douglass published the *Narrative of the Life of Frederick Douglass* and began to edit an anti-slavery weekly journal, *The North Star.* He continued to be an effective and respected speaker at anti-slavery meetings. In about 1846, funds were raised by subscription to secure his legal manumission in order to remove the danger of his being returned to slavery under the provisions of the Fugitive Slave Law.

Beardless, but with a generous moustache, this Douglass portrait reveals a confident man of the world. The portrait is printed in black with the title "FREDERICK DOUGLASS" in raw umber across the top.

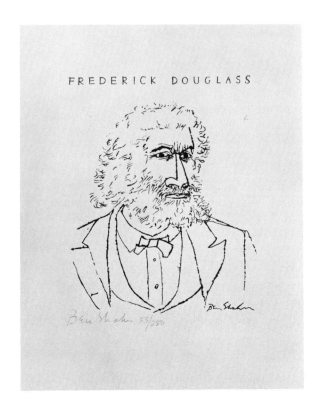

FREDERICK DOUGLASS

Ben Shahn 53/250

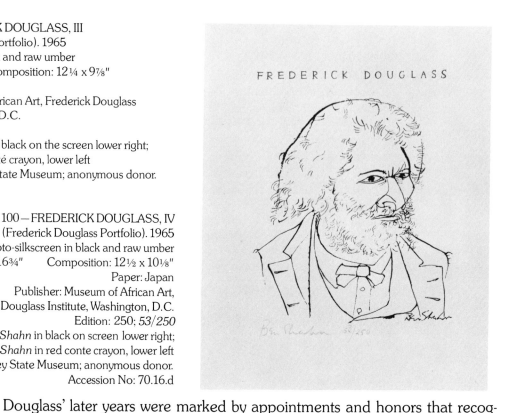

FREDERICK DOUGLASS

Ben Shahn 53/250

Figure 99 — FREDERICK DOUGLASS, III
(Frederick Douglass Portfolio). 1965
Photo-silkscreen in black and raw umber
Sheet: 22 x 16¾" Composition: 12¼ x 9⅞"
Paper: Japan
Publisher: Museum of African Art, Frederick Douglass
 Institute, Washington, D.C.
Edition: 250; *53/250*
Signature: *Ben Shahn* in black on the screen lower right;
 Ben Shahn in red conté crayon, lower left
Collection: New Jersey State Museum; anonymous donor.
 Accession No: 70.16c

Figure 100 — FREDERICK DOUGLASS, IV
(Frederick Douglass Portfolio). 1965
Photo-silkscreen in black and raw umber
Sheet: 22 x 16¾" Composition: 12½ x 10⅛"
Paper: Japan
Publisher: Museum of African Art,
Frederick Douglass Institute, Washington, D.C.
Edition: 250; *53/250*
Signature: *Ben Shahn* in black on screen lower right;
Ben Shahn in red conte crayon, lower left
Collection: New Jersey State Museum; anonymous donor.
Accession No: 70.16.d

While Douglass disapproved of John Brown's attack on Harpers Ferry and declined to take any part in it, he was one of the first to propose that the United States use Negro troops in the Civil War. Two of his sons served in the Union Army. After the war he continued to be a popular lecturer, widely known and respected for his eloquence. In 1871, President Grant appointed him Assistant Secretary of the Santo Domingo Commission.

To Douglass' strong features is added the full beard of the statesman. The turned-down collar indicates a change in men's fashions. Again the portrait is in black, with the raw umber title centered above.

Douglass' later years were marked by appointments and honors that recognized his distinguished career. Made Marshal 1877-81 and Recorder of Deeds 1881-86 for the District of Columbia, he culminated his public career as American Minister in Residence and Consul General to the Republic of Haiti. He spent his last years in a stately home on a hilltop in Anacostia, Maryland, a suburb of Washington, D.C. This home and its contents have since been made a national historic site.

Shahn here portrayed Douglass, the elder statesman, fully bearded according to the custom of his day and with the same strong eyes as before; but the hunched shoulders, the detail of the mouth, the slightly receding hair, and the loose collar suggest a man of advancing years. Again, the raw umber title is centered above the portrait.

Shahn allowed this same drawing to be reproduced for the Nine Drawings Portfolio (see fig. 109). There it is unsigned, unnumbered, and the title, printed in burnt sienna, is a darker shade and nearer to brown than the umber used here.

HUMAN RELATIONS PORTFOLIO/1965

Henry Brandon, of the London *Sunday Times,* once recalled a tape-recorded conversation he had with Ben Shahn. In answer to Brandon's question, "What really inspires you to paint?" Shahn replied: "The life that goes on here. I once told a student [that there] are just two things to paint—the things you are very strongly for and the things you are very strongly against. And I feel pretty strongly about a lot of things. It could take any form…it's generally based on what goes on around me; what goes on politically, what goes on socially, what goes on in the seasons, what goes on emotionally, etc." [144]

When three young civil rights workers were murdered in Mississippi in the summer of 1964, Shahn reacted with characteristic compassion and energy. This portfolio of the three martyrs was his way of expressing his shock and anger, and just as importantly, a means of furthering the cause for which they had died. The proceeds from its sales benefited the Human Relations Council of Greater New Haven, Connecticut.

The story of the tragedy is documented in the newspapers and magazines of that summer. It tells how three young men returning from a week-long conference for northern college students, held on a college campus at Oxford, Mississippi, were arrested in Philadelphia, Mississippi. James Chaney was booked for speeding; Andrew Goodman and Michael Schwerner were held for investigation. Eventually all three were fined twenty dollars and released. They were never to be seen alive again. When their bodies were discovered six weeks later, buried twenty-six feet under a levee at a construction project, the mystery of their disappearance was solved; but for Shahn, the artist and the social commentator, the work had just begun.

The three photo-silkscreen reproductions of Shahn's drawings were enclosed in a portfolio wrapper of plain blue paper with a photo-reproduction of Shahn's signature on the cover. A one-page printed essay, "Martyrology," written by Shahn's neighbor, Edwin Rosskam, was enclosed. Each print was signed and numbered by Shahn.

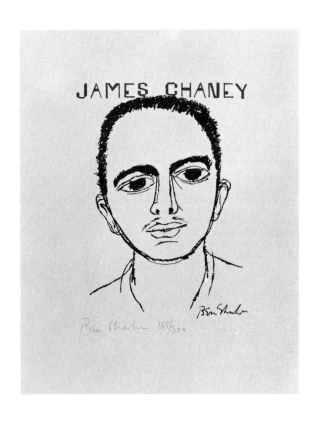

Figure 101 — JAMES CHANEY
 (Human Relations Portfolio). 1965
Photo-silkscreen in black and umber
Sheet: 21⅞ x 16¾" Composition: 12⅝ x 9⅜"
Paper: Japan
Printer: Meriden Gravure Company,
 Meriden, Connecticut
Edition: 300; *185/300* in red conté crayon
Signature: *Ben Shahn* in black on the screen lower right;
 Ben Shahn in red with conté crayon lower left
Collection: New Jersey State Museum; gift of Human
 Relations Council of Greater New Haven, Connecticut.
 Accession No: 68.32.1

Figure 102 — ANDREW GOODMAN
 (Human Relations Portfolio). 1965
Photo-silkscreen in black and umber
Sheet: 21⅞ x 16¾" Composition: 13⅛ x 9⅝"
Paper: Japan
Printer: Meriden Gravure Company,
 Meriden, Connecticut
Edition: 300; *185/300* in red conté crayon
Signature: *Ben Shahn* in black on the screen lower right;
 Ben Shahn in red with conté crayon lower left
Collection: New Jersey State Museum; gift of Human
Relations Council of Greater New Haven, Connecticut.
Accession No: 68.32.2

James Chaney, a Negro, was one of the three young civil rights workers murdered in Mississippi during the summer of 1964. He had attended high school in Meridan, Mississippi, and worked as a plasterer until he attended a CORE (Congress of Racial Equality) Training School in Ohio where he met Michael Schwerner. Chaney then became an aide in the Negro Community Center opened in Meridan by Schwerner, his wife, and Andrew Goodman.

This portrait of the twenty-one-year-old Chaney shows him with a slight moustache. The large eyes and frozen expression give an impression of impending doom. Shahn included a portrait of Chaney (fig. 110) in the *Nine Drawings* portfolio, which was reproduced from the same drawing used for this print. Here, "James Chaney" is printed in umber above the portrait.

Goodman, murdered in Mississippi during the summer of 1964, was a junior at Queen's College, New York. Working with the Schwerners and James Chaney at the Negro Community Center in Meridan, Mississippi, was his second civil rights venture. Previously, he had participated in group picketing of President Johnson at the opening of the New York World's Fair. In this portrait, Shahn stressed the youth of the twenty-year-old college student.

"Andrew Goodman" is printed in umber above the image.

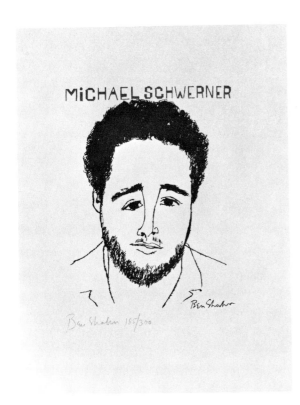

Figure 103—MICHAEL SCHWERNER
　(Human Relations Portfolio). 1965
Photo-silkscreen in black and umber
Sheet: 21⅞ x 16¾"　　Composition: 12⅞ x 9⅝"
Paper: Japan
Printer: Meriden Gravure Company,
　Meriden, Connecticut
Edition: 300; *185/300* in red conté crayon
Signature: *Ben Shahn* in black on the screen lower right;
　Ben Shahn in red with conté crayon lower left
Collection: New Jersey State Museum; gift of Human
　Relations Council of Greater New Haven, Connecticut.
　Accession No: 68.32.3

Schwerner, a 1961 graduate of Cornell University, had been a social worker on the Lower East Side of New York City and had attended a CORE Training School in Ohio.

Subsequently, he and his wife opened a Negro Community Center in Meridan, Mississippi, which included a library of nearly ten thousand books donated by students from the North. While Schwerner worked on voter registration, his wife, Rita, taught reading, citizenship, and use of the sewing machine. He was twenty-four years old when he and Chaney and Goodman were murdered in Mississippi in the summer of 1964.

"Michael Schwerner" is printed in umber above the image.

NINE DRAWINGS PORTFOLIO/1965

"I hate injustice. I guess that's about the only thing I really do hate," Shahn once remarked.[145] These nine photo-offset reproductions of Shahn drawings testify to his deep personal commitment to the cause of social justice, and reflect what he felt to be the "realities of human relationships, of man's emotional and spiritual life, the reality of political decency, of social injustice…which affect men's lives, personality, and sensitivity."[146]

The portfolio was published and distributed as part of a fund-raising effort by the Lawyers Constitutional Defense Committee of the American Civil Liberties Union. The Committee was founded early in 1964 by legal officers of various civil rights and civil liberties organizations to provide legal representation in civil rights cases in the Deep South.

The prints were enclosed in a gray buckram portfolio with Shahn's signature reproduced in white on the cover. A poem by his Roosevelt friend Edwin Rosskam was enclosed. Shahn retained the copyright to the portfolio and McNulty indicates that most of the sheets have the copyright stamped in green, verso.[147] However, Shahn did not apply the green copyright stamp consistently throughout the edition. In the portfolio in the New Jersey State Museum Collection the stamp appears on the lower right of the inside cover. The prints were signed on the plate. Some carry Shahn's hand-applied alphabet chop. Only one print in each portfolio was signed and numbered by the artist; the signed print in the Philadelphia Museum of Art portfolio is *Psalm 133* (fig. 106).

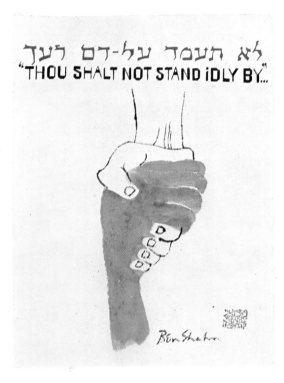

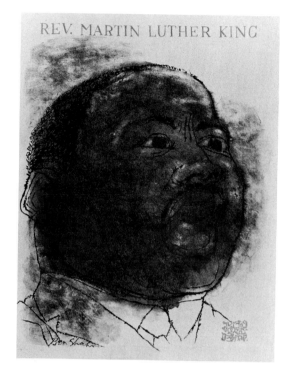

Figure 104—THOU SHALT NOT STAND IDLY BY
 (Nine Drawings Portfolio). 1965
Photo-offset lithograph in black and burnt sienna
Sheet: 22 x 16¾" Composition: 19½ x 16"
Paper: Japan
Publisher: Lawyers Constitutional Defense Committee of
 the American Civil Liberties Union, New York
Printer: The Meriden Gravure Company,
 Meriden, Connecticut
Edition: 300
Signature: *Ben Shahn* in black on the plate lower right
 below orange-red hand-applied chop
Collection: New Jersey State Museum; purchase.
 Accession No: 70.354.1

Figure 105—REV. MARTIN LUTHER KING
 (Nine Drawings Portfolio). 1965
Photo-offset lithograph in black and burnt sienna
Sheet: 22⅛ x 16⅝" Composition: 20¼ x 16"
Paper: Japan
Publisher: Lawyers Constitutional Defense Committee of
 the American Civil Liberties Union, New York
Printer: The Meriden Gravure Company,
 Meriden, Connecticut
Edition: 300
Signature: *Ben Shahn* in black on the plate lower left;
 orange-red hand-applied chop lower right
Collection: New Jersey State Museum; gift of Mr. and Mrs.
 Robert D. Graff. Accession No: 70.354.2

All through his life Shahn regarded the hands as major tools of human expression. In his brush drawing *Variation of Psalm 133* two hands are clasped to symbolize the psalm, as lettered (in Hebrew and English) by Shahn: "Behold, how good and how pleasant it is for breathren [sic] to dwell together in unity..."[148] Here he used the subject of hands coupled with an admonition to action, bearing witness to his belief in the cause of racial justice. The title is taken from Leviticus (19:16): "Thou shalt not go up and down *as* a talebearer among thy people: neither shalt thou stand idly by the blood of thy neighbor."

Here The Hebrew lettering is in a slightly lighter shade than the rest of the titles in this portfolio.

This print is made from the same Shahn wash drawing upon which Stefan Martin based his wood-engraving, *Martin Luther King* (fig. 72). The cover of *Time* magazine of March 19, 1965, carries a reproduction of the Shahn drawing which is identical to the image of this print even to the placement of the signature, lower left; however, the cover does not have the Shahn chop, and the title, "Martin Luther King," is placed on three lines, lower right.

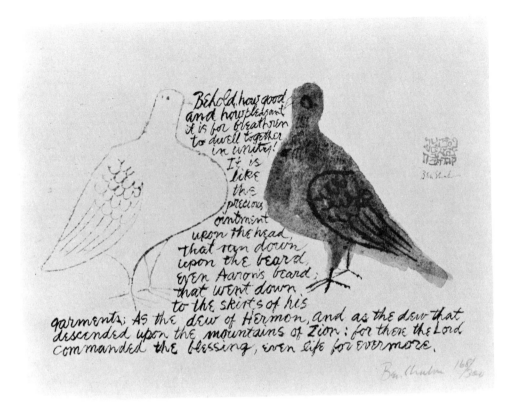

Within the image (handwritten):

Behold, how good and how pleasant it is for brethren to dwell together in unity! It is like the precious ointment upon the head, that ran down upon the beard, even Aaron's beard; that went down to the skirts of his garments; As the dew of Hermon, and as the dew that descended upon the mountains of Zion: for there the Lord commanded the blessing, even life for evermore.

Ben Shahn 168/300

Figure 106—PSALM 133 (Nine Drawings Portfolio).
 1965
Photo-offset lithograph in black
Sheet: 16⅞ x 22⅛" Composition: 12 x 19⅜"
Paper: Japan
Publisher: Lawyers Constitutional Defense Committee
 of the American Civil Liberties Union, New York
Printer: The Meriden Gravure Company,
 Meriden, Connecticut
Edition: 300; *168/300*
Signature: *Ben Shahn* in purple with conté crayon to left
 of edition number; *Ben Shahn* in black on the
 plate below orange-red chop center right
Collection: Philadelphia Museum of Art; gift of the
 Lawyers Constitutional Defense Committee of the
 American Civil Liberties Union

The arrangement of the psalm and the two doves is similar to that in the serigraph (fig. 45) and lithograph (fig. 53) versions of *Psalm 133,* also called *Song of Degrees* (see also fig. 235). Here the lettering is placed closer to the doves and the words are spaced quite differently. Moreover, this print is without the beautiful branching design of the other two versions.

Shahn signed and numbered only one of the nine prints in each portfolio. This is the signed print from the Philadelphia Museum of Art portfolio.

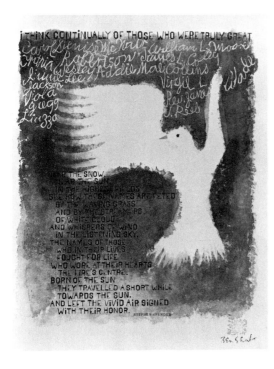

Figure 107 — I THINK CONTINUALLY OF THOSE
WHO WERE TRULY GREAT
(Nine Drawings Portfolio). 1965
Photo-offset lithograph in black and burnt sienna
Sheet: 21⅝ x 16⅝" Composition: 18⅝ x 15¼"
Paper: Japan
Publisher: Lawyers Constitutional Defense Committee of
the American Civil Liberties Union, New York
Printer: The Meriden Gravure Company,
Meriden, Connecticut
Edition: 300
Signature: *Ben Shahn* in black on the plate lower right
below orange-red chop on the screen; verso *copyright
1965 by Ben Shahn*
Collection: New Jersey State Museum; purchase.
Accession No: 70.354.3

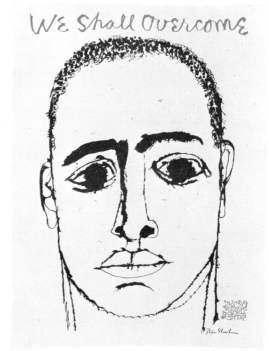

Figure 108 — WE SHALL OVERCOME
(Nine Drawings Portfolio). 1965
Photo-offset lithograph in black and burnt sienna
Sheet: 22 x 16¾" Composition: 21⅝ x 13½"
Paper: Japan
Publisher: Lawyers Constitutional Defense Committee of
the American Civil Liberties Union, New York
Printer: The Meriden Gravure Company,
Meriden, Connecticut
Edition: 300
Signature: *Ben Shahn* in black on the plate below
hand-applied orange-red chop
Collection: New Jersey State Museum; purchase.
Accession No: 70.354.4

Except for the placement of the signature and chop this print is identical to the 1965 serigraph *I Think Continually of Those Who Were Truly Great* (fig. 58). Obviously, this reproduction was taken directly from the Shahn serigraph. The shades of gray representing the wash, the lettering, and even the orange beak are faithfully reproduced.

This portrait, and that of *Rev. Martin Luther King* (fig. 105) are larger than the other portraits in this portfolio, and consequently seem to have a greater importance when all are viewed together. The determined features of this handsome young man and the affirmation "we shall overcome" suggest the strength and confidence of the 1960s civil rights movement.

Figure 109—FREDERICK DOUGLASS
 (Nine Drawings Portfolio). 1965
Photo-offset lithograph in black and burnt sienna
Sheet: 22 x 16⅝" Composition: 12½ x 10⅛"
Paper: Japan
 Publisher: Lawyers Constitutional Defense Committee of
 the American Civil Liberties Union, New York
Printer: The Meriden Gravure Company,
 Meriden, Connecticut
Edition: 300
Signature: *Ben Shahn* in black on the plate lower right
Collection: Philadelphia Museum of Art; gift of the
 Lawyers Constitutional Defense Committee of the
 American Civil Liberties Union

This portrait of the aging statesman is identical to that in the Frederick Douglass Portfolio (see fig. 100), though here the title is printed in a brighter shade.

Figure 110—JAMES CHANEY
(Nine Drawings Portfolio). 1965
Photo-offset lithograph in black and burnt sienna
Sheet: 21¾ x 16¾" Composition: 12⅝ x 9"
Paper: Japan
Publisher: Lawyers Constitutional Defense Committee of
the American Civil Liberties Union, New York
Printer: The Meriden Gravure Company,
Meriden, Connecticut
Edition: 300
Signature: *Ben Shahn* in black on the plate lower right
Collection: New Jersey State Museum; purchase.
Accession No: 70.354.5

This portrait of Chaney and the one in the Human Relations Portfolio (see fig. 101) are identical, including the placement of the printed signature. However, the coloring of the title is brighter here, and this print lacks the handwritten signature and edition number of the other version.

MICHAEL SCHWERNER

Figure 111—MICHAEL SCHWERNER (Nine Drawings Portfolio). 1965
Photo-offset lithograph in black and burnt sienna
Sheet: 22 x 16⅞" Composition: 12¾ x 9⅜" Paper: Japan
Publisher: Lawyers Constitutional Defense Committee of the American
 Civil Liberties Union, New York
Printer: The Meriden Gravure Company, Meriden, Connecticut
Edition: 300
Signature: *Ben Shahn* in black on the plate lower right
Collection: New Jersey State Museum; purchase. Accession No: 70.354.6

This portrait can be distinguished from the earlier version (see fig. 103) by the brighter color of its title. Moreover, it does not bear Shahn's hand-written signature nor the edition number.

Fig. 112—ANDREW GOODMAN
(Nine Drawings Portfolio). 1965
Photo-offset lithograph in black and burnt sienna
Sheet: 22 x 16⅝" Composition: 13⅛ x 9⅝"
Paper: Japan
Publisher: Lawyers Constitutional Defense Committee of
the American Civil Liberties Union, New York
Printer: The Meriden Gravure Company,
Meriden, Connecticut
Edition: 300
Signature: *Ben Shahn* in black on the plate lower right;
verso *copyright 1965 Ben Shahn*
Collection: New Jersey State Museum; purchase.
Accession No: 70.354.7

ANDREW GOODMAN

This portrait, like the other portraits of the slain civil rights workers in this edition, is identical to its counterpart in the Human Relations Portfolio (see fig. 102), except that its title is brighter and it does not carry the hand-written signature or the edition number.

FOR THE SAKE OF A SINGLE VERSE RILKE PORTFOLIO/1968

Rainer Maria Rilke (1875-1926) was one of the most significant figures in twentieth-century German lyric poetry. The *Notebooks of Malte Laurids Brigge* is a bold experiment in narrative technique and is filled with poignant imagery. It is an autobiographical novel in which Rilke tells of his feelings of loneliness and defeat during his early years in Paris, and of the discoveries that resulted in his becoming a writer.

It was in Paris, in 1926, that Shahn first read Rilke's novel. He was just beginning to doubt his own traditional style of painting and was seeking for more personal expressions, when he found in Rilke the same searching, probing, and slow emergence of forms, characteristic of his own experience. Much later, retaining memories of these early impressions, Shahn again turned to Rilke's *Notebooks* for inspiration, choosing, for the theme of his 1968 portfolio, a section that applied to both artists, the poet and the painter. For Shahn, Rilke's writing was art, and yet, such art was inseparable from life. In *Love and Joy About Letters*,[149] there is a drawing of a troubled violinist, frustrated, perhaps, because of the long road he must travel before reaching that ideal of expression and virtuosity which his mind has already perceived. The drawing included substantially the same Rilke quotation that we find in this portfolio:

> For the sake of a single verse, one must see many cities, men and things, one must know the animals, one must feel how the birds fly and know the gesture with which the little flowers open in the morning. One must be able to think back to roads in unknown regions, to unexpected meetings and to partings one had long seen coming; to days of childhood that are still unexplained, to parents whom one had to hurt when they brought one some joy and one did not grasp it (it was a joy for someone else); to childhood illnesses that so strangely begin with such a number of profound and grave transformations, to days in rooms withdrawn and quiet and to mornings by the sea, to the sea itself, to seas, to nights of travel that rushed along on high and flew with all the stars—and it is not yet enough if one may think of all this. One must have memories of many nights of love, none of which was like the others, of the screams of women in labor, and of light, white, sleeping women in childbed, closing again. But one must also have been beside the dying, must have sat beside the dead in the room with the open window and the fitful noises. And still it is not yet enough to have memories. One must be able to forget them when they are many and one must have the great patience to wait until they come again. For it is not yet the memories themselves. Not till they have turned to blood within us, to glance and gesture, nameless and no longer to be distinguished from ourselves— not till then can it happen that in a most rare hour the first word of a verse arises in their midst and goes forth from them.
>
> Rainer Maria Rilke[150]

The Rilke Portfolio was printed by Atelier Mourlot Ltd., New York, from zinc plates. Two hundred portfolios, each containing an unsigned headpiece and twenty-three lithographs, individually signed by the artist, were printed on Richard de Bas handmade paper. In addition, seven hundred and fifty portfolios were printed on Velin d'Arches paper and numbered 201-950, each with the twenty-three lithographs signed on the plate. Ten portfolios were hors commerce.

The New Jersey State Museum's portfolio is number 197. The colophone page is signed as follows: *Ben Shahn* in red with brush, lower center, above the edition number, *197*, stamped in black. The orange-red chop is to the right of the signature.

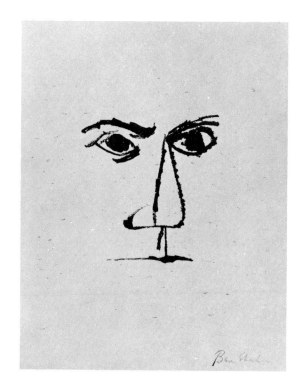

Figure 113—FRONTISPIECE (Rilke Portfolio). 1968
Lithograph in black
Sheet: 22½ x 17¾" Composition: 9¼ x 8¾"
Paper: Richard de Bas
Printer: Atelier Mourlot Ltd., New York
Edition: 200 (197)
Signature: *Ben Shahn* in red with brush lower right
Collection: New Jersey State Museum; purchase.
 Accession No: 68.192.a

Figure 114— HEADPIECE (Rilke Portfolio). 1968
Lithograph in black
Sheet: 22½ x 17⅞" Composition: 13⅛ x 11⅝"
Paper: Richard de Bas
Printer: Atelier Mourlot Ltd., New York
Edition: 200 (197)
Signature: None
Collection: New Jersey State Museum; purchase.
Accession No: 68.192.b

By eliminating entirely the outline of the head and only drawing the major features of a man's face, Shahn gave to the expressive eyes an importance which probably would have been difficult to achieve in a more complete portrait. Shahn used this same face in the 1968 lithograph *Birds Over the City* (fig. 78).

This profile, with its sense of classic dignity, is reminiscent of the profiles in the 1966 *Praise Him With Psaltery and Harp* (fig. 73) and the 1952 *Profile* (fig. 15).

The quotation, in machine lettering, introduces that portion of *The Notebooks of Malte Laurids Brigge* that Shahn was illustrating in this portfolio.

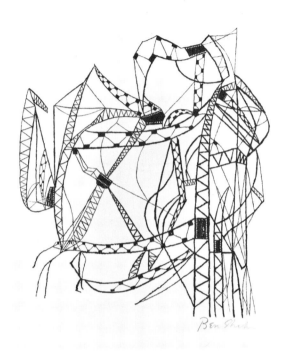

Figure 115—MANY CITIES (Rilke Portfolio). 1968
Lithograph in black
Sheet: 22½ x 17⅝" Composition: 13⅛ x 11⅝"
Paper: Richard de Bas
Printer: Atelier Mourlot Ltd., New York
Edition: 200 (197)
Signature: *Ben Shahn* in red with brush lower right
Collection: New Jersey State Museum; purchase.
 Accession No: 69.192.c

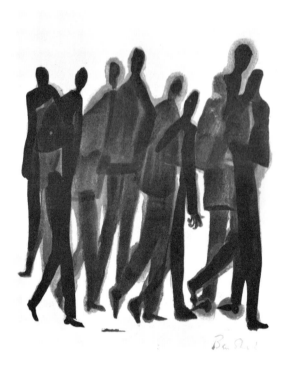

Figure 116—MANY MEN (Rilke Portfolio). 1968
Lithograph in black and gray
Sheet: 22½ x 17¾" Composition: 17⅛ x 15⅛"
Paper: Richard de Bas
Printer: Atelier Mourlot Ltd., New York
Edition: 200 (197)
Signature: *Ben Shahn* in red with brush lower right
Collection: New Jersey State Museum; purchase.
Accession No: 69.192.d

The complicated crossing and interweaving of steel girders give this composition a powerful, three-dimensional appearance. The image recalls Shahn's 1953 drawing, *Arch of Triumph*,[151] where it represents the bomb-twisted cities of World War II Europe. The image is also included as an element in Shahn's mural for the Brady High School in Brooklyn, New York.

 On the facing page are the lines:
 "For the sake of a single verse
 one must see many cities,

The anonymous group of men, tall, narrow, and faceless, their outlines blurred, automatically brings to mind the phrase coined by Shahn's contemporary, David Riesman, in the title of his book, *The Lonely Crowd*. The only sign of tension in the smoothly moving group is the one detailed hand, dark against the white background, with fingers stiffly spread.

 While Shahn did not note a connection between the drawing for this print and an earlier article,[152] to me his words seem applicable to these shadowy figures: "We are living in a time when civilization has become highly expert in the art of destroying human beings and increasingly weak in its power to give meaning to their lives."

 On the facing page, printed in Shahn's hand:
 ...men

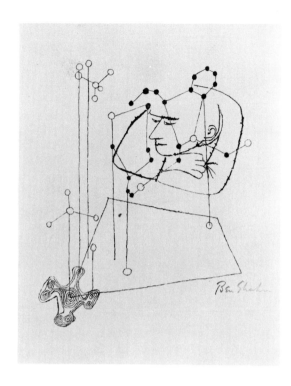

Figure 117—MANY THINGS (Rilke Portfolio). 1968
Lithograph in black
Sheet: 22½ x 17¾" Composition: 14⅝ x 13¾"
Paper: Richard de Bas
Printer: Atelier Mourlot Ltd., New York
Edition: 200 (197)
Signature: *Ben Shahn* in red with brush lower right
Collection: New Jersey State Museum; purchase.
 Accession No: 68.192.e

Figure 118—ONE MUST KNOW THE ANIMALS
(Rilke Portfolio). 1968
Lithograph in black and gray
Sheet: 22½ x 17¾" Composition: 18½ x 15⅜"
Paper: Richard de Bas
Printer: Atelier Mourlot Ltd., New York
Edition: 200 (197)
Signature: *Ben Shahn* in red with brush lower right
Collection: New Jersey State Museum; purchase.
Accession No: 68.192.f

This is a different version of the 1957 serigraph, *Scientist* (fig. 26). There, the hands are folded and the head is bowed as if in prayer. Here the scientist is resting his head on his arms and studiously contemplating the atomic model, the elements of which are more dispersed than in the serigraph.

 Printed in black, on the facing page, in Shahn's writing:
 ...and things,

Shahn knew the animals, but this lovable and humorous creature seems to have been born in the fertile soil of his imagination. It is preceded by a 1957 wash drawing of a similar beast, but there the forest is less defined and the background is barren. In this print the black details are printed over gray.

 On the facing page is written:
 ...one must know the animals,

Figure 119—HOW THE BIRDS FLY
 (Rilke Portfolio). 1968
Lithograph in colors
Sheet: 22½ x 17¾" Composition: 19½ x 16⅞"
Paper: Richard de Bas
Printer: Atelier Mourlot Ltd., New York
Edition: 200 (197)
Signature: *Ben Shahn* in red with brush lower right
Collection: New Jersey State Museum; purchase.
 Accession No: 68.192.g

Figure 120—THE GESTURES OF THE LITTLE
 FLOWERS (Rilke Portfolio). 1968
Lithograph in colors
Sheet: 22½ x 17⅝" Composition: 17 x 14⅜"
Paper: Richard de Bas
Printer: Atelier Mourlot Ltd., New York
Edition: 200 (197)
Signature: *Ben Shahn* in red with brush lower right
Collection: New Jersey State Museum; purchase.
Accession No: 68.192.h

The white bird in flight is very similar to that of the 1965 serigraph and wash, *I Think Continually of Those Who Were Truly Great* (fig. 58). In both, the body of the bird is the white of the paper surrounded by shades of gray. The gray of the serigraph is a wash, hand-applied by Shahn, but in this print the same effect is accomplished with the printer's plate. A very soft gray appears on the tail and wings causing a blurred outline as if the bird were in motion. Black is used for the eye and to darken the background. A bright orange triangle for the beak duplicates, almost exactly, the "eraser-impressed" orange beak of the bird in fig. 58.

 On the facing page:

 …one must feel how the birds fly…

Shahn's love for wild flowers was sensitively expressed in many of his works through the years. The 1959 watercolor, *Still Life with Persian Vase,*[153] is a casually arranged bouquet of flowers, much like the ones in this print. The 1946 tempera, *Spring,*[154] and the exquisite floral illustrations for Louis Untermeyer's 1964 *Love Sonnets,* are further evidence of Shahn's appreciation of living plants.

 Facing on the opposite page:

 …and know the gestures with which the
 little flowers open in the morning.

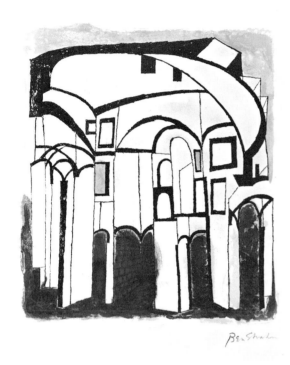

Figure 121 — TO ROADS IN UNKNOWN REGIONS
 (Rilke Portfolio). 1968
Lithograph in colors
Sheet: 22½ x 17¾" Composition: 18½ x 16¼"
Paper: Richard de Bas
Printer: Atelier Mourlot Ltd., New York
Edition: 200 (197)
Signature: *Ben Shahn* in red with brush lower right
Collection: New Jersey State Museum; purchase.
 Accession No: 68.192.i

Figure 122 — UNEXPECTED MEETINGS
(Rilke Portfolio). 1968
Lithograph in black
Sheet: 22½ x 17¾" Composition: 9⅝ x 14¾"
Paper: Richard de Bas
Printer: Atelier Mourlot Ltd., New York
Edition: 200 (197)
Signature: *Ben Shahn* in red with brush lower right
Collection: New Jersey State Museum; purchase.
Accession No: 68.192.j

Although not identical, this lithograph and the 1966 serigraph *Byzantine Memory* (fig. 66) have essentially the same architectural forms of unmistakably eastern origin. The sweep of the curved lines and the placement of windows and portals are similar. In this print, however, a dark foreground replaces the relatively open area of the serigraph with more graduated shading toward the deeper recesses; and the cloud over the structure in the serigraph has been eliminated.

The building is surrounded by a light gray color, which is also used for shading. Two windows, left and right of center, are blue, and blue is carried around the black margins of the upper part of the building.

The accompanying quotation from Rilke reads:

> One must be able to think back
> to roads in unknown regions,

Shahn wrote about his preoccupation with hands in a 1947 *Art News* article: "Hands are very important…I became fascinated with the expressiveness of hands in their many different positions, and how representative they are of people. I tend to judge people by their hands. Quite early I realized that a lot of artists shy away from drawing hands—putting them behind the back of a figure and other such ways…And I was determined to learn how to draw hands in every position."[155]

The image of hands came to Shahn's mind as an illustration of the Rilke phrase:

> …to unexpected meetings

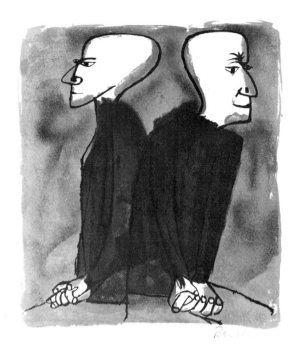

Figure 123—PARTINGS LONG SEEN COMING
 (Rilke Portfolio). 1968
Lithograph in color
Sheet: 22½ x 17¾" Composition: 18¾ x 16¼"
Paper: Richard de Bas
Printer: Atelier Mourlot Ltd., New York
Edition: 200 (197)
Signature: *Ben Shahn* in red with brush lower right
Collection: New Jersey State Museum; purchase.
 Accession No: 68.192.k

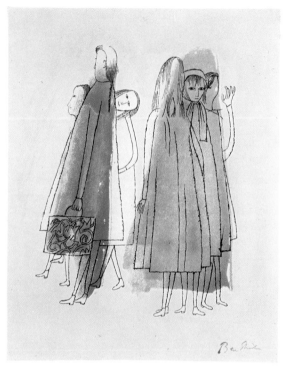

Figure 124—TO DAYS OF CHILDHOOD
(Rilke Portfolio). 1968
Lithograph in colors
Sheet: 22½ x 17¾" Composition: 17¼ x 11½"
Paper: Richard de Bas
Printer: Atelier Mourlot Ltd., New York
Edition: 200 (197)
Signature: *Ben Shahn* in red with brush lower right
Collection: New Jersey State Museum; purchase.
Accession No: 68.192.l

Judging from their expressions, the two men, seated back to back, seem to regard their parting differently. The white of the paper is used for faces and hands. The figures, outlined in black, are given solidity by shadings of gray. The background is of a lighter gray, darkened with small black dots.

Shahn used this subject in a different context in the 1957 wash drawing entitled *Priest and the Prophet*.[156]

On the facing page:

...and partings one had long seen coming;

Youthful whimsy, shyness, apprehension, and above all vulnerability are present in this touching portrayal of young maidens.

On the facing page:

...to days of childhood that are still unexplained,

110

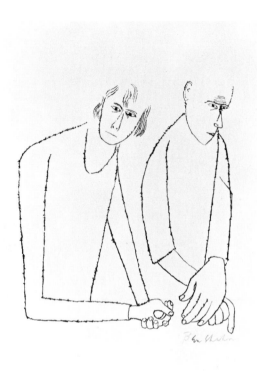

Figure 125 – TO PARENTS ONE HAD TO HURT
 (Rilke Portfolio). 1968
Lithograph in black
Sheet: 22½ x 17¾" Composition: 15¼ x 12¾"
Paper: Richard de Bas
Printer: Atelier Mourlot Ltd., New York
Edition: 200 (197)
Signature: *Ben Shahn* in red with brush lower right
Collection: New Jersey State Museum; purchase.
 Accession No: 68.192.m

Figure 126 – TO CHILDHOOD ILLNESSES
(Rilke Portfolio). 1968
Lithograph in black, gray and beige
Sheet: 22½ x 17⅞" Composition: 21 x 17"
Paper: Richard de Bas
Printer: Atelier Mourlot Ltd., New York
Edition: 200 (197)
Signature: *Ben Shahn* in red with brush lower right
Collection: New Jersey State Museum; purchase.
Accession No: 68.192.n

With extreme economy of line, Shahn has conveyed the impression of sadness in this couple, their shoulders bowed from unknown disappointments.

Coupled with the quotation from Rilke on the facing page, this is another example of Shahn's ability to merge his own art with another's, each reinforcing the other:

> ...to parents whom
> one had to hurt when they brought one
> some joy and one did not grasp it
> (it was a joy for someone else);

The little sick boy peering out of the blanket is delicately drawn and instantly appealing. The lines of hair, facial features, and the upper edge of the blanket are printed in black, contrasting sharply with the white of the paper used for the face. The blanket, pillow, and much of the sheet are colored with a very faint beige-gray, and several grays are used to shade and give depth to the area around the sickbed.

On the facing page:

> ...to childhood illnesses that so
> strangely begin with such a number
> of profound and grave transformations,

111

Figure 127 — IN ROOMS WITHDRAWN AND QUIET
 (Rilke Portfolio). 1968
Lithograph in colors
 Sheet: 22½ x 17⅞" Composition: 18¾ x 14½"
Paper: Richard de Bas
Printer: Atelier Mourlot Ltd., New York
Edition: 200 (197)
Signature: *Ben Shahn* in red with brush lower right
Collection: New Jersey State Museum; purchase.
 Accession No: 68.192.o

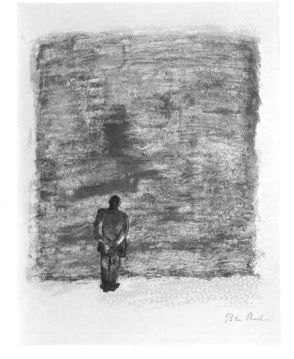

Figure 128 — MORNINGS BY THE SEA
(Rilke Portfolio). 1968
Lithograph in colors
Sheet: 22½ x 17¾" Composition: 18 x 16½"
Paper: Richard de Bas
Printer: Atelier Mourlot Ltd., New York
Edition: 200 (197)
Signature: *Ben Shahn* in red with brush lower right
Collection: New Jersey State Museum; purchase.
Accession No: 68.192.p

The youth, alone and absorbed in thought, is simply outlined and characteristic of many of Shahn's later drawings. The head is only partially portrayed and the genius Shahn displayed in eliminating portrait details is evident in the ease with which the viewer accepts his rendering.

On the facing pages are the words:

> ...to days in rooms withdrawn and
> quiet

The solitary figure, small in contrast with the huge expanse of sea, is outlined in black. The tan color of the beach extends into the sea where the overprinting of blue, green, and grays gives a lively color and heavy density to the water. Tiny dots, predominantly of green, extend well out to the margins of the paper.

The imagery of the poet and the artist seem well suited:

> ...and to mornings by the sea,

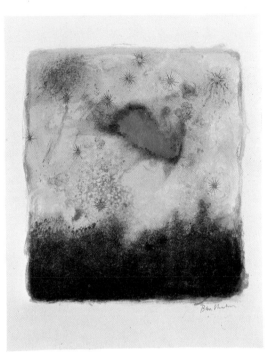

Figure 130—NIGHTS OF TRAVEL THAT FLEW WITH
THE STARS (Rilke Portfolio). 1968
Lithograph in colors
Sheet: 22½ x 17¾" Composition: 17¾ x 15¾"
Paper: Richard de Bas
Printer: Atelier Mourlot Ltd., New York
Edition: 200 (197)
Signature: *Ben Shahn* in red with brush lower right
Collection: New Jersey State Museum; purchase.
Accession No: 68.192.r

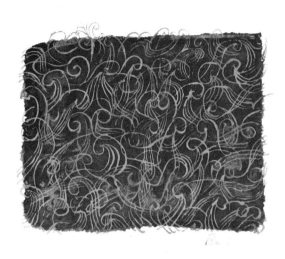

Figure 129—THE SEA ITSELF (Rilke Portfolio). 1968
Lithograph in black and blue
Sheet: 22½ x 17¾" Composition: 12¾ x 15⅝"
Paper: Richard de Bas
Printer: Atelier Mourlot Ltd., New York
Edition: 200 (197)
Signature: *Ben Shahn* in red with brush lower right
Collection: New Jersey State Museum; purchase.
 Accession No: 68.192.q

In this lithograph, several printings have resulted in a very deep black with some variation in density, which adds to the illusion of movement. The formalized blue waves, printed over the black, are reminiscent of the configurations Shahn used in such works as *Cat's Cradle* (fig. 38) and *Branches of Water or Desire* (fig. 56).

Facing, in Shahn's hand:

 …to the sea itself, to seas,

This composition is one of the few where Shahn's characteristic use of line is completely lacking.

In the deluxe portfolios (Nos. 1–200), the stars in the sky are hand-applied gold foil. This time-consuming task was carried out by Mourlot's artisans. For the remainder of the edition, the stars were given their gold color by a complicated method involving printing press and work by hand.

The brilliant blue in the sky, emerging from the gray clouds, seems to have a movement of its own, complementing Rilke's words on the facing page:

 …to nights of travel that rushed
 along on high and flew with
 all the stars—

113

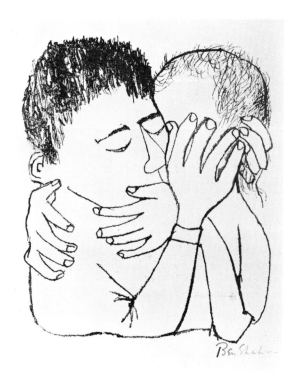

Figure 131—MEMORIES OF MANY NIGHTS OF LOVE
(Rilke Portfolio). 1968
Lithograph in black
Sheet: 22½ x 17¾" Composition: 17½ x 14½"
Paper: Richard de Bas
Printer: Atelier Mourlot Ltd., New York
Edition: 200 (197)
Signature: *Ben Shahn* in red with brush lower right
Collection: New Jersey State Museum; purchase.
 Accession No: 68.192.s

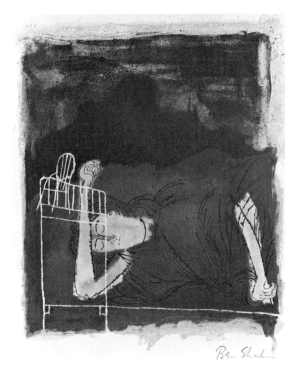

Figure 132—SCREAMS OF WOMEN IN LABOR
(Rilke Portfolio). 1968
Lithograph in black, gray and cream
Sheet; 22½ x 17⅞" Composition: 21⅛ x 17¼"
Paper: Richard de Bas
Printer: Atelier Mourlot Ltd., New York
Edition: 200 (197)
Signature: *Ben Shahn* in red with brush lower right
Collection: New Jersey State Museum; purchase.
Accession No: 68.192.t

Shahn's ability to express emotion in hands is wonderfully affirmed in this print. The hands of the lover tenderly holding the beloved's head, and her equally gentle hands, responding, are sensitive symbols of affection and intimacy. This print is closely related to a poster which Shahn did for Arthur Miller's *A View from the Bridge* (fig. 163).

 On the facing page are the lines quoted from Rilke:

> …and it is not yet enough if one
> may think of all this. One must have
> memories of many nights of love, none
> of which was like the others,

Perhaps the mood of this work more than the actual image conveys a feeling of pain. The white of the paper, used to outline the metal bed and chair, gives a stark contrast to the surrounding grays and blacks. Dark gray encloses the woman. Below the bed, the foreground is a light cream, but the walls above are grimly dark and dismal. Small dots of grays, cream, and black extend well out to the margins.

 On the facing page are Rilke's words:

> …of the screams of women in labor…

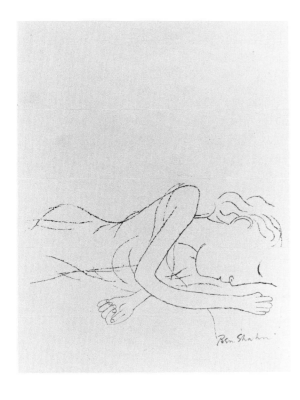

Figure 133 — OF LIGHT, WHITE SLEEPING WOMEN
 IN CHILDBED (Rilke Portfolio). 1968
Lithograph in black
Sheet: 22½ x 17⅞" Composition: 22⅛ x 17¼"
Paper: Richard de Bas
Printer: Atelier Mourlot Ltd., New York
Edition: 200 (197)
Signature: *Ben Shahn* in red with brush lower right
Collection: New Jersey State Museum; purchase.
 Accession No: 68.192.u

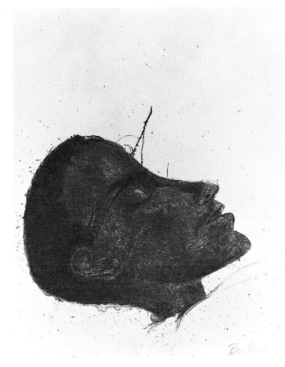

Figure 134 — BESIDE THE DYING (Rilke Portfolio). 1968
Lithograph in black and gray
Sheet: 22½ x 17⅞" Composition: 16 x 14½"
Paper: Richard de Bas
Printer: Atelier Mourlot Ltd., New York
Edition: 200 (197)
Signature: *Ben Shahn* in red with brush lower right
Collection: New Jersey State Museum; purchase.
Accession No: 68.192.v

In this print, Shahn's line, which at times could be rather biting, continues on its mellow course of this series to tenderly reveal the form of a sleeping woman. Her position, the thin arm partially framing the sparsely outlined head, is reminiscent of a child asleep, and suggests a state of complete defenselessness.

On the facing page are the words of the poet:

…and of light, white sleeping women in childbed, closing again.

This image of the sleeping woman is preceded by a 1949 illustration that Shahn produced for a brochure, *Mind in the Shadow,* which was written by Robert Strunsky and advertised a CBS television documentary on the problem of treating the mentally ill. The two reproductions differ in several details but are unmistakably of common origin. Rodman's 1951 book, *Portrait of the Artist as an American,* illustrates another version, in which the sleeping woman is being attacked by an imaginary animal.[157]

The drawings for this and the following print (fig. 135) were done by the artist at the twilight of his career. Death seems to be portrayed as the natural and accepted final link in the chain of life.

The face is predominantly gray with overprintings of gray and black for shading and outline of details. Small dots of black and gray extend to all margins.

On the facing page:

But one must also have been
beside the dying,

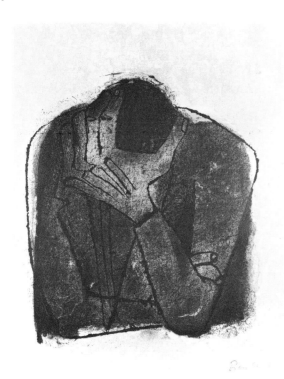

Figure 135—BESIDE THE DEAD
 (Rilke Portfolio). 1968
Lithograph in black and gray
Sheet: 22½ x 17¾" Composition: 22½ x 17¾"
Paper: Richard de Bas
Printer: Atelier Mourlot Ltd., New York
Edition: 200 (197)
Signature: *Ben Shahn* in red with brush lower right
Collection: New Jersey State Museum; purchase.
 Accession No: 68.192.w

Figure 136—THE FIRST WORD OF VERSE ARISES
(Rilke Portfolio). 1968
Lithograph in black
Sheet: 22½ x 17¾" Composition: 16⅜ x 13⅜"
Paper: Richard de Bas
Printer: Atelier Mourlot Ltd., New York
Edition: 200 (197)
Signature: *Ben Shahn* in red with brush lower right
Collection: New Jersey State Museum; purchase.
Accession No: 68.192.x

The helpless attitude of this man in deep sorrow contrasts with his size and physical strength. In this composition, Shahn again employed the hand as a major expressive component, reminiscent of his moving image in *Warsaw 1943* (fig. 54).

Black and gray give density to the figure. The outline and details are overprinted in black. Black and gray dots of color extend out to all margins.

On the facing page:

> …must have sat
> beside the dead in the room
> with the open window and the
> fitful noises.

Here the hand is seen as man's supreme tool. How fitting to end this portfolio with a drawing of the artist's hand, confident fingers in control of the brush transferring to paper the images born in his fruitful mind!

On the facing page is the last of Shahn's chosen quotations from *The Notebooks of Malte Laurids Brigge,* by Rainer Maria Rilke:

> One must be able to forget them when they are many and one must have the great patience to wait until they come again. For it is not yet the memories themselves. Not till they have turned to blood within us, to glance and gesture, nameless and no longer to be distinguished from ourselves—not till then can it happen that in a most rare hour the first word of a verse arises in their midst and goes forth from them.

PART THREE
POSTERS

Figure 137—WE DEMAND THE NATIONAL TEXTILE
 ACT (poster). 1935
Wood-engraving and letterpress in colors
Sheet: 41⅛ x 27½" Composition: 38¾ x 26⅛"
Paper: Machine-made
Printer: Globe Poster Corp., Baltimore, Maryland
Edition: Unknown
Signature: *Ben Shahn* reproduced in black lower right
Collection: New Jersey State Museum;
 Gift of Ford Motor Company. Accession No: 70.64.5

There is no previous record of this poster, which apparently was never published. In all likelihood this example is unique.

Bernarda Shahn remembers the difficulty she and Shahn had in trying to locate an old-fashioned wood-engraver to cut the blocks for this poster. Inquiries, long fruitless, finally brought forth the name of a craftsman in Baltimore who made posters in the old manner. Traveling from Washington, D.C., the Shahns found their man. Using Shahn's idea for a poster espousing the cause of textile workers, the engraver cut the blocks with superb craftsmanship.

During this period Shahn experimented with the use of old type to print messages on his posters. Here, the word "Organize," slightly undulating in the black smoke against the azure sky, commands action. The message is reinforced by the banners being paraded beneath the empty windows of a textile mill.

Figure 138—YEARS OF DUST (poster) 1936
Photo-offset in colors
Sheet: 38 x 24⅞" Composition: 35⅞ x 24"
Paper: Machine-made
Publisher: Resettlement Administration
Printer: U. S. Government Printing Office
Edition: Unknown
Signature: *Ben Shahn* reproduced in black lower right
Collection: New Jersey State Museum; gift of New Jersey State Federation
 of Women's Clubs, Junior Membership Department.
 Accession No: 70.64.9

In 1935, as a step toward a national program of rehabilitation, conservation, and land utilization, President Franklin D. Roosevelt created the Resettlement Administration. The duties of the Administration included the relocation of destitute or low-income families from rural areas who had been stranded on barren, unproductive farms. The Resettlement Administration was transferred to the Department of Agriculture in 1937, and subsequently the name was changed to the Farm Security Administration.

At the time, erosion constituted a serious threat to the livelihood of great numbers of American farmers. Blinding dust storms arose from the dry western plains of Kansas, New Mexico, Colorado, Texas, and Nebraska, carrying away millions of tons of fertile topsoil annually.

Shahn, who had joined the government sponsored Public Works of Art project in 1934, moved to the Resettlement Administration at its creation. Later he became one of a group of photographers under the direction of Roy E. Stryker, who took some 270,000 photographs for the historic archives of the Farm Security Administration. During the period 1935–38 Shahn traveled through the South and Midwest, recording with his camera what he observed of America's farmlands and small towns. He often returned to these photographs in his future work.[158]

There is no doubt that the vivid realism of this poster can be linked to the photographs Shahn took of the American scene. He poignantly preserved the ominous, dust-laden clouds overhead, the barren and drifting soil surrounding the farm buildings, and the despair of the farmer and of the members of his family, who are just barely visible in the window. The original painting for the poster, without the text, is a 1936 gouache, *Dust*.[159]

Figure 139—WEAR GOGGLES
(poster). 1937
Lithograph in colors
Sheet: 20 x 14" Composition: 19 x 12½"
Paper: Machine-made
Publisher: Resettlement Administration
Printer: U. S. Government Printing Office
Edition: Unknown
Signature: *Ben Shahn* in blue on the plate
lower right
Collection: New Jersey State Museum; purchase.
Accession No: 70.320.22

Apparently Shahn's third poster, this one has a less painterly quality than his others of the period.

Figure 140—ORGANIZE...4,000000 WORKERS
SUPPORTING YOU. (Late) 1930s.
Original painting for poster
Size: 38½ x 28½" Composition: Same
Paper: Royal crest illustrating board
Edition: Not printed
Signature: None
Collection: New Jersey State Museum; purchase.
Accession No: 70.64.2

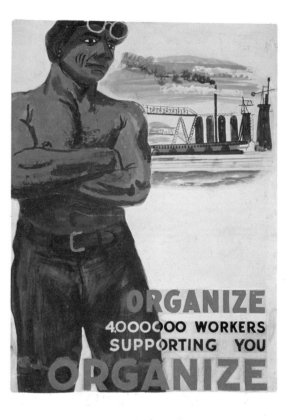

In this painting for a poster, the arms, upper torso, and head have been painted on a separate composition board, cut out, and adhered to the main painting board. The attached portion has begun to separate at the juncture below the right arm. (The unpainted surface underneath is partially visible on the reproduction as a whitish line.)

The monumental appearance of the figure in the foreground is enhanced by the portrayal of a greatly reduced and distant background. The outlines of a manufacturing plant with its billowing smoke stack look rather insignificant compared to the strong and confident-looking worker.

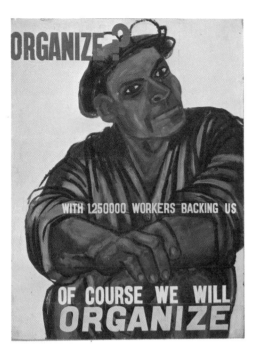

Figure 141—ORGANIZE? WITH
1,250000 WORKERS BACKING
US. (Late) 1930s
Original painting for poster
Size: 40 x 29⅞"
Composition: Same
Paper: Royal crest illustrating board
Edition: Not printed
Signature: None
Collection: New Jersey State Museum;
purchase. Accession No: 70.64.4

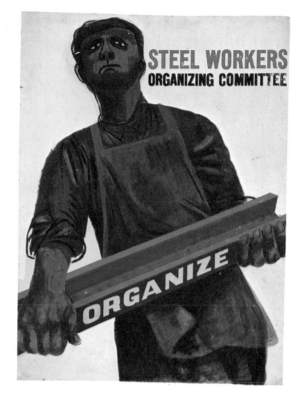

Figure 142—STEEL WORKERS
ORGANIZING COMMITTEE.
(Late) 1930s
Original painting for poster
Size: 40 x 29⅞"
Composition: Same
Paper: Royal crest illustrating board
Edition: Not printed
Signature: None
Collection: New Jersey State Museum;
purchase. Accession No: 70.64.3

In the preceding poster painting (see fig. 140) Shahn directed some attention to the area behind the figure. In this one, however, and in the one that follows (see fig. 142), the background is left clear. All three paintings in the series make a forthright and instant impression, a basic requirement for poster art. Also, in each, the worker has been given a particular sense of alertness by the white applied to the eyes around the irises.

Shahn was capable of a great range of expression in his treatment of hands. Here they are dominant and indicative of the worker's strength. One, however, is partially obscured by the text. The protective glasses are not made a point of interest in this poster, as they are in the later portrayal of welders (see figs. 147 and 148).

This is the third of three original poster paintings (see figs. 140 and 141) that Shahn designed to further union organizing activities. All three feature a strongly masculine worker, exuding an air of confidence, and in all three the message is "organize." None, however, were printed as posters. Bernarda Shahn recalls that at the time there was a great deal of vertical and lateral reorganization within the unions, and that these posters were rejected by one high union leader because the faces and figures were "too ugly to appeal to workers."

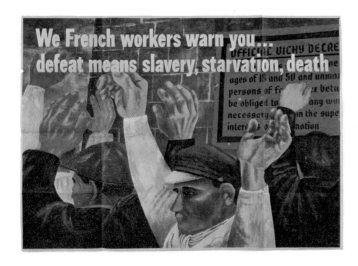

Figure 143—WE FRENCH WORKERS WARN YOU
 (poster). 1942
Photo-offset in colors
Sheet: 28¼ x 39¾" Composition: 27½ x 39¼"
Paper: Machine-made
Publisher: War Production Headquarters, WPB,
 Washington, D.C. Poster A-25
Printer: U. S. Government Printing Office
Edition: Unknown
Signature: *Ben Shahn,* reproduced in red lower right
Collection: New Jersey State Museum; gift of Circle F.
 Accession No: 70.320.24

We French Workers Warn You is Shahn's first war poster. He had been invited to work in the Office of War Information under William Golden with whom he later collaborated at CBS (see *Silent Music,* fig. 11; *Supermarket,* fig. 28; *Wheat Field,* fig. 35; and *The Eagle's Brood,* fig. 238). Shahn recalled his early working relationship with Golden, and in particular the evolution of this poster, in an essay titled "Bill":

> Our first round concerned a war poster. We sat together through a session or two and discussed what a war poster ought to be. It must be neither tricky nor smart. Agreed. The objective is too serious for smartness. It has to have dignity, grimness, urgency. Agreed. It has to be unblinkingly serious; agreed. We then began to suggest, discard, work toward specific image ideas. We agreed upon such an image idea and I undertook it at home over a weekend. I felt its urgency and did not want to undertake it in the unresolved atmosphere of the OWI studio.
>
> Once I had begun to put our poster idea into image form, I became acutely aware of fallacies in it that would never have emerged in a simple conversation. I played around a little with the idea, then came up with a new one, totally different, that was visual and not verbal. It was ultimately known as the *French Workers* poster.
>
> Bill's reaction to what I had created was apoplectic. It wasn't what we had talked about or what we had agreed upon....I think that Bill and I solidified our graphic futures more through that impasse than through any subsequent single experience. What I learned was a hardened determination to put the integrity of an image first and above all other considerations; one must be prepared to retire from any job whatever…rather than abandon the clear vision….
>
> He [Bill Golden] went into the Army; I remained with the OWI….He often visited me and my family. We found ourselves in deepest agreement politically, personally, and in art and food. We talked about *everything under the sun* except the *French Workers* poster which…had been produced and was being sought considerably by collectors.[160]

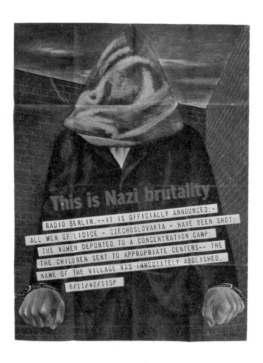

Figure 144 — THIS IS NAZI BRUTALITY
 (poster). 1942
Photo-offset in color
Sheet: 37⅞ x 28¼" Composition: Same
Paper: Machine-made
Publisher: U. S. Office of War Information,
 Washington, D.C.
Printer: U. S. Government Printing Office
Edition: Unknown
Signature: *Ben Shahn* reproduced in black lower right
Collection: New Jersey State Museum; gift of *The Record,*
 Hackensack, N. J. Accession No: 70.320.25

The enormity of the Nazi crime against the citizens of Lidice, Czechoslovakia, was made known to the peoples of the world by official German announcement on June 11, 1942, the very day of the destruction of the village. The Germans had suspected that some of the inhabitants had been involved in the killing of the German Police General and Reichsprotektor for Bohemia and Moravia. The announcement stated that all male inhabitants, irrespective of age, and fifty-six women had been executed immediately. The rest of the women had been put into concentration camps and the children carried off to correction schools. All buildings had been leveled to the ground and the name of the village abolished.

Shahn let the chilling and brazen announcement tell its own story of inhumanity by printing it as if it were a ticker tape. The hooded prisoner, cornered and chained, has no means of escape from the finality of the horrifying message. The small section of blue sky above is dark and ominous and adds to the atmosphere of doom.

But this unforgettable portrayal of a great tragedy was too vivid. According to Rodman, Shahn was shocked when he found that the forty thousand copies ordered for distribution by a Czechoslovakian-American organization had been cancelled by a civilian morale expert on the grounds that the message was too violent.[161]

This poster and *We French Workers Warn You* (fig. 143) were issued during the eleven months Shahn spent with the Office of War Information. Many of his rejected poster designs were later used by the CIO Political Action Committee in their voter registration campaigns.

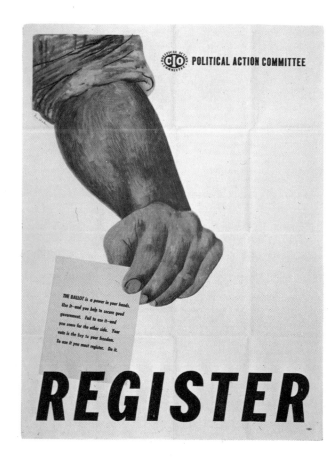

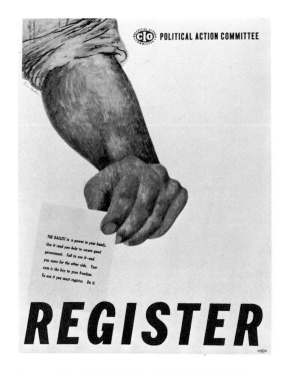

Figure 145—REGISTER...THE BALLOT IS A POWER
IN YOUR HANDS (poster). 1944
Photo-offset in colors
Sheet: 39¾ x 29⅞" Composition: 36¾ x 26¾"
Paper: Machine-made
Publisher: CIO Political Action Committee
Edition: 12,500
Signature: *Ben Shahn* reproduced in gray upper left
Collection: New Jersey State Museum; gift of Public
 Service Electric and Gas Company.
 Accession No: 70.64.10

Figure 146—REGISTER...THE BALLOT IS A
POWER IN YOUR HANDS (variant poster). 1944
Photo-offset in colors
Sheet: 19⅞ x 14⅞" Composition: 18⅜ x 13¾"
Paper: Machine-made
Publisher: CIO Political Action Committee
Edition: 2,500
Signature: *Ben Shahn* reproduced in black upper left
Collection: New Jersey State Museum; gift of Public
 Service Electric and Gas Company.
 Accession No: 70.320.14

In the fall of 1943, the CIO established the Political Action Committee and authorized it to conduct a broad and intensive program of education aimed at mobilizing CIO members as well as members of other unions for the purpose of effective labor action on the political front. The goal was to protect the political rights of the working man, the returning service man, the farmer, and the small-business man.

The committee was much concerned with the 1944 national elections, and in March, 1944, it started a nation-wide drive to register voters—particularly CIO members and their families. The Great Depression was over and labor had made many gains. But now it was felt that union members and other workers, while toiling to support the war effort, were apathetic about exercising their citizenly right to vote.

It was this complacency among the workers that the Political Action Committee was fighting against, using posters like this one to get the message across. Shahn's succinct, visual statement is superb. The foreshortened muscular arm with its powerful worker's hand combines with the message to make a compelling command for action.

This is a reduced version of the previous poster of the same title (see fig. 145). The signature is in black here instead of gray as in the large poster.

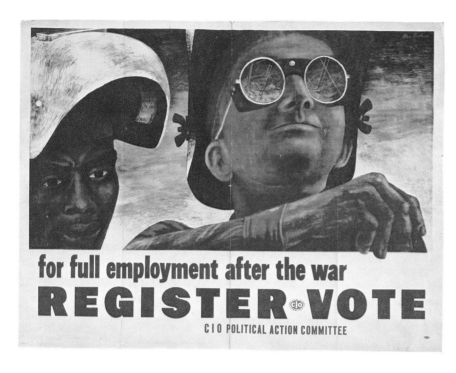

for full employment after the war
REGISTER·VOTE
CIO POLITICAL ACTION COMMITTEE

Figure 147—WELDERS, or, FOR FULL EMPLOYMENT AFTER THE WAR (poster). 1944
Lithograph in colors
Sheet: 29¾ x 39⅜" Composition: 27⅜ x 37⅜" Paper: Machine-made
Publisher: CIO Political Action Committee Edition: 17,750
Signature: *Ben Shahn* reproduced in blue upper right
Collection: New Jersey State Museum; gift of Circle F. Accession No: 70.64.13

Welders was one of the posters Shahn designed while working for the U.S. Office of War Information. It was originally meant to serve the cause of anti-discrimination, but was rejected by the OWI as not suitable for mass-communication. Rodman points out that when *Welders* was subsequently issued by the CIO's Political Action Committee as a poster for the 1944 presidential campaign, it was well received and was reproduced in the press, with the result that it eventually reached some twenty-five million people. Shahn had produced a poster which transformed an everyday scene into a "conception far beyond the OWI's propaganda for unity in the shipyards or the CIO's 'Register and Vote!' "[162]

Many of the poster designs rejected by the OWI, and several new ones, were later reproduced by the Political Action Committee for use in the CIO's voter-registration campaign. In his work for the Committee, Shahn found that he could put to use his ideas as well as his extensive knowledge of the technical aspects of the graphic field. Working with a small staff, he was happy with what was accomplished. However, James Grunbaum, one of Shahn's staff assistants, recalls that not all of the top labor leaders were pleased with what they considered to be "the militancy" of Shahn's posters. He suggests that their displeasure was the reason why stacks of posters were later found unused in union headquarters.[163]

Figure 148 — WELDER (poster proof). 1944
Lithograph in colors
Sheet: 20 x 27¼" Composition: 18⅝ x 18"
Paper: Machine-made
Edition: Unknown
Signature: *Ben Shahn* in blue on the plate upper right
Collection: New Jersey State Museum; gift of Circle F. Accession No: 70.320.27

This poster proof is a reduced and reworked version of the right half of the larger *Welders* (fig. 147). It may have been tried and rejected as a smaller poster. On the other hand, there is a record of a smaller poster, printed and distributed in an edition of 2,500, and it may be an impression pulled in preparation for that printing. There are no copies known to me of the smaller edition.

The worker's protective goggles are used with great effect in both this and the preceding poster, reflecting the blue of the sky and the outlines of what appears to be metal girders. These lines, in somewhat subdued red in fig. 147, are accented here with white.

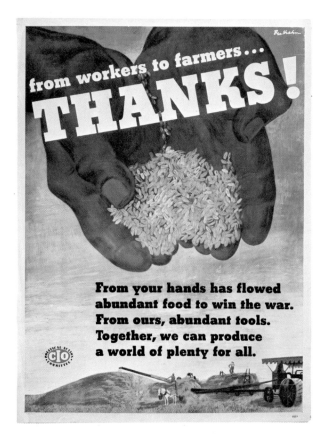

Figure 149—FROM WORKERS TO FARMERS…THANKS!
 (poster). 1944
Photo-offset in colors
Sheet: 39½ x 29¾" Composition: 37¾ x 28"
Paper: Machine-made
Publisher: CIO Political Action Committee
Edition: 20,000
Signature: *Ben Shahn* reproduced in white upper right
Collection: New Jersey State Museum; gift of Mr. and Mrs. Maurice
 Rosenthal. Accession No: 70.64.7

Figure 150—HERE THERE IS NO POLL TAX (poster). 1944
Lithograph in black and maroon
Sheet: 43½ x 27½" Composition: 41¾ x 27¼"
Paper: Machine-made
Publisher: CIO Political Action Committee
Edition: 3,000
Signature: *B.S.* in white on the plate lower right corner of box
Collection: New Jersey State Museum; purchase.
Accession No: 70.64.14

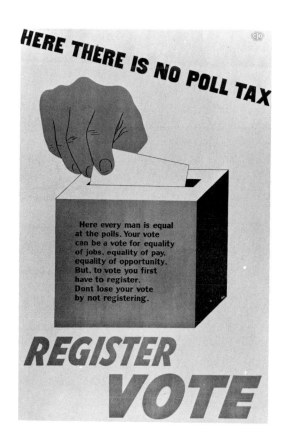

In words and images this poster transmits the desire of the CIO to stress the common bond between worker and farmer as a means of achieving united political action. This poster was designed for display in farmers' union headquarters and in CIO booths at county fairs. The former governor of Minnesota, Elmer A. Benson, referred to it as "one of the finest, strongest, and most effective gestures in the direction of goodwill made by labor toward farmers."[164]

The exhortative message in this poster calls to the citizen's attention his privilege and duty as a member of a democracy—to register and to vote.

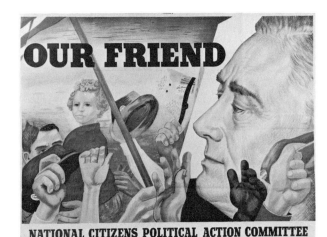

Figure 151—OUR FRIEND (poster). 1944
Lithograph in colors
Sheet: 30 x 39¾" Composition: 28¼ x 38⅞"
Paper: Machine-made
Publisher: National Citizens Political Action Committee
Edition: 31,250
Signature: *Ben Shahn* in brown on the plate lower left
Collection: New Jersey State Museum; gift of Mr. and Mrs.
 R. George Kuser. Accession No: 70.64.8

This poster was used in the hotly contested 1944 campaign in support of Franklin D. Roosevelt's fourth term. Shahn presented Roosevelt as a warmly sympathetic man, whose visage looms father-like above the crowd. Shahn surely must have wrestled with the problem of what to include in the design to support the Roosevelt image. As one examines the poster one is amazed at the number of symbols included in the composition: buttons for the AFL and the CIO, hat tickets for the Grand Lodge and the National Farm Bureau, a soldier's hat, the hands of the black and white races, the red and white stripes of the flag, and a child symbolizing the nation's future. The blue sky above is un-doubtedly meant to be a good omen.

One thousand copies of this popular poster were also reproduced for use on billboards throughout the country (see fig. 151a) and Shahn greatly enjoyed the displays.

Bernarda Shahn recalls that for the printing of *Our Friend* Shahn left the original painting with an experienced lithographer, giving such instructions as he deemed necessary. Curiously, Shahn's early years as a lithographer's apprentice had not prepared him for the changes which he subsequently found on the printed posters. He was amazed to discover that many of the details had been "improved" by the craftsman, who had detected "flaws" in Shahn's original. Thus fingers "brought up to standard" resulted in hands not entirely typical of Shahn, with such "improvements" as soft curving which Shahn regarded as lifeless. However, he considered the changes a joke on himself and refused to have the posters reprinted.

Figure 151a—OUR FRIEND
(Billboard photograph). 1944
Collection: Bernarda Bryson Shahn

To my knowledge, there are no existing copies of the billboard version of Shahn's poster, *Our Friend* (fig. 151). As a permanent record this photograph is reproduced here with Mrs. Shahn's kind permission.

Approximately five hundred billboard copies were printed as twenty-four sheet poster sections and five hundred more in an unknown sheet size.

Bernarda Shahn fondly remembers that her husband used their son, Jonathan, as the model for the curly headed youth on the soldier's arm. This photograph, from Mrs. Shahn's family collection, was taken by Shahn as three of his children, Jonathan, Susanna, and Abby, posed and giggled in front of the poster. The likeness of Jonathan to the poster child is quite obvious.

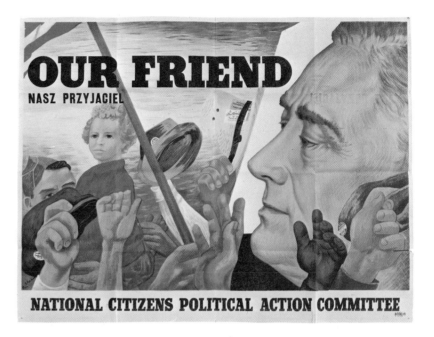

Figure 152—OUR FRIEND NASZ PRZYJACIEL (poster). 1944
Lithograph in colors
Sheet: 29⅞ x 39¾" Composition: 28¼ x 38⅞"
Paper: Machine-made
Publisher: CIO Political Action Committee
Edition: Unknown
Signature: *Ben Shahn* in brown on the plate lower left
Collection: New Jersey State Museum; purchase. Accession No: 70.320.26

Presumably this variation of *Our Friend* (fig. 151), with a Polish translation printed under the English text, was made for use in meeting halls in those sections of the country with large numbers of Polish workers. There is no record of other foreign language editions printed.

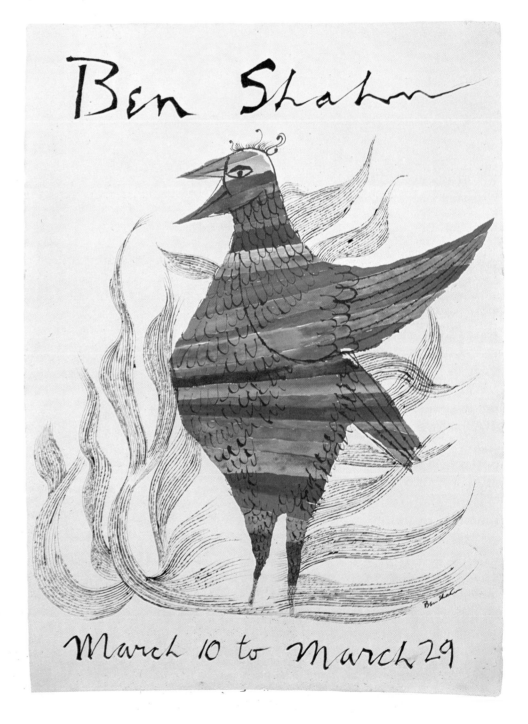

Bernarda Shahn recalls that this poster, which Shahn made for his 1944 one-man exhibition at the Downtown Gallery, was the first of the *Phoenix* series (figs. 13, 14, 85, and 165). The 1952 hand-colored serigraph *Phoenix* (fig. 14) is so faithful to this original as to seem identical. Shahn must have cherished the thought of having this symbol of renewed life announce his exhibition, for he used it again, thirteen years later, as a poster (*see* fig. 165) for his 1956 exhibition at the Fogg Art Museum. Judged by the formalized flames, which relate to the 1948 Hickman story, the author would be inclined to give this poster painting a somewhat later date.

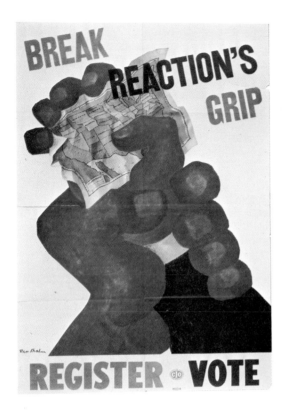

Figure 154—BREAK REACTION'S GRIP (poster).
 1946
Photo-offset in colors
Sheet: 41¼ x 29" Composition: 40⅞ x 28"
Paper: Machine-made
Publisher: CIO Political Action Committee
Edition: Unknown
Signature: *Ben Shahn* reproduced in black lower left
Collection: New Jersey State Museum; purchase.
 Accession No: 70.64.11

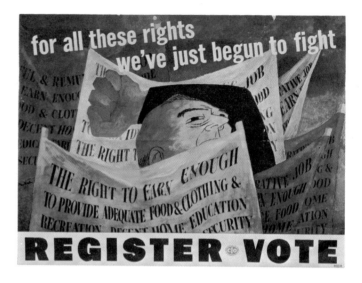

Figure 155—FOR ALL THESE RIGHTS WE'VE JUST BEGUN TO
 FIGHT (poster). 1946
Lithograph in colors
Sheet: 28⅞ x 38¼" Composition: 28¼ x 38¾"
Paper: Machine-made
Publisher: CIO Political Action Committee
Edition: Unknown
Signature: *Ben Shahn* reproduced in black lower center left
Collection: New Jersey State Museum; gift of Mr. and Mrs. Michael
 Lewis. Accession No: 69.156

The one arm, dressed in coat sleeve and shirt cuff, with hand clasping a colorful map of the United States, represents the country's supposedly small but powerful, reactionary forces. The poster suggests that, however strong, their power could be broken by the greater strength of the progressive forces, as represented by the larger, sleeveless arm. The command "Register…Vote" directs the way to remedial action.

The militant posture of the orator in this poster attests to the CIO's championing of the various workers' rights, which are enumerated on the colorful banners. This demonstration of union activity on behalf of the workers is coupled with the exhortative message "Register…Vote," which is repeated on all the CIO posters of this series. According to Bernarda Shahn, the title is from a campaign speech of Franklin D. Roosevelt.

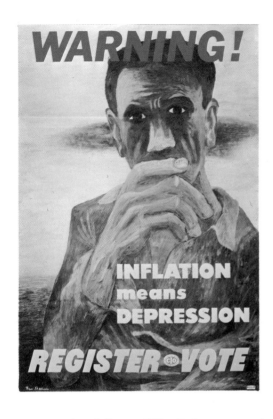

Figure 156 — WARNING! INFLATION MEANS DEPRESSION (poster). 1946
Photo-offset in colors
Sheet: 41⅛ x 27¾" Composition: Same
Paper: Machine-made
Publisher: CIO Political Action Committee
Edition: Unknown
Signature: *Ben Shahn* reproduced in white lower left
Collection: New Jersey State Museum; gift of McGraw-Hill. Accession No: 70.64.12

Figure 157 — WE WANT PEACE (poster). 1946
Lithograph in colors
Sheet: 41⅜ x 26⅞" Composition: Same
Paper: Machine-made
Publisher: CIO Political Action Committee
Edition: Unknown
Signature: *Ben Shahn* reproduced in black lower right
Collection: New Jersey State Museum; purchase. Accession No: 70.320.30

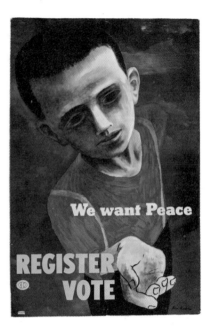

The antecedent work of this poster is a 1943 tempera, *1943 A.D.*[165] According to Bernarda Shahn, her husband did the painting during his stay in the Office of War Information, basing his work on a photograph he had taken in the thirties while traveling through the hills of Arkansas. The photograph was of a farmer, whose seeming integrity and strength greatly impressed Shahn. Engaging his subject in conversation, Shahn found out that the farmer estimated the value of his crop at one dollar and fifty cents. The farmer in the meantime had sent out his two boys with a shotgun and two shells to hunt for their dinner. Before long they returned with two squirrels.

In the poster, the blue-shirted worker, chin in hand, seems fearful and confused. The appealingly simple proposition, "*a equals b,* therefore do *c,*" was presented by Shahn as "Inflation equals Depression, therefore Register and Vote." However, the image of this troubled man lingers with the viewer and takes on a meaning far beyond the intent of the poster message. His facial expression suggests even deeper anxieties, which may be explained by the fact that the painted image first originated during a period in Shahn's life when the cruelties of the Second World War were foremost in his mind.

The painting, *Hunger,* from which this poster derives, was painted and rejected during Shahn's sojourn with the Office of War Information. Later used by the CIO in a voter registration drive, it represents, perhaps, the best of Shahn's poster work. One cannot soon erase the memory of the hollow-eyed young face begging for peace. Nowhere is Shahn's genius for drawing more evident than in the thrust of the pleading hand. Its sickly pallor, matching that of the face and emphasized by the dark surrounding hues, tells of cruel deprivation and suffering.

The hungry looks and outstretched hands of children had regrettably become a familiar sight to our nation's soldiers, who were returning to their homes in the year that this poster was issued. Although peace was a reality to them, there was no peace for the needy children.

Using the image of this child in the context of an election campaign seems to say that in a democracy the first step toward healing the ravages of war is to exercise one's right to vote.

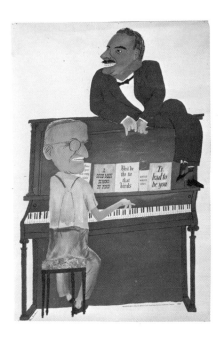

Figure 158—A GOOD MAN IS HARD TO FIND (poster).
1948
Lithograph in colors
Sheet: 43⅝ x 29¾" Composition: 42¾ x 27¾"
Paper: Machine-made
Publisher: Progressive Party, New York City
Edition: Unknown
Signature: *Ben Shahn* in brown on the plate lower left
Collection: New Jersey State Museum; gift of New Jersey
 Junior and Community College Association. Accession
 No: 70.64.6

In describing the 1948 watercolor, *Truman and Dewey*, which is the prototype of this poster, Soby's words are much to the point:

> A large percentage of Shahn's graphic works…portrays the human figure, with or without those inanimate accessories among which musical instruments play a role second only to architecture. The emotional and stylistic range of his drawings and watercolors of human subjects is altogether exceptional, alternating between caricatural humor and reflective solemnity. To the former category belongs the unforgettable cartoon of Truman and Dewey, executed during the political campaign of 1948. The two candidates, on whom Shahn obviously looked with equal suspicion, are ingeniously placed, Dewey atop a piano and Truman at its keyboard, before sheets of music whose titles are a vital part of the artist's satirical message and whose varied styles of printing attest to Shahn's lifelong interest in typographical matters. Details are handled with remarkable acuteness: the strained cordiality of Dewey's smile, for example; the wrinkles in Truman's trousers and the amateurish flourish with which his right hand strikes a chord; the definition of both candidates' feet. Yet distortions and elisions are just as important, as in the aggrandizement of the two politicians' heads and the subtle way in which Truman's *eyeglasses* are left blank and the teeth of both men are frozen in bright evenness. This is an image intended to provoke laughter regardless of one's political convictions. I suspect it will take its place among the most effective caricatures of recent times.[166]

Another 1948 watercolor, *Hot Piano*,[167] featuring a very similar image of Truman alone at the piano, is in the collection of the Harry S. Truman Library, a gift from Governor Nelson Rockefeller to the former President of the United States. There is no sheet music in the watercolor and the piano is merely suggested.

In 1947, while discussing politics and the coming election, Shahn remarked that "some work is going to have to be done about it."[168] His intent was to present the two major parties as indistinguishable, with only the Progressive Party offering the voters a bid for change. It is difficult to estimate the effect of his contribution to the Progressive Party's candidate, or indeed to the election itself. Yet, the watercolors and the posters continue to delight students of art and history.

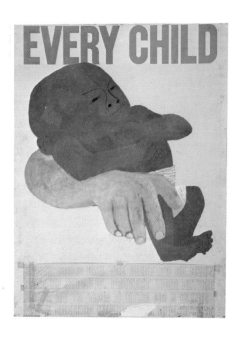

Figure 159 — EVERY CHILD. 1948–53
Original painting for poster
Size: 39⅞ x 29⅞" Composition: same
Paper: Bainbridge Board No. 80
Edition: Not printed
Signature: None
Collection: New Jersey State Museum; purchase. Accession No: 70.64.1

Figure 160 — LET YOUR HELP MATCH HIS COURAGE. 1949
Original painting; tempera on paper over composition board
Edition: Not printed
Size: 46 x 30" Composition: Same
Signature: *Ben Shahn* with brush upper right
Collection: The Museum of Modern Art, New York; gift of the National
Foundation for Infantile Paralysis. Accession No: Study collection of the
Painting and Sculpture Department

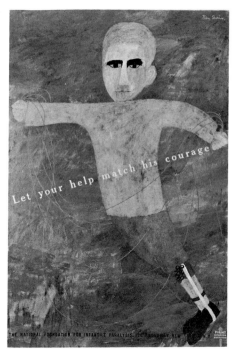

About 1948, according to Professor Erik Barnouw, Columbia University contracted with the U.S. Public Health Service to produce a series of radio programs on syphilis, followed by films, posters, and juke box records to be sold to state and local health departments for regional campaigns. In a letter to the author, Professor Barnouw recalls Shahn's association with the project:

> As supervisor of this activity, I discussed it with Ben Shahn, who at once said he would be delighted to do a poster. The arrangement he suggested was extraordinarily generous. He named a very low price (I forget the exact amount) and said: "If you can use it, you pay me. If not, you pay me nothing, and the poster remains mine." Unfortunately, public health officials found it abhorrent. None wanted to use it, and it never went into distribution. Shahn then published it in an annual. As I recall, the caption identified it as a poster "rejected by Columbia University." It looked beautiful.

The phrase lettered on the poster "Every child has a right…" and the jarring visual impact of the helpless baby certainly would command attention even today.

Shahn's poster was one of twenty-two commissioned by The National Foundation for Infantile Paralysis (now The National Foundation — March of Dimes) and The Museum of Modern Art. The illustration here is taken from a photograph, through the courtesy of the foundation.

The invited group of artists were given statistical data regarding the disease, were instructed as to the size of the poster and the name and symbol to be included, and were advised to stress such things as recovery, research, and the need for financial aid. In other matters they could range freely in their designs.

Shahn's poster of a young boy skipping rope, his one leg tightly laced and braced, was not an award winner and consequently not reproduced as a poster. Reviewer Aline B. Louchheim, in the November 6, 1949, Sunday issue of *The New York Times,* took no special note of Shahn's painting. To her, the photographic entries were the most successful.

Figure 161 — THE WORLD OF SHOLOM
 ALEICHEM (poster). 1953
Photo-offset in black and white on blue
Sheet: 23⅛ x 8¾" Composition: 21¼ x 7⅛"
Paper: Machine-made
Edition: Unknown
Signature: *Ben Shahn* reproduced in black lower
 right verso
Collection: New Jersey State Museum; gift of
 Bernarda Bryson Shahn. Accession No: 71.84.1

Figure 162 — PAVILLON VENDOME
(poster). 1954
Photo-offset in colors
Sheet: 25¼ x 17½" Composition: 24⅝ x 16¾"
Paper: Machine-made
Printer: Les Presses Artistiques
Edition: unknown
Signature: none
Collection: New Jersey State Museum; purchase.
Accession No: 70.64.22

This poster, advertising Arnold Pearl's English-language dramatization of Sholom Aleichem's writings, includes drawings Shahn made to illustrate a 1953 booklet, *The World of Sholom Aleichem.* The booklet provides an introduction to the work of this Russian-born, Yiddish humorist by Aleichem's son-in-law, B. Z. Goldberg, together with Goldberg's assessment of Pearl's dramatization.

Aleichem, whose real name was Solomon J. Rabinowitz, taught his people to look at the ridiculous side of tragedy and to make the walls of Jericho tumble with their laughter. "The world of Sholom Aleichem is physically no more," writes Goldberg. "It was swept off the face of the earth by war and revolution. But people never die. They go on, generation to generation, only slightly disarranged by the winds of time. So the world of Sholom Aleichem is still with us."[169]

The building in this poster is obviously related to the two 1953 serigraphs *Paterson* (figs. 18 and 19) and interestingly combines elements of both. It appears that here Shahn applied color to a version of the black and white *Paterson* (fig. 18).

Figure 163—A VIEW FROM THE BRIDGE (poster). 1955
Photo-offset in colors
Sheet: 21½ x 13⅝" Composition: 20⅞ x 13"
Paper: Cardboard
Printer: Artcraft Lithography and Printing Co., New York
Edition: unknown
Signature: *Ben Shahn* reproduced in black lower center right
Collection: New Jersey State Museum; gift of Circle F. Accession
 No: 70.320.16

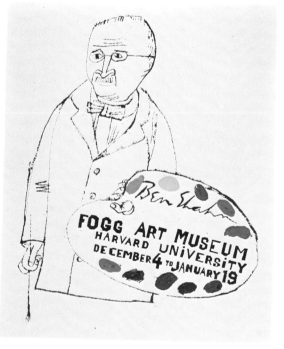

Figure 164—BEN SHAHN FOGG ART MUSEUM (poster). 1956
Photo-offset in black with hand coloring
Sheet: 11 x 9" Composition: 7⅞ x 6⅜"
Paper: Machine-made
Edition: Unknown
Signature: *Ben Shahn* reproduced in black on the palette, center
Collection: New Jersey State Museum; gift of the Fogg Art
Museum. Accession No: 70.187

The central figures in this poster closely resemble the tender couple in the 1968 lithograph *Memories of many nights of love* (fig. 131) in the Rilke Portfolio. However, the two are clearly taken from different drawings. Here again is an example of how Shahn convincingly reused favored images in different contexts.

The lettering of the play's title illustrates the integral role Shahn's calligraphy played in many of his compositions, particularly as contrasted with the dull perfection of the machine-lettered message below.

This poster depicting the artist was issued in connection with the Fogg Art Museum's exhibition "The Art of Ben Shahn," a major exhibition of forty-nine paintings, nineteen drawings, eleven prints, three Christmas cards, and five posters, that was arranged during Shahn's term (1956–57) as a Charles Eliot Norton Professor at Harvard University.

One of the men who helped mount the show, George Cohen, recently recalled that it was "an exacting job," particularly in regards to preparing the posters. The printed portion included the circles on the palette, to which Shahn, Cohen, and others later applied the gouache colors by hand. This helps to explain the slight color variations between different examples of the poster.

Although this copy is not signed, Shahn did personally inscribe other copies, which he presented to friends. The author's signed copy reads "for Ken/Ben Shahn."

A similar image of the artist was once used on the cover of a Downtown Gallery exhibition catalogue.[170]

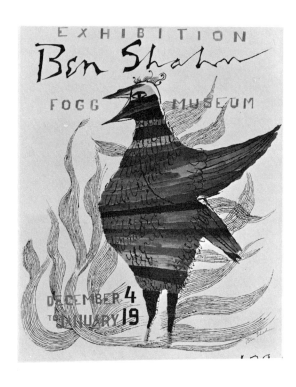

Figure 165 — BEN SHAHN FOGG MUSEUM (poster). 1956
Serigraph in black with hand coloring and hand lettering
Paper: Illustration board
Sheet: 27⅝ x 22¼" Composition: 26⅛ x 21½"
Edition: Presumed to be unique
Signature: *Ben Shahn* in red with brush lower right and *Ben Shahn* in black
 with brush across top
Collection: Fogg Art Museum, Harvard University; gift of Ben Shahn.
 Accession No: M13,334

Figure 166 — LIEBESLIEDER FÜR DAS ANDERE AMERIKA
(poster). c.1956
Serigraph in black and red
Sheet: 34 x 16⅝" Composition: 30⅜ x 15¾"
Paper: Machine-made
Edition: Unknown
Signature: *Ben Shahn* in black on the screen lower right
Collection: New Jersey State Museum; purchase.
Accession No: 70.320.23

For this 1956 Fogg Art Museum exhibition poster, Shahn made a black serigraphic printing of the *Phoenix* (fig. 13) on poster board and hand-colored it, following very closely the 1944 original poster painting, *Ben Shahn March 10 to March 29* (fig. 153) and the later, 1952 serigraph *Phoenix* (fig. 14). "Ben Shahn," brushed across the top, is in black, as are the two numbers "4" and "19." The rest of the hand lettering is in raw umber. The reason for the partial black letters or numbers at the lower right margin is unknown.

Following the exhibition, Shahn presented this original poster to the Fogg Museum along with eight of his rare and early posters.

The exact image of this lean, barefoot boy was reproduced in James Thrall Soby's *Ben Shahn His Graphic Art* and was attributed to a drawing commissioned by Edward R. Murrow and Fred W. Friendly of the Columbia Broadcasting System for the 1956 film *Ambassador Satchmo*.[171] Any connection between this poster and the film, and indeed, the reason for the German title, are unknown to me.

The two lines of text (in English, "Lovesongs for the Other America") are printed in red over the black.

EXHIBIT-JEROME ROBBINS "BALLETS U.S.A."-U.S.I.S. GALLERY 41 GROSVENOR SO. LONDON W.1. SEPT. 15-OCT. 23. 1959

Figure 167—BALLETS U.S.A. (poster). 1959
Serigraph in colors
Sheet: 31⅜ x 21⅜" Composition: 30¼ x 21⅜"
Paper: Machine-made
Edition: Unknown
Signature: *Ben Shahn* in black on the screen lower right
Collection: New Jersey State Museum; gift of U.S. Embassy, London,
 England. Accession No: 70.225.1

Figure 168—BEN SHAHN SERIGRAFIE E XILOGRAFIE (poster). 1959
Photo-offset in black and sepia
Sheet: 12⅜ x 8½" Composition: 10¾ x 4⅞"
Paper: Machine-made
Edition: Unknown
Signature: *Ben Shahn* reproduced in sepia lower right
Collection: New Jersey State Museum; gift of Bernarda Bryson Shahn.
Accession No: 71.84.2

Memories of the colorful dye patterns in the windows of Paterson, N.J., (see fig. 19) lingered on with Shahn and were a frequent source of new and vibrant inspirations. In this poster the pulsating pigments parading behind the bold, black letters communicate a sense of the vital energy of a ballet performance.

This poster announced a photographic exhibition arranged by the United States Information Service to tell the story of the U.S. ballet.

This 1959 poster is a reduced reproduction of a signed 1952 serigraph, *Profile*. The chop signature, found on the New Jersey State Museum's copy of *Profile* (fig. 16), was not on the serigraph from which this poster was made.

Profile was one of the sixteen prints in an exhibition of Shahn's work given in Rome in 1959. The works are listed on the reverse side of this poster along with other pertinent information.

Figure 169—FREDA MILLER MEMORIAL CONCERT
 (poster). 1960s
Letterpress in black
Sheet: 18⅜ x 12⅜" Composition: 15 x 10⅜"
Paper: Sunray Ingres
Edition: Unknown
Signature: *Ben Shahn* reproduced in black lower right
Collection: New Jersey State Museum; purchase.
 Accession No: 70.320.15

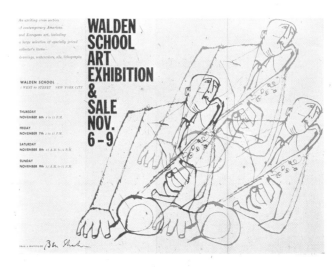

Figure 170—WALDEN SCHOOL ART EXHIBITION (poster).
 1960s
Photo-offset in colors
Sheet: 10⅞ x 14⅝" Composition: 10⅜ x 14⅜"
Paper: Machine-made
Edition: Unknown
Signature: *Ben Shahn* reproduced in black lower left
Collection: New Jersey State Museum; gift of Bernarda Bryson
 Shahn. Accession No: 71.84.3

The original drawing from which this poster was derived was
one of several commissioned by National Educational Tele-
vision for their 1967 production of *Five Ballets of the Five
Senses* by John Butler. Besides being used in the televised
program, the drawing was featured on the cover of the net-
work's program guide, where it illustrated the second of the
ballets, the *Scent of Flight.*

The five heads in the composition are reminiscent of the
six heads of *Words of Maximus* (fig. 76). The bird with wings
spread in display is similar to an open-winged bird illustrated
in *The Shape of Content.*[172]

A note adjacent to the signature indicates that the
design for this poster was taken from a drawing.
The single image in the drawing, which was part
of the exhibition, was multiplied in colors for the
poster. Mr. Richard D. Leonard of the Walden
School recalls that an unknown number of repro-
ductions were made of Shahn's drawing and of
the drawings of nineteen other artists. Assembled
in sets, these reproductions of drawings by twenty
artists were sold at the exhibition.

The image in the poster closely resembles
one of a series commissioned by Edward R.
Murrow and Fred W. Friendly of CBS, for the
1956 film *Ambassador Satchmo.*[173]

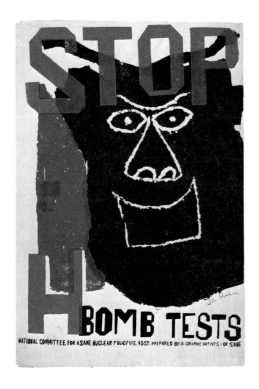

Figure 171—STOP H BOMB TESTS (poster). 1960s
Serigraph in colors
Sheet: 43⅜ x 29⅝" Composition: 39½ x 29⅛"
Paper: Machine-made
Edition: 128
Signature: *Ben Shahn* in red with brush on the screen lower
 right
Collection: New Jersey State Museum; purchase. Accession
 No: 70.64.15

Figure 172—McCARTER GUILD (poster). 1961
Photo-offset in black and yellow
Sheet: 14 x 22" Composition: 12⅝ x 21"
Paper: Cardboard
Signature: *Ben Shahn* reproduced in yellow lower right
Edition: Unknown
Collection: New Jersey State Museum; purchase. Accession
 No: 70.64.19

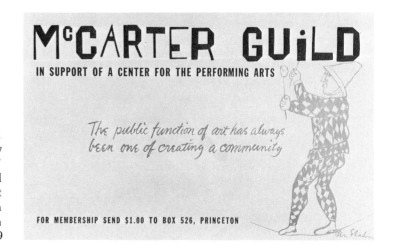

The devil mask was a motif used by Shahn several times, notably for the two prints entitled simply *Mask:* one a serigraph (fig. 39) and the other a lithograph (fig. 51).

The frightening devil mask suggests the evil consequences of hydrogen bomb tests. The red "stop," overprinted on the black mask, acts as a barrier between the viewer and the mask, visually suggesting that the evil can be averted.

The edition is based on an example in the Cornell University Collection which is numbered *67/128*. It was produced for a fund-raising effort in a campaign advocating control of nuclear bomb tests.

Except for the bulbous end of one of the drumsticks, which is hidden here by the letter "i," this is the same image as in the drawing of a clown reproduced in *The Shape of Content,* and also in Michael Adam's autobiographical essay *A Matter of Death and Life.*[174] In all likelihood that drawing was the source of the acrobat in this poster. In Adam's book, the illustration accompanies the author's view on life and explains perhaps why Shahn chose the clown for a theater poster: "Tragedy and good fortune are two things of one kind: between them and by means of them, we may walk the abyss with all the ease of acrobats. We may go with the seriousness of clowns about the business of earning our lives in a circus of unpredictable circumstance."[175]

D. Brooks Jones, then associate producer of the Princeton University's McCarter Theater, organized the McCarter Guild and planned to establish others throughout the state of New Jersey to stimulate interest in the performing arts as well as to disseminate information about the theater. Arthur W. Lithgow, executive director of McCarter Theater, remembers Jones telling him how he and Shahn sat down one evening over a beer to discuss the poster and decided to use the improvised phrase "The public function…" simply because it sounded so good.

The clown and the central quotation are printed in soft, golden yellow. The remaining lettering is black.

140

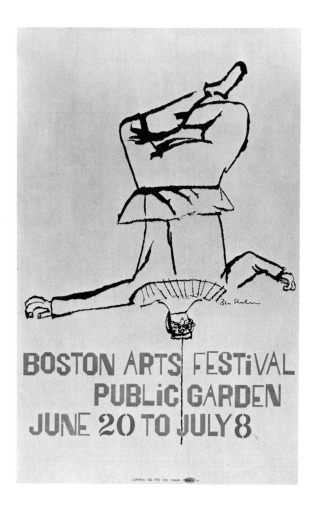

Figure 173—BOSTON ARTS FESTIVAL
 (poster). 1962
Serigraph in black, gray and red
Sheet: 44 x 27⅞"
 Composition: 36½ x 26⅛"
Paper: Machine-made
Edition: Unknown
Signature: *Ben Shahn* in black on the screen
 center right
Collection: New Jersey State Museum; gift of
 New Jersey Junior and Community College
 Association. Accession No: 70.64.16

This is one of Shahn's many variations on the theme of balancing acrobats. The tightrope-walking clown in his *McCarter Guild* (fig. 172) and the portrait of himself as a sure-footed clown atop a horse in *Ben Shahn January 18 to February 12* (fig. 186), are two other poster examples.

A 1950 drawing, *Bicycle Act*,[176] and a closely related 1950 tempera, *Epoch*,[177] both include a dwarf-sized man doing a precarious handstand on the heads of two tumblers pedaling unicycles. And in the 1954 tempera *Everyman*,[178] the image is of a rather smug and pious looking character who seems oblivious to the precarious balance he maintains among experienced tumblers. The theme again occurs in the 1956 drawing *Circus Tumblers*,[179] which features a jungle of balancing tumblers; and in *The Biography of a Painting*,[180] where one clown is doing a handstand on the back of another.

Yet all of these feats seem like simple stunts compared to that of the tumbler in this poster, who balances on his head atop a thin pole. In positioning the arms, Shahn introduced an eerie sense of momentary loss of balance.

Figure 174 — BEN SHAHN GALLERIA NAZIONALE D'ARTE MODERNA (poster). 1962
Photo-offset in black and red
Sheet: 39¼ x 27⅜" Composition: 38 x 25⅝"
Paper: Machine-made
Printer: Istituto Grafico Tiberino, Roma
Edition: Unknown
Signature: None
Collection: New Jersey State Museum; purchase. Accession No: 70.358

Some years ago The Museum of Modern Art, New York City, organized a comprehensive exhibition, *The Works of Ben Shahn,* which was circulated abroad by the museum's International Program. Comprised of one hundred thirty-nine works, the exhibition included paintings, prints, posters, and other graphics dating from the 1930s to the 1960s. The exhibition opened at the Stedelijk Museum in Amsterdam on December 15, 1961, traveled to Brussels and Rome, and closed in Vienna on June 24, 1962.

This poster, announcing the exhibition in Rome, is printed in red and black, with the name *Ben Shahn* and the three lines with the show's dates and times printed in red. The design is also on the cover of the Rome catalogue, where the black outline of the hands is printed over the red name.

Although these hands differ from the ones in *Partings long seen coming* (fig. 123), they are folded exactly the same way as in the antecedent of that print, a 1957 drawing, *Priest and the Prophet.*[181]

To those familiar with Shahn's work, the hands are so characteristic that the identification, lettered across them, seems redundant.

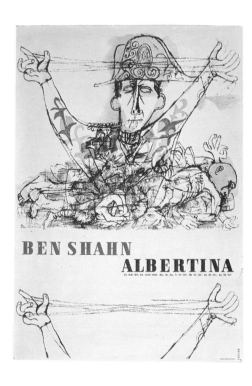

Figure 175 — BEN SHAHN ALBERTINA (poster). 1962
Photo-offset in colors
Sheet: 33 x 23⅛" Composition: 32 x 22½"
Paper: Machine-made
Printer: Fabigan, Piller-Druck, Vienna
Edition: Unknown
Signature: *Ben Shahn* reproduced in black center left
Collection: New Jersey State Museum; gift of Mrs. John H. Wallace.
Accession No: 70.320.20

The decorated and uniformed central figure, emerging from the heap of grotesquely frozen corpses, is the same as that in Shahn's 1956 watercolor, *Study for "Goyescas,"*[182] which preceded the 1956 watercolor *Goyescas.*[183] The titles refer to Francisco Goya's characterizations of military men. It may be of interest to note that Shahn did the watercolors in the year of the Hungarian uprising. In view of his strong feelings about war and its unavoidable manifestations of cruelty, it is not surprising to see him portraying the military in this way.

The appearance of a cat's cradle in the original *Goyescas* watercolors predated the use of this motif in the 1959 serigraphs (see figs. 37 and 38). Although the game can be joyfully viewed in those works, it takes on a somber connotation in a military context. War games inevitably lead to death and destruction when turned into reality. To this poster a second cat's cradle has been added under the announcement.

Ben Shahn Albertina was issued in connection with the opening in Vienna, in May, 1962, of The Museum of Modern Art's traveling exhibition, *The Works of Ben Shahn* (see fig. 174).

Figure 176—BEN SHAHN GRAPHIK BADEN-BADEN
 (poster). 1962
Photo-offset in black
Sheet: 33⅞ x 24" Composition: 30⅞ x 21⅜"
Paper: Machine-made
Edition: Unknown
Signature: None
Collection: New Jersey State Museum; gift of
 Mr. and Mrs. Donald B. Kipp. Accession No: 70.64.21

According to his wife, Bernarda, Shahn often printed proofs on whatever paper was closest at hand. In this poster, newsprint became a part of the design, whether or not this was the original intent. The newspaper is a double-page spread of a *New York Times* want ad section, but there does not seem to be any special significance attached to the choice. This poster was intended for the opening in Baden-Baden, in August, 1962, of the Museum of Modern Art's exhibition, *Ben Shahn Graphics* (see fig. 179). From Baden-Baden, the show traveled to Zagreb and Stockholm, and closed in Jerusalem in June, 1963.

The quotation is from *Passion of Sacco and Vanzetti* (fig. 31) and was also issued as a separate serigraph, *Immortal Words* (fig. 33).

Figure 177—LINCOLN CENTER
 FOR THE PERFORMING ARTS
 (poster). 1962
Photo-offset in black and serigraph
 in colors
Sheet: 46 x 30″
Composition: 43½ x 28⅞″
Paper: Machine-made
Edition: 10,000
Signature: *Ben Shahn* reproduced
 in black lower right
Collection: New Jersey State
 Museum; gift of New Jersey
 Junior and Community College
 Association.
 Accession No: 65.15.2

Figure 178—LINCOLN CENTER
 FOR THE PERFORMING ARTS
 (variant poster). 1962
Photo-offset in black and yellow
Sheet: 11 x 21″
Composition: 10 x 20″
Paper: Cardboard
Edition: Unknown
Signature: *Ben Shahn* reproduced
 in black lower right edge
Collection: New Jersey State
 Museum; purchase.
 Accession No: 70.64.18

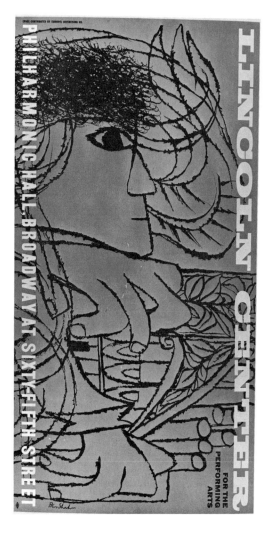

Shahn's love of music, musicians, and instruments, modern as well as ancient, is reflected in his many works dealing with musical themes. The image here of an angel playing the organ is similar to the cover illustration for Louis Untermeyer's *Love Sonnets* but more closely resembles the 1955 drawing *Bach.*[184] The graceful swirls of the feathery wings and the trance-like, ecstatic posture of the organist have that eye-arresting quality so important in poster art.

This poster announced the opening of Philharmonic Hall in the new Lincoln Center for the Performing Arts in New York City and was the first to be commissioned by the Center, under a gift from the Albert A. List Foundation.

Used for display in subways and buses, this poster features a major portion of the preceding work (see fig. 177). The black image is printed over a golden yellow. The lettering is white and black. Along the left margin is a credit line for the Subways Advertising Company, which contributed the space.

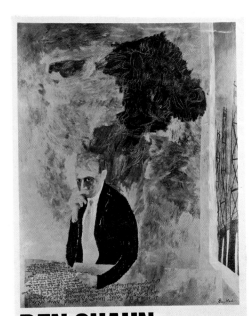

BEN SHAHN

en amerikansk kommentar

Moderna Museet 16 februari – 10 mars 1963

Figure 179 — BEN SHAHN EN AMERIKANSK KOMMENTAR (poster). 1963
Photo-offset in colors
Sheet: 30¾ x 19¾" Composition: 29¾ x 18½"
Paper: Machine-made
Printer: J. Olséns Litografiska Anstalt
Signature: *Ben Shahn* reproduced in black lower right as it appears
 on the painting
Collection: New Jersey State Museum; gift of Mr. and Mrs. Kenneth W. Prescott.
 Accession No: 70.48

This poster shows a color reproduction of Shahn's 1962 tempera portrait, *Dag Hammarskjöld,* owned by the Nationalmuseum of Sweden and housed in the Castle of Gripsholm, Sweden's National Portrait Gallery. The portrait of the former Secretary-General of the United Nations was commissioned by the Nationalmuseum under the authority of the Swedish Government's "Honorary Portraits" program. In explaining the museum's decision to commission an American artist to do the portrait, the Nationalmuseum's director, Carl Nordenfalk, stated that Ben Shahn was not essentially a portrait painter but a "highly cultured artist deeply interested in human affairs…[Shahn] had also drawn penetrating studies of Ernest Hemmingway [sic] and of Sigmund Freud…." Hammarskjöld was amused to be in company with Hemingway and Freud. "What a troika of loners," he wrote.[185] There is a large drawing for the portrait in the Hammarskjöld Library in Uppsala, Sweden.

Shahn seated Hammarskjöld in his U.N. office, with the outline of a bridge seen through the window. Overhead, an ominous atomic cloud threatens. On the desk, running across and spilling over a notepaper, Shahn lettered excerpts from Hammarskjöld's famous resolution concerning the role of the U.N. in relation to large and small nations.

In a letter Shahn described how he approached his subject: "I did not like the notion of a conventional portrait. That seemed to me a commonplace. I wanted to express his loneliness and isolation, his need, actually, for such remoteness in space that he might be able to carry through, as he did, the powerful resolution to be just. His unaffiliated kind of justice, it seems to me, held the world together through many crises that might have deteriorated into world conflicts. I have had a truly profound feeling for this man, and I hope that it will be felt through the painting. I must mention, too, the threat that hung over him as it hung over the world, and does still. All this is my mood in doing this piece of work."[186]

It would be difficult to find a more appropriate subject for a poster announcing an exhibition of Shahn's work in Sweden's Moderna Museet in Stockholm (see fig. 176).

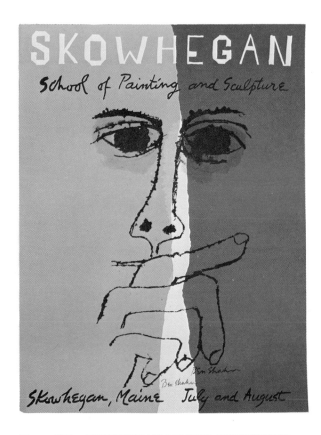

Figure 180—SKOWHEGAN SCHOOL OF PAINTING
 AND SCULPTURE (poster). 1963
Photo-offset in colors
Sheet: 29 x 22" Composition: same
Paper: Machine-made
Edition: 1,000
Signature: *Ben Shahn* in black with conte crayon lower
 center below *Ben Shahn* reproduced in black lower
 center
Collection: New Jersey State Museum; purchase.
 Accession No: 70.320.19

John Eastman, Jr., director of the Skow-
hegan School of Painting and Sculpture
in Skowhegan, Maine, recalls that it was
in the year 1963 that Shahn did the ink-
wash drawing and color overlay used to
produce this poster, the smaller variant
(fig. 181), and the cover for the School Cata-
logue for the years 1963-68.

In that same year Shahn drew many ver-
sions of the poster image that were similar
in technique and feeling, including *Study of
Distressed Man*,[187] and *Drawing of Distressed
Man*.[188] The watercolor *Distressed Man*,[189]
also dating from 1963, conveys the same
mood, as do a series of drawings which
Shahn did for the 1959 CBS television
production of *Hamlet*.

Shahn produced another poster for the
Skowhegan School in 1965, the one titled
*Lenox Hill Hospital and Skowhegan
School* (fig. 188). As a visiting artist, Shahn
enjoyed the opportunities the Skowhegan
School gave him to exchange thoughts and
ideas with students and faculty. The Skow-
hegan posters were meant to express his
appreciation to the school's administrators
and board of directors.

Figure 181—SKOWHEGAN SCHOOL OF
 PAINTING AND SCULPTURE (variant
 poster). 1963
Photo-offset in colors
Sheet: 11½ x 8⅜" Composition: same
Paper: Machine-made
Edition: 1,500
Signature: *Ben Shahn* reproduced in black
 lower center
Collection: New Jersey Museum; gift of
 Skowhegan School of Painting and
 Sculpture. Accession No: 70.315.1

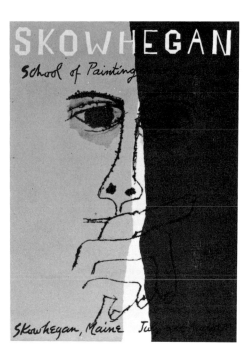

This poster is a reduced version of
fig. 180.

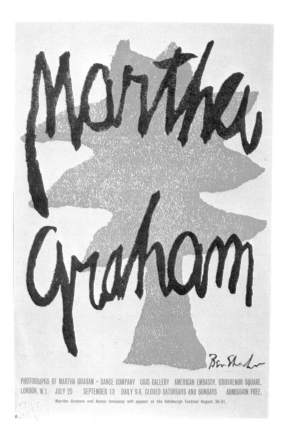

Figure 182—MARTHA GRAHAM DANCE COMPANY
 (poster). 1963
Photo-offset in black, green and gray
Sheet: 30 x 20⅛" Composition: 27⅜ x 19⅜"
Paper: Machine-made
Edition: Unknown
Signature: *Ben Shahn* reproduced in black lower right
Collection: New Jersey State Museum; gift of
 Mr. and Mrs. Robert D. Graff. Accession No: 70.98.2

Figure 183—MARTHA GRAHAM (variant poster).
 1963
Photo-offset in black and green
Sheet: 30 x 20⅛" Composition: 24⅞ x 19⅜"
Paper: Machine-made
Edition: Unknown
Signature: *Ben Shahn* reproduced in black lower right
Collection: New Jersey State Museum; gift of
 Mr. and Mrs. Robert D. Graff. Accession No: 70.98.1

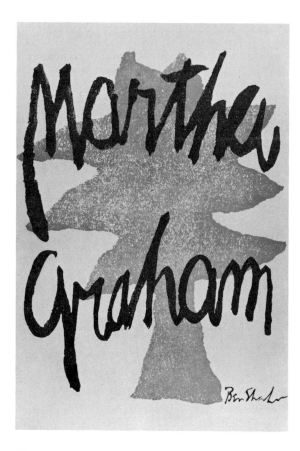

The broadly brushed black script printed on top of the bright green tree simply and strongly proclaims the name of the famous American dancer. The poster announces the appearance of her ballet company and the opening of an exhibition of photographs of the troupe. The companion poster (see fig. 183) lacks the announcement.

The green tree and the black overprinting of the name "Martha Graham" are identical to the preceding poster (see fig. 182), but this version lacks the additional informative text.

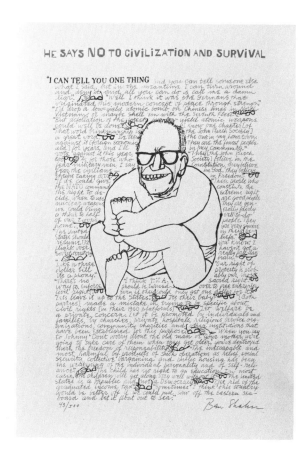

Figure 184—I CAN TELL YOU ONE THING
(poster). 1964
Photo silkscreen in black and gray
Sheet: 27⅞ x 22" Composition: 22 x 13¾"
Paper: Machine-made white wove
Edition: 500, *43/500*
Signature: *Ben Shahn* in black with felt pen lower right
Collection: New Jersey State Museum; purchase.
 Accession No: 68.36.8

Figure 185—SAY NO TO THE NO-SAYER (poster).
1964
Photo-offset in black and red
Sheet: 28¼ x 22" Composition: 18⅞ x 13¾"
Paper: Machine-made white wove
Edition: 500
Signature: *Ben Shahn* in brown conté crayon lower right
Collection: New Jersey State Museum; purchase.
Accession No: 68.36.9

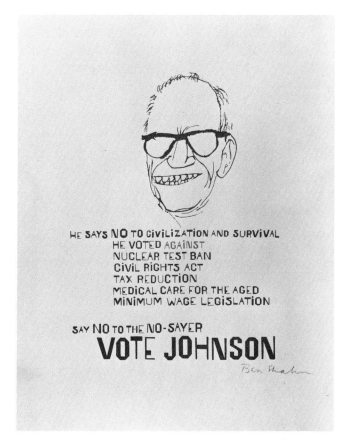

The unmistakable caricature of the Republican candidate for President of the United States in 1964, Senator Barry Goldwater, is a bitter expression of Shahn's contempt for the man. The presentation of the candidate as a babe in swaddling clothes in the process of putting his foot in his mouth, is meant to remove all confidence in him as a potential leader of the nation. To support his low opinion, Shahn chose excerpts from Goldwater's speeches, which he felt would be more damaging to the image of the candidate than anything Shahn could say.

To the voters in the 1964 presidential campaign, this head was easily recognized as that of Senator Barry Goldwater. The message on this poster lists the issues that the Senator had voted against, but which Shahn considered of great importance to the country. Shahn was implying that a vote for Johnson would be a repudiation of Goldwater, the no-sayer to vital legislation. The word "against" is printed in red, isolated and emphasized by its color; the poster is otherwise executed in black ink.

 The edition size is based on an example in the collection of the Philadelphia Museum of Art which carries Shahn's signature and the number *44/500,* written in purple ink.

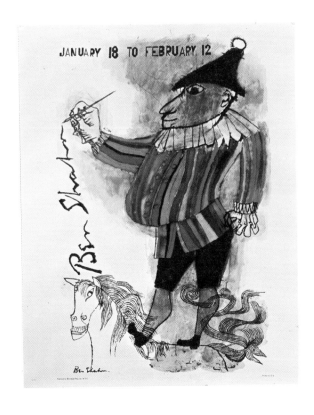

Figure 186—BEN SHAHN JANUARY 18 TO FEBRUARY 12
 (poster). 1964
Photo-offset in colors
Sheet: 28½ x 22½" Composition: 26⅝ x 17½"
Paper: Machine-made
Publisher and Printer: Shorewood Press, Inc., New York
Edition: Unknown
Signature: *Ben Shahn* reproduced in black lower left
Collection: New Jersey State Museum; gift of Mr. and Mrs. Martin
 Bressler. Accession No: 71.4.3

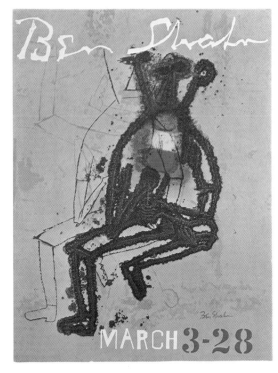

Figure 187—BEN SHAHN MARCH 3-28 (poster). 1964
Photo-offset in colors
Sheet: 28⅝ x 22½" Composition: 27⅛ x 20⅝"
Paper: Machine-made
Publisher and Printer: Shorewood Press, Inc., New York
Edition: Unknown
Signature: *Ben Shahn* reproduced in red lower right
Collection: New Jersey State Museum; purchase.
Accession No: 70.64.20

This colorful and gay poster was taken from the 1955 watercolor, *Clown*[190] and probably designed for the one-man exhibition that marked his twenty-fifth year of association with The Downtown Gallery. The late Edith Halpert, founder and owner of the gallery, had offered Shahn his first New York representation. Through the years, as he climbed from obscurity to international acclaim, he never forgot that she had believed in him from the beginning and he remained intensely loyal to her. Although this poster version was not printed until September of 1964, it undoubtedly refers to the anniversary exhibition (see fig. 187).

One of the studies for the multi-colored clown is a 1955 brush drawing, *The Jester.*[191]

The original work, from which this poster is reproduced, was painted by Shahn for his 1952 Downtown Gallery exhibition. It appears to be the exact image of the boy in *Triple Dip* (fig. 17), and one suspects that a multiple printing of the serigraph was the basis for the painting.

Reproductions of this and the previous poster (see fig. 186) were published by Shorewood Press, Inc. of New York City in September, 1964, thus making two important Shahn works available to the public.

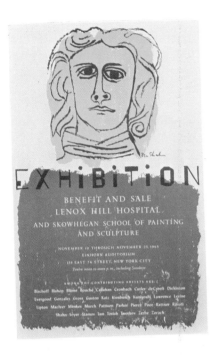

Figure 188—LENOX HILL HOSPITAL AND
 SKOWHEGAN SCHOOL (poster). 1965
Photo-offset in colors
Sheet: 22 x 14" Composition: 20¾ x 13⅛"
Paper: Machine-made
Edition: 1,200
Signature: *Ben Shahn* reproduced in black center right
Collection: New Jersey State Museum; gift of Skowhegan
 School of Painting and Sculpture.
 Accession No: 70.315.2

The youthful features in this poster are
identical to those found in the 1965 wood-
engraving *Skowhegan* (fig. 62). Both were
produced in connection with the fund-
raising affair advertised in the poster. Spon-
sors of the benefit exhibition who
contributed one hundred dollars were
given a copy of *Skowhegan,* signed by both
Ben Shahn and Stefan Martin, the engraver.

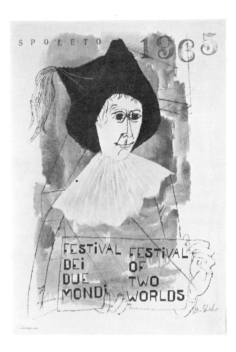

Figure 189—SPOLETO FESTIVAL DEI DUE MONDI
 (poster). 1965
Photo-offset in colors
Sheet: 39¼ x 27⅝" Composition: 35½ x 25⅝"
Paper: Machine-made
Printer: Istituto Grafico Tiberino, Roma
Edition: Unknown
Signature: *Ben Shahn* reproduced in black lower right
Collection: New Jersey State Museum; gift of Ford Motor
 Company. Accession No: 65.15.1

This festively-donned promotor of the 1965
Spoleto Festival was preceded by an earlier
counterpart in the 1955 drawing, *Sad
Clown,*[192] who is similarly dressed in a large
hat and pleated collar. In this poster, the black
hat is in striking contrast to the white face
with its soulful eyes. The expressive quality
is characteristic of Shahn's work of these
years. The delicately drawn fingers support
the sign that bears the announcement
printed in Shahn's superb calligraphy.

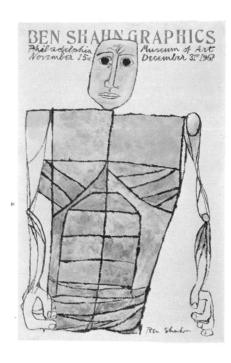

Figure 190—BEN SHAHN
GRAPHICS PHILADELPHIA
MUSEUM OF ART (poster). 1967
Photo-offset in colors
Sheet: 45 x 30⅛"
Composition: 42⅝ x 28"
Paper: Machine-made
Publisher and Printer: Posters Original
Limited, New York
Edition: Approximately 5,000
Signature: *Ben Shahn* reproduced in
black lower right
Collection: New Jersey State
Museum; gift of Ben Shahn.
Accession No: 68:112

Figure 191—BEN SHAHN
PHILADELPHIA MUSEUM OF ART
(variant poster). 1967
Photo-offset in colors
Sheet: 44⅞ x 30"
Composition: 41¼ x 28"
Paper: Machine-made white wove
Publisher and Printer: Posters
Original Limited, New York
Edition: 300
Signature: *Ben Shahn* reproduced in
black lower right, *Ben Shahn* in
black with conte crayon upper left
under orange-red chop
Collection: Philadelphia Museum
of Art.
Accession No: 67—228—1

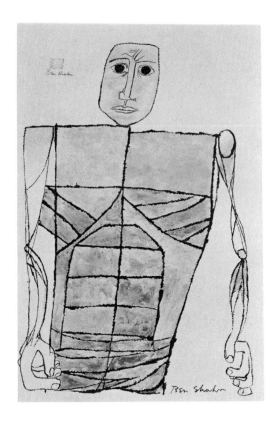

The forlorn-looking, multi-sectional man in this poster is closely related to an elongated figure in a wash drawing illustrated in Shahn's *The Biography of a Painting*.[193] Both have the curious tendon-like delineation of the arms, the extension of the rib cage to the arm on the left, the uneven juxtaposition of the shoulders, and even the segmented stomach. This unusual anatomical concept is found in other Shahn works, e.g., *Ecclesiastes*[194] and the acrylic, charcoal, and gold painting *Peabody,* done in 1968.[195]

A special edition of three hundred copies of the poster were printed without the announcement, and these Shahn signed in pencil and with his chop (see fig. 191).

This variant of the preceding poster, omitting the lettered announcement, was signed in pencil by Shahn and also carries his chop signature. Of the edition, the publisher retained two hundred copies for distribution, and the rest were offered to collectors at one hundred dollars each by the Department of Prints and Drawings of the Philadelphia Museum of Art. The museum announcement of this offering is a one-fold sheet, 7⅞ x 10¾" with this variant poster reduced to 6⅜ x 4¼" and printed on the cover. The opened sheet has Shahn's orange-red chop printed in the lower right hand corner of page 2; the description of the sale is printed on page 3; and page 4 is blank.

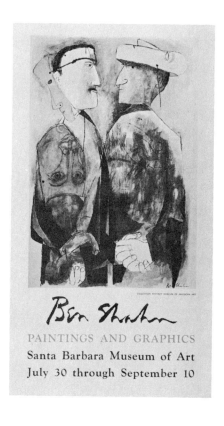

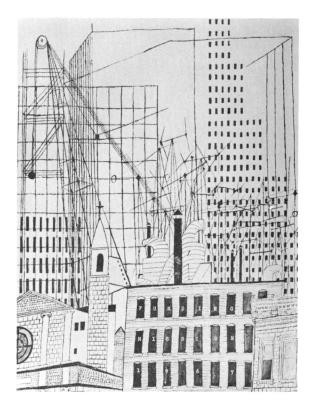

The exhibition of seventy-eight works which opened at Santa Barbara Museum of Art on July 30, 1967, also appeared, with minor changes, at the La Jolla Museum of Art and the Herron Museum of Art, Indianapolis, where it closed on January 3, 1968. This poster was reproduced from a 1958 watercolor, *Conversations,* now in the Whitney Museum of American Art. The calligraphy is printed in black except for one line in blue. Brown is the prevalent color in the composition, ranging from nearly black to off-white, with very soft shades of blue and purple for background. Some bright colors are introduced on the masks. The presence of these masks is indicative of Shahn's continued interest in the many faces of man.

Nothing is known of this small poster which Mrs. Shahn found in her husband's studio shortly after his death. Its existence came as a surprise to her and this is the only copy known.

At first glance the image looks like a portion of the serigraph, *All That Is Beautiful* (fig. 55). However, differences in the intersections of lines, in the number of windows, and in other building details suggest that some other drawing was the basis of this poster reproduction.

Figure 194 — McCARTHY PEACE (poster). 1968
Photo-offset in colors
Sheet: 38⅛ x 25⅛" Composition: 33⅞ x 23"
Paper: Machine-made
Publisher: Health Professions for McCarthy
Printer: Lincoln Graphics, New York
Edition: 10,200
Signature: *Ben Shahn* reproduced in black right center
Collection: New Jersey State Museum; purchase.
 Accession No: 70.46

1968 was another presidential election year and again Shahn responded to the political situation by supporting a candidate by means of his art. His choice, not surprising to those who knew his views on the Vietnam war, was Senator Eugene McCarthy, who had entered the primary elections as an opponent of the war, and in so doing captured the energies and loyalties of many young persons.

The dove-like bird with its colorful stripes brings to mind the equally striking serigraph *Phoenix* (fig. 14), the poster painting *Ben Shahn March 10 to March 29* (fig. 153), and the poster *Ben Shahn Fogg Museum* (fig. 165). Shahn also produced a variation of the McCarthy poster for a peace convocation at Rutgers University (see fig. 206).

From the edition of 10,200 posters, Shahn signed 200 by hand. Darien House, Inc., is currently distributing an unlimited edition of photo-offset copies of this poster in its "Contemporary Poster Classics" series (see fig. 200).

Figure 195 — FRANK THOMPSON
(poster). 1968
Serigraph in black and red
Sheet: 28 x 22"
Composition: 26½ x 21¼"
Paper: glazed cardboard
Edition: Unknown
Signature: None
Collection: New Jersey State
Museum; gift of Mr. Abbot
Low Moffat.
Accession No: 69.278.1

Figure 196 — PRINCETON NEEDS
ARCHIE ALEXANDER (poster). 1968
Serigraph in black and red
Sheet: 24 x 18"
Composition: 22⅝ x 17⅛"
Paper: Yellow cardboard
Printer: Rainieri's Art Service,
Hopewell, New Jersey
Edition: 100 (50 on yellow and 50
on white stock)
Signature: *Ben Shahn* in black conte
crayon center right and *Ben Shahn*
reproduced in black along the edge
center right
Collection: New Jersey State
Museum; gift of Bernarda Bryson
Shahn. Accession No: 71.96

Shahn's support of New Jersey Congressman Thompson for reelection in 1968 is evident by the wording in this poster and by the fact that he took the time to produce it himself. Each of the several examples in the State Museum collection has two holes crudely punched through the cardboard for hemp twine. In this illustration the impressions from the twine are slightly visible next to the letters "N" and "P" in the top line.

"Frank Thompson" is printed in bright red and the script is black.

In the Princeton mayoral contest of 1968, Shahn was approached by the "Friends of Alexander" and agreed to design a poster for their candidate. Salvatore Rainieri was engaged to produce it and after watching Shahn complete the original in Roosevelt, Rainieri took it back to his Hopewell print shop where he prepared the screen and printed the edition. The red and black composition was printed on yellow and on white cardboard stock. Rainieri presented both yellow and white versions to the State Museum.

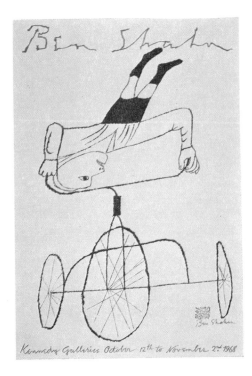

Figure 197—BEN SHAHN KENNEDY GALLERIES (poster). 1968
Lithograph in colors
Sheet: 35½ x 24½" Composition: 34¼ x 23¼"
Paper: Velin d'Arches Publisher: Kennedy Graphics, Inc., New York
Printer: Atelier Mourlot Ltd., New York Edition: 100
Signature: *Ben Shahn* in black conté crayon lower right under orange-red chop
Collection: New Jersey State Museum; gift of The Frelinghuysen Foundation.
Accession No: 69.288.14

Figure 198—ATELIER MOURLOT (poster). 1968
Lithograph in colors
Sheet: 27⅞ x 21" Composition: 25⅝ x 21"
Paper: Radar Vellum Bristol
Publisher and Printer: Atelier Mourlot Ltd., New York
Edition: 3,500
Signature: *Ben Shahn* in gray on the plate lower right
Collection: New Jersey State Museum; gift of Mr. Kenneth Goldberg.
Accession No: 68.111.2

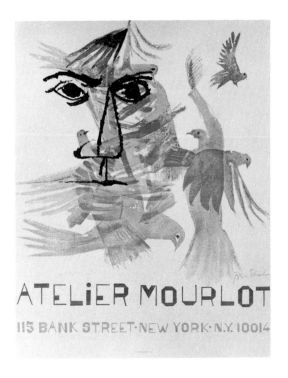

The boy balanced precariously on the tricycle was first used by Shahn for a 1947 Christmas card, *Boy on Tricycle* (fig. 7), which he printed himself in several versions and distributed to friends. Shahn also used this image in a hand-lettered poster for a Downtown Gallery exhibition, but the original poster has been lost. Because the early serigraphs have become very rare, the reappearance of this image, in slightly altered form, was welcomed by collectors and other admirers of Shahn's graphics.

Besides this hand-signed poster edition, Kennedy Graphics, Inc. also issued at the same time an edition of five hundred posters on Radar Vellum Bristol paper which were signed on the plate by the artist. Two hundred additional lithographs without the text were also made available (*see Headstand on Tricycle* fig. 79).

The images in this composition are the same as those in the lithograph *Birds Over the City* (fig. 78) except that the Byzantine structure in the lithograph has been replaced here by lettering. The sparsely outlined facial features are also found in the frontispiece of the Rilke Portfolio (fig. 113).

Jacques Mourlot, for whom this poster was designed, is the only son of Fernand Mourlot, owner of the Imprimerie Mourlot in Paris. Having worked in his father's renowned lithography studio since 1950, the younger Mourlot helped to found the Atelier Mourlot Ltd. in New York City in November of 1967. Using zinc plates as well as stones that he had brought from Paris, Mourlot's firm offered lithographic services to artists, galleries, and publishing houses. In January, 1969, the firm was reorganized and incorporated as Mourlot Graphics, Ltd., with Jacques Mourlot as sole owner.

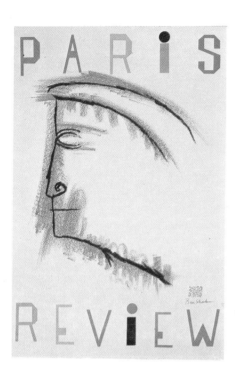

Figure 199—PARIS REVIEW (poster). 1968
Lithograph in colors
Sheet: 39¼ x 25¾" Composition: 36⅞ x 24½"
Paper: Velin d'Arches
Publisher: Poster Originals
Printer: Atelier Mourlot Ltd., New York
Edition: 200, *151/200*
Signature: *Ben Shahn* in black with conté crayon below orange-red chop
 lower right
Collection: New Jersey State Museum; gift of *The Record,* Hackensack,
 New Jersey. Accession No: 70.320.29

Poster Originals of New York City published this poster as the twenty-seventh in a set of thirty-two, the Shahn poster being available only with a purchase of the entire set. The image is preceded by the two *Profile* serigraphs (figs. 15 and 16), and is faithful to the latter, the black and umber, although there are subtle differences between the two.

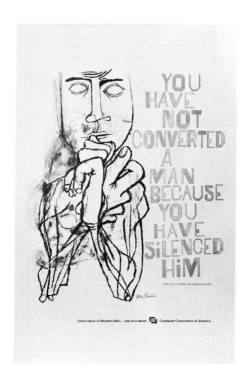

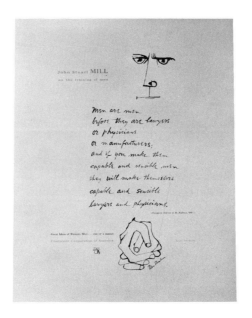
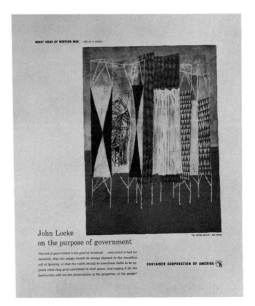

Figure 200 — YOU HAVE NOT
 CONVERTED A MAN (poster).
 1968
Photo-offset in black and brown
Sheet: 45 x 30"
Composition: 32⅞ x 26¼"
Paper: No. 70 offset stock
Publisher: Container Corporation
 of America
Printer: Darien House, Inc.,
 New York
Edition: Unlimited
Signature: *Ben Shahn* reproduced
 in black lower center
Collection: New Jersey State
 Museum; gift of Barbara E.
 Johnson. Accession No: 71.3

This poster, copyrighted by the Container Corporation of America, is being distributed by Darien House, Inc. as one of their "Contemporary Poster Classics." It was reproduced from an advertisement by Shahn, done for the Container Corporation's series, "Great Ideas of Western Man." The figure is instantly recognizable as the pensive artist that Shahn portrayed several times through the years (see fig. 82), and serves here to emphasize the quote on compromise by John, Viscount Morley.

Two other concepts of Shahn's were included in the series but were not made into posters. Illustrating the quotation on training by John Stuart Mill, *Men Are Men* (fig. 200a), are two characteristic images, the intertwined hands and the thoughtful facial features of a man, both of which Shahn favored during this period. In *The Voting Booths* (fig. 200b), Shahn created a bright and colorful counterpart to John Locke's thoughts on the purpose of government.

All three of Shahn's contributions to the series exist as photo-reproductions in color:

200 — *You Have Not Converted a Man,* in black and brown

200a — *Men Are Men,* in black and blue, gift of Container Corporation of America

200b- *The Voting Booths,* in multi-colors, gift of Container Corporation of America

The Container Corporation of America began its series of "Great Ideas of Western Man" in 1950. It has published six portfolios, totaling 186 "ideas" illustrated by internationally recognized artists.

Figure 201—OPPENHEIMER (poster). 1970
Photo-offset in colors
Sheet: 40¼ x 28⅝" Composition: Same
Paper: Machine-made
Edition: Unknown
Signature: *Ben Shahn* reproduced in black lower right as it appears
 on the drawing
Collection: New Jersey State Museum; gift in memory of Joseph
 Demarais from Mr. and Mrs. Kenneth W. Prescott.
 Accession No: 70.177.b

The reproduction of Shahn's 1954 brush drawing of J. Robert Oppenheimer, now in the New Jersey State Museum Collection, was one of three posters announcing a major Shahn retrospective exhibition in Japan (see also figs. 202 and 203). The exhibition, organized in the United States by Kennedy Galleries and the New Jersey State Museum, was sponsored by the National Museum of Modern Art and the newspaper *The Tokyo Shimbun,* and patronized by Japan's Ministry of Education. It began its tour in April, 1970, at the Ishibashi Art Museum in Kurume, traveled to the National Museum of Modern Art in Tokyo, the Imai Department Store in Sapporo, and the Osaka City Museum, closing at the Hiroshima City Museum in October, 1970.

This poster announces the official opening of the exhibition in Tokyo, at the National Museum, May 21–July 5. The poster was seen throughout the city, and reproductions appeared as poster cards in taxicabs, on kiosks, and in the major hotels. Furthermore, *Oppenheimer* was featured on the cover of the comprehensive bilingual (Japanese and English) catalogue of the exhibition, which consisted of 170 paintings, drawings, prints, and posters.

Figure 202—NOCTURNE (poster). 1970 Photo-offset in colors
Sheet: 28⅝ x 20¼" Composition: 24¾ x 15⅞"
Paper: Machine-made Edition: Unknown
Signature: *Ben Shahn* reproduced in black lower right as it appears on the painting
Collection: New Jersey State Museum; gift in memory of Joseph Demarais from
 George Korn and Richard Kemble. Accession No: 70.177.a

This poster, one of three announcing the 1970 Shahn retrospective
exhibition in Japan (*see* figs. 201 and 203), was reproduced from the
1949 tempera *Nocturne,* loaned for the exhibition by Willard Straight
Hall of Cornell University. The image of Shahn, holding brush and
palette, is taken in slightly altered form from the 1956 Fogg Art
Museum poster (fig. 164).

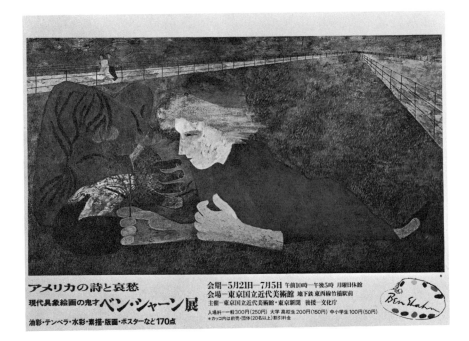

Figure 203—SPRING (poster). 1970
Photo-offset in colors
Sheet: 14¼ x 20¼" Composition: 12⅞ x 19½"
Paper: Machine-made
Edition: Unknown
Signature: *Ben Shahn* reproduced in black lower right as it appears on the painting
Collection: New Jersey State Museum; purchase. Accession No: 70.177.c

Spring was the third of three posters used in connection with a major
retrospective exhibition of Shahn works which toured Japan in 1970
(*see* figs. 201 and 202). The exhibition was widely acclaimed and
heavily attended.

 This poster is a reproduction of the 1947 tempera painting *Spring,*
which was loaned for the touring exhibition by the Albright-Knox
Gallery, Buffalo.

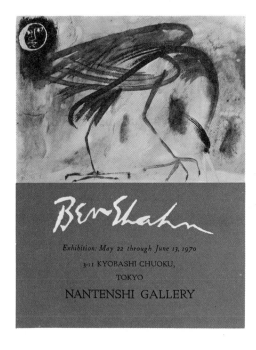

Figure 204 — THE HERON OF CALVARY (poster). 1970
Photo-offset in colors
Sheet: 27⅛ x 20⅜" Composition: Same
Paper: Machine-made Edition: Unknown
Signature: *Ben Shahn* reproduced in black center left
 as it appears on the painting
Collection: New Jersey State Museum; gift of Lederle
 Laboratories, Division of the American Cyanamid
 Company. Accession No: 71.78

The Heron of Calvary announces the showing of Shahn's works at the Nantenshi Gallery of Tokyo, which took place at approximately the same time as the 1970 Shahn retrospective at Tokyo's National Museum of Modern Art. Forty-six paintings, drawings, and prints were on exhibit at the gallery and available for purchase. One of the paintings was the 1962 *The Heron of Calvary,* reproduced for this poster.

The choice of *The Heron of Calvary* for a poster and the brush drawing of a hand for the gallery's catalogue cover, were particularly appropriate, displaying as they did Shahn's masterful use of the quick, flowing line that is so appealing to the Japanese.

Figure 205—APRIL 26-29 BIENNIAL RELIGIOUS
 CONFERENCE (poster). Date unknown
Unknown medium
Sheet: Unknown Composition: Unknown
Paper: Unknown Edition: Unknown
Signature: *Ben Shahn* in black lower right
Collection: Unknown

This poster is reproduced here (©Estate of
Ben Shahn) from an illustration in Shahn's
book *Love and Joy About Letters*.[196] It is in
bright red and black on a pale yellow back-
ground. There is no indication in the book
whether the illustration was taken from an
original poster painting or from a printed
copy of one. It is quite possible that it was
never published.

Figure 206—PEACE (poster). Date unknown
Unknown medium
Sheet: Unknown Composition: Unknown
Paper: Unknown Edition: Unknown
Signature: *Ben Shahn* in blue center right
Collection: Unknown

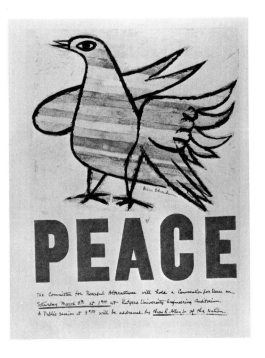

This peace dove is reproduced here (©Estate
of Ben Shahn) from an illustration in Shahn's
Love and Joy About Letters,[197] and does not
reflect the brilliant colors of the bird, which
are blue, red, green, and yellow against a
pale multihued background. The outline of
the dove is basically the same as that in the
McCarthy Peace poster (fig. 194). In both,
"Peace" is in bright blue.

As in the case of the preceding poster,
there is nothing in Shahn's book to indicate
whether the illustration is taken from an
original poster painting or from a printed
copy. The whereabouts of the original are
unknown. Probably the poster was never
published.

PART FOUR

MISCELLANEOUS REPRODUCTIONS, GREETING CARDS, UNPUBLISHED WORKS, AND POSTHUMOUS WORKS

MISCELLANEOUS REPRODUCTIONS

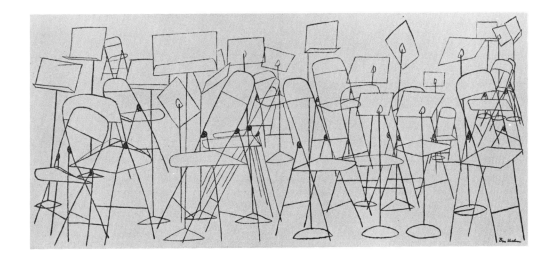

Figure 207—MUSICAL CHAIRS. 1948
Photo-offset in black
Sheet: 10¾ x 23⅞" Composition: 10¼ x 23¼"
Paper: Machine-made wove
Edition: Unknown
Signature: *Ben Shahn* reproduced in black lower right
Collection: New Jersey State Museum; purchase. Accession No: 70.185.1

The reduced size and the placement of the signature between the two outermost chair legs (right) easily distinguish this version from the 1950 serigraph *Silent Music.* This reproduction is made from a 1948 drawing, *The Empty Studio* (see fig. 11).

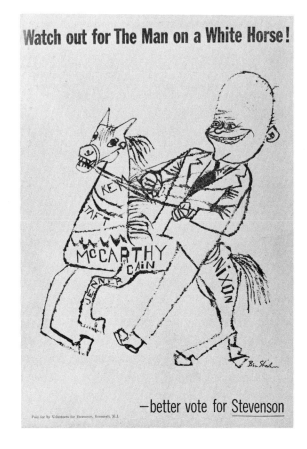

Figure 208—WATCH OUT FOR THE MAN ON A WHITE HORSE! (broadside). 1952
Photo-offset in black
Sheet: 14⅜ x 10" Composition: 13¼ x 9⅛"
Paper: Newsprint
Publisher: Volunteers for Stevenson, Roosevelt, N.J.
Edition: Unknown
Signature: *Ben Shahn* reproduced in black lower right
New Jersey State Museum; gift of Bernarda Bryson Shahn. Accession No: 71.84.6

At times, Shahn's brush revealed a biting, satirical side of his nature. This cartoon treats the Republican candidate for President, General Eisenhower, unkindly, to be sure, but the location of the Vice-Presidential candidate's name on the horse is even less flattering. The horse itself, a far cry from a high-stepping military charger, more closely resembles the wooden merry-go-round variety. The cartoon does not disclose Shahn's opinion of the Democratic opponent, Adlai Stevenson, but it does reveal how he regarded the prospect of an Eisenhower administration. Although Shahn by this time had turned from what he called "social realism" to a more "personal realism" in his art, he by no means had isolated himself from society; rather, he relished being in the mainstream.

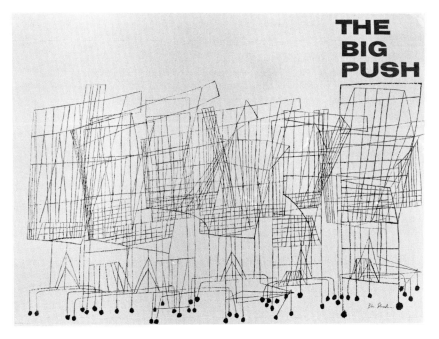

THE BIG PUSH

Figure 209—THE BIG PUSH. 1957
Photo-offset in black
Sheet: 14 x 19¼"
Composition: 13¼ x 18¼"
Paper: Machine-made
Edition: Unpublished, one known
Signature: *Ben Shahn* reproduced in
 black lower right
Collection: New Jersey State Museum;
 gift of Public Service Electric and
 Gas Co. Accession No: 70.320.17

Figure 210—MAN AS STARS. 1957
Photo-offset in sepia
Sheet: 10⅜ x 6¾"
Composition: 8½ x 6½"
Paper: Arches Laid
Printer: Crafton Graphic
Co., New York
Edition: Approximately 40
Signature: *Ben Shahn* in gray with brush
lower right
Collection: New Jersey State Museum;
purchase. Accession No: 69.237.a

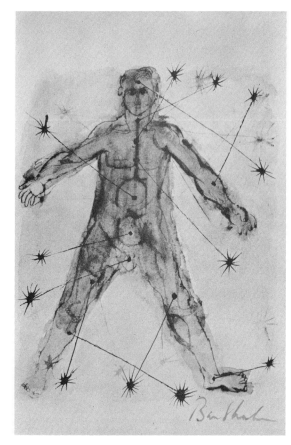

This reproduction is taken from a drawing commissioned by CBS Television for a network ad, *The Big Push,* which appeared in *Variety,* June 12, 1957. The supermarket baskets and the title appeared as here, with the text of the advertisement to the right (*see* p. 29).

Shahn reproduced the drawing for this ad in *Love and Joy About Letters* and commented on the relationship of the non-Shahn lettering to the drawing: "Contemporary lettering has reached that degree of perfection at which letters are both flawless and anonymous. When such letters are juxtaposed to drawings in which perhaps the essential quality is that of the foibles, the nervousness, the personal twists of an artist, the effect is disquieting. In…'The Big Push,' I feel that the lettering clashes with the drawings."[198]

The serigraph, *Supermarket* (fig. 27), closely resembles this reproduction except that there the baskets are fewer, resulting in greater areas of white space. There also, the right side of the composition lines up with the margin rather than having the baskets projecting unevenly.

Of the forty-one Shahn drawings illuminating Edward Dahlberg's *The Sorrows of Priapus,* four were singled out to be reproduced as photo-offset lithographs and signed by the artist. Of these, one was folded in with each copy of a limited edition of 150 numbered books. Besides *Man as Stars,* the drawings *Medusa, Drowning Man,* and *Man with Arrow*[199] were chosen for reproduction.

Mr. Robert M. MacGregor, who was with the Crafton Graphic Company when the edition was printed, states that the four different photo-offset lithographs were printed simultaneously in red-brown ink on one sheet of paper, which was then cut for insertion in the books. To the edition of forty sheets, a few were added as *hors de commerce.*

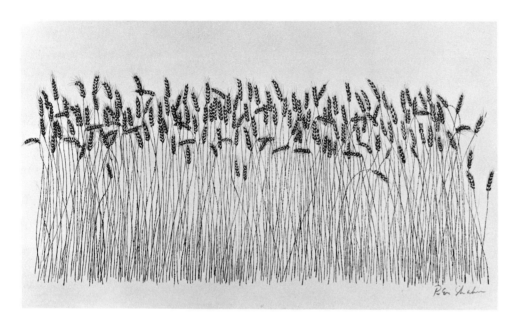

Figure 211—WHEAT FIELD. c. 1958
Photo-offset in black
Sheet: 15⅝ x 25½"
Composition: 10⅝ x 24½"
Paper: Cardboard
Edition: Approximately 40
Signature: *Ben Shahn* in red
 with brush lower right
Collection: New Jersey State Museum; gift of
 Barbara E. Johnson. Accession No: 70.226

Although at first glance, this print seems to be a smaller and uncolored version of the larger *Wheat Field* (fig. 35), a close examination proves it to be slightly different. Its right half is, however, identical to the CBS drawing *Harvest* as illustrated in *The Visual Craft of William Golden.*[200] The full image was used for the end papers of *Ben Shahn His Graphic Art* by James Thrall Soby.

This edition, made especially for the now defunct Little Gallery of Princeton, New Jersey, is little known. Larom Munson, who owned the gallery, remembers that Shahn brought him approximately forty copies of this smaller *Wheat Field,* to be sold exclusively through the gallery. Although thought to be a lithograph, the exact likeness to the CBS version and other printing characteristics suggest that this is a photo-offset reproduction of the full-size drawing.

Figure 212—O LORD
OUR FATHER
(broadside). 1964
Letterpress in black
Sheet: 21¾ x 16⅝"
Composition: 19⅛ x 11⅜"
Paper: Machine-made
Edition: Unknown
Signature: *Ben Shahn* in
black conte crayon upper
left below orange-red
chop; *Ben Shahn*
reproduced in black
center right above text
Collection: New Jersey
State Museum; gift of
Association for the Arts
of the New Jersey State
Museum. Accession
No: 70.4.2

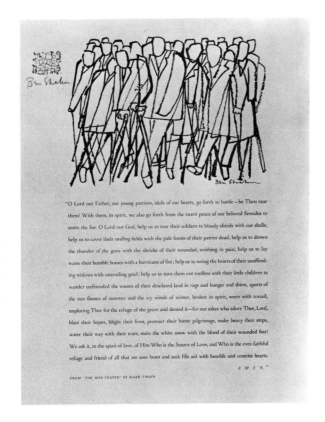

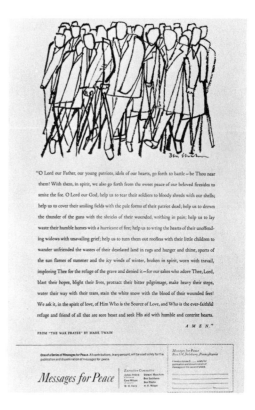

Figure 213—O LORD OUR FATHER
(variant broadside). 1964
Photo-offset in black
Sheet: 17 x 11" Composition: 16¾ x 10¾"
Paper: Machine-made
Edition: Unknown
Signature: *Ben Shahn* reproduced in black center
 right above text
Collection: New Jersey State Museum; gift of
 Mr. and Mrs. Williard Sloshberg.
 Accession No: 70.47.2

The drawing of this crowd of faceless men, supported by crutches and aided by canes, first appeared in the 1956 book, *Thirteen Poems by Wilfred Owen.* It is also reproduced in the 1959 *A Matter of Death and Life* by Michael Adams, and in Shahn's book, *The Shape of Content.*[201]

On one of my visits to Shahn's studio early in 1964, he showed me the original drawing, explaining that he was receiving contributions from those who sympathized with its sentiments, and that when he collected enough money he intended to have the drawing printed full-page in *The New York Times.* This he subsequently did. The ad, six columns and occupying about seven-eighths of a page, appeared in the *Times* on May 29, 1966 (section E, p. 5). Each contributor received a copy of the broadside.

This reduced version of fig. 212 has the additional *Messages for Peace* coupon at the bottom.

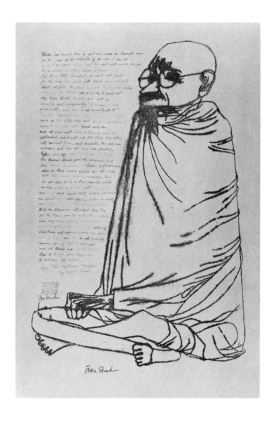

Figure 214—GANDHI AND "THE
MYSTERIOUS STRANGER"
(broadside). 1965
Collotype in black
Sheet: 38 x 25"
Composition: 32 x 21"
Paper: Fabriano (Italy)
Edition: 200
Printer: Meriden Gravure Co.,
 Meriden, Connecticut
Signature: *Ben Shahn* printed in
 black lower center and *Ben Shahn*
 in brown conté crayon above knee,
 left, below orange-red chop
Collection: New Jersey State
 Museum; purchase.
 Accession No: 68.31.14

Figure 215—GANDHI AND "THE
MYSTERIOUS STRANGER" (variant
broadside). 1965
Photo-offset in black
Sheet: 17 x 11"
Composition: 14⅞ x 10¾"
Paper: Machine-made
Printer: Meriden Gravure Co.,
 Meriden, Connecticut
Edition: Unknown
Signature: *Ben Shahn* reproduced
in black lower center
Collection: New Jersey State Museum;
gift of Mr. and Mrs. Williard Sloshberg.
Accession No: 70.47.1

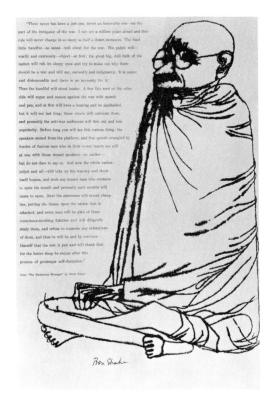

The image of the seated Gandhi seems identical to that of the serigraph *Gandhi* (fig. 57), except for a slight reduction in size and the blurriness of the line, which results in a regrettable loss of detail.

The calligraphy illustrates Shahn's genius for using quotations to reinforce his own artistic expressions and personal viewpoints. The quotation is from Mark Twain's *Mysterious Stranger,* in which Satan robs a young boy of his ideals and beliefs (see fig. 215 for type-set quotation).

This reduced version of fig. 214 has the Mark Twain quotation reproduced from type-set copy instead of from Shahn's handwriting. The blurred line of the collotype has given way to coarser lines printed with heavy ink, which bear no resemblance to the exquisite delineation in the serigraph *Gandhi* (fig. 57).

The image and text of this broadside were reproduced as a "Message for Peace" in a *New York Times* advertisement on December 31, 1967 (section E, p. 5). The ad was six columns wide and occupied approximately five-sixths of the page.

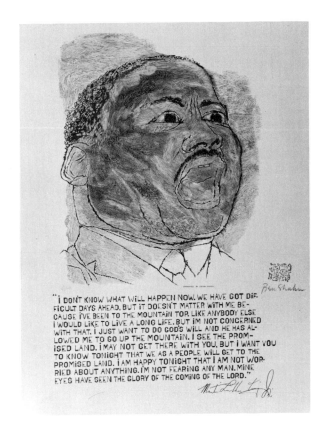

"I DON'T KNOW WHAT WILL HAPPEN NOW. WE HAVE GOT DIF-
FICULT DAYS AHEAD, BUT IT DOESN'T MATTER WITH ME BE-
CAUSE I'VE BEEN TO THE MOUNTAIN TOP. LIKE ANYBODY ELSE
I WOULD LIKE TO LIVE A LONG LIFE. BUT I'M NOT CONCERNED
WITH THAT. I JUST WANT TO DO GOD'S WILL AND HE HAS AL-
LOWED ME TO GO UP THE MOUNTAIN. I SEE THE PROM-
ISED LAND. I MAY NOT GET THERE WITH YOU, BUT I WANT YOU
TO KNOW TONIGHT THAT WE AS A PEOPLE WILL GET TO THE
PROMISED LAND. I AM HAPPY TONIGHT THAT I AM NOT WOR-
RIED ABOUT ANYTHING. I'M NOT FEARING ANY MAN. MINE
EYES HAVE SEEN THE GLORY OF THE COMING OF THE LORD."

Figure 216—MARTIN LUTHER KING. 1968
Photo-offset in black
Sheet: 28⅜ x 21⅞" Composition: 25⅝ x 15¾"
Paper: Machine-made Edition: 160 *(4/160)*
Signature: *Ben Shahn* in black conte crayon center
 right under orange-red chop; *engraved by Stefan*
 Martin reproduced in black, center above text
Collection: New Jersey State Museum; gift of Mr. and
 Mrs. Martin Bressler. Accession No: 68.277

Figure 217—NO MAN CAN COMMAND MY
CONSCIENCE! c.1968
Photostat
Sheet: 18 x 13½" Composition: 15⅝ x 11⅞"
Paper: Photographic Stock Edition: Unknown
Signature: *Ben Shahn* reproduced in black lower right;
14⅜ x 18⅜" in pencil lower right below the margin
Collection: New Jersey State Musuem; gift of Bernarda
Bryson Shahn. Accession No: 71.84.7

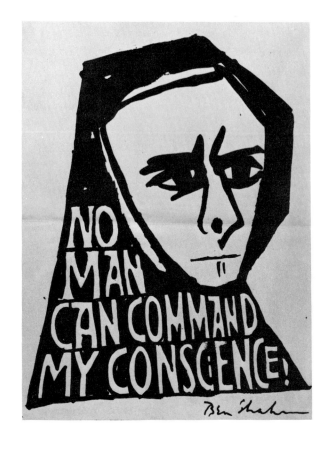

In 1968, Shahn had an edition printed of one hundred photo-offset copies of the wood-engraving which Stefan Martin had done from his portrait of Martin Luther King (see fig. 72). The new edition carried a printed recognition of the engraver of the original, and Shahn also added an excerpt in his own hand from King's famous speech. The copies were used by the Southern Christian Leadership Conference in a fund raising campaign. Subsequently, early in 1969, Shahn authorized another edition of 160 copies to be printed for the Friends of Clinton Hill as part of their annual charity fund drive, which included an art exhibition, *Masters of American Art,* co-sponsored by the Kennedy Galleries. Although hospitalized, Shahn sent for the edition and signed each copy as he had intended. These were, in all likelihood, the last works signed by him.

Mrs. Shahn found this photostat in her husband's studio after his death. This was the first time she had seen it, and she has no recollection of its execution or purpose.

Apparently, the photostat is taken of an unknown study relating to Shahn's *Credo* prints (figs. 40 and 67) of 1960 and 1966. The quotation from Martin Luther, used in the two serigraphs, ended with the title phrase of this work. The face is unmistakably recognizable as that of the man holding the book in the large *Credo* (fig. 67).

GREETING CARDS (*see also fine arts prints, figs.* 7, 9, 10, and 12)

Figure 218—LEVEN LORDS A LEAPING (holiday
greeting). Early 1950s
Photo-offset in colors
Sheet: 6¾ x 5¼" Composition: 6¼ x 4⅝"
Paper: Machine-made
Edition: Unknown
Signature: *Ben Shahn* reproduced in blue lower right
Collection: New Jersey State Museum; on extended
loan from Bernarda Bryson Shahn.
Accession No: 70.336.1

The title and the black outline of the leaping lord are
printed over broad bands of color. The exquisitely
lettered phrase from the ancient song, "A Partridge
in a Pear Tree," serves not only as frame but as inter-
esting counterpoint to the freely drawn figure.

The date is based on Bernarda Shahn's recollec-
tion and on a record of a watercolor of the subject,
delivered to The Downtown Gallery in the year 1952.

Figure 219—LOVE AND JOY (holiday booklet). 1950s
Photo-offset in black and yellow
Sheet: 6¾ x 11⅞" (open)
Paper: Machine-made
Signature: None
Collection: New Jersey State Museum; gift of Bernarda Bryson Shahn. Accession No: 71.152.2

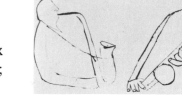

Reproduced from Shahn's drawings, this holiday booklet consists of six sheets, folded and stapled. *Love and Joy* on the cover are printed in yellow; illustrations and all other lettering are in black.

Love and joy (image: 4⅝ x 4⅝")
 A clarinet player sounds the opening notes.
Come to you,/love and joy (image: 5⅝ x 5¼")
 The saxophone player is from the drawing commissioned by Edward R. Murrow and Fred W. Friendly of CBS for the 1956 film *Ambassador Satchmo* (see fig. 170).
And to you/come to you, (image: 4¾ x 5⅛")
 Shahn ingeniously conveyed the trombone player's strength and disciplined use of breath.
Your was-sail too,/and to you (image: 5½ x 5½")
 The three ornate goblets are also illustrated in Shahn's *Love and Joy About Letters* along with the words and music.
And God bless you,/your was-sail too, and (image: 5⅜ x 5")
 The musician seems to be reading the music on the opposite page.
And send you/God send you (image: 3½ x 5⅛")
 With a few deft lines, Shahn caught the percussionist in action.
A Happy New Year,/a Happy New Year, (image: 5⅜ x 5¼")
 The trumpeter mutes his horn while sounding his New Year's greeting.
And God send you (image: 5⅝ x 5¼")
 This saxophonist is caught in a rather relaxed moment.
A Happy New Year. (image: 5⅛ x 5½")
 Shahn has curiously emphasized the arms on the musician who closes this holiday greeting. The subject is taken from the 1956 brush drawing, *Clarinet Player.*[202]

Figure 220—THE TRUMPETER
(holiday greeting). 1950s
Photo-offset in colors
Sheet: 6⅞ x 5⅝" (cover) Composition: 6 x 5¾"
Paper: Machine-made
Edition: Unknown
Signature: *Ben Shahn* reproduced in black lower right,
Ben Shahn in pencil in the margin lower right
Collection: New Jersey State Museum; purchase.
Accession No: 70.320.8

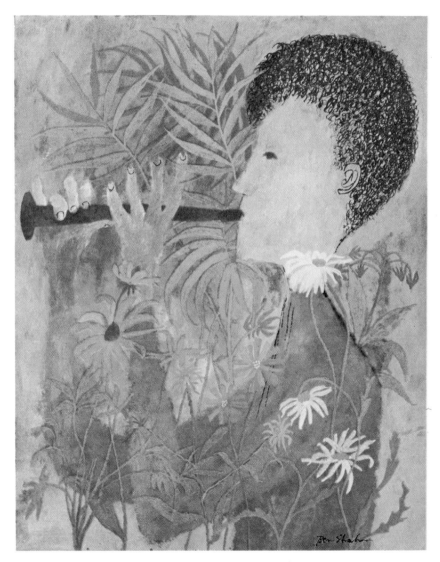

Combined here with the delicate and colorful wild flowers favored by Shahn (see *The gestures of the little flowers,* fig. 120) is a musical motif. Shahn's fascination with music, its instruments, performers, rhythms, and settings, is evident in much of his work. The young musician is reminiscent of the central figure in the 1956 watercolor and gouache, *Folk Song.*[203] But, whereas the mood in this print is one of serene tranquility, the painting exudes an air of "hot" music and excitement.

This example of the folded card has no greeting. On the back is printed in English, French, and Spanish: *"The Trumpeter*...Heralds a world of peace and security. Designed and contributed to benefit UNICEF, the United Nations Children's Fund, by Ben Shahn of U.S.A."

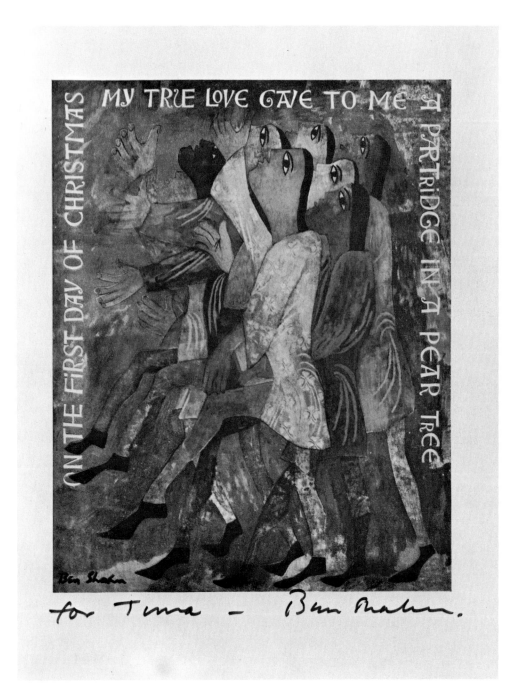

Figure 221—ON THE FIRST DAY OF CHRISTMAS (holiday greeting). 1950s
Photo-offset in colors
Sheet: 13⅛ x 11⅛" Composition: 9⅜ x 7½"
Paper: Machine-made
Edition: Unknown
Signature: *Ben Shahn* reproduced in black lower left as on the painting: *for Tina—*
 Ben Shahn in black with felt-tip pen at bottom.
Collection: Mr. and Mrs. Kenneth W. Prescott

This reproduction of the 1949 tempera painting of the same name[204] was autographed by Shahn for the author's daughter about 1967. There appeared to be twenty to thirty copies on Shahn's studio shelf at the time.

Another version of the high-stepping lords was included in the holiday booklet, *A Partridge in a Pear Tree* (fig. 222).

Figure 222—A PARTRIDGE IN A PEAR TREE (holiday booklet). 1950
Photo-offset in black
Sheet: 8⅛ x 18¾" (open)
Paper: 100# Stoneridge and H. W. Sterling
Printer: The Meriden Gravure Co., Meriden, Connecticut
Edition: Unknown (#62 in pencil lower left of turtle dove, p. 2 recto)
Signature: *Ben Shahn* in pencil lower right, p. 2 recto
Collection: New Jersey State Museum; gift of Helen Valentine. Accession No: 70.184

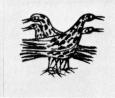

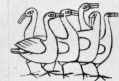

On the first day...A partridge in a pear tree (image: 7½ x 7⅞")
 The partridge is perched on a stylized tree that is laden with fruit.

On the second day...Two turtle doves...(image: 6⅞ x 7⅝")
 The two doves in the song are here represented by one. A favorite image of Shahn's, the dove was used on the *McCarthy Peace* poster (fig. 194). The left wing is positioned abnormally far back on the body, which serves to emphasize the extended, rounded breast, so characteristic of the dove.

On the third day...Three French hens...(image 6½ x 8½")
 The graceful and imaginary hens seem alert and wary as they peer beyond the confines of the page.

On the fourth day...Four collie birds...(image: 5 x 6½")
 Shahn's collie [sic] birds are spotted and lively-looking creatures of his imagination.

On the fifth day...Five golden rings...(image: 4⅜ x 8½")
 The delicate hand wears the golden rings with grace.

On the sixth day...Six geese alaying...(image: 6⅛ x 8⅜")
 Six extended heads and necks fit the order of the day.

On the seventh day...Seven swans aswimming...(image: 7⅛ x 8¾")

One arch-necked and graceful swan complements the seventh verse. Shahn drew another version of a swimming swan in similarly formalized water waves for an illustration in *The Sorrows of Priapus*.[205]

On the eighth day... Eight maids amilking...(image: 6¼ x 7⅞")

There is something apprehensive about the expression of both creature and maids.

On the ninth day...Nine pipers piping...(image: 6¾ x 4⅝")

In this illustration of two hands with fingers poised to perform on a simple pipe, Shahn returned again to the familiar theme of musicians and instruments (see Psalm 150, p. 197, and Hallelujah Suite, pp. 202). In other versions of this Christmas carol, the ninth verse introduces the "nine ladies dancing."

On the tenth day...Ten drummers drumming...(image: 7¾ x 6¾")

The ten are represented in this drawing by one drummer, holding the sticks high as if waiting to strike.

On the eleventh day...leven lords aleaping...(image: 7⅝ x 8½")

The upturned faces, hands, and slippered feet in this drawing are also found in Shahn's 1949 tempera painting *On the First Day of Christmas*,[206] which has been commercially reproduced in color (fig. 221). There is a lively, yet reverent air about these high-stepping lords.

On the twelfth day...twelve ladies dancing...(image: 7⅛ x 8⅜")

Shahn closed this holiday greeting with the dancing ladies, nine in number as they are in some arrangements of the verses. Their flowing gowns and bodies are worked into a symphony of lines, suggestive of harmonious movements. The exact image and the lettered verse are found in Shahn's *Love and Joy About Letters*.

Figure 223 — TWO TURTLE DOVES
(holiday card). 1952
Letterpress in colors
Sheet: 6½ x 5⅛" (cover) Composition: 5⅞ x 4½"
Paper: Machine-made
Edition: Unknown
Publisher: The Museum of Modern Art, New York
Signature: *Ben Shahn* reproduced in black lower left
Collection: New Jersey State Museum; gift of Bernarda
Bryson Shahn. Accession No: 70.336.6

The dove on the front of this folded greeting card is more compressed and not nearly as graceful or dove-like as the bird illustrating the second day of Christmas in the booklet, *A Partridge in a Pear Tree* (fig. 222). The broad stripes of color are reminiscent of those of the dove in the *Peace* poster (fig. 206), but here they form a background for the bird rather than representing colorful plumage. In this example, the inner two pages are blank, and on the back of the card is printed "Design by Ben Shahn. Copyright The Museum of Modern Art 1952/1509."

Figure 224—MENORAH (holiday card). 1953
Photo-offset in black
Sheet: 5⅛ x 6⅛" (cover) Composition: 4¼ x 5½"
Paper: Japan Edition: Approximately 1,000
Publisher: Charles-Fourth Gallery, New Hope, Pennsylvania Signature: None
Collection: New Jersey State Museum; gift of Mr. and Mrs. Michael Lewis. Accession No: None

In 1953, Mr. and Mrs. Michael Lewis, then owners of the Charles-Fourth Gallery in New Hope, Pennsylvania, arranged to have a holiday card printed from a design by Shahn (see also fig. 225). Printed on off-white Japan paper containing a silky fiber, the twice-folded sheet opens to the words "Holiday Greetings;" elsewhere, the gallery is identified, and on the back is imprinted "Menorah by Ben Shahn."

The Menorah image in this and the following card is taken from the same drawing which Shahn used for an illustration in *The Alphabet of Creation*.[207]

Figure 225—MENORAH (holiday card, variant). 1953
Photo-offset in black
Sheet: 4½ x 6¼" (cover) Composition: 4¼ x 5½"
Paper: Japan "Tea" Edition: Approximately 1,000
Publisher: Charles-Fourth Gallery, New Hope, Pennsylvannia Signature: None
Collection: New Jersey State Museum; gift of Mr. and Mrs. Michael Lewis. Accession No: None

The black image of this *Menorah* and that of the preceding one (fig. 224) are the same, but here it is printed on a thin paper of various golden shades, which in turn is adhered to a heavy, blue, folded paper. The card opens to "Holiday Greetings" and the identification "Menorah by Ben Shahn." The gallery's name is printed on the back.

Figure 226—PRAISE YE THE LORD (holiday card). 1953
Photo-offset in black and yellow
Sheet: 8½ x 21½" Composition: 8¼ x 21"
Paper: Machine-made
Edition: Unknown
Signature: *Ben Shahn* reproduced in black lower right
Collection: Mr. and Mrs. Michael Lewis

Psalm 150, lettered by Shahn for this card, was the inspiration for many works (see figs. 250-283). Here the flying angel is praising the Lord "with the sound of the trumpet." Shahn included this composition as an illustration in his 1963 book, *Love and Joy About Letters*.

Figure 227—SWEET WAS THE SONG (holiday booklet). 1956
Photo-offset in black
Sheet: 3¼ x 9¾" (open) Paper: Machine-made
Edition: Unknown Signature: None
Collection: New Jersey State Museum; gift of Lessing J. Rosenwald. Accession No: 69.94.1

This holiday booklet with text borrowed from an old English carol has been issued in at least two forms. In this example, the eight unnumbered sheets were cut from the same off-white paper, folded in half, and stapled. The illustrations are complemented by Shahn's hand-lettering of the musical notation and the words of the song.

The title page, with its graceful, airborne angels (image: 2¼ x 4¾"), opens to:

Sweet was the song/the Virgin sung (image: 3⅛ x 4½")
The angelic organist is an image favored by Shahn (see *Lincoln Center for the Performing Arts*, fig. 178).

When She to/Bethe'lem was come (image: 2¾ x 4¾")
Shahn often turned to architectural forms and building details to complement the human story he wanted to tell.

And was deliver/ed of Her Son (image: 2½ x 4½")

That blessed Jesus/hath to name (image: 2¼ x 4¾")
Over the years Shahn often returned to the theme of youthful musicians playing ancient instruments. The lily in this composition is similar to the one used to illustrate Michael Adam's essay, *A Matter of Death and Life*.[208]

Lulla, lulla/lullaby (image: 3⅛ x 4")
The medieval mood prevalent in this group of musicians blends harmoniously with the old carol.

Lulla, lulla, lullaby/sweet babe quoth She (image: 2¾ x 4")
The baby's elongated form and the elaborately designed garments serve to unite the two figures in this gentle presentation of the Virgin and Child.

My son, and eke/a saviour borne (image: 3 x 3½")
 The angel proclaims the holy birth.

Who hath vouchsafed/from on high (image: 2¼ x 2¾")

To visit us/that were forlorne (image: 3⅛ x 4½")
 The drawing reproduced here of a bird amidst exuberant foliage was also used as an illustration in *Love and Joy About Letters*.

Lulla, lulla, lullaby/sweet babe sang She (image: 2¼ x 3½")

And sweetly rockt Him/rockt Him, rockt Him (image: 2¼ x 4¾")
 In tune with the tenderness of the song are the little wildflowers, which Shahn so loved to portray (see *The gestures of the little flowers,* fig. 120).

And sweetly rockt Him/rockt Him, and sweetly (image: 3⅛ x 4")
 The angel is playing on a stringed instrument, which is one of several versions Shahn drew of early forerunners of the violin (see *Youth Playing "Violin,"* fig. 266, and *Small Boy Playing "Violin,"* fig. 278).

Sweetly rockt Him/on Her knee (image: 2½ x 4")

Shahn concluded the booklet with another touching presentation of the Virgin and Child, the graceful folds of the mother's garments enclosing the baby's safe resting place on her knee.

The 1965 Odyssey Press hard-cover edition of this booklet contains the same illustrations in black, but a wealth of colors have been added to the images and backgrounds. The final page in that edition carries in print Shahn's orange-red chop and the inscription "for Bernarda/Ben Shahn."

Figure 228—ALPHABET (greeting card). 1960s
Photo-offset in black and red
Sheet: 3⅝ x 4⅝" Composition: same
Paper: Umbria
Edition: Unknown
Signature: *Ben Shahn* reproduced in red lower right
Collection: New Jersey State Museum; gift of Bernarda Bryson Shahn.
 Accession No: 70.273

This alphabet greeting card is a greatly reduced photo-offset reproduction of a rubbing made from Shahn's alphabet cardboard cut-out (*see* figs. 24, 63 and 64). The red signature was printed over the alphabet and on the third run through the press a plate mark was embossed along the margin of the print. The red signature extending over the plate mark appears at first to be handwritten, but it is not.

Bernarda Shahn is especially fond of this card, which she considers to be an intimate expression of Shahn's art. She does not recall the year the copies were printed, but both she and Shahn used them from time to time. The image appears on the title page of *Love and Joy About Letters*.

Figure 229—A MERRY CHRISTMAS AND A HAPPY NEW
YEAR (Christmas card). 1960s
Photo-offset in colors
Sheet: 5⅜ x 7" Composition: 5¼ x 6¾"
Paper: Machine-made
Edition: Unknown
Signature: *Ben Shahn* reproduced in blue lower right
Collection: New Jersey State Museum;
gift of Mr. and Mrs. Paul Douglas.
Accession No: 70.320.9

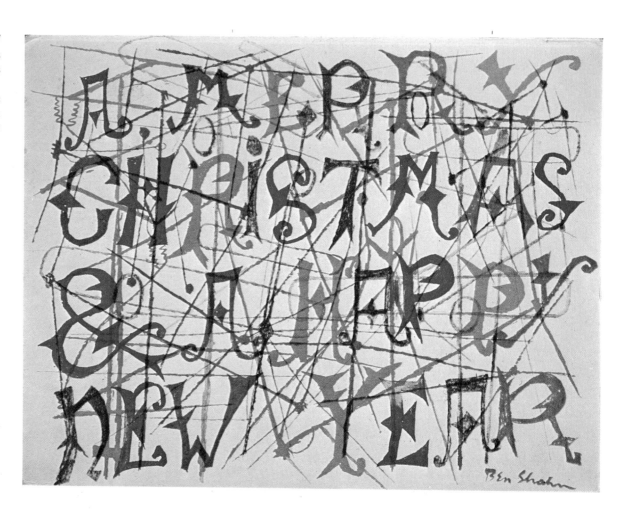

This holiday card exists in two sizes, the one shown
here and a slightly larger version in which the com-
position measures 8 x 10¾". An illustration of this
greeting in Shahn's *Love and Joy About Letters*
contains a rose-colored period after the final "R,"
which is lacking here.

The secular gaiety of this Christmas card departs
from the religious quality of most of Shahn's holi-
day cards.

Come up and see us sometime!
Ben and Bernarda Shahn

Figure 230—DOVE IN FLIGHT (holiday card). 1960s
Photo-offset in black and red
Sheet: 10 x 12⅞" Composition: 8⅜ x 12½"
Paper: Machine-made Edition: Unknown
Signature: *Ben and Bernarda Shahn* in blue ink with pen lower left;
 red chop reproduced in red upper left
Collection: New Jersey State Museum; gift of Barbara E. Johnson.
 Accession No: 70.233.3

The essence of feathery flight and the blurred wing movements of an ascending, airborne bird are superbly rendered in the wash drawing from which this reproduction is taken. The straining curvature of the primaries, the fan-like spread of the tail, and the faint wash outlining the body suggest a dove startled into flight.

Though this card was used primarily as a holiday greeting, Shahn also inscribed personal copies on other occasions. On my personal copy, which he autographed in his studio, he wrote: "For Ken — — Ben Shahn/ Roosevelt July 1965." A slightly reduced version is reproduced as a color illustration (pl. 12) in M. Bentivoglio's Italian language book *Ben Shahn* (1963). It is faithful in color and in the placement of the chop, suggesting that both versions were reproduced from the same wash drawing. Other than the chop, there is no reproduced signature. Bentivoglio has identified it as a Christmas card and dated it 1961.

Figure 231 — TREES (holiday card). 1960s
Letterpress in black
Sheet: 4⅜ x 6¼" (cover) Composition: 3¾ x 5⅝"
Paper: Machine-made Edition: Unknown
Signature: *Ben Shahn* reproduced in black lower right
Collection: New Jersey State Museum; gift of Bernarda Bryson Shahn.
 Accession No: 70.336.7

Figure 232 — WILLOW TWIG
(holiday card). 1960s
Photo-offset in sepia
Sheet: 6 x 4½" (cover)
Composition: 4⅝ x 4⅛"
Paper: Machine-made
Edition: Unknown
Signature: *Ben Shahn* reproduced in
sepia lower center
Collection: New Jersey State Museum;
gift of Bernarda Bryson Shahn.
Accession No: 70.366.2

In this winter scene the stark, black forms outlined against the clear paper give an immediate impression of cold, leafless trees emerging from deep snow.

Bernarda Shahn recalls that she and her husband used this small holiday card in the 1960s. It is folded once and opens up to "Seasons Greetings." On the back is imprinted "Design by Shahn" and "Friends of Harmony, Mississippi."

The identical image appears as an illustration in John Berryman's 1956 edition of *Homage to Mistress Bradstreet.*

Always a keen observer of nature, Shahn recorded with beguiling simplicity the pristine beauty of the willow, then firmly anchored the rootless branch with his signature. The card recalls the delicate beauty of the Japanese gardens Shahn loved so well.

The Shahns used this twice-folded card for holiday greetings and notes. The date of issue is not known.

A reproduction of the drawing *Willow Twig,* seemingly identical to this greeting appears in the 1967 edition of *A Christmas Story* by Katherine Anne Porter.

WHO iS GOD?*WELL IT iS AN iNViSiBLE PERSON AND HE LiVES UP iN HEAVEN* i GUESS UP iN OUTER SPACE*HE MADE THE EARTH AND THE HEAVEN & THE STARS AND THE SUN AND THE PEOPLE*HE MADE LiGHT HE MADE DAY HE MADE NiGHT*HE HAS SUCH POWER-FUL EYES HE DOESN'T HAVE MiLLiONS AND THOUSANDS AND BiLLiONS AND HE CAN STiLL SEE US WHEN WE'RE BAD* HE STARTED ALL THE PLANTS GROWiNG*TO ME i THiNK OF HiM WHO MAKES FLOWERS & GREEN GRASS & THE BLUE SKY & THE YELLOW SUN*GOD iS EVERYWHERE & i DON'T KNOW HOW HE COULD DO iT

Figure 233—WHO IS GOD? (holiday card). 1960s
Photo-offset in black
Sheet: 7 x 12" Composition: 6½ x 11⅞"
Paper: Machine-made Edition: Unknown
Signature: *Ben and Bernarda*, verso
Collection: New Jersey State Museum; gift of Barbara E. Johnson.
 Accession No: 70.233.1

WHO iS GOD?*WELL IT iS AN iNViSiBLE PERSON AND HE LiVES UP iN HEAVEN* i GUESS UP iN OUTER SPACE*HE MADE THE EARTH AND THE HEAVEN & THE STARS AND THE SUN AND THE PEOPLE*HE MADE LiGHT HE MADE DAY HE MADE NiGHT*HE HAS SUCH POWER-FUL EYES HE DOESN'T HAVE MiLLiONS AND THOUSANDS AND BiLLiONS AND HE CAN STiLL SEE US WHEN WE'RE BAD* HE STARTED ALL THE PLANTS GROWiNG*TO ME i THiNK OF HiM WHO MAKES FLOWERS & GREEN GRASS & THE BLUE SKY & THE YELLOW SUN*GOD iS EVERYWHERE & i DON'T KNOW HOW HE COULD DO iT

Figure 234—WHO IS GOD (holiday card variant). 1960s
Photo-offset in black with brush drawing
Sheet: 7 x 12" Composition: 6½ x 11⅞"
Paper: Machine-Made
Edition: Unique
Signature: None
Collection: New Jersey State Museum; gift of Bernarda Bryson Shahn.
 Accession No: 70.336.3

Bernarda Shahn recalls that a New York acquaintance named Tony Schwartz once asked Shahn to design a holiday card to be distributed by his firm along with a small phonograph recording called "Christmas in New York." The recording included the voices of various children expressing their thoughts on Christmas. Shahn combined their phrases to complement his image of a soulful young boy pondering the eternal question, "Who is God?"

In lettering this card Shahn again used the style that had grown out of his interest in what he called a "folk alphabet," which, through the years, he combined with his vast knowledge of formal lettering to create new and very personal forms. Usually, as in this example, his lettering is an integrated part of the composition, of equal importance to the image.

This particular card, which the Shahns sent at Christmas to a Princeton friend, Barbara E. Johnson, includes a personal message on the reverse side.

One afternoon, as Mrs. Shahn and I were looking through materials in Shahn's studio, we came upon this holiday card. It illustrates Shahn's thinking as, brush in hand, he contemplated a variation on an image already produced. He was apparently wondering whether the angelic wings would improve the composition.

This variant of the preceding card (see fig. 233) was folded, placing the image of the boy on the cover and the text on the back.

Figure 235—BEHOLD HOW GOOD
(holiday card). 1960s
Photo-offset in black and red
Sheet: 13 x 10″ Composition: 12½ x 9¾″
Paper: Machine-made
Edition: unknown
Signature: *Ben and Bernarda* in pencil lower right
Collection: New Jersey State Museum;
gift of Barbara E. Johnson. Accession No: 70.233.2

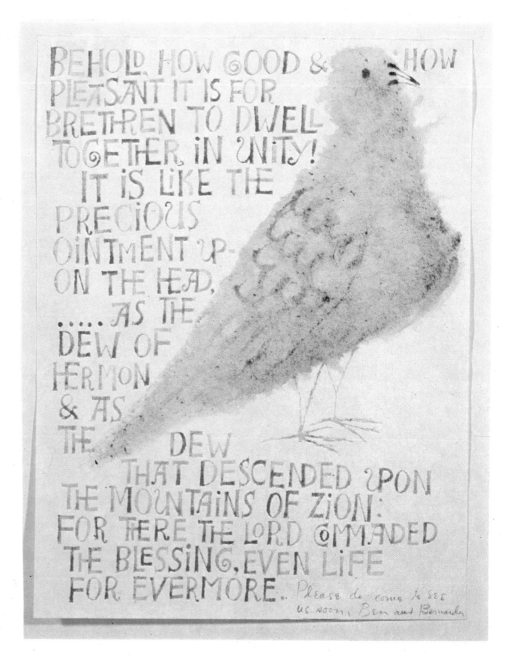

Shahn combined the dove, symbol of peace, with Psalm 133 in several works (see figs. 45, 53, and 106). Whereas the full text of the psalm is included in those other works, here it is somewhat abridged to facilitate the more spacious lettering from his very personal alphabet. The robust dove in this picture is more realistic, from an ornithological viewpoint, than the stiff forms of the other doves. The delicate gray, combined with a few darker swirls on the wings, effectively suggests the softness of feathers.

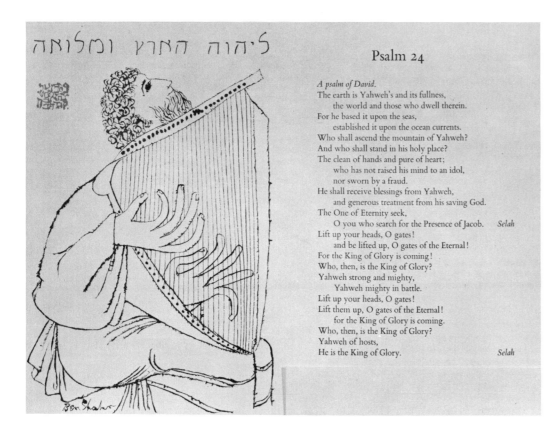

לַיהוָה הָאָרֶץ וּמְלוֹאָהּ

Psalm 24

A psalm of David.
The earth is Yahweh's and its fullness,
 the world and those who dwell therein.
For he based it upon the seas,
 established it upon the ocean currents.
Who shall ascend the mountain of Yahweh?
And who shall stand in his holy place?
The clean of hands and pure of heart;
 who has not raised his mind to an idol,
 nor sworn by a fraud.
He shall receive blessings from Yahweh,
 and generous treatment from his saving God.
The One of Eternity seek,
 O you who search for the Presence of Jacob. *Selah*
Lift up your heads, O gates!
 and be lifted up, O gates of the Eternal!
For the King of Glory is coming!
Who, then, is the King of Glory?
Yahweh strong and mighty,
 Yahweh mighty in battle.
Lift up your heads, O gates!
Lift them up, O gates of the Eternal!
 for the King of Glory is coming.
Who, then, is the King of Glory?
Yahweh of hosts,
He is the King of Glory. *Selah*

Figure 236—PSALM 24 (holiday card). 1965
Photo-offset in black
Sheet: 7¾ x 10¾" Composition: 7⅜ x 9¾"
Paper: Machine-made
Printer: Clarke and Way, Inc.
Edition: Unknown
Signature: *Ben Shahn* reproduced in black lower left and
 red chop reproduced upper left; *Ben and Bernarda,* verso
Collection: New Jersey State Museum; gift of Barbara E. Johnson.
 Accession No: 70.233.5

This holiday card, sent by the Shahns to their friend Barbara E. Johnson, has a personal inscription (covered, lower right) which begins, "Barbara dear…," and is completed and signed "Ben and Bernarda" verso.

The front of the card is blank and the image and text appear as the card is opened. Expressed in three words in Hebrew is the opening phrase of the psalm. The translation on the card is from The Anchor Bible. The back carries copyright information, identification of the artist, and a note about the history of the Psalms and the translation.

This image of a bearded man playing a cithara was repeated by Shahn in a 1969 drawing, which was published posthumously as one of the Psalm 150 lithographs, *Man Playing Cithara* (fig. 251). Another version (see fig. 265) is in the posthumous Hallelujah Suite. Although all three are instantly recognizable as Shahn's works, they are distinct in many details. *Psalm 24* is the only one with the text as part of the composition. The commercial type, used for the psalm's text, is barren next to Shahn's calligraphy.

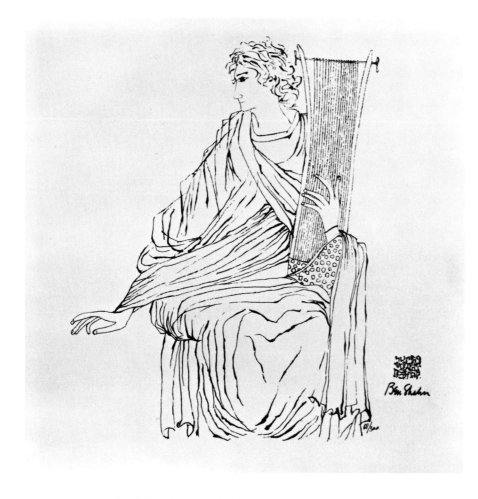

Figure 237 — PSALM 57 (holiday card). 1966
Photo-offset in black
Sheet: 5⅞ x 11⅝" (open) Composition: 5 x 4⅝"
Paper: Machine-made Printer: Zinn Ltd., New York Edition: 1500
Signature: *Ben Shahn* reproduced in black lower right below chop
 reproduced in black
Collection: New Jersey State Museum; gift of Bernarda Bryson Shahn.
 Accession No: 70.336.4

This image is familiar from the 1966 serigraph *Praise Him with Psaltery and Harp* (fig. 73), which was commissioned by the Benrus Watch Company, Inc., and presented to a limited number of the company's business associations. Copies of this greeting card were given to various executives for personal use and sent to selected accounts.[209]

The edition number, *68/300,* seen on the holiday card, was written on the serigraph from which the card was reproduced.

The folded card opens, on the right, to "Seasons Greetings" in four languages; and, facing, on the left is Psalm 57:8-9:

Awake, my glory; awake, psaltery and harp;
I will awake the dawn.
I will give thanks unto Thee, O Lord, among the peoples;
I will sing praises unto Thee among the nations.

A variation of this subject appears in the posthumous Hallelujah Suite (see fig. 282).

UNPUBLISHED WORKS

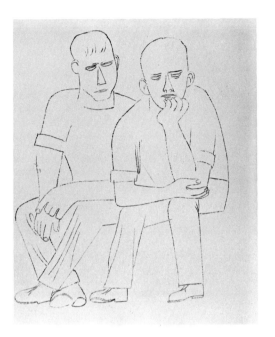

Figure 238—THE EAGLE'S BROOD.
c.1947
Photo-offset in red
Sheet: 15 x 12" Composition: 13 x 10¼"
Paper: Machine-made
Edition: Unpublished; 105 known
Signature: None
Collection: New Jersey State Museum;
purchase. Accession No: 70.320.3

After the war Shahn again collaborated with William Golden of CBS (see fig. 143) to produce a folder on the subject of the growing problem of delinquency in the United States. It was to be named *The Eagle's Brood* and used in connection with a 1947 television program of the same name. Shahn wrote about this assignment: "I was indeed deeply moved by the material in hand, and especially by the treatment given it in the CBS program."[210]

This reproduction is of one of the studies which Shahn did for the brochure. In another study, a drawing of the same subject, the boy on the left has his head turned slightly in the other direction.[211]

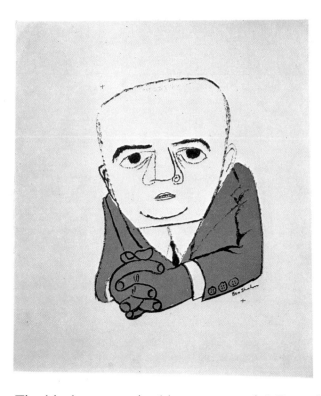

Figure 239—J. PARNELL THOMAS. c.1949
Letterpress in black and blue
Sheet: 13½ x 11¾" Composition: 9¼ x 6⅝"
Paper: Newspaper stock
Edition: Unpublished; approximately 3
Signature: *Ben Shahn* reproduced in black lower right
Collection: New Jersey State Museum; gift of Mrs. Allison Stern.
 Accession No: 70.320.7

Figure 240—J. PARNELL THOMAS. c.1949
Letterpress in black and red
Sheet: 16½ x 11¾" Composition: 8¾ x 6⅞"
Paper: Newspaper stock
Edition: Unpublished; approximately 3
Signature: *Ben Shahn* reproduced in black lower right
Collection: New Jersey State Museum; gift of Mrs. Allison Stern.
Accession No: 70.320.6

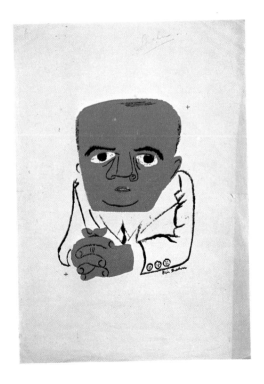

The black print in this blue version of J. Parnell Thomas (see also the red version fig. 240) is a reproduction of a brush drawing, *Friend of the Artist*, now in the New Jersey State Museum Collection.[212] The title of the drawing was found on the mat, although apparently not in Shahn's handwriting. It may have been given by the artist in a moment of wry humor, or it may have been the work of a prankster.

On December 9, 1949, J. Parnell Thomas, Congressman from New Jersey, pleaded nolo contendere (no defense) in a Washington, D.C. Federal District Court to the charge of padding his congressional payroll. He was fined ten thousands dollars and sentenced to six to eighteen months in prison. Previously, as Chairman of the House Un-American Activities Committee, he had won national attention during a 1947 investigation of what he called Communist influence in Hollywood. The following year he was again in the spotlight when, surrounded by newsreel cameras and microphones, he confronted Alger Hiss and Whittaker Chambers in hearings which resulted in the indictment of Hiss for perjury.

In the red version of J. Parnell Thomas the details of the black outline differ somewhat from the blue one (see fig. 239). The line is altogether missing in some areas, where the red delineates the figure.

Near the top of the sheet, the artist has written and underlined "Shahn," not as he customarily signed a print but seemingly to identify it for someone else.

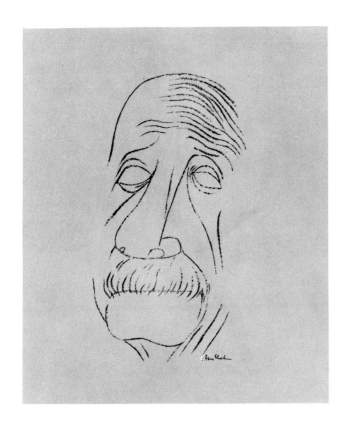

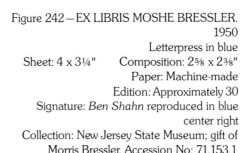

Figure 241—EINSTEIN. 1950
Photo-offset in black
Sheet: 17⅞ x 12" Composition: 8⅞ x 4¾"
Paper: Machine-made
Edition: Unpublished; approximately 30
Signature: *Ben Shahn* reproduced lower right
Collection: New Jersey State Museum;
 purchase. Accession No: 70.320.4

Figure 242—EX LIBRIS MOSHE BRESSLER.
1950
Letterpress in blue
Sheet: 4 x 3¼" Composition: 2⅝ x 2⅜"
Paper: Machine-made
Edition: Approximately 30
Signature: *Ben Shahn* reproduced in blue
center right
Collection: New Jersey State Museum; gift of
Morris Bressler. Accession No: 71.153.1

Shahn's drawing of the late Albert Einstein was used to illustrate the great scientist's article "On the Generalized Theory of Gravitation" in the April, 1950, edition of *Scientific American.* The image in this reproduction is identical to the drawing, now in a private collection. Approximately thirty copies of the unpublished edition were found in Shahn's studio after his death. There is no way of knowing how many he may have given away.

To the knowledge of the author, this is the only book plate by Shahn. He designed it for his old friend, Morris Bressler, using Bressler's Hebrew name on the plate. It was Bressler who had called Shahn's attention to the Talmudic lines "A man of the sword is not a man of the book," and who had also helped with the Hebrew script for the 1950 serigraph, *Where There Is a Book There Is No Sword* (fig. 12).

The head of the mystical fire beast was depicted by Shahn in many different versions. The one in *Ex Libris Moshe Bressler* has no pupil in the right eye. The cover of the 1960 Vintage edition of *The Shape of Content* is reproduced from still another version where the right eye is also empty.

In 1971, Bressler had one thousand copies printed on gray machine-made paper (rather than white, as above) from a photograph taken of an impression from the original edition. It is slightly reduced and printed on a smaller sheet (3⅜ x 2⅜").

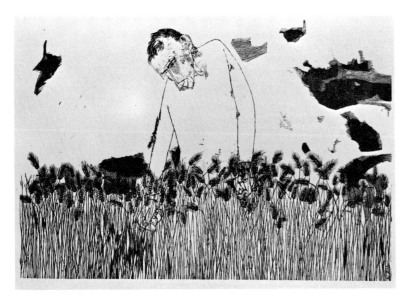

Figure 243—BEATITUDES. 1955
Wood-engraving in black
Sheet: 17 x 22" Composition: 10⅛ x 15⅛"
Paper: Japan
Edition: Unpublished; approximately 50 Printer: Leonard Baskin
Signature: *Ben Shahn* in black on the block lower right and *LB SC* in black
on the block lower left
Collection: New Jersey State Museum; gift of Mr. and Mrs. David Deitz.
Accession No: 70.320.1

In 1955, Leonard Baskin executed an edition of wood-engravings, *Beatitudes,* after a painting by Shahn. The engraved impressions were printed in black, and colors were added with linoleum cuts (see fig. 21). For his and Shahn's own use Baskin pulled a number of impressions (this one included) without adding the colors. Baskin once told me that he had given unsigned copies to friends; and the copies found in Shahn's studio after his death were not signed by hand.

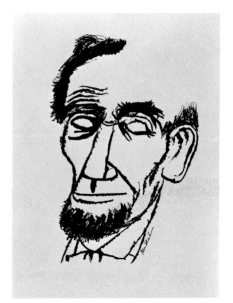

Figure 244—ABRAHAM LINCOLN. 1955
Photo-offset in black
Sheet: 16⅛ x 12¼" Composition: 10⅞ x 7¼"
Paper: Machine-made
Edition: Unpublished; approximately 1,000
Signature: *Ben Shahn* in black on the plate
lower right
Collection: New Jersey State Museum; purchase.
Accession No: 70.320.5

The sure brush strokes delineating the facial features in this strong and sympathetic portrait of Abraham Lincoln have the unmistakable characteristics of a work by Shahn. At one time Shahn had a stock of approximately one hundred copies in his studio, and he enjoyed signing them for friends.

The Lincoln portrait was commissioned by Charles Pfizer & Co., the pharmaceutical firm, for the cover of both the company magazine *Pfizer Spectrum* and an advertising insert in the *Journal of the American Medical Association.*[213] In the company magazine the Lincoln cover illustrated a one page article titled "Death of a President." In both the magazine and the insert the words "Pfizer Spectrum" were printed in the upper right of the open section of the forehead.

In addition to the *J.A.M.A.* circulation, Pfizer had approximately 25,000 copies of the insert printed for private distribution. Pfizer also made available to the public about one thousand copies printed "on heavy paper, suitable for framing, without Spectrum identification." Mr. Leon Summit, formerly editor of *Spectrum,* informed me that about one hundred copies were requested and distributed. Later, he salvaged approximately fifteen from a large number that had been discarded in a trash barrel. The specific information in relation to Pfizer is based on Mr. Summit's personal files and recollection.

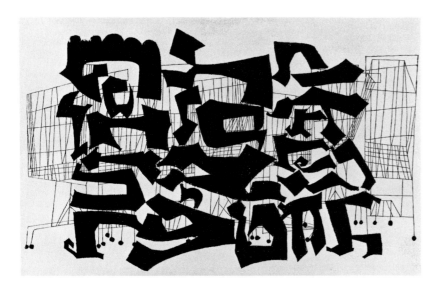

Figure 245—ALPHABET AND SUPERMARKET. 1957
Serigraph in black
Sheet: 27⅛ x 40½" Composition: 22⅛ x 38¼"
Paper: A. Milbourne & Co., British handmade
Edition: Unpublished and unique
Signature: None
Collection: New Jersey State Museum; purchase.
 Accession No: 70.320.23

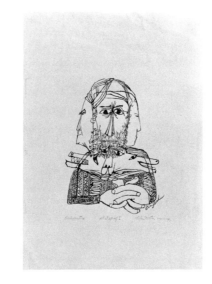

Figure 246—ECCLESIASTES. 1965
Wood-engraving in black
Sheet: 14½ x 10½" Composition: 7½ x 5¾"
Paper: Japan goyu Printer: Stefan Martin
Edition: Unpublished; approximately 30 A.P.
Signature: *Ben Shahn* in black on the block lower right;
 S.M. in white on the block center right; *Ecclesiastes
 artists proof I Stefan Martin, inc. imp.* in pencil below
Collection: New Jersey State Museum; gift of Kramer,
 Hirsch and Carchidi Foundation.
 Accession No: 70.320.12

In 1966, Shahn experimented with conté crayon rubbings made from a cardboard cutout of *Alphabet of Creation* (fig. 24). He combined the rubbings with other motifs in two unique prints, *Alphabet and Maximus* (fig. 63) and *Alphabet and Warsaw* (fig. 64). In this version, *Alphabet of Creation,* turned horizontally, is superimposed on a serigraphic image of *Supermarket* (fig. 27).

On the reverse side of the paper is an unsatisfactory impression of *Supermarket,* in which some of the lines are faulty.

This exquisitely engraved print by Stefan Martin is very faithful to the Shahn serigraph, *Ecclesiastes* (fig. 68). Two-hundred and eighty-five unnumbered engravings, with Hebrew calligraphy added in sepia from a separate block, were bound in Shahn's 1965 limited edition of *Ecclesiastes, or The Preacher,* published by The Spiral Press. Also included in the book were the engravings *Maimonides* (fig. 248) and *Rex* (fig. 249). A small number of artist's proofs, of which this is one, were pulled by Martin and shared with Shahn.

In December 1970, the executors of the Estate of Ben Shahn authorized Stefan Martin to produce an edition of one hundred prints, numbered and signed, and five artist's proofs of each of the three engravings in the series. The cancellation proofs were delivered to the estate upon completion of the editions. The prints were placed on consignment with the Kennedy Galleries, with the net proceeds from sales to be shared equally between the estate and Martin.

These posthumous editions were executed according to plans that Shahn had discussed with Martin before his death.

The turbaned and bearded man in this portrait is Maimonides, the twelfth-century Jewish philosopher and master of rabbinical literature. His head is recognizable from several other works by Shahn: the 1956 watercolor *Apotheosis* (detail);[214] the 1954 watercolor *Maimonides;*[215] and the 1954 drawing *Study for "Maimonides."*[216]

Engraved by Stefan Martin after a drawing by Shahn, this print, with the addition of Hebrew calligraphy, was used for the frontispiece of the 1965 edition of *Ecclesiastes, or The Preacher* (see fig. 246). The example shown here is one of about thirty artist's proofs which Martin shared with Shahn.

Figure 247—MAIMONIDES. 1965
Wood-engraving in black
Sheet: 14½ x 10½" Composition: 7¾ x 6¼"
Paper: Japan goyu
Printer: Stefan Martin
Edition: Unpublished; approximately 30 A.P.
Signature: *Ben Shahn* in black on the block lower right; *S.M.* in white on the block lower center left; *Maimonides artists proof I Stefan Martin, inc. imp.* in pencil below
Collection: New Jersey State Museum; purchase.
 Accession No: 70.320.11

Figure 248—MAIMONIDES WITH CALLIGRAPHY. 1965
Wood-engraving in black and sepia
Sheet: 14½ x 10½" Composition: 9⅜ x 7⅛"
Paper: Japan goyu
Printer: Stefan Martin
Edition: Unpublished, artist's proof; approximately 40 A.P.
Signature: *Ben Shahn* in black on the block lower right; *S.M.* in white on the block lower center left; *'Ecclesiastes book; Maimonides artists proof Stefan Martin inc. imp.* in pencil below
Collection: New Jersey State Museum; gift of Kramer, Hirsch and Carchidi Foundation.
 Accession No: 70.320.13

This artist's proof of *Maimonides* is the same as fig. 247, but with the addition of Hebrew calligraphy, which was engraved by Stefan Martin on a separate block and added in sepia to the black impression. The engraving was used in this form as the frontispiece of the 1965 *Ecclesiastes, or The Preacher* (see fig. 246). The Hebrew inscription is from Ecclesiastes, 1:1-2 and reads, in the King James Version:

The words of the Preacher, the son of David, king in Jerusalem.
Vanity of vanities, saith the Preacher, vanities of vanities; all *is* vanity.

In 1970, a posthumous edition of one hundred copies of this version of *Maimonides* was authorized by the Estate of Ben Shahn (see fig. 246).

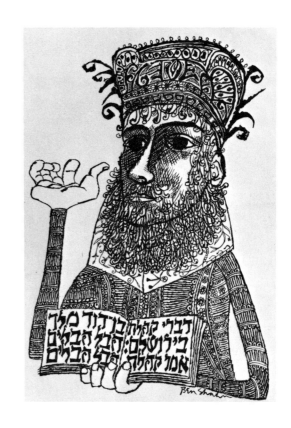

Figure 249—REX. 1965
Wood-engraving in black
Sheet: 14½ x 10½" Composition: 9⅜ x 6½"
Paper: Japan goyu
Printer: Stefan Martin
Edition: Unpublished; approximately 30 A.P.
Signature: *Ben Shahn* in black on the block lower right;
Rex artists proof I Stefan Martin, inc. imp. in pencil below
Collection: New Jersey State Museum; gift of
Samuel J. Hamelsky. Accession No: 70.320.10

This regal figure was engraved by Stefan Martin after a Shahn drawing for the 1965 book, *Ecclesiastes, or The Preacher* (see fig. 246). The Hebrew inscription is the same quotation from Ecclesiastes as in *Maimonides* (fig. 248). Besides the book edition, Martin pulled approximately thirty artist's proofs which he shared with Shahn. This example does not have the letters *S.M.* engraved within the lower left Hebrew letter, but the engraver's initials were added on the block for the book edition; they are therefore also found in the 1970 posthumous edition of one hundred, authorized by the Estate of Ben Shahn (see fig. 246).

WORKS PUBLISHED POSTHUMOUSLY

PSALM 150 Posthumous Edition/1969-70

In the late sixties, Mr. and Mrs. Robert H. Smith and Mr. and Mrs. Robert P. Kogod of the Washington, D.C., area invited Shahn to create a mosaic mural for a Jewish community center in Rockville, Maryland. They gave him free rein in selection of theme, design, and installation of the mural. Shahn responded enthusiastically and prepared a series of magnificent drawings of musicians with ancient instruments, inspired by the exultant lines in Psalm 150, "A Hallelujah Chorus:"

> Praise ye the Lord. Praise God in his sanctuary:
> praise him in the firmament of power.
> Praise him for his mighty acts: praise him according to his excellent greatness.
> Praise him with the sound of the trumpet:
> praise him with psaltery and harp.
> Praise him with the timbrel and dance:
> praise him with the stringed instruments and organs.
> Praise him upon the loud cymbals:
> praise him upon the high sounding cymbals.
> Let everything that hath breath praise the Lord.
> Praise ye the Lord.

Unfortunately, the plans for the mural never went beyond the drawing stage because of Shahn's untimely death in 1969. However, the executors of the Ben Shahn Estate authorized the posthumous publication of a series of eight lithographs taken from the mural drawings. Faithfully reproduced in exact size by Mourlot Graphics Ltd., New York, for Kennedy Graphics, Inc., the lithographs, together with the *Hallelujah Suite,* add an important concluding dimension to the graphic work of Ben Shahn.

In the same manner in which he had collaborated with Shahn on earlier editions, Jacques Mourlot executed the series of eight, making copies of the drawings on transfer paper in preparation for the lithographic printing from zinc plates.

Figure 250—CHIME-BELL PLAYER (Psalm 150).
 1969-70
Lithograph in black
Sheet: 40⅝ x 25⅞" Composition: 37¾ x 24¾"
Paper: Velin d'Arches
Publisher: Kennedy Graphics, Inc., New York
Printer: Mourlot Graphics Ltd., New York
Edition: 125
Signature: *Signed for Ben Shahn by Bernarda B. Shahn*
 in pencil lower left; *Mourlot Lith.* in pencil lower right
Collection: New Jersey State Museum; purchase.
 Accession No: 69.269.3

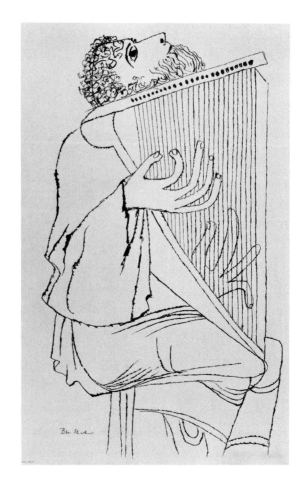

Figure 251—MAN PLAYING CITHARA (Psalm 150).
1969-70
Lithograph in black
Sheet: 40⅝ x 25⅞" Composition: 38¾ x 22¼"
Paper: Velin d'Arches
Publisher: Kennedy Graphics, Inc., New York
Printer: Mourlot Graphics Ltd., New York
Edition: 125
Signature: *Ben Shahn* in black on plate lower left above
J. Mourlot Grav. Lith. in black on plate
Collection: New Jersey State Museum; purchase.
Accession No: 69.269.4

Occasionally, Shahn portrayed people with empty faces or with heads only partially enclosed, as in *Andante* (fig. 65) and *Triple Dip* (fig. 17). In this lithograph, the details are omitted in order not to compete with the musician's upraised arms, poised to strike the bells. The beautifully arranged folds in the garment, enshrouding the elongated torso, carry the viewer's attention to the arrested action.

The lithograph is taken from a brush drawing titled *Drummer*[217] (see p. 197). Shahn drew another version for the Hallelujah Suite, *Man Striking Chime-Bells* (fig. 272) which includes the bells.

There is an almost mysterious unity of musician and instrument in this presentation of the cithara player. In the outline of his hair and clothing the deeply attentive musician seems to reflect the very vibrations of the instrument.

Shahn included another version of the same musician in the Hallelujah Suite, *Man Playing Cithara* (fig. 265). See also the holiday card, *Psalm 24* (fig. 236).

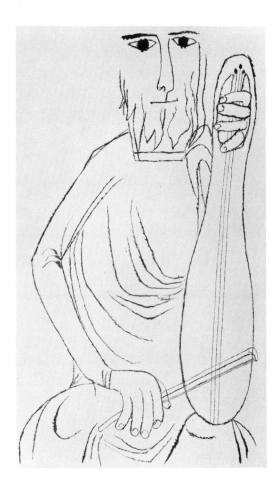

Figure 252—OLD MAN PLAYING CROWTH
 (Psalm 150). 1969-70
Lithograph in black
Sheet: 40⅝ x 25⅞" Composition: 36 x 21¾"
Paper: Velin d'Arches
Publisher: Kennedy Graphics, Inc., New York
Printer: Mourlot Graphics Ltd., New York
Edition: 125
Signature: *Signed for Ben Shahn by Bernarda B. Shahn*
 in pencil lower left; *Mourlot Lith.* in pencil lower right
Collection: New Jersey State Museum; purchase.
 Accession No: 69.269.2

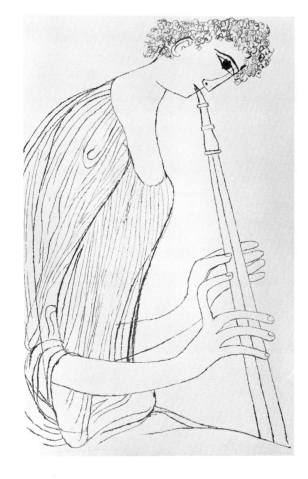

Figure 253—YOUNG MAN PLAYING DOUBLE OBOE
(Psalm 150). 1969-70
Lithograph in black
Sheet: 40⅝ x 25⅞" Composition: 38¾ x 25"
Paper: Velin d'Arches
Publisher: Kennedy Graphics, Inc., New York
Printer: Mourlot Graphics Ltd., New York
Edition: 125
Signature: *Signed for Ben Shahn by Bernarda B. Shahn*
in pencil lower left; *Mourlot Lith.* in pencil lower right
Collection: New Jersey State Museum; purchase.
Accession No: 69.269.1

The stringed instrument in this print is the crowth, as pictured in an eleventh-century manuscript, where it is shown to have the same basic shape—three strings and an opening for the fingers—but is being played with a curved bow. In a later version which Shahn drew for the Hallelujah Suite, *Old Man Playing Crowth* (fig. 267), the player is shown using a curved bow.

Shahn used great economy of line in portraying this musician. A few jagged lines indicate the beard and the folds of the loose garment. The upper margin of the paper cuts the image off just above the eyebrows, helping to focus attention on the player's intense eyes, which gaze straight at the viewer. Shahn often left the details of his portraits to the imagination of the beholder, as in *Wilfred Owen* (fig. 23) and *Abraham Lincoln* (fig. 244).

This lithograph was taken from a brush drawing (see p. 197).[218]

The height of the young oboe player is emphasized by the now familiar view of a head reaching beyond the limit of the paper for its completion. Reinforcing the elongation of the torso are the narrow, vertical folds of the soft garment.

This version is taken from a brush drawing (see p. 197).[219] Another version is included in the Hallelujah Suite, *Young Man Playing Double Oboe* (fig. 280).

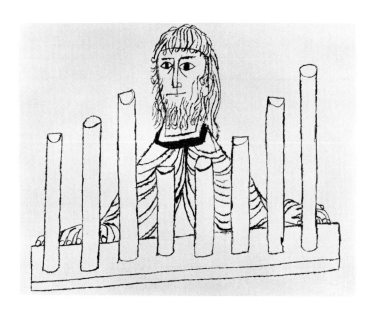

Figure 254—MAN PLAYING ORGAN
 (Psalm 150). 1969-70
Lithograph in black
Sheet: 20⅛ x 25½"
Composition: 19 x 22¾"
Paper: Velin d'Arches
Publisher: Kennedy Graphics, Inc.,
 New York
Printer: Mourlot Graphics Ltd., New York
Edition: 125
Signature: *Mourlot Lith.* in pencil lower
 right
Collection: New Jersey State Museum;
 gift of New Jersey Bell Telephone Co.
Accession No: 70.185.2

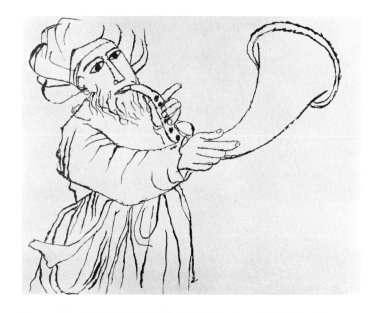

Figure 255—MAN SOUNDING HORN (Psalm 150). 1969-70
Lithograph in black
Sheet: 20⅛ x 25½" Composition: 19½ x 23⅜"
Paper: Velin d'Arches
Publisher: Kennedy Graphics, Inc., New York
Printer: Mourlot Graphics Ltd., New York
Edition: 125
Signature: *Mourlot Lith.* in pencil lower right
Collection: New Jersey State Museum; purchase.
 Accession No: 70.185.3

Shahn drew several versions of angels playing organs, including the one for the poster *Lincoln Center for the Performing Arts* (fig. 177). Always the angel is seated in front of the organ with his head tilted back as if in ecstasy, his softly curving wings falling in a mass of feathers from his shoulders. In this print, Shahn pictured a mortal, seated behind the organ and framed by its pipes. The impression is of fingers, resting on the keyboard in anticipation, and of alert eyes watching for the cue to begin the music.

This lithograph is taken from a brush drawing (see p. 197).[220] Another version of *Man Playing Organ* appears in the Hallelujah Suite (fig. 259).

The heavily gowned and turbaned man is playing a large curved horn with finger holes, of the type found in Eastern Europe and Persia. In another version, *Man Sounding Shofar* (fig. 263), included in the Hallelujah Suite, the horn is shown without finger holes and therefore is more like the old Hebrew shofar.

This version is taken from a brush drawing (see p. 197).[221]

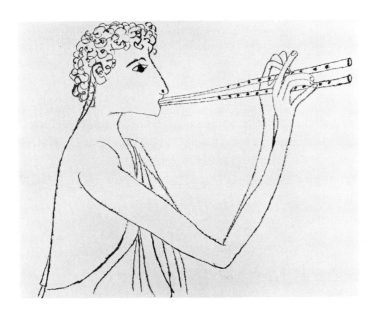

Figure 256—YOUNG MAN PLAYING DOUBLE PIPE (Psalm 150).
 1969-70
Lithograph in black
Sheet: 20 x 25½" Composition: 19¾ x 23¼"
Paper: Velin d'Arches
Publisher: Kennedy Graphics, Inc., New York
Printer: Mourlot Graphics Ltd., New York
Edition: 125
Signature: *Mourlot Lith.* in pencil lower right
Collection: New Jersey State Museum; purchase.
 Accession No: 71.85.2

Figure 257—CLANGING CYMBALS (Psalm 150). 1969-70
Lithograph in black
Sheet: 20 x 25½" Composition: 18⅛ x 21¼"
Paper: Velin d'Arches
Publisher: Kennedy Graphics, Inc., New York
Printer: Mourlot Graphics Ltd., New York
Edition: 125
Signature: *Mourlot Lith.* in pencil lower right
Collection: New Jersey State Museum; purchase.
 Accession No: 71.85.1

The extremely elongated arms of this youthful musician lift the long pipes with great ease. Another version of *Young Man Playing Double Flute* appears in the Hallelujah Suite (fig. 262). The subject is taken from a brush drawing, *Angel Playing Flute* (see p. 197).[222]

The subject of this lithograph was taken from a brush drawing, *Hands*,[223] which was one of Shahn's sketches for an unfinished mural design (see p. 197). It also exists in another version, in the Hallelujah Suite (fig. 279).

HALLELUJAH SUITE Posthumous Edition/1970-71

The fifty lithographs (including images and calligraphy) in the Hallelujah Suite are bound in book form in a limited deluxe edition of 240 numbered copies. (The New Jersey State Museum's copy is numbered 2.) There are also ten copies lettered A to J. The series illustrates, in picture and calligraphy, Psalm 150 of the Old Testament. The typography was arranged and printed at The Spiral Press, and the binding and cases executed by the Moroquain Bindery, New York.

Just prior to his death, Ben Shahn completed all drawings for this work and arranged them in a mock-up, indicating in detail how he wished to have them produced and assembled. Kennedy Graphics, Inc., New York, with the permission of the executors of the Shahn Estate, published this last work, faithfully following Shahn's instructions.

In preparing the suite, Shahn used many of the same motifs as in the drawings for an unfinished mural design intended for a community center in Rockville, Md. (see p. 197). However, most of the Hallelujah Suite drawings differ markedly from the earlier versions and are particularly important because they represent Shahn's last work.

From his original drawings (measuring roughly 8¾ x 7½") and their related calligraphy, Shahn made photostatic enlargements, which he planned to redraw on transfer paper for preparation of the lithographic plates. But he died before this last stage could be accomplished. Jacques Mourlot, who had been working closely with Shahn on the project, completed the transfer and supervised the production of the edition by his staff artisans.

On the back cover of the Hallelujah Suite, and on the slipcase, is a black square of simulated leather with the Hebrew characters for "Hallelujah" and Ben Shahn's signature reproduced in gold. The design is taken from Shahn's drawing for the Hebrew title. The suite is intended to be read from back to front, in the Hebrew tradition. On the front cover, "Hallelujah" appears in Roman lettering, again in gold on a black background, and accompanied by Shahn's signature.

When discussing production procedures with Jacques Mourlot,

Shahn had been concerned that the size of his compositions would leave unused space at the bottom of the expensive paper. He therefore proposed to make photostatic copies of the drawings in reduced size, which would be transferred to the plates and printed at the same time as the full-sized lithographs. Shahn thought that the smaller lithographs would be useful in promotion of the suite and as gifts to friends. His wishes in this respect were also followed and resulted in two editions of miniatures. One is the unbound edition of Hallelujah Miniatures No. 1 with Calligraphy, figs. 284 to 309 inclusive. The other is the unbound edition of Hallelujah Miniatures No. 2 Without Calligraphy, figs. 310 to 333 inclusive.

Bernarda Bryson Shahn was especially desirous that the Hallelujah Suite drawings be published "exactly as Ben wanted them." In her introduction, she discusses Shahn's return to religious themes:

> During the later years of Ben's life there was a certain resurgence of religious imagery in his work. It seemed to me that, since he had rather emphatically cast off his religious ties and traditions during his youth, he could now return to them freely with a fresh eye, and without the sense of moral burden and entrapment that they once held for him. He rediscovered myth and story and a holy spirit that had once offended him but that now held tremendous charm, even amusement, and that he could now depict with a light touch and with affectionate tenderness....

The publication of the Hallelujah Suite was a fitting culmination to Shahn's friendship with Fernand Mourlot and his son Jacques, which began in Paris in 1963 when three of Shahn's lithographs (see figs. 50, 51, and 53) were produced in the elder Mourlot's atelier. The introduction to the Hallelujah Suite includes a warmly emotional letter from Fernand Mourlot in which he draws attention to Shahn's thoroughness in planning this last work.

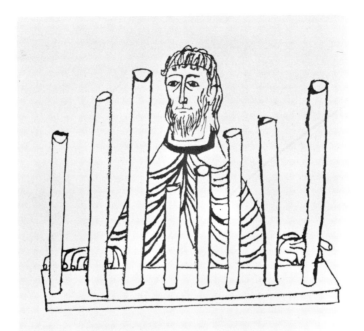

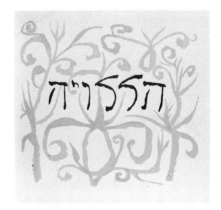

Figure 259A

Figure 258—HEBREW HALLELUJAH (Hallelujah
 Suite). 1970-71
Lithograph in black
Sheet: 16¼ x 35″ Composition: 7½ x 8½″
Paper: Arches Grand Velin
Publisher: Kennedy Graphics, Inc., New York
Printer: Mourlot Graphics Ltd., New York
Edition: 250
Signature: *Ben Shahn* on the plate lower center
Collection: New Jersey State Museum; purchase.
 Accession No: None

Figure 259—MAN PLAYING ORGAN (Hallelujah Suite). 1970-71
Lithograph in black and yellow
Sheet: 16¼ x 35″ Composition: 13⅛ x 31⅞″ (text and image)
Paper: Arches Grand Velin
Publisher: Kennedy Graphics, Inc., New York
Printer: Mourlot Graphics Ltd., New York
Edition: 250
Signature: None
Collection: New Jersey State Museum; purchase. Accession No: 70.288.a

In his rendering of the Hebrew title, Shahn arranged the characters into a handsome design, which reminds the viewer of his deep and lasting love affair with calligraphy.

The dignified and robed organist differs greatly from other works by Shahn on the same theme, which feature an ecstatic angel at the organ (see *Lincoln Center for the Performing Arts*, fig. 177). He is however, essentially the same figure as that in *Man Playing Organ* (fig. 254) of Psalm 150, although drawn with a heavier line.

 On the facing page the black Hebrew calligraphy, "Hallelujah" (fig. 259a), is enclosed in a yellow branching design. Variations on this design occur throughout the suite.

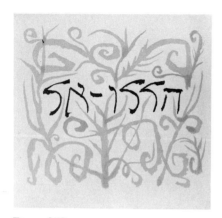

Figure 260a

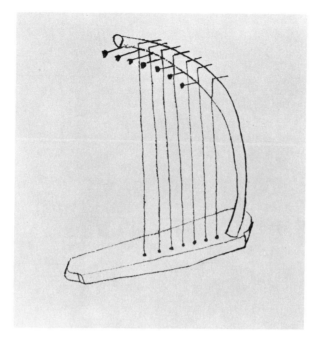

Figure 260 — PSALTERY (Hallelujah Suite). 1970-71
Lithograph in black and yellow
Sheet: 16¼ x 35" Composition: 12⅞ x 30⅛" (text and image)
Paper: Arches Grand Velin
Publisher: Kennedy Graphics, Inc., New York
Printer: Mourlot Graphics Ltd., New York Edition: 250
Signature: None
Collection: New Jersey State Museum; purchase. Accession No: 70.288.b

In a few of the lithographs in this series, instruments are presented without their performers. Here a primitive stringed instrument complements the Hebrew "Praise God" (fig. 260a) on the facing page.

Figure 261a

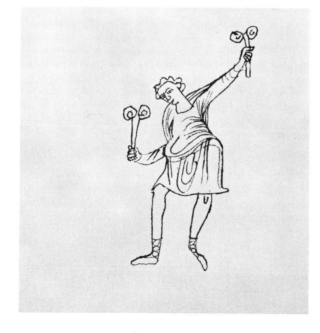

Figure 261 — YOUNG MAN PLAYING SISTRUM (Hallelujah Suite). 1970-71
Lithograph in black and yellow
Sheet: 16¼ x 35" Composition: 12½ x 26¾" (text and image)
Paper: Arches Grand Velin
Publisher: Kennedy Graphics, Inc., New York
Printer: Mourlot Graphics Ltd., New York Edition: 250
Signature: None
Collection: New Jersey State Museum; purchase. Accession No: 70.288.c

The subject of this lithograph is the same as in one of Shahn's brush drawings for an unfinished mural design (see p. 197),[224] although this version lacks the youthful grace of the performer in the sketch. The line is heavier here and it seems that the whole arm is involved in the motion of the sistrum, whereas in the earlier version Shahn masterfully indicated that the motion is provided by the wrist.

The Hebrew calligraphy on the facing page reads: "In His Sanctuary" (fig. 261a).

Figure 262a

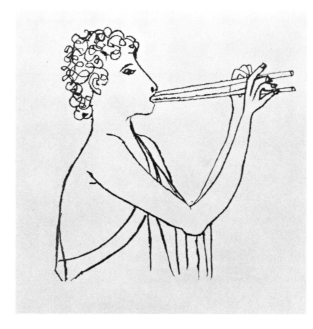

Figure 262—YOUNG MAN PLAYING DOUBLE FLUTE
 (Hallelujah Suite). 1970-71
Lithograph in black and yellow
Sheet: 16¼ x 35" Composition: 13 x 30¼" (text and image)
Paper: Arches Grand Velin
Publisher: Kennedy Graphics, Inc., New York
Printer: Mourlot Graphics Ltd., New York
Edition: 250
Signature: None
Collection: New Jersey State Museum; purchase. Accession No: 70.288.d

The young musician is recognizable from *Young Man Playing Double Pipe* (fig. 256) of Psalm 150. In that version, Shahn indicated a series of finger holes which required delicate fingering. The fingering is implied here too, even though the holes are missing.

The Hebrew calligraphy on the facing page reads: "Praise Him" (fig. 262a).

Figure 263a

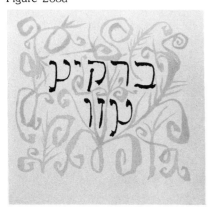

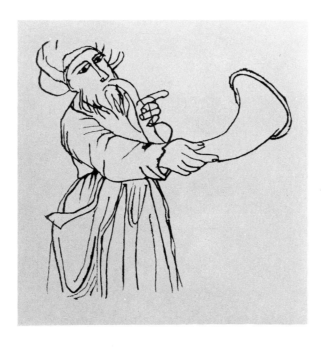

Figure 263—MAN SOUNDING SHOFAR (Hallelujah Suite). 1970-71
Lithograph in black and yellow
Sheet: 16¼ x 35" Composition: 13½ x 31⅞" (text and image)
Paper: Arches Grand Velin Publisher: Kennedy Graphics, Inc., New York
Printer: Mourlot Graphics Ltd., New York Edition: 250 Signature: None
Collection: New Jersey State Museum; purchase. Accession No: 70.288.e

Again, the image is familiar from the Psalm 150 series, where it appears as *Man Sounding Horn* (fig. 255). Here Shahn has eliminated the finger holes on the horn, making it the old Hebrew type of instrument. The fingering, however, is the same.

The Hebrew calligraphy on the facing page reads: "In the Firmament of His Power" (fig. 263a).

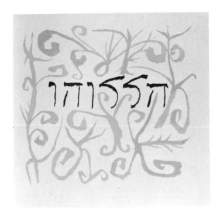

Figure 264a

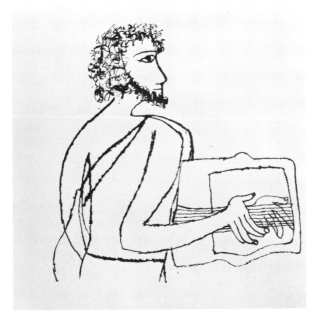

Figure 264 — MAN PLAYING KETHARAH (Hallelujah Suite). 1970-71
Lithograph in black and yellow
Sheet: 16¼ x 35" Composition: 13⅜ x 29¾" (text and image)
Paper: Arches Grand Velin
Publisher: Kennedy Graphics, Inc., New York
Printer: Mourlot Graphics Ltd., New York
Edition: 250
Signature: None
Collection: New Jersey State Museum; purchase. Accession No: 70.288.f

Although the subject is the same as in the Shahn brush drawing *Harpist* (see p. 197),[225] Shahn used a much heavier and rougher line when he prepared the drawing for this lithograph. The instrument is also pictured with a lesser number of strings.

The Hebrew calligraphy on the facing paper reads: "Praise Him" (fig. 264a).

Figure 265a

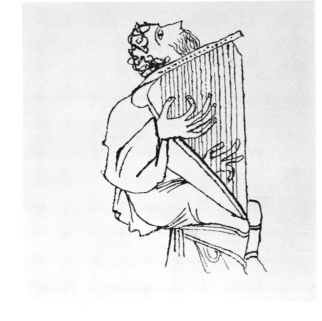

Figure 265 — MAN PLAYING CITHARA (Hallelujah Suite). 1970-71
Lithograph in black and yellow
Sheet: 16¼ x 35" Composition: 13¼ x 28⅝" (text and image)
Paper: Arches Grand Velin
Publisher: Kennedy Graphics, Inc., New York
Printer: Mourlot Graphics Ltd., New York
Edition: 250
Signature: None
Collection: New Jersey State Museum; purchase. Accession No: 70.288.g

Man Playing Cithara is a recurring subject in Shahn's work. It is familiar from the lithograph of the same title (fig. 251) in the Psalm 150 series. He also used the image in a 1965 holiday card (see fig. 236), where it was accompanied by Psalm 24.

The Hebrew calligraphy on the facing page reads: "For His Mighty Acts" (fig. 265a).

Figure 266a

Figure 266—YOUTH PLAYING "VIOLIN" (Hallelujah Suite). 1970-71
Lithograph in black and yellow
Sheet: 16¼ x 35" Composition: 12⅞ x 28⅜" (text and image)
Paper: Arches Grand Velin Publisher: Kennedy Graphics, Inc., New York
Printer: Mourlot Graphics Ltd., New York Edition: 250 Signature: None
Collection: New Jersey State Museum; purchase. Accession No: 70.288.h

Although Shahn's interest in presenting musicians in classical garments, performing on ancient instruments, seemed to intensify during the last year or so of his life, the love for the subject had been with him for many years. In 1966 he did a brush drawing, titled *Study of Angel with Lute*,[226] and this lithograph is a variation. The youth is playing what must be an early relative of today's violin.

The Hebrew calligraphy on the facing page reads: "Praise Him" (fig. 266a).

Figure 267a

Figure 267—OLD MAN PLAYING CROWTH (Hallelujah Suite). 1970-71
Lithograph in black and yellow
Sheet: 16¼ x 35" Composition: 13½ x 29½" (text and image)
Paper: Arches Grand Velin Publisher: Kennedy Graphics, Inc., New York
Printer: Mourlot Graphics Ltd., New York Edition: 250 Signature: None
Collection: New Jersey State Museum; purchase. Accession No: 70.288.i

Old Man Playing Crowth is remembered from the lithograph of the same name (fig. 252) in the Psalm 150 series. Here, as in the other instances, it is found that the line is heavier than in the early version. By this time, too, Shahn seems to have decided that a curved bow was more suitable for the ancient instrument than a straight one.

The Hebrew calligraphy on the facing page reads: "According to His Abundant Greatness" (fig. 267a).

Figure 268a

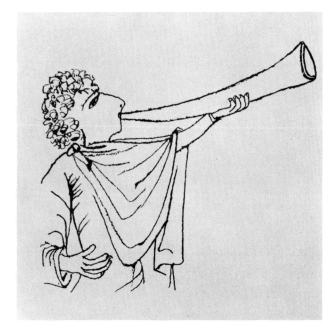

Figure 268—YOUTH SOUNDING TRUMPET (Hallelujah Suite). 1970-71
Lithograph in black and yellow
Sheet: 16¼ x 35" Composition: 12¾ x 31¾" (text and image)
Paper: Arches Grand Velin Publisher: Kennedy Graphics, Inc., New York
Printer: Mourlot Graphics Ltd., New York Edition: 250 Signature: None
Collection: New Jersey State Museum; purchase. Accession No: 70.288.j

A precursor of this work is among the studies Shahn did for his unfinished mural design (see p. 197),[227] In that earlier version, a cape is barely suggested, and only a portion of the head is indicated by little curls of hair. Here, however, the head and figure are more complete and the clothing is outlined in some detail.

An angel in the 1953 holiday card *Praise Ye the Lord* (fig. 226) is sounding praise with a trumpet similar to the one seen here.

The Hebrew calligraphy on the facing page reads: "Praise Him" (fig. 268a).

Figure 269a

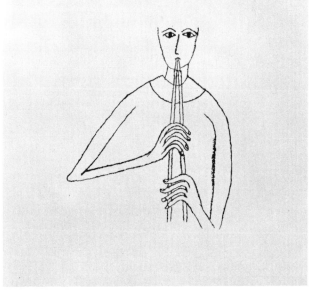

Figure 269—YOUTH PLAYING TWIN REEDS (Hallelujah Suite). 1970-71
Lithograph in black and yellow
Sheet: 16¼ x 35" Composition: 13 x 30" (text and image)
Paper: Arches Grand Velin
Publisher: Kennedy Graphics, Inc., New York
Printer: Mourlot Graphics Ltd., New York
Edition: 250
Signature: None
Collection: New Jersey State Museum; purchase. Accession No: 70.288.k

The slenderness of the reeds or pipes seems to echo the elongated and uncommonly thin arms of this musician. Lack of detail in clothing and an uncompleted head leave the emphasis on the eyes and the act of playing.

The impression of frailness, engendered by the image in this print, contrasts sharply with the phrase from the psalm, printed in Hebrew calligraphy on the facing page: "With the Blast of the Horn" (fig. 269a).

Figure 270a

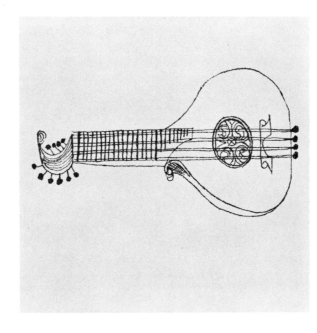

Figure 270—LUTE (Hallelujah Suite). 1970-71
Lithograph in black and yellow
Sheet: 16¼ x 35" Composition: 12¾ x 32" (text and image)
Paper: Arches Grand Velin
Publisher: Kennedy Graphics, Inc., New York
Printer: Mourlot Graphics Ltd., New York
Edition: 250
Signature: None
Collection: New Jersey State Museum; purchase. Accession No: 70.288.1

Shahn's fascination with lutes dates back, in his graphic works, to the 1957 serigraph *Lute* (fig. 25), which was followed in 1958 by the serigraphs *Lute and Molecule, No. 1 and No. 2* (figs. 29 and 30). Compared to the primitive look of the other instruments in the Hallelujah Suite, this lute is quite sophisticated, with attention given to carved details.

The Hebrew calligraphy on the facing page reads: "Praise Him" (fig. 270a).

Figure 271a

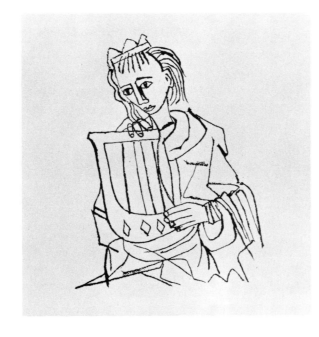

Figure 271—YOUTH WITH LYRE (Hallelujah Suite). 1970-71
Lithograph in black and yellow
Sheet: 16¼ x 35" Composition: 13⅛ x 30⅞" (text and image)
Paper: Arches Grand Velin
Publisher: Kennedy Graphics, Inc., New York
Printer: Mourlot Graphics Ltd., New York
Edition: 250
Signature: None
Collection: New Jersey State Museum; purchase. Accession No: 70.288.m

One can judge by his dress that this melancholy youth playing the lyre may be a priest. The heaviness of the cloth is well defined in the outline of the garment.

The Hebrew calligraphy on the facing page reads: "With Psaltery and Harp" (fig. 271a).

Figure 272a

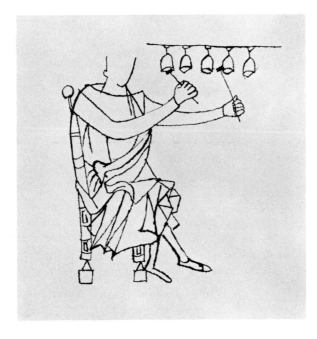

Figure 272 — MAN STRIKING CHIME-BELLS (Hallelujah Suite). 1970-71
Lithograph in black and yellow
Sheet: 16¼ x 35" Composition: 12¾ x 30¼" (text and image)
Paper: Arches Grand Velin
Publisher: Kennedy Graphics, Inc., New York
Printer: Mourlot Graphics Ltd., New York
Edition: 250
Signature: None
Collection: New Jersey State Museum; purchase. Accession No: 70.288.n

The mystery of the missing instrument in the *Chime-Bell Player* (fig. 250) of the Psalm 150 series is solved in this later version of the same subject.

The Hebrew calligraphy on the facing page reads: "Praise Him" (fig. 272a).

Figure 273a

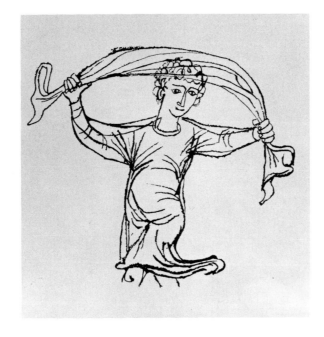

Figure 273 — DANCING VIRGIN (Hallelujah Suite). 1970-71
Lithograph in black and yellow
Sheet: 16½ x 35" Composition: 13⅛ x 32⅝" (text and image)
Paper: Arches Grand Velin
Publisher: Kennedy Graphics, Inc., New York
Printer: Mourlot Graphics Ltd., New York
Edition: 250 Signature: None
Collection: New Jersey State Museum; purchase. Accession No: 70.288.o

This young maiden may have put the timbrel aside for a moment while she lifts her gossamery shawl and whirls in her dance.

The Hebrew calligraphy on the facing page reads: "With the Timbrel and Dance" (fig. 273a).

Figure 274a

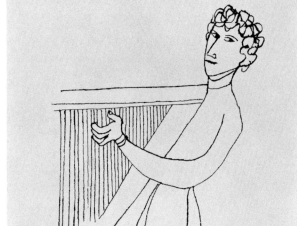

Figure 274—YOUNG MAN PLAYING LYRE (Hallelujah Suite). 1970-71
Lithograph in black and yellow
Sheet: 16¼ x 35" Composition: 13⅛ x 30¼" (text and image)
Paper: Arches Grand Velin
Publisher: Kennedy Graphics, Inc., New York
Printer: Mourlot Graphics Ltd., New York
Edition: 250
Signature: None
Collection: New Jersey State Museum; purchase. Accession No: 70.288.p

Of the numerous brush drawings which Shahn made for his unfinished mural design (see p. 197), his drawing of a young man playing a lyre[228] was perhaps one of the most engaging in its simplicity and classical beauty. This is another version of the same subject.

The Hebrew calligraphy on the facing page reads: "Praise Him" (fig. 274a).

Figure 275a

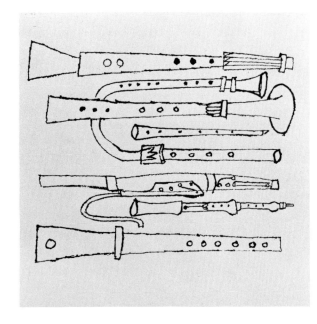

Figure 275—WIND INSTRUMENTS (Hallelujah Suite). 1970-71
Lithograph in black and yellow
Sheet: 16¼ x 35" Composition: 12¾ x 32⅜" (text and image)
Paper: Arches Grand Velin
Publisher: Kennedy Graphics, Inc., New York
Printer: Mourlot Graphics Ltd., New York
Edition: 250
Signature: None
Collection: New Jersey State Museum; purchase. Accession No: 70.288.q

This print continues the musical theme of the Hallelujah Suite with drawings of several ancient wind instruments. They accompany the Hebrew calligraphy on the facing page which reads: "With Stringed Instruments and the Pipe" (fig. 275a).

Figure 276a

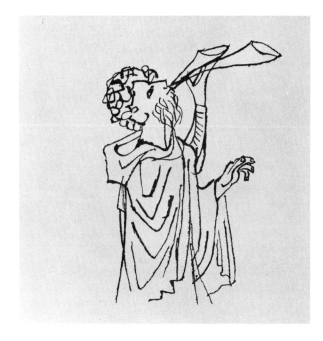

Figure 276—MAN SOUNDING JUBILEE TRUMPET
 (Hallelujah Suite). 1970-71
Lithograph in black and yellow
Sheet: 16¼ x 35" Composition: 13¼ x 27⅞" (text and image)
Paper: Arches Grand Velin
Publisher: Kennedy Graphics, Inc., New York
Printer: Mourlot Graphics Ltd., New York
Edition: 250
Signature: None
Collection: New Jersey State Museum; purchase. Accession No: 70.288.r

The subject of this work is also found in Shahn's grace-
ful *Angel Playing Horn*,[229] a brush drawing for his un-
finished mural design (see p. 197). This later figure,
however, is drawn with a much heavier line, emphasizing
the weight of the hooded cloak, and a second trumpet
has been added.

 The Hebrew calligraphy on the facing page reads:
"Praise Him" (fig. 276a).

Figure 277a

Figure 277—MAIDEN WITH LOUD-SOUNDING CYMBALS
 (Hallelujah Suite). 1970-71
Lithograph in black and yellow
Sheet: 16¼ x 35" Composition: 12½ x 30½" (text and image)
Paper: Arches Grand Velin
Publisher: Kennedy Graphics, Inc., New York
Printer: Mourlot Graphics Ltd., New York
Edition: 250
Signature: None
Collection: New Jersey State Museum; purchase. Accession No: 70.288.s

With the wind catching her shawl to frame her frail
figure, a young woman proclaims her praise according
to the Old Testament psalm.

 The Hebrew calligraphy on the facing page reads:
"With the Loud-sounding Cymbals" (fig. 277a).

Figure 278a

Figure 278—SMALL BOY PLAYING "VIOLIN"
 (Hallelujah Suite). 1970-71
Lithograph in black and yellow
Sheet: 16¼ x 35" Composition: 13⅜ x 29¾" (text and image)
Paper: Arches Grand Velin
Publisher: Kennedy Graphics, Inc., New York
Printer: Mourlot Graphics Ltd., New York
Edition: 250
Signature: None
Collection: New Jersey State Museum; purchase. Accession No: 70.288.t

This young boy seems lost in reverie. His ancient, stringed instrument has no holes in the sounding board, unlike the other violin in this series (see fig. 266).

The Hebrew calligraphy on the facing page reads: "Praise Him" (fig. 278a).

Figure 279a

Figure 279—CLANGING CYMBALS (Hallelujah Suite). 1970-71
Lithograph in black and yellow
Sheet: 16¼ x 35" Composition: 13⅛ x 28⅝" (text and image)
Paper: Arches Grand Velin
Publisher: Kennedy Graphics, Inc., New York
Printer: Mourlot Graphics Ltd., New York
Edition: 250
Signature: None
Collection: New Jersey State Museum; purchase. Accession No: 70.288.u

The *Clanging Cymbals* are also the subject of a lithograph in the Psalm 150 series (fig. 257). Although the cymbals are positioned a little differently, the images are very similar in the two prints.

The Hebrew calligraphy on the facing page reads: "With the Clanging Cymbals" (fig. 279a).

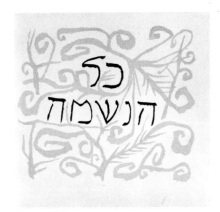

Figure 280a

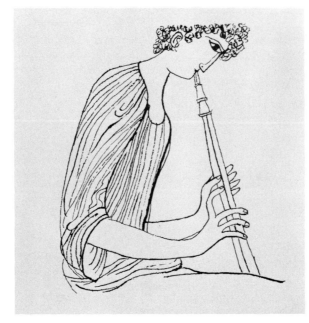

Figure 280—YOUNG MAN PLAYING DOUBLE OBOE
 (Hallelujah Suite). 1970-71
Lithograph in black and yellow
Sheet: 16¼ x 35" Composition: 13⅝ x 30" (text and image)
Paper: Arches Grand Velin
Publisher: Kennedy Graphics, Inc., New York
Printer: Mourlot Graphics Ltd., New York
Edition: 250
Signature: None
Collection: New Jersey State Museum; purchase. Accession No: 70.288.v

More than most images in the Hallelujah Suite, this oboist conveys the charm and grace with which Shahn endowed his musicians in the drawings for his unfinished mural design (see p. 197). The lithograph of the same name in the Psalm 150 series (fig. 253), is very similar to this print.

The Hebrew calligraphy on the facing page reads: "Let Every Thing That Hath Breath" (fig. 280a).

Figure 281a

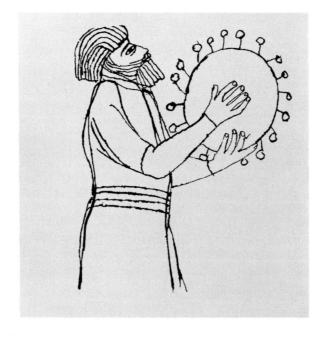

Figure 281—MAN PLAYING TAMBOURINE (Hallelujah Suite). 1970-71
Lithograph in black and yellow
Sheet: 16¼ x 35" Composition: 13⅜ x 29¾" (text and image)
Paper: Arches Grand Velin
Publisher: Kennedy Graphics, Inc., New York
Printer: Mourlot Graphics Ltd., New York
Edition: 250
Signature: None
Collection: New Jersey State Museum; purchase. Accession No: 70.288.w

Man Playing Tambourine is another subject in this series that also appears among the sketches Shahn prepared for an unfinished mural design (see p. 197).[230] Again, the lines are heavier in this, the later version.

The Hebrew calligraphy on the facing page reads: "Praise the Lord" (fig. 281a).

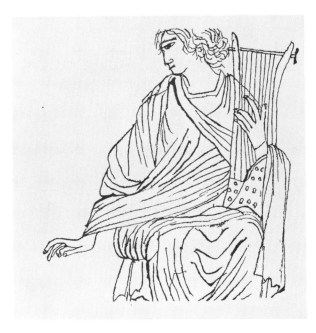

Figure 282—YOUTH WITH CITHARA (Hallelujah Suite). 1970-71
Lithograph in black and yellow
Sheet: 16¼ x 35" Composition: 13½ x 32" (text and image)
Paper: Arches Grand Velin
Publisher: Kennedy Graphics, Inc., New York
Printer: Mourlot Graphics Ltd., New York Edition: 250 Signature: None
Collection: New Jersey State Museum; purchase. Accession No: 70.288.x

Figure 282a

Figure 283—ENGLISH HALLELUJAH
 (Hallelujah Suite). 1970-71
Lithograph in black
Sheet: 16¼ x 35" Composition: 7¼ x 6"
Paper: Arches Grand Velin
Publisher: Kennedy Graphics, Inc., New York
Printer: Mourlot Graphics Ltd., New York
Edition: 250
Signature: None
Collection: New Jersey State Museum; purchase.
 Accession No: None

This is the last version of a subject to which Ben Shahn paid homage many times. The exquisitely graceful 1966 serigraph, *Praise Him with Psaltery and Harp* (fig. 73) and the holiday card taken from it, *Psalm 57* (fig. 237), were followed by a 1969 version which was one of the sketches Shahn prepared for his unfinished mural design (see p. 197).[231] The torso in that sketch is exceedingly elongated, and contributes to a spiritual quality not present to the same extent in this lithograph.

The suite ends as it began, with the black "Hallelujah" in Hebrew on the facing page (fig. 282a).

The English title page for the Hallelujah Suite is printed in black and without Shahn's signature, as it is described in the above caption. The design for the cover, illustrated here, was taken from the English title page. See also the corresponding miniature lithograph, *English Hallelujah* (fig. 309).

HALLELUJAH MINIATURES No. 1 WITH CALLIGRAPHY
Posthumous Edition/1970-71

The twenty-six lithographs, Hallelujah Miniatures No. 1 with Calligraphy (counting the Hebrew and English title pages), are reduced versions of the full-sized Hallelujah Suite. Published by Kennedy Graphics, Inc. and executed by Mourlot Graphics Ltd., they were printed on Arches Grand Velin paper in an edition of 250, using both sides of the lower portion of the sheets on which the full-sized lithographs were printed (see Hallelujah Suite p. 202 and Hallelujah Miniatures No. 2 Without Calligraphy p. 224). Whereas the *Hallelujah Suite* is in book form, these prints are loose. If read as a group they should, however, be folded as if bound and turned from back to front in the Hebrew tradition. Unfolded, the calligraphy does not complement the images as described in the Hallelujah Suite.

Figure 284—HEBREW HALLELUJAH (Hallelujah Miniatures No. 1 with Calligraphy). 1970-71
Lithograph in black and yellow
Sheet: 7⅛ x 15¼" Composition: 5½ x 12¾"
Collection: New Jersey State Museum; purchase. Accession No: 70.337.26
See fig. 258.

Figure 285—MAN PLAYING ORGAN (Hallelujah Miniatures No. 1 with Calligraphy). 1970-71
Lithograph in black and yellow
Sheet: 7⅛ x 15¼" Composition: 5¾ x 14¼"
Collection: New Jersey State Museum; purchase. Accession No: 70.337.1
See fig. 259.

Figure 286— PSALTERY (Hallelujah Miniatures No. 1 with Calligraphy). 1970-71
Lithograph in black and yellow
Sheet: 7⅛ x 15¼" Composition: 5¼ x 12⅞"
Collection: New Jersey State Museum; purchase. Accession No: 70.337.2
See fig. 260.

Figure 287—YOUNG MAN PLAYING SISTRUM (Hallelujah Miniatures No. 1 with Calligraphy). 1970-71
Lithograph in black and yellow
Sheet: 7⅛ x 15¼" Composition: 5⅜ x 12"
Collection: New Jersey State Museum; purchase. Accession No: 70.337.3
See fig. 261.

Figure 288—YOUNG MAN PLAYING DOUBLE FLUTE (Hallelujah Miniatures No. 1 with Calligraphy). 1970-71
Lithograph in black and yellow
Sheet: 7⅛ x 15¼" Composition: 5⅝ x 12⅞"
Collection: New Jersey State Museum; purchase. Accession No: 70.337.4

See fig. 262.

Figure 289—MAN SOUNDING SHOFAR (Hallelujah Miniatures No. 1 with Calligraphy). 1970-71
Lithograph in black and yellow
Sheet: 7⅛ x 15¼" Composition: 5½ x 13½"
Collection: New Jersey State Museum; purchase. Accession No: 70.337.5

See fig. 263.

Figure 290—MAN PLAYING KETHARAH (Hallelujah Miniatures No. 1 with Calligraphy). 1970-71
Lithograph in black and yellow
Sheet: 7⅛ x 15¼" Composition: 5⅝ x 13⅛"
Collection: New Jersey State Museum; purchase. Accession No: 70.337.6

See fig. 264.

Figure 291—MAN PLAYING CITHARA (Hallelujah Miniatures No. 1 with Calligraphy). 1970-71
Lithograph in black and yellow
Sheet: 7⅛ x 15¼" Composition: 5⅜ x 12¼"
Collection: New Jersey State Museum; purchase. Accession No: 70.337.7

See fig. 265.

Figure 292—YOUTH PLAYING "VIOLIN" (Hallelujah Miniatures No. 1 with Calligraphy). 1970-71
Lithograph in black and yellow
Sheet: 7⅛ x 15¼"　　Composition: 5⅜ x 12⅝"
Collection: New Jersey State Museum; purchase. Accession No: 70.337.8

See fig. 266.

Figure 293—OLD MAN PLAYING CROWTH (Hallelujah Miniatures No. 1 with Calligraphy). 1970-71
Lithograph in black and yellow
Sheet: 7⅛ x 15¼"　　Composition: 5¼ x 12⅞"
Collection: New Jersey State Museum; purchase. Accession No: 70.337.9

See fig. 267.

Figure 294—YOUTH SOUNDING TRUMPET (Hallelujah Miniatures No. 1 with Calligraphy). 1970-71
Lithograph in black and yellow
Sheet: 7⅛ x 15¼"　　Composition: 5⅜ x 13¾"
Collection: New Jersey State Museum; purchase. Accession No: 70.337.10

See fig. 268.

Figure 295—YOUTH PLAYING TWIN REEDS (Hallelujah Miniatures No. 1 with Calligraphy). 1970-71
Lithograph in black and yellow
Sheet: 7⅛ x 15¼"　　Composition: 5⅜ x 12⅞"
Collection: New Jersey State Museum; purchase. Accession No: 70.337.11

See fig. 269.

Figure 296—LUTE (Hallelujah Miniatures No. 1 with Calligraphy). 1970-71
Lithograph in black and yellow
Sheet: 7⅛ x 15¼" Composition: 5⅛ x 13⅝"
Collection: New Jersey State Museum; purchase. Accession No: 70.337.12
See fig. 270.

Figure 297—YOUTH WITH LYRE (Hallelujah Miniatures No. 1 with Calligraphy). 1970-71
Lithograph in black and yellow
Sheet: 7⅛ x 15¼" Composition: 5¼ x 13⅛"
Collection: New Jersey State Museum; purchase. Accession No: 70.337.13
See fig. 271.

Figure 298—MAN STRIKING CHIME-BELLS (Hallelujah Miniatures No. 1 with Calligraphy). 1970-71
Lithograph in black and yellow
Sheet: 7⅛ x 15¼" Composition: 5⅜ x 12⅞"
Collection: New Jersey State Museum; purchase. Accession No: 70.337.14
See fig. 272.

Figure 299—DANCING VIRGIN (Hallelujah Miniatures No. 1 with Calligraphy). 1970-71
Lithograph in black and yellow
Sheet: 7⅛ x 15¼" Composition: 5¼ x 13¾"
Collection: New Jersey State Museum; purchase. Accession No: 70.337.15
See fig. 273.

Figure 300—YOUNG MAN PLAYING LYRE (Hallelujah Miniatures No. 1 with Calligraphy). 1970-71
Lithograph in black and yellow
Sheet: 7⅛ x 15¼" Composition: 5¼ x 12⅞"
Collection: New Jersey State Museum; purchase. Accession No: 70.337.16

See fig. 274.

Figure 301—WIND INSTRUMENTS (Hallelujah Miniatures No. 1 with Calligraphy). 1970-71
Lithograph in black and yellow
Sheet: 7⅛ x 15¼" Composition: 5¼ x 13⅝"
Collection: New Jersey State Museum; purchase. Accession No: 70.337.17

See fig. 275.

Figure 302—MAN SOUNDING JUBILEE TRUMPET (Hallelujah Miniatures No. 1 with Calligraphy). 1970-71
Lithograph in black and yellow
Sheet: 7⅛ x 15¼" Composition: 5½ x 12⅜"
Collection: New Jersey State Museum; purchase. Accession No: 70.337.18

See fig. 276.

Figure 303—MAIDEN WITH LOUD-SOUNDING CYMBALS
 (Hallelujah Miniatures No. 1 with Calligraphy). 1970-71
Lithograph in black and yellow
Sheet: 7⅛ x 15¼" Composition: 5¼ x 12⅞"
Collection: New Jersey State Museum; purchase. Accession No: 70.337.19

See fig. 277.

Figure 304—SMALL BOY PLAYING "VIOLIN" (*Hallelujah Miniatures No. 1 with Calligraphy*). 1970-71
Lithograph in black and yellow
Sheet: 7⅛ x 15¼" Composition: 5½ x 13"
Collection: New Jersey State Museum; purchase. Accession No: 70.337.20
See fig. 278.

Figure 305—CLANGING CYMBALS (*Hallelujah Miniatures No. 1 with Calligraphy*). 1970-71
Lithograph in black and yellow
Sheet: 7⅛ x 15¼" Composition: 5¼ x 12⅛"
Collection: New Jersey State Museum; purchase. Accession No: 70.337.21
See fig. 279.

Figure 306—YOUNG MAN PLAYING DOUBLE OBOE (*Hallelujah Miniatures No. 1 with Calligraphy*). 1970-71
Lithograph in black and yellow
Sheet: 7⅛ x 15¼" Composition: 5½ x 13"
Collection: New Jersey State Museum; purchase. Accession No: 70.337.22
See fig. 280.

Figure 307—MAN PLAYING TAMBOURINE (*Hallelujah Miniatures No. 1 with Calligraphy*). 1970-71
Lithograph in black and yellow
Sheet: 7⅛ x 15¼" Composition: 5⅜ x 13"
Collection: New Jersey State Museum; purchase. Accession No: 70.337.23
See fig. 281.

Figure 308—YOUTH WITH CITHARA (Hallelujah Miniatures No. 1 with Calligraphy). 1970-71
Lithograph in black
Sheet: 7⅛ x 15¼" Composition: 5⅜ x 5⅜".
Collection: New Jersey State Museum; purchase. Accession No: 70.337.24

See fig. 282.

Figure 309—ENGLISH HALLELUJAH (Hallelujah Miniatures No. 1 with Calligraphy). 1970-71
Lithograph in black
Sheet: 7⅛ x 15¼" Composition: 4¾ x 3⅞"
Collection: New Jersey State Museum; purchase. Accession No: 70.337.25

See fig. 283. Since these miniatures were intended to be bound, the corresponding pages for this and the preceding lithograph would have been empty ones at the opposite ends of the book. Hence, the absence of calligraphy from these pages.

HALLELUJAH MINIATURES No. 2 WITHOUT CALLIGRAPHY
Posthumous Edition (not illustrated)/1970-71

The twenty-four lithographs, Hallelujah Miniatures No. 2 Without Calligraphy are reduced versions of the figures and instruments in the Hallelujah Suite and the exact size of those in the Hallelujah Miniatures No. 1 with Calligraphy (see p. 202 and p. 216). Published by Kennedy Graphics, Inc. and executed by Mourlot Graphics Ltd., they were printed on Arches Grand Velin paper in an edition of 250, using both sides of the lower portion of the sheets on which the full-sized lithographs were printed. However, the first and last sheets (figs. 310 and 333) were printed on only one side, since the corresponding calligraphy for the title pages was not included. The edition has not been illustrated here because the images are identical in size and execution to those of the preceding edition.

Copies from this second edition of miniatures were distributed among Shahn's friends and collectors as mementos of his last series of drawings.

Hallelujah Miniatures No. 2 Without Calligraphy—Posthumous Edition/1970-71

Figure 310—MAN PLAYING ORGAN (Hallelujah
 Miniatures No. 2 Without Calligraphy). 1970-71
Lithograph in black
Sheet: 7⅛ x 15¼" Composition: 5½ x 6½"
Collection: New Jersey State Museum; gift of
 Kennedy Graphics, Inc. Accession No: 70.338.1

See figs. 259 and 285. This sheet and
fig. 333 are printed on only one side con-
trary to the rest of the edition.

Figure 311—PSALTERY (Hallelujah Miniatures
 No. 2 Without Calligraphy). 1970-71
Lithograph in black
Sheet: 7⅛ x 15¼" Composition: 5⅛ x 4"
Collection: New Jersey State Museum; gift of
 Kennedy Graphics, Inc. Accession No: 70.338.2

See figs. 260 and 286.

Figure 312—YOUNG MAN PLAYING SISTRUM
 (Hallelujah Miniatures No. 2 Without Calligraphy).
 1970-71
Lithograph in black
Sheet: 7⅛ x 15¼" Composition: 5½ x 3"
Collection: New Jersey State Museum; gift of
 Kennedy Graphics, Inc. Accession No: 70.338.3

See figs. 261 and 287.

Figure 313—YOUNG MAN PLAYING DOUBLE
 FLUTE (Hallelujah Miniatures No. 2 Without
 Calligraphy). 1970-71
Lithograph in black
Sheet: 7⅛ x 15¼" Composition: 5½ x 5½"
Collection: New Jersey State Museum; gift of
 Kennedy Graphics, Inc. Accession No: 70.338.4

See figs. 262 and 288.

Figure 314—MAN SOUNDING SHOFAR (Hallelujah
 Miniatures No. 2 Without Calligraphy). 1970-71
Lithograph in black
Sheet: 7⅛ x 15¼" Composition: 5¼ x 5½"
Collection: New Jersey State Museum; gift of
 Kennedy Graphics, Inc. Accession No: 70.338.5

See figs. 263 and 289.

Figure 315—MAN PLAYING KETHARAH (Hallelujah
 Miniatures No. 2 Without Calligraphy). 1970-71
Lithograph in black
Sheet: 7⅛ x 15¼" Composition: 5⅜ x 5⅛"
Collection: New Jersey State Museum; gift of
 Kennedy Graphics, Inc. Accession No: 70.338.6

See figs. 264 and 290.

Figure 316—MAN PLAYING CITHARA (Hallelujah
 Miniatures No. 2 Without Calligraphy). 1970-71
Lithograph in black
Sheet: 7⅛ x 15¼" Composition: 5⅜ x 3¾"
Collection: New Jersey State Museum; gift of
 Kennedy Graphics, Inc. Accession No: 70.338.7

See figs. 265 and 291.

Figure 317—YOUTH PLAYING "VIOLIN"
 (Hallelujah Miniatures No. 2 Without Calligraphy).
 1970-71
Lithograph in black
Sheet: 7⅛ x 15¼" Composition: 5 x 4⅛"
Collection: New Jersey State Museum; gift of
 Kennedy Graphics, Inc. Accession No: 70.338.8

See figs. 266 and 292.

Figure 318—OLD MAN PLAYING CROWTH
 (Hallelujah Miniatures No. 2 Without Calligraphy).
 1970-71
Lithograph in black
Sheet: 7⅛ x 15¼" Composition: 5⅜ x 4⅛"
Collection: New Jersey State Museum; gift of
 Kennedy Graphics, Inc. Accession No: 70.338.9

See figs. 267 and 293.

Figure 319—YOUTH SOUNDING TRUMPET
 (Hallelujah Miniatures No. 2 Without Calligraphy).
 1970-71
Lithograph in black
Sheet: 7⅛ x 15¼" Composition: 5⅜ x 6¼"
Collection: New Jersey State Museum; gift of
 Kennedy Graphics, Inc. Accession No: 70.338.10

See figs. 268 and 294.

Figure 320—YOUTH PLAYING TWIN REEDS
 (Hallelujah Miniatures No. 2 Without Calligraphy).
 1970-71
Lithograph in black
Sheet: 7⅛ x 15¼" Composition: 4½ x 3¾"
Collection: New Jersey State Museum; gift of
 Kennedy Graphics, Inc. Accession No: 70.338.11

See Nos. 269 and 295.

Figure 321—LUTE (Hallelujah Miniatures No. 2
 Without Calligraphy). 1970-71
Lithograph in black
Sheet: 7⅛ x 15¼" Composition: 3⅛ x 5⅞"
Collection: New Jersey State Museum; gift of
 Kennedy Graphics, Inc. Accession No: 70.338.12

See figs. 270 and 296.

Figure 322—YOUTH WITH LYRE (Hallelujah
 Miniatures No. 2 Without Calligraphy). 1970-71
Lithograph in black
Sheet: 7⅛ x 15¼" Composition: 5⅛ x 4¼"
Collection: New Jersey State Museum; gift of
 Kennedy Graphics, Inc. Accession No: 70.338.13

See figs. 271 and 297.

Figure 323—MAN STRIKING CHIME-BELLS
 (Hallelujah Miniatures No. 2 Without Calligraphy).
 1970-71
Lithograph in black
Sheet: 7⅛ x 15¼" Composition: 5¼ x 5"
Collection: New Jersey State Museum; gift of
 Kennedy Graphics, Inc. Accession No: 70.338.14

See figs. 272 and 298.

Figure 324—DANCING VIRGIN (Hallelujah
 Miniatures No. 2 Without Calligraphy). 1970-71
Lithograph in black
Sheet: 7⅛ x 15¼" Composition: 5 x 5¾"
Collection: New Jersey State Museum; gift of Kennedy
 Graphics, Inc. Accession No: 70.338.15

See figs. 273 and 299.

Figure 325—YOUNG MAN PLAYING LYRE
 (Hallelujah Miniatures No. 2 Without Calligraphy).
 1970-71
Lithograph in black
Sheet: 7⅛ x 15¼" Composition: 5⅛ x 4½"
Collection: New Jersey State Museum; gift of
 Kennedy Graphics, Inc. Accession No: 70.338.16

See figs. 274 and 300.

Figure 326—WIND INSTRUMENTS (Hallelujah
 Miniatures No. 2 Without Calligraphy). 1970-71
Lithograph in black
Sheet: 7⅛ x 15¼" Composition: 4⅝ x 5⅞"
Collection: New Jersey State Museum; gift of
 Kennedy Graphics, Inc. Accession No: 70.338.17

See figs. 275 and 301.

Figure 327—MAN SOUNDING JUBILEE TRUMPET
 (Hallelujah Miniatures No. 2 Without Calligraphy).
 1970-71
Lithograph in black
Sheet: 7⅛ x 15¼" Composition: 5½ x 4"
Collection: New Jersey State Museum; gift of
 Kennedy Graphics, Inc. Accession No: 70.338.18

See figs. 276 and 302.

Figure 328—MAIDEN WITH LOUD-SOUNDING
 CYMBALS (Hallelujah Miniatures No. 2 Without
 Calligraphy). 1970-71
Lithograph in black
Sheet: 7⅛ x 15¼" Composition: 5⅛ x 5⅜"
Collection: New Jersey State Museum; gift of
 Kennedy Graphics, Inc. Accession No: 70.338.19

See figs. 277 and 303.

Figure 329—SMALL BOY PLAYING "VIOLIN"
 (Hallelujah Miniatures No. 2 Without Calligraphy).
 1970-71
Lithograph in black
Sheet: 7⅛ x 15¼" Composition: 5½ x 5⅛"
Collection: New Jersey State Museum; gift of
 Kennedy Graphics, Inc. Accession No: 70.338.20

See figs. 278 and 304.

Figure 330—CLANGING CYMBALS (Hallelujah
 Miniatures No. 2 Without Calligraphy). 1970-71
Lithograph in black
Sheet: 7⅛ x 15¼" Composition: 3½ x 3¼"
Collection: New Jersey State Museum; gift of
 Kennedy Graphics, Inc. Accession No: 70.338.21

See figs. 279 and 305.

Figure 331—YOUNG MAN PLAYING DOUBLE
 OBOE (Hallelujah Miniatures No. 2 Without
 Calligraphy). 1970-71
Lithograph in black
Sheet: 7⅛ x 15¼" Composition: 5½ x 5"
Collection: New Jersey State Museum; gift of
 Kennedy Graphics, Inc. Accession No: 70.338.22

See figs. 280 and 306.

Figure 332—MAN PLAYING TAMBOURINE
 (Hallelujah Miniatures No. 2 Without Calligraphy).
 1970-71
Lithograph in black
Sheet: 7⅛ x 15¼" Composition: 5⅜ x 4⅝"
Collection: New Jersey State Museum; gift of
 Kennedy Graphics, Inc. Accession No: 70.338.23

See figs. 281 and 307.

Figure 333—YOUTH WITH CITHARA
 (Hallelujah Miniatures No. 2 Without Calligraphy).
 1970-71
Lithograph in black
Sheet: 7⅛ x 15¼" Composition: 5⅜ x 5⅜"
Collection: New Jersey State Museum; gift of
 Kennedy Graphics, Inc. Accession No: 70.338.24

See figs. 282 and 308. This sheet and fig.
310 are printed on only one side contrary
to the rest of the edition.

APPENDIX A

BIOGRAPHICAL OUTLINE (selected)

1898 Born September 12, Kovno, Lithuania.

1906 Immigrates with family to Brooklyn, New York.

1913-17 Employed as lithographer's apprentice at Hessenberg's lithography shop on Beekman Street in Manhattan;
Attends high school night classes.

1919-22 Attends New York University and City College of New York;
With scholarship aid, studies biology two summers at the U. S. Marine Biological Station, Woods Hole, Massachusetts;
Leaves City College to study at the National Academy of Design and later at the Art Students League.

1922 Marries Mathilda (Tillie) Goldstein.

1924-25 Travels with wife to North Africa, Spain, Italy, Austria, Holland, and France, settling in Paris.

1926 Returns to U. S.;
Spends summer painting in Truro, Massachusetts;
Refuses offer of exhibition at the Montross Gallery, New York, believing his work to be too derivative.

1927-29 Returns to Paris;
Spends most of one year on the island of Djerba, off North Africa.

1929 Returns to America, living on Willow Street in Brooklyn Heights and painting during the summer at Truro;
Shares studio on Bethune Street with photographer Walker Evans.

1930 Three works included in group exhibition, The Downtown Gallery, New York, January 28-February 15;
First one-man exhibition, The Downtown Gallery, April 8-27: watercolors and drawings of African subjects and three oil paintings of studio compositions; paints during the summer at Truro.

1931 Publishes first fine art prints (lithographs), the *Levana* portfolio;
Three works included in the Eleventh International Watercolor Exhibition, Art Institute of Chicago, April 30-May 31;
Paints twelve gouache border illustrations for a text of the *Haggadah* (first published 1965).

1932 Meets artist-writer Bernarda Bryson, who was to become his second wife;
The Downtown Gallery exhibits twenty-three small gouache paintings and two large panels on the Sacco and Vanzetti trial, April 5-17;
The Harvard Society of Contemporary Art, Cambridge, Massachusetts, exhibits the Sacco and Vanzetti gouaches and thirteen watercolors of the Dreyfus trial, October 17-29;
The Museum of Modern Art, as part of a group show, exhibits two tempera studies for Sacco and Vanzetti mural (used in 1967 for a mural for Syracuse University).

1932-33 Works included in "First Biennial Exhibition of Contemporary American Painting," Whitney Museum of American Art, New York, November 22-January 5.

1933 The Downtown Gallery exhibits fifteen gouache paintings and one tempera panel on the Mooney trial, May 5-20, with catalogue introduction by Diego Rivera;

Works as assistant to Diego Rivera on Rockefeller Center murals (later removed due to controversial content).

1934 Produces eight tempera paintings on the subject of prohibition for the New York City Public Works of Art Project, the series being intended for a mural (never installed) for a building in Central Park;
Photographs New York City street scenes and makes studies in preparation for a mural commissioned by the Federal Emergency Relief Administration for corridor in Riker's Island Penitentiary in New York City (joint commission with painter Lou Block).

1934-35 Works included in fifth anniversary exhibition, The Museum of Modern Art, New York, November 20-January 20.

1935 Studies for Riker's Island mural approved by Mayor Fiorello LaGuardia and Commissioner of Correction, but rejected by Municipal Art Commission;
Produces first signed poster, *We Demand the National Textile Act*;
Work included in exhibition of "American Painting and Sculpture of the 18th, 19th, and 20th Centuries," Wadsworth Atheneum, Hartford, Connecticut. January 29-February 19.

1935-38 Employed by Resettlement Administration as artist, designer, and photographer;
Travels through the South and Midwest photographing rural and urban scenes of poverty.

1936 Work included in group exhibition of documentary photographs from the files of the Resettlement Administration, WPA Federal Art Project Gallery, New York, December.

1937 Begins sketches on Wisconsin's independent political movement, submitted in competition for mural for town hall near Milwaukee.

1937-38 Completes first mural, a fresco, for the community center of a federal housing development at Roosevelt, New Jersey.

1938 Included in American Artists Congress, Inc., "Second Annual Membership Exhibition," John Wanamaker's Department Store, New York, May 5-21.

1938-39 With Bernarda Bryson, completes thirteen large egg tempera fresco panels for a mural for the Central Annex Post Office, Bronx, New York (commissioned by the Section of Fine Arts, Public Buildings Administration, U.S. Treasury Department).

1939 Work included in exhibition of "20th Century Artists," Whitney Museum of American Art, September 13-December 4;
Establishes residence at Roosevelt, New Jersey.

1939-40 Completes nine studies on Four Freedoms for St. Louis, Missouri, post office mural; studies are rejected but wins consolation commission for over-door panel for Jamaica, New York, post office.

1940 Exhibits "Sunday Paintings," works produced during non-salaried hours while employed at governmental agencies, Julien Levy Gallery, New York, May 7-21.

1940-42 Wins competition for murals for the main corridor of the Federal Security Administration Building, Washington, D.C. (sponsored by the Section of Fine Arts, Public Buildings Administration, U.S. Treasury Department).

1941 Prints first serigraph, *Immigrant Family*;
Work included in exhibition circulated in Latin America by the Museum of Modern Art, New York.

1942-44 Designs posters for the Office of War Information, Washington, D.C.
1943 Exhibits eleven works in group show, "American Realists and Magic Realists," The Museum of Modern Art, New York, February 10-March 21.
1944 One-man exhibition, The Downtown Gallery, November 14-December 2;
 Work included in Second Annual Purchase Exhibition, Walker Art Center, Minneapolis, August 18-September 11.
1945 Work included in "38th Annual Exhibition," St. Louis City Art Museum, February 10-March 12;
 Exhibition of eighty-nine designs for the Container Corporation of America, Art Institute of Chicago, April 27-June 23.
1945-46 As director of the graphic arts division, produces posters for the CIO.
1946 Work included in group exhibition of American painting, Tate Gallery, London, June-July;
 Work included in "Watercolor—USA," exhibition circulated in Latin America by the National Gallery of Art, Washington, D.C.
1947 One-man exhibition, The Downtown Gallery, April 1-26;
 Work included in "International Water Color Exhibition: Fourteenth Biennial," Brooklyn Museum, April 8-27;
 Monograph on work published in Penguin Modern Painters series, London and New York;
 Circulates ten paintings to galleries in London, Brighton, Cambridge, and Bristol, under auspices of the Arts Council of Great Britain.
1947-48 Retrospective exhibition of paintings, drawings, posters, illustrations, and photographs, The Museum of Modern Art, New York, September 30-January 4.
1948 Designs posters and campaign material for Henry Wallace's "Third Party";
 Selected by *Look* magazine as one of America's ten leading painters.
1949 One-man exhibition, The Downtown Gallery, October 25-November 12.
1950 One-man exhibitions at Albright Art School, Buffalo, New York, Frank Perls Gallery, Los Angeles, and Phillips Memorial Gallery, Washington, D.C.;
 Teaches summer session at University of Colorado at Boulder.
1951 One-man exhibition, The Downtown Gallery, May 22-June 8;
 Three-man show with Willem de Kooning and Jackson Pollock, Arts Club of Chicago, October 2-27;
 Teaches at Brooklyn Museum Art School.
1952 One-man exhibitions at The Downtown Gallery, New York, in April, and the Boris Mirski Gallery, Boston, May 12-29;
 Group show with Lee Gatch and Karl Knaths at three California museums: Santa Barbara Museum, Los Angeles County Museum of Art, and California Palace of the Legion of Honor, San Francisco;
 Sketches convention activities while attending Democratic Convention in Chicago.
1953 One-man exhibition, Minneapolis Institute of Arts, November 8-December 6.
1953-54 Five works exhibited, Bienal o Museu de Arte Moderna de São Paulo, Brasil, December-February, wins cash award.
1954 Represents the United States with Willem de Kooning at the Venice Biennale;
 Three works included in Sixty-first Annual American Exhibition, Art Institute of Chicago, October 21-December 5.
1955 Retrospective exhibition, The Downtown Gallery, January 18-February 12, commemorating twenty-five years with the gallery.

1956 Elected member of the National Institute of Arts and Letters;
 Awarded the Joseph E. Temple Medal Award by the Pennsylvania Academy of Fine Arts;
 Travels in Europe.
1956-57 Retrospective exhibition, Fogg Art Museum, Harvard University, Cambridge, Massachusetts, December 4-January 19;
 Teaches at Harvard University as Charles Eliot Norton Professor of Poetry.
1957 Completes mosaic for William E. Grady Vocational High School, Brooklyn, New York (commissioned by the New York City Board of Education);
 "Ben Shahn, a Documentary Exhibition," Institute of Contemporary Art, Boston, April 10-May 31.
1958 Work included in Venice Biennale exhibition, "American Artists Paint the City;"
 Awarded American Institute of Graphic Arts Gold Medal;
 Designs sets for Jerome Robbins' ballet *New York Export—Opus Jazz*.
1959 Exhibition at The Downtown Gallery, March 3-28;
 Exhibitions at the Leicester Galleries, London, and the Katonah Gallery, Katonah, New York;
 Elected member of American Academy of Arts and Sciences;
 Receives annual award at North Shore Art Festival, Long Island, New York;
 Completes mosaic for Congregation Oheb Shalom, Nashville, Tennessee.
1959-60 Three works included in the Sixty-Third Annual American Exhibition, Art Institute of Chicago, December 1-January 31.
1960 Exhibition of serigraphs, University of Louisville, November 22-December 31;
 Exhibition of graphics, University of Utah;
 Group exhibition with Abraham Rattner and Jack Levine, Jewish Community Center, Milwaukee, Wisconsin, February;
 Completes mural for Congregation Mishkan Israel, New Haven, Connecticut;
 Travels to Far East, including Japan.
1961 Exhibition of eleven paintings from the Lucky Dragon series, The Downtown Gallery, October 10-November 4;
 Work included in exhibition, "Posters Against Nazism," Galleria dell' Obelisco, Rome, opened May 20;
 Exhibition, the New Haven Jewish Community Center, Connecticut, April 9-29;
 Designs sets for e. e. cummings' play, *Him*, and for Jerome Robbins' ballet, *Events*.
1961-62 "The Works of Ben Shahn," traveling exhibition of 137 paintings, prints, and posters sponsored by the International Council of The Museum of Modern Art, New York: opens at the Stedelijk Museum, Amsterdam, December 22, 1961, travels to the Palais des Beaux-Arts, Brussels, and the Galleria Nazionale d'Arte Moderna, Rome, and closes at the Albertina, Vienna, June 24, 1962.
1962 Exhibition of graphics, Armand Gallery, Sarasota, Florida;
 Completes mural for LeMoyne College, Memphis, Tennessee.
1962-63 "Ben Shahn: Watercolors, Drawings, and Graphics," traveling exhibition of 139 graphic works and paintings sponsored by the International Council of The Museum of Modern Art, New York: opens in Baden-Baden, August 3, 1962, travels to Zagreb and Stockholm, and closes in Jerusalem, June 16, 1963.

1963-64 Completes designs for two mosaic murals for the S.S. *Shalom*, purchased (1968) by the New Jersey State Museum subsequent to the sale of the vessel.

1964 Exhibition, the Leicester Galleries, London, June-July;

Completes mosaic mural for Mr. and Mrs. Sydney Spivack, New Jersey

1965 Creates two stained glass window designs for Temple Beth Zion, Buffalo, New York.

1966 Exhibition of drawings and watercolors, The Saint Paul Art Center, Minnesota, February.

1967 Completes design for Sacco and Vanzetti mosaic mural for Syracuse University.

1967-68 Exhibition of seventy-eight works opens at Santa Barbara Museum of Art, California, July 30-September 10, 1967, travels to the La Jolla Museum of Art, California, October 5-November 12, and closes at the Herron Museum of Art, Indianapolis, Indiana, December 3, 1967-January 3, 1968.

1968 Exhibition of sixty-four paintings, drawings, prints, and posters, Kennedy Galleries, Inc., New York, October 12-November 2;

Exhibition of twenty prints on the theme of human rights, Frederick Douglass Institute of Negro Arts and History, Museum of African Art, Washington, D.C.

1969 Dies, March 14;

Retrospective exhibition of 133 paintings, drawings, prints, posters, and the two mosaic murals from the S.S. *Shalom*, New Jersey State Museum, Trenton, September 20-November 16;

Exhibition of seventy-four paintings and drawings, Kennedy Galleries, Inc., New York, November 5-29;

Exhibition of photographs, Fogg Art Museum, Harvard University, Cambridge, Massachusetts, October 29-December 14.

1970 Retrospective exhibition of 170 works, all mediums, in Japan: Ishibashi Art Museum, Kurume, April 16-May 10; The National Museum of Modern Art, Tokyo, May 21-July 4; Imai Department Store Galleries, Sapporo, July 14-26; Osaka City Museum, August 4-30; Hiroshima City Museum, September 19-October 4;

Exhibition, "The Drawings of Ben Shahn," Kennedy Galleries, Inc., October.

1971 Exhibition of paintings, drawings, prints, and posters, Gallery Ann, Houston, Texas, May;

Exhibition of paintings and drawings, Kennedy Galleries, Inc., November 6-27.

APPENDIX B

SELECTED BIBLIOGRAPHY

Adopted from earlier Shahn bibliographies by James Thrall Soby, Peggy Lewis initially prepared the draft for this bibliography while Publications Editor, New Jersey State Museum; revisions and additions were made subsequently by the author.

CONTENTS:
Writings by Ben Shahn
Works Illustrated by Shahn
Limited Edition Portfolios Illustrated by Shahn
Books, Essays, and Addresses about Shahn
Articles about Shahn
Exhibition Catalogues

WRITINGS BY BEN SHAHN

Correspondence concerning the Riker's Island murals. New York, 1933-36. (A collection of original letters from Lou Block and Shahn to the commissioning agencies, in the Museum of Modern Art Library, New York.)

Miller, Dorothy C. and Alfred H. Barr, Jr. (eds.). *American Realists and Magic Realists.* New York: The Museum of Modern Art, 1943. (Catalogue of exhibition; statement by Shahn, pp. 52-53.)

"Photos for Art," *U.S. Camera* (May, 1946), pp. 30-32.

"An Artist's Credo," *College Art Journal* (Autumn, 1949), pp. 43-45. (Condensation of paper read at the Second Annual Art Conference, Woodstock, New York, August 28-29, 1948.)

"The Artist's Point of View," *Magazine of Art* (November, 1949), pp. 266, 269. (Text of paper presented on Art Education sponsored by The Museum of Modern Art, New York, March 18-20, 1949. Balcomb Greene, Robert Motherwell, and Shahn participated in the session, "The Artist's Point of View.")

"Aspects of the Art of Paul Klee," *Museum of Modern Art Bulletin* (Summer, 1950), pp. 6-9. (Speech delivered at the first of a series of symposia presented by the Junior Council of The Museum of Modern Art, New York.)

Symposium: The Relation of Painting and Sculpture to Architecture. New York: The Museum of Modern Art, 1951. (Typescript of symposium, in The Museum of Modern Art Library; includes remarks by Shahn. Published report in *Interiors,* May, 1951, p. 102.)

"The Future of the Creative Arts: A Symposium." *University of Buffalo Studies* (February, 1952), pp. 125-28. (One of several symposia on the theme, "The Outlook for Mankind in the Next Half-Century," at the Niagara Frontier Convocation, December 7-8, 1951. Includes text by Shahn; remarks reprinted in Alfred H. Barr, Jr., ed., *Masters of Modern Art,* New York: The Museum of Modern Art, 1954, p. 162.)

Paragraphs on Art. New York: The Spiral Press, 1952, unnumbered pp. 1-12 plus three illustrations. (Paragraphs by Shahn gathered from speeches made at various times and places by Shahn.) Also in *Graphis 62,* Zurich (1955-56), pp. 468-485.

"What Is Realism in Art?" *Look* (January 13, 1953), pp. 44-45.

"The Artist and the Politicians," *Art News* (September, 1953), pp. 34-35, 67.

Alphabet of Creation. New York: Pantheon Books, 1954; 50 copies, numbered 1-50, on Umbria paper, including an original drawing; 500 copies, numbered 51-550, on Rives paper, all signed, in slipcase. Trade editions: New York: Schocken Books, 1963 (hard cover), Schocken Paperback, 1965, 1967. (*Alphabet of Creation* is one of the legends from the *Sefer Ha-Zohar,* or *Book of Splendor,* an ancient Gnostic work written in Aramaic by a thirteenth-century Spanish scholar, Moses de Leon. This is a free adaptation by Shahn taken from several sources.)

"How an Artist Looks at Aesthetics," *Journal of Aesthetics and Art Criticism.* (September, 1954), pp. 46-51. (Paper presented at the annual meeting of the American Society for Aesthetics, East Lansing, Michigan, November 20, 1953.)

"They Can Rank with the Greatest Works of Art, But...Famous Painter Asks: Are Cartoons Now Among the Obits?" *Art News* (October, 1954), p. 50.

"In the Mail: Art Versus Camera," *The New York Times* (February 13, 1955), sec. 2, p. 15. (A letter to the editor in which Shahn takes exception to Aline B. Saarinen's, "The Camera Versus the Artist," a review of the photographic exhibition, "The Family of Man," organized by Edward Steichen.)

The Biography of a Painting. Cambridge, Massachusetts; Harvard University, Fogg Art Museum, 1956 (Fogg Picture Book No. 6).

"Nonconformity; Excerpt from *Shape of Content,*" *Atlantic Monthly* (September, 1957), pp. 36-41.

"Realism Reconsidered," *Perspecta.* New Haven: Yale University (December, 1957), pp. 28-35. (Text of talk given before the Institute of Contemporary Art, London, February, 1956, in connection with the Tate Gallery's exhibition, "Modern Art in the United States.")

The Shape of Content. Cambridge, Massachusetts: Harvard University Press, 1957 (hard cover); New York: Random House, 1957 (paper). (The Charles Eliot Norton Lectures of 1956-57.)

"Artists in Colleges," *The Christian Scholar.* (Summer, 1960), pp. 97-113.

The Shape of Content. New York: Vintage, 1960. (The Charles Eliot Norton Lectures of 1956-57 reprinted as Vintage Books V-108. Published in Italian in 1964; in Japanese in 1965.)

"Shahn in Amsterdam," *Art in America* (No. 3, 1961), pp. 62-67. (Shahn's presentation and interpretation of a wide selection of his paintings, some of which were to be shown in a major retrospective exhibition arranged by the International Council of The Museum of Modern Art, New York.)

"Bill," *The Visual Craft of William Golden* (Cipe Pineless Golden, Kurt Weihs, Robert Strunsky, eds.). New York, George Braziller, 1962, pp. 126-27. (Includes reproductions of Shahn's works for the Columbia Broadcasting System.)

"Concerning 'Likeness' in Portraiture." Statens Konstsamlingars Tillväxt och Förvaltning Nationalmuseum, Meddelanden från Nationalmuseum no. 87. Stockholm, 1962, pp. 88-90.

Love and Joy About Letters. New York: Grossman, 1963.

Love and Joy About Letters. London: Cory, Adams, and Mackay, 1964; text arranged by Joseph Blumenthal and set at The Spiral Press, New York.

The Biography of a Painting. New York: Paragraphic Books; and Canada: Fitz Henry and Whiteside, Ltd., 1966. (Same as 1956 edition but more profusely illustrated.)

"Imagination and Intention," *Review of Existential Psychology and Psychiatry* (Winter, 1967), pp. 13-17.

"In Defense of Chaos," talk at the International Design Conference, Aspen, Colorado (July 1966), reprinted in: *The Collected Prints of Ben Shahn,* Philadelphia Museum of Art, 1967, pp. 13-16; and *Ramparts,* December 14, 1968, pp. 12-13.

"American Painting at Mid-Century: An Unorthodox View," in *Ben Shahn: The Passion of Sacco and Vanzetti.* Syracuse University Press, 1968, pp. 48-76.

WORKS ILLUSTRATED BY SHAHN

cummings, e.e. *Tom.* New York: Arrow Editions, 1935 (Frontispiece by Shahn).

The Eagle's Brood. New York: Columbia Broadcasting System, illustrated by Ben Shahn, 1947.

The First Day of Christmas. New York: Crafton Graphic Company, December 24, 1948; a limited edition of two hundred printed for Shahn, numbered and signed in pencil on p. 3.

Strunsky, Robert. *Mind in the Shadow.* New York: Columbia Broadcasting System, illustrated by Ben Shahn, 1949.

A Partridge in a Pear Tree. New York: The Museum of Modern Art, 1949; revised, 1951; fifth printing, 1967.

Maund, Alfred. *The Untouchables.* New Orleans: Southern Conference Educational Fund, 1952 (now located in Louisville, Kentucky).

Samstag, Nicholas. *Kay Kay Comes Home: A Fable of Enthusiasm.* New York: Curt Valentin, 1952.

Goldberg, B. Z. *The World of Sholom Aleichem.* New York: R. L. Leslie, 1953.

The Cherry Tree Legend. New York: The Museum of Modern Art, 1953.

Fleg, Edmund. *The Alphabet of Creation, An Ancient Legend from the Zohar.* New York: The Spiral Press, Pantheon Books, 1954.

Howe, Irving (ed.). *A Treasury of Yiddish Stories.* New York: Viking Press, 1954.

Aleichem, Sholom. *The Old Country.* New York: Crown, 1954.

Aleichem, Scholom. *Eine Hochzeit ohne Musikanten.* Frankfurt, Germany: Insel-Verlag, 1955.

Berryman, John. *Homage to Mistress Bradstreet.* New York: Farrar, Straus & Cudahy, 1956.

Owen, Wilfred. *Thirteen Poems by Wilfred Owen.* Northampton, Massachusetts: Gehenna Press, 1956. (Four hundred copies; portrait of Owen wood-engraved by Leonard Baskin from a drawing by Ben Shahn and printed from the wood block; numbers 1-35 bound in half leather with an extra proof of wood engraving printed on Japanese vellum and signed by artist and engraver.)

Sweet Was the Song (illustrations, musical score, and calligraphy by Ben Shahn). New York: The Museum of Modern Art, 1956.

I Sing of a Maiden. Private publication by Ben Shahn. Roosevelt, New Jersey, 1957.

Dahlberg, Edward. *The Sorrows of Priapus.* New York: New Directions, 1957. (Limited edition of 150 on mould-made Arches paper signed by author and artist, with one loose photo-offset copy of one of the four illustrations; also a trade edition.)

A Portion of Jubilate Agno, A Poem by Christopher Smart, 1722-1771. Cambridge, Massachusetts: Harvard University-Fogg Art Museum, 1957. (Fogg Picture Book No. 8.)

Perelman, J. S. *The Road to Miltown.* New York: Simon and Schuster, 1957.

Reid, Alastair. *Ounce Dice Trice.* Boston, Toronto: Little, Brown. 1958.

Lee, Robert E. *The Fundamental Creed.* New York: The Spiral Press, 1958.

Adam, Michael. *A Matter of Death and Life.* Marazion, Cornwall, England: Out of the Ark Press, 1959.

Hamlet. New York: Crafton Graphic Company, February 16, 1959. (A TV script illustrated by Shahn, adapted by Michael Benthall and Ralph Nelson for presentation on the CBS TV network by the Old Vic Company on February 24, 1959.)

Rabinowitz, Shalom. "Eine Hochzeit ohne Musikanten," in *Erzählungen Scholem Aleichem,* Frankfurt, Germany: Insel-Verlag, 1961; text in German.

Samstag, Nicholas. *Kay Kay Comes Home.* New York: Ivan Obolensky, Inc., 1962.

Ish-Kishor, Sulamith. *A Boy of Old Prague.* New York: Pantheon Books, 1963.

Shahn, Ben. *Maximus of Tyre.* New York: The Spiral Press, 1964, (©1963).

Berry, Wendell. *November Twenty-Six, Nineteen Hundred Sixty-Three.* New York: George Braziller, 1964. (Both a limited and a first edition.)

Untermeyer, Louis (ed.). *Love Sonnets.* New York: The Odyssey Press, 1964.

Aleichem, Sholom. *Inside Kasrilevke.* New York: Schocken Books, 1965.

Dugan, Alan, "Branches of Water or Desire," *Art in America* (October, 1965), pp. 30-31.

Ecclesiastes or, The Preacher, in the King James translation of the Bible, with drawings by Ben Shahn, engraved in wood by Stefan Martin. Calligraphy by David Soshensky. New York: The Spiral Press, 1965. (A limited edition of 285 numbered copies.)

Haggadah for Passover. Copied and illustrated by Ben Shahn with a translation, introduction and historical notes by Cecil Roth. Boston: Little, Brown; and Paris: Trianon Press, 1965.

Hudson, Richard. *Kuboyama and the Saga of the Lucky Dragon.* New York, London: Thomas Yoseloff, 1965. (Text by Richard Hudson is based on the book, *The Voyage of the Lucky Dragon,* by Ralph E. Lapp.)

Sweet was the Song. New York: The Odyssey Press, 1965.

Haggadah for Passover (Deluxe edition), with a translation, introduction, and historical notes by Cecil Roth. Paris: Trianon Press, 1966. (Box, 13 x 17″, covered in parchment with brass clasps and gold lettering; XXIV vols., 935 pp., twelve color illustrations and double title page, 15¾ x 12″; first edition, 292 copies bearing artist's signature and cypher on frontispiece, and including: eighteen copies numbered i-xviii, *hors commerce;* ten copies, lettered A-J, each containing one artist's original illustration of "An Only Kid," printed on Auvergne handmade pure rag paper, including two extra sets of color plates, one on Japanese Nacré, one on Arches Grand Vélin, and one set of plates left uncolored, on Arches Vergé paper; sixteen copies, lettered K-Z on Arches Grand Vélin pure rag paper, including extra set of color plates on Auvergne, a set of plates left uncolored on Arches Vergé, three of original guide sheets and stencils, and two proof states of the lithograph frontispiece; twenty copies, numbered I-XX, printed on Arches Grand Vélin pure rag paper, including an extra set of color plates on Arches Vergé paper, a set of plates left uncolored on Arches Vergé, and a proof state of the lithograph frontispiece; 228 copies, numbered 1-228, printed on pure rag Arches Vergé paper especially manufactured to match the paper used by the artist, plus eighteen copies NFS.

The Cherry Tree Legend. New York: The Museum of Modern Art, 1967.

Five Ballets of the Five Senses. New York: National Educational Television, 1967.

Ecclesiastes (handwritten and illustrated by Ben Shahn). Paris: Trianon Press, 1967. (Slipcase, 10 x 13⅛″ covered with green morocco binding; twenty-six copies, lettered A-Z on Arches Grand Vélin, containing two original lithographed drawings signed by the artist, with extra set of illustrations and a progressive series of states of the plates; 200 copies, numbered 1-200 on Arches Vergé, containing one original lithographed drawing signed by the artist; fourteen copies, *hors commerce.*)

A Partridge in a Pear Tree. New York: The Museum of Modern Art, 1949; revised, 1951; fifth printing, 1967.

Porter, Katherine Anne. *A Christmas Story.* New York: The Delacorte Press, 1967.

Hallelujah (twenty-four lithographs plus twenty-four plates of hand calligraphy and two title pages illustrating Psalm 150 with introduction by Bernarda Bryson Shahn and letter from Fernand Mourlot). New York: Kennedy Graphics, Inc., 1971. (Lithographs for this book reproduced by Mourlot Graphics on Arches Grand Velin paper, typography arranged and printed by The Spiral Press, binding and cases executed by The Moroquain Bindery, all in New York; limited to 240 numbered copies and ten copies lettered

A-J; two miniature versions, unbound, one with calligraphy and one without were also printed, each in a limited edition of 250 unnumbered copies. Drawn just before his death, and published posthumously, this was Shahn's last completed work.

Ecclesiastes or, The Preacher, hand written and illuminated by Ben Shahn. New York: Grossman; and Paris: Trianon Press, 1971. (Posthumous edition.)

LIMITED EDITION PORTFOLIOS ILLUSTRATED BY SHAHN

Levana and Our Ladies of Sorrow (a portfolio of ten lighographs by Ben Shahn, with text of Thomas De Quincey's essay). Brooklyn, New York: Philip Van Doren Stern, 1931. (Edition of 212 portfolios containing ten original lithographs drawn on the stone, 13 x 10″, and printed in sepia on Canson & Montgolfier's *Papier Ancien;* 1-12 contain a suite of numbered, mounted, and signed lithographs. De Quincey's essay, never before printed separately since original publication in *Blackwood's Magazine* in 1845, was issued especially for this edition; it was set in Goudy's Deepdene type and printed on Alexandra Japan.)

For the Sake of a Single Verse (from *The Notebooks of Malte Laurids Brigge* by Rainer Maria Rilke). New York: Atelier Mourlot, 1968. (Edition of 950 containing twenty-four original lithographs, each sheet 22½ x 18″; nos. 1-200 printed on *Richard de Bas* hand-made paper, numbered and signed by the artist; nos. 201-950 have lithographs signed on the stone; all portfolios are signed by the artist.)

BOOKS, ESSAYS AND ADDRESSES ABOUT SHAHN

Clark, Sir Kenneth (ed.) and Alfred H. Barr, Jr. (American Ed.). *Ben Shahn.* West Drayton, Middlesex, England: Penguin Books, Ltd., 1947.

Soby, James Thrall. *Ben Shahn (The Penguin Modern Painters).* New York: The Museum of Modern Art and Penguin Books, 1947.

——————. *Contemporary Painters.* New York: The Museum of Modern Art, 1948, pp. 40-50.

Larkin, Oliver. *Art and Life in America.* New York: Rinehart, 1949, pp. 430, 437-38, 441, 465, 466, 476-79.

Rodman, Selden. *Portrait of the Artist as an American. Ben Shahn: A Biography with Pictures.* New York: Harper, 1951.

Pearson, Ralph M. *The Modern Renaissance in American Art.* New York: Harper, 1954, pp. 117-23.

Baur, John (ed.). *New Art in America: Fifty Painters of the 20th Century.* Greenwich, Connecticut: New York Graphic Society in cooperation with Frederick A. Praeger, Inc., New York, 1957. ("Ben Shahn" by James Thrall Soby, pp. 118-23; statement by the artist, p. 123.)

Eliot, Alexander. *Three Hundred Years of American Painting.* New York: Time, Inc., 1957, pp. 237, 239-41, 242.

Rodman, Selden. *Conversations with Artists.* New York: The Devin-Adair Co., 1957, pp. 189-93, 221-28; Capricorn Books, New York, 1961, pp. 189-93, 221-28. (Interview with Shahn.)

Solby, James Thrall. *Ben Shahn. His Graphic Art.* New York: George Braziller, 1957; second printing, 1963.

Vollmer, Hans. *Allgemeines Lexikon der Bildenden Künstler.* Leipzig: 1958, vol. IV, pp. 268-69.

Golden, Cipe Pineles. *A Medal for Ben.* New York: American Institute for Graphic Arts, 1959. (Remarks delivered by Mrs. Golden at the presentation of the medal of the American Institute of Graphic Arts to Ben Shahn at dinner meeting in New York, November 13, 1958.)

Canady, John. *Mainstreams of Modern Art.* New York: Holt, Rinehart and Winston, 1959, pp. 518-520.

Goodrich, Lloyd and John Baur. *American Art of Our Century.* New York: Published for the Whitney Museum of American Art by Frederick A. Praeger, Inc., 1961, pp. 158, 163, 165.

Nordenfalk, Carl. *Ben Shahn's Portrait of Dag Hammarskjöld.* Stockholm, Statens Konstsamlingars Tillväxt och Förvaltning, Meddelanden fran Nationalmuseum, 1962, No. 87: pp. 84-87.

Bentivoglio, Mirella. *Ben Shahn.* Rome: De Luca Editore, 1963.

Soby, James Thrall. *Ben Shahn Paintings.* New York: George Braziller, 1963.

Guercio, Antonio. *Ben Shahn.* Rome: Editore Riuniti, 1964.

"Ben Shahn," *Masterpieces of the World,* Vol. 16. Tokyo: Heibonsha Publishers, 1965.

Guitar, Mary Anne. *Twenty-two Famous Painters and Illustrators Tell How They Work.* New York: David McKay, 1965, pp. 184-95.

Bush, Martin H., *Ben Shahn: The Passion of Sacco and Vanzetti.* New York: Syracuse University Press, 1968.

Kingman, Lee, and others (comps.). *Illustrators of Children's Books, 1957-1966.* Boston: Horn Book, 1968, pp. 171-72.

Tassi, Roberto, *I Maestri Del Colore.* Milan: Fabbri Editore, 1969.

Weiss, Margaret (ed.). *Ben Shahn, Photographer.* New York: Da Capo Press, 1973. (Selection of Shahn's photos taken in the 1930s for the Farm Security Administration).

ARTICLES ABOUT SHAHN

"Ben Shahn: The Downtown Gallery," *Art News* (April 19, 1932), p. 10. (Review of Sacco-Vanzetti exhibition.)

Gutman, Walter, "The Passion of Sacco-Vanzetti," *The Nation* (April 20, 1932), p. 475. (Review of the Downtown Gallery exhibition.)

Josephson, Matthew, "Passion of Sacco-Vanzetti," *New Republic* (April 20, 1932), p. 275.

"Ben Shahn: The Downtown Gallery," *Art News* (May 13, 1933) p. 5. (Review of Mooney exhibition.)

Charlot, Jean, "Ben Shahn," *Hound and Horn* (July-September, 1933), pp. 632-34.

Gellert, Hugo, "We Captured the Walls!" *Art Front* (November, 1934), p. 8. (About the proposed rejection of murals submitted for the Museum of Modern Art exhibition.)

Davis, Stuart, "We Reject—the Art Commission," *Art Front* (July, 1935), pp. 4-5. (Protests the rejection of the proposed Riker's Island mural by the Municipal Art Commission; illustrations of a section and a detail of the proposed mural.)

Whiting, Philippa. "Speaking About Art: Riker's Island," *The American Magazine of Art* (August, 1935), pp. 492-96. (About the rejection of Shahn's and Block's sketches; includes opinions of prisoners at the Riker's Island Penitentiary.

"The Bronx—A Typical Treasury Competition," *Art Digest* (June 1, 1938), p. 26.

Morse, John D., "Ben Shahn: An Interview," *Magazine of Art* (April, 1944), pp. 136-41.

"New Deal Defeatism," *Daily Mirror,* New York (October 16, 1944), p. 17. (Election campaign, anti-Roosevelt editorial using as its starting point Shahn's poster *For Full Employment After The War—Register—Vote.*)

Coates, Robert M. "New Show at the Downtown Gallery," *The New Yorker* (December 2, 1944), p. 95.

Connolly, Cyril, "An American Tragedy," *New Statesman and Nation,* London (June 29, 1946), pp. 467-68. (Review of the Tate Gallery exhibition of American Art.)

Wilenski, R. H., "A London Look at U. S. Painting in the Tate Gallery Show," *Art News,* (August, 1946), pp. 23-29. (Refers to Shahn's *Liberation.)*

Abell, Walter, "Art and Labor," *Magazine of Art* (October, 1946), pp. 231, 235-36, 239, 254-56. (Discusses Shahn's contribution to the CIO Political Action Committee.)

Morse, John D., "Henri Cartier-Bresson," *Magazine of Art* (May, 1947), p. 189. (Quotes Shahn's views on the photographer and on photography in general.)

Soby, James Thrall, "Ben Shahn," *Museum of Modern Art Bulletin,* New York (Summer, 1947), pp. 1-47. (Special issue devoted to Shahn retrospective; supplement to the Penguin monograph.)

Chamberlain, Betty, "Ben Shahn at the Museum of Modern Art," *Art News* (October 1, 1947), pp. 40-56.

Soby, James Thrall, "Ben Shahn and Morris Graves," *Horizon,* London (October, 1947), pp. 48-57.

Greenberg, Clement, "Art" (column), *The Nation* (November 1, 1947), p. 481. (Review of the Museum of Modern Art retrospective.)

Soby, James Thrall, "Ben Shahn," *Graphis 4,* no. 22, Zurich (1948), pp. 102-7, 188-89.

Hess, Thomas B., "Ben Shahn Paints a Picture," *Art News* (May, 1949), pp. 20-22, 55-56. (Photographs by Thelma Martin.)

Bryson, Bernarda, "The Drawings of Ben Shahn," *Image,* London (Autumn, 1949), pp. 31-50. (includes reproductions of drawings for the CBS programs, *Fear Begins at Forty* and *Mind in the Shadow,* and for articles in the *New Republic, Fortune,* and *Harper's Magazine.)*

Chanin, A. L., "Shahn, Sandburg of the Painters," *The Sunday Compass* (October 30, 1949), magazine section, p. 14.

Rodman, Selden, "Ben Shahn," *Portfolio* (The Annual of the Graphic Arts, 1951). Cincinnati: The Zebra Press, 1951, pp. 6-21.

—————— (ed.), "Ben Shahn Speaking," *Perspectives USA,* London (January, 1952), pp. 59-72.

——————, "Ben Shahn: Painter of America," *Perspective USA* London (Fall, 1952), pp. 87-96.

"The Artist and the Politicians," *Art News* (September, 1953), pp. 34-35.

Loucheim, Aline B., "Ben Shahn Illuminates," *The New York Times* (August 30, 1953), sec. 2, p. 8. ("Artist makes drawings for Off-Broadway production of three plays called 'The World of Sholom Aleichem.'")

"L'artista e il critica," *Selearte,* Firenze (November-December, 1954), pp. 4-9.

Barr, Alfred H., Jr., "Gli Stati Uniti alla Biennale: Shahn e de Kooning—Lachaise, Lassaw, e Smith," *La Biennale di Venezia,* (April-June 1954), pp. 62-67.

Masters of Modern Art, The Museum of Modern Art, 1954, p.162.

"Political Cartoons Today," *Art News* (October, 1954), p. 50.

Moe, Ole Henrik, "Ben Shahn," *Kunsten Idag,* Oslo (no. 1, 1956), pp. 30-52, 56-58. (Text in Norwegian and English.)

Peck, Edward S., "Ben Shahn, His 'Personal Statement' in Drawings and Prints," *Impression* (September, 1957), pp. 6-13.

"Ben Shahn," in "After Hours" (column), *Harper's Magazine* (December, 1957), pp. 79-81. (About Shahn's illustrations for *Harper's* articles.)

B., A., "Portrait: Ben Shahn," *Art in America* (winter, 1957-58), pp. 46-50. (Photographs of the artist at work by Fernandez.)

Brandon, Henry, "Art and Egg-Head: A Conversation with Ben Shahn," *The New Republic* (July 7, 1958), pp. 15-18. (A taped conversation for the *Sunday Times,* London, which appeared in the March 16, 1958 issue of that newspaper.)

Werner, Alfred, "Ben Shahn," *Reconstructionist* (October 3, 1958), pp. 16, 19-22.

Coates, Robert, "Should Painters Have Ideas?" *The New Yorker* (March 14, 1959), pp. 154-55. (Review of exhibition at the Downtown Gallery.)

Hale, Herbert D., "Ben Shahn," *Art News* (April, 1959), p. 13. (Review of exhibition at the Downtown Gallery.)

Kramer, Hilton, "Month in Review" (column), *Arts* (April, 1959), pp. 44-45. (Review of exhibition at The Downtown Gallery.)

Werner, Alfred, "Ben Shahn's Magic Line," *The Painter and Sculptor,* London (Spring, 1959), pp. 1-4.

Golden, Cipe Pineles, "Ben Shahn and the Artist as Illustrator," *Motif* (September, 1959), pp. 94-95.

"Man is Ultimate Value," *Time* (March 16, 1959), p. 62.

"The Gallic Laughter of André François," *Horizon* (May, 1959), pp. 108-121.

"Protiv Tečenija," *Amerika,* Washington (May, 1959), pp. 16-210.

Farr, Dennis, "Graphic Work of Ben Shahn at the Leicester Galleries," *Burlington Magazine,* London (December, 1959), pp. 470.

"Exhibition at The Downtown Gallery," review of the Lucky Dragon paintings, *Art News* (November 1961), p. 20.

Getlein, Frank, "Ben Shahn on Fallout," *The New Republic* (November 27, 1961), pp. 20-21.

Gilroy, Harry, "A Happy Response to Ben Shahn in Amsterdam," *The New York Times* (January 21, 1962), sec. 2, p. 17. (A report of the exhibition circulated by the International Council of the Museum of Modern Art.)

"In Homage," in "The Talk of the Town," *The New Yorker* (September 29, 1962), pp. 31-33. (Interview with Shahn on the memorial dedicated to President Franklin D. Roosevelt at Roosevelt, New Jersey.)

"200 Years of American Painting," *St. Louis Museum Bulletin XLVIII* (Nos. 1-2, 1964), p. 45.

Getlein, Frank, "Letter and the Spirit," *New Republic* (January 25, 1964), pp. 25-26.

"Ben Shahn Wins National Institute of Arts and Letters Gold Medal," *The New York Times* (January 28, 1964), p. 28.

McLean, R., "Book Production Notes; Two Recent Books on Ben Shahn," *The Connoisseur,* London (April, 1964), pp. 267-68.

"Ben Shahn Shows in London," *Studio International,* Kent, England (June, 1964), pp. 240-41 (Illustrations: "Maximus," drawing for "Labyrinth"; "Labyrinth," painting in color; "Shakespeare," drawing.)

"Exhibition at Leicester Galleries," *Apollo News Series,* London (June, 1964), p. 508. (Illustration: "Portrait of a Man," drawing.)

Roberts, L., "London Exhibition," *Burlington Magazine,* London (June, 1964), p. 354.

Willard, Charlotte, "Drawing Today," *Art in America* (October, 1964), p. 64.

"Ceramics by Twelve Artists," *Art in America* (December, 1964), p. 40.

Lionni, Leo. "Ben Shahn. His Graphic Work," *Graphis 62,* Zurich (1965), pp. 468-85. (Includes selection from Shahn's *Paragraphs on Art;* cover by Shahn.)

Frankel, Haskel, "Glass Houses and Green Rooms," *Saturday Review* (May 15, 1965), p. 30.

"Personal Backgrounds," *House and Garden* (December, 1965), pp. 178-79.

"Professor Wyschogrod Scores Use of Term 'Creativity' in Occupational Therapy, Entertainment, and Business as a Vulgarization," *The New York Times* (January 31,

1966), p. 1. (Speech to American Association of Existential Psychology and Psychiatry Conference; Shahn and Dr. Morris B. Parloff speak on creativity and the individual.)

"Trianon Press Offers Limited Editions of Haggadah Illustrated and Lettered by Ben Shahn for $450-1,600," *The New York Times* (April 10, 1966), p. 65.

Getlein, Frank, "The $475 Bargain," *The New Republic* (April 30, 1966), pp. 27-28.

"Fine Arts Medalist," *AIA Journal* (May, 1966), p. 16.

"Pratt Institute Commencement—Three Get Honorary Degrees," *The New York Times* (June 11, 1966), p. 28.

"Aspen, Quote Unquote," *Print* (September, 1966), p. 44.

"Senate Confirms Appointments of E. A. Ring, Dr. G. Conrad, Ben Shahn, Dean Pratt, Rex Gorleigh, Mrs. R. S. Conahay 3d, Mrs. M. Baker, St. J. Terrell and D. Schary," *The New York Times* (December 13, 1966), p. 34.

"Ben Shahn Ill," *The New York Times* (December 19, 1966), p. 51.

"Ben Shahn Ill," *The New York Times* (December 21, 1966), p. 29.

"The Drawings of Ben Shahn," *Spindrift*, The Saint Paul Art Center, Minnesota (February, 1966), pp. 4-9.

"In Hospital with Heart Ailment," *The New York Times* (February 1, 1967), p. 19.

"Harvard University Commencement," *The New York Times* (June 16, 1967), p. 46. (Professor Reischauer Speaks: he, 13 others get honorary degrees....)

Lewis, Peggy, "Ben Shahn...An Art Human and Spiritual," *Sunday Times Advertiser*, Pleasure section, Trenton, (November 26, 1967), pp. 1, 2. (Review of "The Graphic Work of Ben Shahn," exhibition at the Philadelphia Museum.)

"Avant-Garde Magazine Sponsors 'No More War' Poster Contest," *The New York Times* (September 5, 1967), p. 40. (Alexander Calder, Leonard Baskin, Edward Steichen, Ben Shahn, and Dwight MacDonald judges; Ralph Ginsburg comments.)

"Mellowed Militant," *Time* (September 15, 1967), pp. 72-73.

Barshay, Annette, "Ben Shahn Mosaics Will Come Back Home," *The Evening Times*, Trenton (July 18, 1968), p. 21. (New Jersey State Museum purchases murals from the S. S. Shalom.)

"Ben Shahn at Kennedy," *Arts Magazine* (September, 1968), p. 22. (Illustration: "Our House in Skowhegan.")

"Comments on Shahn's Work," *The New York Times* (September 11, 1968), p. 49. (Interview.)

"Exhibitions at Kennedy Gallery," *Art News*, New York (October, 1968), p. 67. (Illustrations: "Farmer Seated on a Porch," p. 6; "Vox Pop," p. 9.)

"Ben Shahn Interview," *The New York Times* (October 13, 1968), sec. 2, p. 39.

Kramer, Hilton, "Ben Shahn: Retrospective," *The New York Times* (October 27, 1968), sec. 2, p. 25.

"Exhibition at Kennedy Galleries," *Apollo News Series*, London (November, 1968), p. 392. (Illustration: "Portrait of Senator Fulbright.")

"Ben Shahn Gives Channel 13 Limited Edition of a Lithograph for Use in TV Station's Fund Raising Drive," *The New York Times* (November 14, 1968), p. 93.

"Shahn Mural at Syracuse," *AIA Journal* (Winter, 1968-69), p. 202.

"Ben Shahn—Drawings and Graphics at Kennedy Gallery," *Arts Magazine* (February, 1969), p. 63.

"Canadian Galleries," *Arts Magazine* (February, 1969), p. 53.

"Exhibition at Kennedy Gallery," *Art News* (February, 1969), p. 68.

"Ben Shahn Dies, 70," *The New York Times* (March 15, 1969), sec. 1, p. 2. (Portrait; paintings illustrated.)

"Shahn Funeral Set," *The New York Times* (March 16, 1969), p. 92.

Obituary, *Time* (March 21, 1969), p. 67.

Canaday, John, "Tribute," *The New York Times* (March 23, 1969), sec. 2, p. 30. (Portrait.)

Williams, Hon. Harrison A., Jr., of New Jersey in the Senate of the United States, "Death of Ben Shahn," *Congressional Record* (April 1, 1969), pp. E2529-30 (Includes article, "Shalom, Ben Shahn" by Peggy Lewis, from *Sunday Times Advertiser*, Pleasure section, Trenton, March 23, 1969.

Obituary, *Newsweek* (March 24, 1969), p. 94.

Levine, J., Obituary, *The Nation* (March 31, 1969), p. 390.

Obituary, *Publishers' Weekly* (April 7, 1969), p. 35.

Obituary, *Das Kunstwerk* (April, 1969), p. 47.

Obituary, *Art News* (May, 1969), p. 8.

Stermer, D., "In Memorium: Ben Shahn," *Ramparts*, (May, 1969), pp. 17-20.

Obituary, *Connaissance des Arts* (May, 1969), p. 31.

Obituary, *Current Biography* (May, 1969), p. 47.

Obituary, *Progressive Architecture* (May, 1969), p. 61.

Glueck, Grace, "Blam! to the Top of Pop," *The New York Times* (September 21, 1969), sec. 2, p. 31.

De Shazo, Edith, "Ben Shahn: Early Forms of Protest," *Camden Courier-Post Weekend Magazine* (September 27, 1969), p. 9.

Lensen, Michael, "Ben Shahn Show," *Newark Sunday News* (September 28, 1969), sec. 6, p. E19.

Werner, Alfred, "Ben Shahn: Involved Artist," *The Progressive* (October, 1969), pp. 35-37.

"Exhibition at Kennedy Galleries," *Art News* (November, 1969), p. 88.

Lewis, Peggy, "Ben Shahn Retrospective at the New Jersey State Museum," *Arts Magazine* (November, 1969), p. 53.

"Exhibition at Kennedy Galleries," *Arts Magazine* (December, 1969), p. 64.

Obituary, *Current Biography Yearbook 1969* (1970), p. 473.

Wasserman, Burton, "Ben Shahn in Retrospect," *Art Education* (April, 1970), pp. 23-25.

Prescott, Kenneth W., "Ben Shahn (1898-1969), Artist of the Exalted and the Common," *The Connoisseur*, London (August, 1970), p. 310. (Illustration: "Skowhegan Parade," Cover, "Television Antennae.")

Weiss, Margaret R., "Ben Shahn Photographer," *Saturday Review*, (November 7, 1970), pp. 26, 27.

Shahn, Bernarda, "Ben Shahn's Lettering," *Publishers' Weekly* (December 7, 1970), pp. 38, 40.

EXHIBITION CATALOGUES

Paintings and Drawings, Ben Shahn. New York: The Downtown Gallery, April 8-27, 1930.

The Passion of Sacco-Vanzetti. New York: The Downtown Gallery, April 5-17, 1932.

Ben Shahn. Cambridge: Harvard Society of Contemporary Art. Catalogue of exhibition of Sacco-Vanzetti and Dreyfus case paintings, October 17-29, 1932.

The Mooney Case by Ben Shahn. New York: The Downtown Gallery. Catalogue of exhibition of sixteen gouaches, May 2-20, 1933. Foreword by Diego Rivera.

Sunday Paintings. New York: The Julien Levy Gallery, May 7-21, 1940.

Shahn Paintings. New York: The Downtown Gallery, November 14-December 2, 1944.

American Painting from the 18th Century to the Present Day. London: The Tate Gallery, July 15-August 5, 1946.

Ben Shahn. London: Mayor Gallery, May, 1947. Exhibition circulated in England by the Arts Council of Great Britain, June-July, 1947.

Ben Shahn. New York: The Museum of Modern Art. Retrospective exhibition of paintings, drawings, posters, illustrations, and photographs, September 30, 1947-January 4, 1948.

New Paintings and Drawings. New York: The Downtown Gallery, October 25-November 12, 1949.

Ben Shahn Drawings. Buffalo: The Little Gallery of the Albright Art School, March 17-April 27, 1950.

Ben Shahn, Willem de Kooning, Jackson Pollock. Chicago: The Arts Club of Chicago, October 2-27, 1951.

Ben Shahn. Paintings. New York: The Downtown Gallery, March 11-29, 1952.

Paintings by Lee Gatch, Karl Knaths, Ben Shahn. Santa Barbara: Museum of Art; San Francisco: California Palace of the Legion of Honor; Los Angeles County Museum. June-August, 1952.

Four Americans from the Real to the Abstract. Houston: Contemporary Arts Museum, January 10-February 11, 1954.

Ben Shahn, Charles Sheeler, Joe Jones. Detroit: Institute of Arts, March 9-April 11, 1954.

Ben Shahn. Chicago: Renaissance Society, at the University of Chicago. Exhibition of eight serigraphs, two drawings, November 6-20, 1954.

Ben Shahn. Drawings and Serigraphs. Carbondale: Allyn Art Gallery, Southern Illinois University, November 1-24, 1954.

2 Pittori: de Kooning, Shahn; 3 Scultori: Lachaise, Lassaw, Smith. Esposizione organizzata dal Museum of Modern Art, New York. Venice: Esposizione Biennale Internazionale D'Arte XXVII, 1954. Stati Uniti d'America. Catalogue of American section; texts in Italian and English by Andrew C. Ritchie and James Thrall Soby, with statements by the artists.

Ben Shahn. Paintings and Drawings. New York: The Downtown Gallery, January 18-February 12, 1955.

The Art of Ben Shahn. Cambridge: Fogg Art Museum, Harvard University, December 4, 1956-January 19, 1957.

The Graphic Works of Ben Shahn. New York: American Institute of Graphic Arts, March 1-28, 1957.

Ben Shahn: A Documentary Exhibition. Boston: Institute of Contemporary Art. Mimeographed catalogue of the exhibition, April 10-May 31, 1957. Foreword by T. M. Messer.

Ben Shahn. New York: The Downtown Gallery, March 3-28, 1959. Essay by Ben Shahn.

Shahn Silkscreen Prints. Louisville: University of Louisville, November 22-December 31, 1960.

Ben Shahn. Silkscreen Prints, 1950-1959. New York: The Downtown Gallery, December 8-24, 1960.

Ben Shahn: The Saga of the Lucky Dragon. New York: The Downtown Gallery. Catalogue of exhibition of paintings and drawings, October 10-November 4, 1961.

Ben Shahn. Amsterdam: Stedlijk Museum. Catalogue of exhibition circulated by the International Council of the Museum of Modern Art, December 22, 1961-January 22, 1962.

Ben Shahn. Brussels: Palais des Beaux-Arts. Catalogue of exhibition circulated by the International Council of the Museum of Modern Art, February 3-25, 1962.

Ben Shahn. Rome: Galleria Nazionale d'Arte Moderna. Catalogue of exhibition circulated by the International Council of the Museum of Modern Art, March 31-April 29, 1962.

Ben Shahn. Vienna: Albertina. Catalogue of exhibition circulated by the International Council of the Museum of Modern Art, May 22-June 25, 1962.

Ben Shahn. Baden-Baden: Kunsthalle. Catalogue of the exhibition circulated by the International Council of the Museum of Modern Art, August 3-September 9, 1962. Introduction by Dietrich Mahlow; essay by James Thrall Soby and Mildred Constantine.

Art from New Jersey. Trenton: New Jersey State Museum. Catalogue of exhibition, April 8-June 12, 1966.

Ben Shahn. Santa Barbara Museum of Art; La Jolla Museum of Art; the Art Association of Indianapolis, Herron Museum of Art. Catalogue of the exhibition, July, 1967-January, 1968. Introduction by William J. Hesthal.

The Collected Prints of Ben Shahn. Philadelphia: Museum of Art. Catalogue of the exhibition, November-December, 1967. Introduction by Kneeland McNulty; essay and commentary by Ben Shahn.

Ben Shahn. New York: Kennedy Galleries. Catalogue of exhibition, October 12-November 2, 1968. Introduction by Frank Getlein.

Ben Shahn on Human Rights. Washington, D.C.: Museum of African Art, 1968. Exhibition folder, with introduction by Warren Robbins.

Ben Shahn: A Retrospecitve Exhibition. Trenton: New Jersey State Museum. Catalogue of the exhibition, September 20-November 16, 1969. Statement by Kenneth W. Prescott; annotated chronology by Leah P. Sloshberg, bibliography by Peggy Lewis.

Ben Shahn. New York: Kennedy Galleries. Catalogue of the exhibition, November 5-29, 1969. Introduction by Lawrence A. Fleischman.

Ben Shahn as Photographer. Cambridge: Fogg Art Museum. Catalogue of exhibition of sixty-nine photographs, October 29-December 14, 1969. Introduction by Davis Pratt.

Ben Shahn. Tokyo: The National Museum of Modern Art. Catalogue of exhibition of paintings, drawings, graphics, and posters circulated by Kennedy Galleries in cooperation with the New Jersey State Museum, May 21-July 5, 1970. Essays by Bernarda Shahn, Kenneth W. Prescott, and William A. Smith. Japanese and English language editions.

Ben Shahn. Tokyo: Nantenshi Gallery. Catalogue of exhibition, May 22-June 13, 1970. Text in Japanese; introduction, "Thinking of Ben Shahn," by Yasuo Kamon, Director of the Bridgestone Gallery, Tokyo.

The Drawings of Ben Shahn. New York: Kennedy Galleries. Catalogue of the exhibition, October, 1970. Introduction by Kenneth W. Prescott.

Ben Shahn (1898-1969). New York: Kennedy Galleries. Catalogue of the exhibition of fifty-three paintings and drawings, November 6-27, 1971. Introduction by Kenneth W. Prescott.

APPENDIX C
INSTITUTIONAL HOLDINGS OF SHAHN PRINTS — A PARTIAL LISTING

(based on sales records and 1970-71 survey)

CALIFORNIA

San Francisco Museum of Art
BEATITUDES

Santa Barbara Museum of Art
TRIPLE DIP
SILENT NIGHT

University of California, Los Angeles Art Galleries
BEATITUDES

University of California, Santa Barbara, The Art Gallery
MARTIN LUTHER KING (wood-engraving)

COLORADO

University of Colorado Art Gallery (Boulder)
BEATITUDES
WHERE THERE IS A BOOK THERE IS NO SWORD

CONNECTICUT

New Britain Museum of American Art
ALL THAT IS BEAUTIFUL

Wadsworth Atheneum (Hartford)
BEATITUDES
FUTILITY

Wesleyan University, Davison Art Center (Middletown)
WHERE THERE IS A BOOK THERE IS NO SWORD

Yale University Art Gallery (New Haven)
POET
SKOWHEGAN

DISTRICT OF COLUMBIA

The Corcoran Gallery of Art
BRANCHES OF WATER OR DESIRE

Library of Congress
ALGERIAN MEMORY
ALPHABET OF CREATION
CAT'S CRADLE (in black and blue)
LUTE AND MOLECULE, No. 2
MASK (serigraph)
MINE BUILDING
PASSION OF SACCO AND VANZETTI
PHOENIX (in black)
PLEIADES
PSALM 133 (serigraph)
SUPERMARKET (in black)

WHEAT FIELD
WHERE THERE IS A BOOK THERE IS NO SWORD

Museum of African Art
FREDERICK DOUGLASS PORTFOLIO

National Gallery of Art
ALPHABET OF CREATION
BEATITUDES
BLIND BOTANIST (serigraph)
LUTE AND MOLECULE
PORTRAIT OF SACCO AND VANZETTI
PLEIADES
SILENT MUSIC
WHEAT FIELD
WHERE THERE IS A BOOK THERE IS NO SWORD

GEORGIA

University of Georgia Museum of Art (Athens)
BEATITUDES
MARTIN LUTHER KING (wood-engraving)

HAWAII

Honolulu Academy of Arts (Island of Oahu)
ALGERIAN MEMORY
CAT'S CRADLE (in black and blue)
LUTE AND MOLECULE, No. 1
MASK (serigraph)
POET
PSALM 133 (serigraph)
SUPERMARKET (in black with hand coloring)

ILLINOIS

The Art Institute of Chicago
LAISSEZ-FAIRE

INDIANA

Indiana University Museum of Art (Bloomington)
MASK (serigraph)
PHOENIX (in black)

IOWA

Des Moines Art Center
PATERSON (in black with hand coloring)

KANSAS

University of Kansas, Museum of Art (Lawrence)
LUTE AND MOLECULE

Washburn University, Mulvane Art Center (Topeka)
SCIENTIST
SUPERMARKET (in black with hand coloring)
TV ANTENNAE

KENTUCKY

Berea College Art Museum
BEATITUDES
FUTILITY

University of Kentucky,
University Art Gallery (Lexington)
LUTE AND MOLECULE, No. 2

University of Louisville, Allan R. Hite Art Institute
LUTE AND MOLECULE, No. 1

MAINE

Portland Museum of Art
SILENT MUSIC

MARYLAND

The Baltimore Museum of Art
ALL THAT IS BEAUTIFUL
BEATITUDES
FUTILITY
WHERE THERE IS A BOOK THERE IS NO SWORD

MASSACHUSETTS

De Cordoba and Dana Museum and Park (Lincoln)
SUPERMARKET (in black with hand coloring)
HUMAN RELATIONS PORTFOLIO

Harvard University, Fogg Art Museum (Cambridge)
SILENT MUSIC
TV ANTENNAE

Museum of Fine Arts (Boston)
LUTE AND MOLECULE, No. 1
PATERSON (black and white)
PHOENIX (in black with hand coloring)
PROFILE
SILENT MUSIC
SUPERMARKET (trial proof)

Museum of Fine Arts of Houston, Texas
PHOENIX (in black with hand coloring)
PHOENIX (in black)
WHERE THERE IS A BOOK THERE IS NO SWORD

Texas Technological College,
West Texas Museum (Lubbock)
BLIND BOTANIST (serigraph)

VIRGINIA
Randolph-Macon Woman's College,

Art Gallery (Lynchburg)
GANDHI (serigraph)

WISCONSIN
Milwaukee Art Center, Inc.
SILENT NIGHT

University of Wisconsin, Elvejhem Art Center (Madison)
PATERSON
TV ANTENNAE

AUSTRIA
Albertina, Vienna
MINE BUILDING
SILENT MUSIC

DENMARK
Royal Museum of Fine Arts (Copenhagen)
CAT'S CRADLE (in black and blue)
PRENATAL CLINIC
WARSAW 1943

APPENDIX D

LITERATURE CITED

Foreword

1. Ben Shahn, *Love and Joy About Letters*, 1963, p. 5.
2. *Ibid.*, p. 5.
3. Selden Rodman, *Portrait of the Artist as an American*, 1951, p. 170.
4. *Ibid.*, p. 168.
5. Ben Shahn, *The Shape of Content*, Vintage ed., 1960, p. 35.
6. Shahn, *Love and Joy*, pp. 11-13.
7. *Ibid.*, p. 13.
8. Shahn, *Shape of Content*, p. 41.
9. *Ibid.*, p. 42.
10. James Thrall Soby, *Ben Shahn Paintings*, 1963, pl. 7.
11. *Ben Shahn as Photographer*, Fogg Art Museum catalogue, unnumbered p. 1.
12. *Ibid.*, unnumbered p. 2.
13. Shahn, *Shape of Content*, p. 47.
14. *Ibid.*, p. 48.
15. *Ibid.*, p. 55.
16. Cipe Pineles Golden, Kurt Weihs, Robert Strunsky, *The Visual Craft of William Golden*, 1962, p. 127.
17. *Ibid.*
18. Selden Rodman, "Ben Shahn," *Portfolio*, 1951, p. 7.
19. Soby, *Paintings*, pl. 77.
20. Ben Shahn, *Paragraphs on Art*, 1952, unnumbered p. 4.

Part One—Prints

21. Soby, *Paintings*, p. 26.
22. Ben Shahn, "Shahn in Amsterdam," *Art in America*, no. 3, 1961, p. 62.
23. Kneeland McNulty, *The Collected Prints of Ben Shahn*, 1967, p. 5.
24. John D. Morse, "Ben Shahn, An Interview," *Magazine of Art*, vol. 37, April, 1944, p. 138.
25. Robert M. Coates, "New Show at the Downtown Gallery," *The New Yorker*, vol. 20, December 2, 1944, p. 95.
26. McNulty, p. 58.
27. *Ibid.*, p. 34.
28. Leo Lionni, "Ben Shahn. His Graphic Work," *Graphis 62*, vol. 11, no. 62, 1955, p. 483.
29. Shahn, *Love and Joy*, p. 68.
30. Soby, *Paintings*, pl. 50.
31. McNulty, p. 142.
32. Kennedy Galleries, *Ben Shahn* (exhibition catalogue), 1969, pl. 31.
33. Ben Shahn, "The Artist's Point of View," *Magazine of Art*, vol. 42, November 1949, p. 266.
34. McNulty, p. 48.
35. Soby, *Paintings*, pl. 45.
36. Nantenshi Gallery, Tokyo, *Ben Shahn* (exhibition catalogue), 1970, pl. 12.
37. Shahn, *Love and Joy*, p. 69.
38. Rodman, *Portfolio*, p. 19.
39. McNulty, p. 142.
40. Golden, Weihs, Strunsky, p. 119.
41. Soby, *Paintings*, pl. 47.
42. Rodman, *Portrait*, p. 27.
43. McNulty, p. 4.
44. *Ibid.*
45. Shahn, *Shape of Content*, pp. 35-38.
46. Ben Shahn, *The Biography of a Painting*, Paragraphic Books ed., 1966, unnumbered p. 3.
47. *Ibid.*, unnumbered p. 21.
48. Kennedy Galleries, *Ben Shahn* (exhibition catalogue), 1968, unnumbered plate.
49. Shahn, *Paragraphs*, unnumbered.
50. McNulty, p. 90.
51. *Ibid.*, p. 5.
52. Rodman, *Portrait*, p. 3.
53. Soby, *Ben Shahn His Graphic Art*, 1957, p. 48.
54. Selden Rodman, "Ben Shahn: Painter of America," *Perspectives/USA*, no. 1, Fall, 1952, p. 98.
55. McNulty, p. 86.
56. Soby, *Graphic Art*, p. 48.
57. *Ibid.*, p. 74; Shahn, *Biography*, unnumbered p. 88.
58. Shahn, *Shape of Content*, p. 74.
59. McNulty, p. 118.
60. Golden, Weihs, Strunsky, pp. 64-65.
61. *Art News*, vol. 54, November, 1955, p. 17.
62. McNulty, p. 28.
63. Soby, *Graphic Art*, p. 50; Shahn, *Shape of Content*, p. 53.
64. Shahn, *Paragraphs*, unnumbered p. 7.
65. Soby, *Graphic Art*, p. 19.
66. McNulty, p. 82.
67. Soby, *Graphic Art*, pp. 15-16.
68. *Harper's*, December, 1957, p. 79.
69. Shahn, *Love and Joy*, pp. 13, 37.
70. Soby, *Graphic Art*, p. 80.
71. Soby, *Paintings*, pl. 78.
72. McNulty, p. 70.
73. Soby, *Paintings*, pl. 80.
74. *Ibid.*, pl. 82.
75. Soby, *Graphic Art*, p. 72.
76. McNulty, p. 70.
77. Downtown Gallery. Ben Shahn (exhibition catalogue), 1959.
78. Shahn, "Artist's Point of View," p. 266.
79. Golden, Weihs, Strunsky, p. 42.
80. McNulty, p. 114.
81. *Ibid.*, p. 7.
82. *Art News*, vol. 30, April 9, 1932, p. 10.
83. New Jersey State Museum, *Ben Shahn: A Retrospective Exhibition* (exhibition catalogue), 1969.
84. Soby, *Graphic Art*, p. 63.
85. McNulty, p. 5.
86. Selden Rodman, *Conversation with Artists*, 1961, pp. 224-25.

87. Shahn, *Love and Joy*, p. 47.
88. Shahn, *Shape of Content*, p. 47.
89. Shahn, *Love and Joy*, p. 63.
90. *Ibid.*, p. 52.
91. Ben Shahn, *Ecclesiastes or, The Preacher*, 1967, unnumbered p. 13.
92. McNulty, p. 18.
93. Kennedy Galleries, 1968, pl. 65.
94. Shahn, *Biography*, unnumbered p. 49.
95. Shahn, *Shape of Content*, p. 69.
96. McNulty, p. 40.
97. Soby, *Paintings*, pl. 83.
98. Shahn, *Biography*, unnumbered p. 55.
99. McNulty, p. 74.
100. *Ibid.*, p. 42.
101. Shahn, *Biography*, unnumbered p. 1.
102. *Ibid.*, frontispiece; Shahn, *Shape of Content*, frontispiece.
103. McNulty, p. 92.
104. New Jersey State Museum, pl. 86.
105. McNulty, p. 104.
106. Soby, *Graphic Art*, p. 89.
107. Soby, *Paintings*, pl. 69.
108. Shahn, *Biography*, unnumbered p. 13.
109. McNulty, p. 30.
110. Soby, *Paintings*, pl. 84.
111. Edward Dahlberg, *The Sorrows of Priapus*, 1957, p. 61.
112. Ben Shahn, *Haggadah for Passover*, 1965, p. viii.
113. Dorothy and Sydney Spivack Collection.
114. The National Museum of Modern Art, Tokyo, *Ben Shahn* (exhibition catalogue), 1969, pl. 46.
115. Solomon Grayzel, *A History of the Jews*, 1947, pp. 87-88.
116. Howard Morley Sachar, *The Course of Modern Jewish History*, 1963, pp. 452-63.
117. Soby, *Paintings*, pl. 61.
118. Shahn, *Biography*, unnumbered p. 87.
119. McNulty, p. 20.
120. Alan Dugan, "Branches of Water or Desire," *Art in America*, October, 1965, pp. 30-31.
121. Leo Rosten, "They Made Our World...Gandhi," *Look*, vol. 28, no. 17, August 25, 1964, p. 60.
122. McNulty, p. 6.
123. Shahn, *Ecclesiastes*, unnumbered p. 33.
124. Shahn, *Love and Joy*, p. 74.
125. Soby, *Graphic Art*, p. 116.
126. Soby, *Paintings*, pl. 60.
127. Kennedy Galleries, 1968, pl. 50.
128. Shahn, *Biography*, unnumbered p. 1.
129. Shahn, *Shape of Content*, p. 134.
130. Shahn, *Biography*, unnumbered p. 20.
131. McNulty, p. 50.
132. Louis Untermeyer, *Love Sonnets*, 1964, p. 40.
133. McNulty, p. 96.

134. The National Museum, Tokyo. pl. 100; Kennedy Galleries, 1969, pl. 59.
135. Shahn, *The Alphabet of Creation*, Schocken ed., 1967, unnumbered p. 4; *Shape of Content*, p. 19.
136. Soby, *Graphic Art*, p. 102.
137. Untermeyer, *Sonnets*, pp. 20, 24.
138. Alastair Reid, *Ounce Dice Thrice*, 1958, p. 16.
139. Shahn, *Biography*, unnumbered p. 6.
140. Shahn, *Shape of Content*, p. 25; Soby, *Graphic Art*, frontispiece; Kennedy Galleries, 1968, pl. 27; *Biography* cover.
141. Soby, *Graphic Art*, p. 50.

Part Two— Portfolios
142. Rodman, *Portrait*, pp. 124-29.
143. McNulty, pp. 3-4.
144. Henry Brandon, "...A conversation with Ben Shahn," *The New Republic*, July 7, 1958, pp. 18-18.
145. John D. Morse, "Ben Shahn: An Interview," *Magazine of Art*, vol. 37, April, 1944, p. 136.
146. Shahn, "Artist's Point of View," p. 266.
147. McNulty, p. 136.
148. Shahn, *Love and Joy*, p. 56.
149. *Ibid.*, p. 33.
150. Rainer Maria Rilke, *The Notebooks of Malte Laurids Brigge*, Norton ed., 1964, pp. 26-27.
151. Soby, *Graphic Art*, p. 76.
152. Shahn, "Artist's Point of View," p. 266.
153. Soby, *Paintings*, pl. 86.
154. *Ibid.*, pl. 29.
155. Betty Chamberlain, "Ben Shahn at the Museum of Modern Art," *Art News*, vol. 46, October 1, 1947, p. 56.
156. Soby, *Graphic Art*, p. 122.
157. Rodman, *Portrait*, p. 2.

Part Three— Posters
158. Margaret R. Weiss, "Ben Shahn Photographer," *Saturday Review*, November 7, 1970, p. 26.
159. Kennedy Galleries, 1968, pl. 13.
160. Golden, Weihs, Strunsky, p. 126.
161. Rodman, *Portrait*, p. 63.
162. *Ibid.*, pp. 64-65.
163. *Ibid.*, p. 55.
164. Walter Abell, "Art and Labor," *Magazine of Art*, vol. 39, October, 1946, p. 236.
165. Santa Barbara Museum of Art, *Ben Shahn* (exhibition catalogue), 1967, pl. 26.
166. Soby, *Graphic Arts*, p. 17.
167. Santa Barbara, catalogue, pl. 43.
168. Chamberlain, *Art News*, p. 56.
169. B. Z. Goldberg, *The World of Sholom Aleichem*, 1953, unnumbered p. 5.
170. Downtown Gallery, catalogue of exhibition of January 12-February 12, 1955.
171. Soby, *Graphic Art*, p. 25.
172. Shahn, *Shape of Content*, p. 80.
173. Soby, *Graphic Art*, p. 26.

174. Shahn, *Shape of Content*, p. 143; Michael Adam, *A Matter of Death and Life*, 1959, pp. 48-49.
175. Adam, *Ibid.*
176. Soby, *Graphic Art*, p. 53.
177. Soby, *Paintings*, pl. 50.
178. *Ibid.*, pl. 65.
179. Soby, *Graphic Art*, pp. 112-113.
180. Shahn, *Biography*, unnumbered p. 57.
181. Soby, *Graphic Art*, p. 122.
182. *Ibid.*, p. 71.
183. Soby, *Paintings*, p. 67.
184. Soby, *Graphic Art*, p. 95.
185. Carl Nordenfalk, *Statens Konstsamlingars Tillväxt och Förvaltning 1962*, 1963, p. 84.
186. *Ibid.*, p. 87.
187. Kennedy Galleries, The Drawings of Ben Shahn (exhibition catalogue) 1970, cover and pl. 58.
188. *Ibid.*, 1969, pl. 49.
189. *Ibid.*, 1968, pl. 43.
190. Soby, *Graphic Art*, jacket and p. 70.
191. Kennedy Galleries, 1969, pl. 37.
192. Soby, *Graphic Art*, p. 92.
193. Shahn, *Biography*, p. 33.
194. Shahn, *Ecclesiastes*, unnumbered p. 40.
195. Kennedy Galleries, 1969, pl. 47.
196. Shahn, *Love and Joy*, p. 64.
197. *Ibid.*, p. 57.

Part Four— Photo-Reproductions, Unpublished Prints, and Works Published Posthumously
198. *Ibid.*, p. 78.
199. Dahlberg, pp. 57, 61, and 65.
200. Golden, Weihs, Strunsky, p. 64.

201. Shahn, *Shape of Content*, p. 92.
202. Kennedy Galleries, 1970, pl. 24.
203. Soby, *Paintings*, pl. 70.
204. *Ibid.*, pl. 51.
205. Dahlberg, p. 37.
206. Soby, *Paintings*, pl. 51.
207. Shahn, *Alphabet*, unnumbered p. 18.
208. Adam, p. 39.
209. Author's correspondence with Mrs. Mary S. Kiniry, advertising department, Benrus Watch Company.
210. Golden, Weihs, Strunsky, p. 127.
211. Soby, *Graphic Art*, p. 44.
212. Kennedy Galleries, 1970, pl. 26.
213. *J.A.M.A.*, vol. 157, no. 7, February 12, 1955, pp. 19-30.
214. Shahn, *Love and Joy*, p. 20.
215. Soby, *Paintings*, pl. 55.
216. Soby, *Graphic Art*, p. 88.
217. Kennedy Galleries, 1969, pl. 64.
218. *Ibid.*, pl. 56.
219. *Ibid.*, pl. 57.
220. *Ibid.*, pl. 51.
221. *Ibid.*, pl. 53.
222. *Ibid.*, pl. 61.
223. *Ibid.*, pl. 62.
224. *Ibid.*, pl. 54.
225. *Ibid.*, pl. 63.
226. *Ibid.*, 1970, pl. 59.
227. *Ibid.*, 1969, pl. 52.
228. *Ibid.*, pl. 58.
229. *Ibid.*, pl. 60.
230. *Ibid.*, pl. 55.
231. *Ibid.*, pl. 59.

APPENDIX E
CHRONOLOGICAL LISTING OF FIGURES

PART ONE — **PRINTS**

1936
Fig. 1 Seward Park
1941
Fig. 2 Immigrant Family
Fig. 3 Prenatal Clinic
Fig. 4 4½ Out of Every 5
Fig. 5 Vandenberg, Dewey, and Taft
1942
Fig. 6 The Handshake
1947
Fig. 7 Boy on Tricycle
Fig. 8 Laissez-faire
1948
Fig. 9 Deserted Fairground
1949
Fig. 10 Silent Night
1950
Fig. 11 Silent Music
Fig. 12 Where There Is a Book There Is No Sword
1952
PHOENIX THEME
Fig. 13 Phoenix (in black)
Fig. 14 Phoenix (in black with hand coloring)
Fig. 15 Profile (in black)
Fig. 16 Profile (in black and umber)
Fig. 17 Triple Dip
1953
PATERSON THEME
Fig. 18 Paterson (in black)
Fig. 19 Paterson (in black with hand coloring)
Fig. 20 TV Antennae
1955
Fig. 21 Beatitudes
1956
Fig. 22 Mine Building
Fig. 23 Wilfred Owen
1957
Fig. 24 Alphabet of Creation
LUTE AND MOLECULE THEME
Fig. 25 Lute
Fig. 26 Scientist
SUPERMARKET THEME
Fig. 27 Supermarket (in black)
Fig. 28 Supermarket (in black with hand coloring)

1958
Fig. 29 Lute and Molecule, No. 1 (brown version)
Fig. 30 Lute and Molecule, No. 2 (white version)
SACCO AND VANZETTI THEME
Fig. 31 Passion of Sacco and Vanzetti
Fig. 32 Portrait of Sacco and Vanzetti
Fig. 33 Immortal Words
Fig. 34 Three Penny Opera
Fig. 35 Wheat Field
1959
Fig. 36 Algerian Memory
CAT'S CRADLE THEME
Fig. 37 Cat's Cradle (in black)
Fig. 38 Cat's Cradle (in black and blue)
Fig. 39 Mask (serigraph)
1960
CREDO THEME
Fig. 40 Credo (in black)
Fig. 41 Futility
Fig. 42 Pleiades
Fig. 43 Poet
Fig. 44 Fragment of the Poet's Beard (original drawing)
Fig. 45 Psalm 133 (serigraph)
1961
BLIND BOTANIST THEME
Fig. 46 Blind Botanist (serigraph with hand coloring)
Fig. 47 Blind Botanist (serigraph)
Fig. 48 Decalogue
1962
Fig. 49 Martyrology
1963
Fig. 50 Blind Botanist (lithograph)
Fig. 51 Mask (lithograph)
Fig. 52 Maximus of Tyre
Fig. 53 Psalm 133 (lithograph)
Fig. 54 Warsaw 1943
1965
Fig. 55 All That Is Beautiful
Fig. 56 Branches of Water or Desire
Fig. 57 Gandhi
Fig. 58 I Think Continually of Those Who Were Truly Great (serigraph)
JEREMIAH THEME
Fig. 59 And Mine Eyes a Fountain of Tears (in black with brown English calligraphy)

Fig. 60 And Mine Eyes a Fountain of Tears (in red with black Hebrew calligraphy)
Fig. 61 Menorah
Fig. 62 Skowhegan
1966
Fig. 63 Alphabet and Maximus
Fig. 64 Alphabet and Warsaw
Fig. 65 Andante
Fig. 66 Byzantine Memory
Fig. 67 Credo (in black and blue)
ECCLESIASTES THEME
Fig. 68 Ecclesiastes (in black with sepia calligraphy)
Fig. 69 Ecclesiastes (in sepia with black calligraphy)
Fig. 70 Haggadah
Fig. 71 Levana
MARTIN LUTHER KING THEME
Fig. 72 Martin Luther King (wood-engraving)
Fig. 73 Praise Him with Psaltery and Harp
1967
Fig. 74 Ecclesiastes Man
Fig. 75 Ecclesiastes Woman
Fig. 76 Words of Maximus
1968
Fig. 77 Baseball
Fig. 78 Birds Over the City
Fig. 79 Headstand on Tricycle
Fig. 80 Culture (with brown calligraphy)
Fig. 81 Culture (with red calligraphy)
Fig. 82 Flowering Brushes
Fig. 83 Owl, No. 1
Fig. 84 Owl, No. 2
Fig. 85 Phoenix (in black with wash)
1969
Fig. 86 Epis

PART TWO — **PORTFOLIOS**

1931
LEVANA AND OUR LADIES OF SORROW
Fig. 87 Behold what is greater
Fig. 88 I saw dimly relieved
Fig. 89 Eternal silence reigns
Fig. 90 Rachel weeping
Fig. 91 She it was that stood
Fig. 92 Every slave
Fig. 93 Every woman
Fig. 94 She also is the mother
Fig. 95 He worshipped the worm
Fig. 96 To plague his heart

PART FOUR—
MISCELLANEOUS REPRODUCTIONS, GREETING CARDS, UNPUBLISHED WORKS, AND POSTHUMOUS WORKS

Miscellaneous Reproductions

Greeting Cards

Unpublished Works

Posthumous Works

INDEX

Works by Ben Shahn are indexed alphabetically according to the first word of the title and printed in italics. Page numbers referring to illustrations are also in italics. The Appendices are not indexed.

248